Philosophers on Art
from Kant
to the Postmodernists

**Philosophers on Art
from Kant
to the Postmodernists**
A Critical Reader

Edited by
Christopher Kul-Want

Columbia University Press
New York

Columbia University Press

Publishers Since 1893

New York Chichester, West Sussex

Copyright © 2010 Columbia University Press

All rights reserved

Library of Congress Cataloging-in-Publication Data

Philosophers on art from Kant to the postmodernists: a critical reader / edited by
Christopher Kul-Want.

 p. cm.

 Includes bibliographical references and index.

 ISBN 978-0-231-14094-2 (cloth: alk. paper)—ISBN 978-0-231-14095-9 (pbk.: alk.
paper)

 1. Aesthetics. 2. Art—Philosophy. 3. Philosophy, Modern. I. Want, Christopher.
 BH39.P47175 2010

 701—dc22

 2009042784

Casebound editions of Columbia University Press books are printed on permanent and
durable acid-free paper.

Printed in the United States of America

c 10 9 8 7 6 5 4 3 2 1

p 10 9 8 7 6 5

References to Internet Web sites (URLs) were accurate at the time of writing. Neither
the author nor Columbia University Press is responsible for Web sites that may have
expired or changed since the book was prepared.

For Catherine
and Enna Thea

Contents

Preface

This book is for those who want to know what philosophers have said about art and how their ideas relate historically and conceptually. At the book's core is the ongoing challenge that Immanuel Kant has bequeathed not just to philosophy but also to thinking and theoretical writing in his declaration that art is not an object of knowledge. For those European philosophers writing in the wake of Kant's legacy, this thesis has entailed a completely new orientation toward the nature of aesthetic experience, since this may affect not just approaches to art but also the conception of subjectivity itself.

Exploring this legacy this book brings together a compilation of the seminal texts on aesthetics and art by Continental philosophers from the past two and half centuries whose thought has been challenged yet shaped by art's incommensurability with recognized orders of knowledge. The contents and organization of the book draw a great deal upon my experience of teaching postgraduate students at Byam Shaw School of Art at Central St. Martins' College of Art and Design, University of the Arts, London. I am very grateful to my colleague Clive Hodgson for highlighting the keen desire that art students possess to engage with philosophy when we established the master's course at Byam Shaw School of Art ten years ago. This book owes much to the enthusiasm of my students to the subject of philosophers on art that forms the nucleus of the masters seminar program at Byam Shaw. I believe this strong response has arisen in part from the fact that while philosophy has its own forms and expression, nevertheless, it has deeply shared concerns and interests for those who make art. Among other things, these revolve around issues of resolution and completion with regard to the work of art and the possibility of transformation in the face of doubt, and even failure.

Bringing this book to fruition has entailed extensive correspondence with publishers' copyright departments, and I am very grateful for their assistance

in securing copyright for the book's texts. Jane Gibb and Professor Martin Woolley of the research department at Central St. Martins' have also been extremely helpful in securing several grants from the college to help pay for copyright purchases. I very much appreciate the support of the principal of my college, Alister Warman, who granted me a term's sabbatical leave to research this book. I would like to thank my editors, Wendy Lochner and Christine Mortlock at Columbia University Press, for their advice in the writing and organization of this book. In addition, I thank Simão Costa and Gregory McNamee for their very able assistance in editing and formatting the manuscript. My particular thanks are to my partner Catherine for her support throughout the realization of this project.

Texts in the following chapters are taken from these sources, listed by the author's last name: Theodor W. Adorno, *Aesthetic Theory*, edited by Gretel Adorno and Rolf Tiedemann, copyright 1997 by the University of Minnesota; Giorgio Agamben, *The Man Without Content*, copyright © 1999 by the board of Trustees of the Leland Stanford Jr. University; Alain Badiou, *Art and Philosophy* from *Handbook of Inaesthetics*, copyright © 2005 by the board of Trustees of the Leland Stanford Jr. University for the English translation, 1998 Editions du Seuil; Roland Barthes, *Camera Lucida: Reflections on Photography*, translated by Richard Howard, translation copyright © 1981 by Farrar, Straus & Giroux, Inc., reprinted by permission of Hill & Wang, a division of Farrar, Straus & Giroux; Georges Bataille, *Visions of Excess: Selected Writings, 1927–1939*, translated by Allan Stoekl, with Carl R. Lovitt and Donald M. Leslie Jr., copyright 1985 by the University of Minnesota; Walter Benjamin, *One-Way Street and Other Writings*, copyright granted by permission of Verso; Gilles Deleuze, *Francis Bacon: The Logic of Sensation*, copyright 2002 Les Edition du Seuil, English translation copyright Continuum International Publishing Group Ltd.; Jacques Derrida, *Spurs: Nietzsche's Styles*, copyright granted by permission of University of Chicago Press; Michel Foucault, *The Order of Things*, Copyright © 1970 by Random House, Inc., New York, copyright © 1966 by Editions Gallimard, reprinted by permission of Georges Borchardt Inc. for Editions Gallimard; Sigmund Freud, *Beyond the Pleasure Principle*, translated by James Strachey, copyright 1961 by James Strachey, used by permission of Liveright Publishing Corporation; Sigmund Freud, *Leonardo Da Vinci and a Memory of His Childhood*, translated by Alan Tyson, copyright 1957 by The Institute of Psycho-Analysis, used by permission of W. W. Norton & Company, Inc., and Taylor & Francis Books UK; Martin Heidegger, *Basic Writings*, revised

Philosophers on Art
from Kant
to Postmodernism

Introduction:
Art and Philosophy

███████████████

"I passed beyond the unreality of the thing represented, I entered crazily into the spectacle, into the image."[1] So wrote Roland Barthes in 1980 about his passionate relationship to the image. Such a response, he proposed, arose because images have an immeasurable power—the power to overwhelm the subject and shatter their sense of self. This sublime experience of losing oneself in the image is underpinned by an approach that sees the image as equivalent with reality, and vice versa. Inseparable, and yet in an unstable relationship owing to their interchangeability yet their difference, image and reality implode in a disintegrative process that touches Barthes "like the delayed rays of a star."[2] The experience of loss, of an otherness or alterity,[3] that dissolves the subject through the implosive power of the image and its effect upon the status of reality, has been a central concern in Western philosophy and aesthetics since Kant published his three *Critiques* in the eighteenth century, shaping philosophical approaches to both representation and art.

This book covers the period from 1780 (the date of the publication of Kant's first *Critique*) to the present, which marks a paradigmatic shift in philosophy from the emphasis on metaphysical and Cartesian conceptions of truth to a preoccupation with experience and the instability of the subject. Both aesthetics, the branch of philosophy concerned with the study of experience,[4] and art, as a site of experience, are crucial to this shift, with

the result that, whereas these topics were once thought to be adjuncts to philosophical inquiry, they are now positioned at its kernel, interrelated with all other major philosophical concerns. Any inquiry into aesthetic experience inevitably raises questions about how experience may be represented and who is representing it, which leads to questions about the very conception of the subject "I." The problematic of the subject as the determinant of representation has underpinned philosophy and aesthetics since the inauguration of modern philosophy by Kant and Hegel, followed by Nietzsche, Marx, and Freud at the end of the nineteenth and the beginning of the twentieth centuries. The starting point of this introduction is to outline the question of representation and the subject, as conceived of by modern philosophy. Thereafter, it will address the ongoing concern since Kant with experience, as this is thought through alterity, and how these issues relate to philosophical approaches to art.[5] Subsequently, it will indicate some ways to approach the issue of postmodernity for the purposes of the thematics of the book, and thereafter it will discuss some of the concerns of recent philosophy insofar as they inform ideas about art.

THE SUBJECT AND REPRESENTATION

Writing in *Twilight of the Idols* in 1888, Friedrich Nietzsche stated, "I am afraid we are not rid of God because we still have faith in grammar."[6] For Nietzsche, metaphysics, or ontotheology, is sustained by the ideology of the subject that pervades Western thinking right down to the level of the structure of representation and language. The ideology of the subject is perhaps most simply encapsulated in René Descartes's famous maxim, "I think, therefore I am,"[7] in which there is an assumption that Being is one with consciousness (Descartes's doubting, skeptical mind) and that the subject "I" is identical with Being through consciousness. This idea is a particularly extreme manifestation of the ideology of the subject as a unified ego, conscious of his Being. As such, it equates with one possible interpretation of the first section in Nietzsche's passage in *Twilight of the Idols*, "How the 'True World' Finally Became a Fable: The History of an Error" (see chapter 3), in which the statement, "I, Plato, *am* the truth" might be seen as an egoistic declaration of the subject's self-identification with Being.[8] (A different interpretation of this section is offered by Heidegger in his essay "Nietzsche's Overturning of Platonism" [chapter 7]). The subsequent passage delineates a different, more complex model of the ideology of the subject, which revises the Carte-

sian idea of the subject as a unified entity, substituting instead a model composed of two related, but unequal, elements: a dialectic between an ideal of unity (represented by the divine "true world") and a subject who is not unified but is in thrall to this ideal. It is this dialectic which for all modern and postmodern thinkers—beginning with Nietzsche, Freud, and Marx—is the fundamental component constituting fantasy and ideology (irrespective of whether it has a specifically Christian or religious dimension). For these thinkers, fantasy, like ideology, is based upon ego ideals of unity, self-sufficiency, and control. In Nietzsche's opinion, grammar sustains a Cartesian idea of the subject, since it revolves around the illusion of synonymity between the addressor, representation, and meaning.

Adopting Freud's theory of identification, the psychoanalyst Jacques Lacan, in essays such as "The Mirror-Phase as Formative of the Function of the *I*" (chapter 8), analyzed the dialectic of the subject in terms of "lack," meaning that the subject is not unified as fondly imagined, but is rather always already inadequate or lacking in comparison with the ego ideal after which he strives and models himself.[9] Nietzsche's discussion in "History of an Error" of Western humanity dominated by ideals of truth and perfection ties in with Lacan's own account in "The Mirror-Phase," in which the dialectic of the subject forms the fundamental component of psychic repression. Lacan's analysis also relates to Nietzsche's belief that the notion of the subject is derived from metaphysics. While it may be true, to quote Nietzsche, that "God is dead" and that secularism permeates Western society, the ideology of the subject reproduces metaphysics at the level of its *structure,* since both revolve around a dialectic composed of an ideal (in metaphysics, this is the ideal of Being and presence) and a subject who is divided from this ideal and yet impelled by it.

Dialectics not only structures the idea of the subject, but it also shapes the way in which representation is thought about traditionally, and this applies to both language and the image. In this model of thinking, representation refers to an outside, or even absent, referent. This might take the form of the traditional idea of a drawing based upon life or, as in metaphysics, in the transcendent essence of an invisible God. Psychoanalytic theory adopts a similar approach to representation insofar as "symptoms" are understood to refer to unresolved aspects of the Oedipal complex in the unconscious. Structuralism, based upon Ferdinand de Saussure's linguistic theories, developed before the First World War,[10] broke with this model insofar as it suggested that the signifier is arbitrary and bears no relationship to an actual referent, whether in the "real world" or absent. Structuralism has

been enormously influential upon twentieth-century philosophy, and certain writers, such as Roland Barthes, have propagated a structuralist approach to semiotics. Nevertheless, Barthes, like other philosophers of his generation, recognized the limits of structuralist ideas (see chapter 12). For, insofar as structuralism suggests that meaning is deferred along the signifying chain from signifier to signifier ad infinitum, it can be seen to conform to metaphysics by implying that representation is always deficient in relation to any ultimate meaning. Thus, whether the referent is tied to reality or is transcendent, as advocated by metaphysics, or is discounted as in structuralism, representation is thought of in terms of lack and never in its own terms.

In the light of his insight into the pervasive influence of metaphysics, Nietzsche called for "a revaluation of all values," a new form of thinking and approach to the subject and representation that exceeded dialectics and, indeed, all oppositions, while not falling back into an ideal of unity or "presence." Because these changes in philosophy's objectives are traceable back to Kant, it is appropriate at this point to turn to his ideas and development of the study of aesthetics wherein a new approach to these issues is first glimpsed.

ART AND THE BEGINNINGS OF AESTHETICS

Although Kant was a firmly committed Christian, he boldly declared that philosophy has no business dealing with the existence of God because this is not a subject of knowledge but of faith.[11] Furthermore, Kant suggested that the world is an indeterminate reality consisting of no more than a projection of our own thoughts and categories. With this in mind, Kant duly situated philosophy within the bounds of phenomena, as the site of "sensible knowledge," firmly divided from the realm of the metaphysical, which he termed *noumenon*.[12] By stressing the division between phenomena and noumena and between what can and cannot be experienced or represented, Kant gave more urgency than had hitherto been the case in philosophy to the question of the unrepresentable and, by implication, the experience of a radical otherness, or alterity, which is irreducible to dialectical representation. Traditionally, in metaphysics the concept of the transcendent absolute (God and the divine) is purportedly unrepresentable, and yet this unrepresentability is always conceived of as lying on the other side of representation in a dialectical relationship with it. Thus, paradoxically, the unrepresentable is defined and understood through what it is not. Kant tried to give the unrepresentable an unqualified dimension by separating it from phenomena into

noumena, but, ultimately, he left intact the opposition between representation and the unrepresentable, since he maintained the duality between the two in which each defines the other. (These ideas explain Nietzsche's comments about Kant in section 3 of "History of an Error.")

A similar equivocation runs throughout the rest of Kant's critical philosophy, in which he places the problematic of the unrepresentable at the forefront of his thinking only to delimit its implosive force upon representation by recourse to metaphysics. In the *Critique of Pure Reason* (1780), Kant embarked upon a philosophy of knowledge, asking how it is possible to evaluate and judge knowledge in cases where it is genuinely new and beyond existing conceptualization. Kant's answer to this was to suggest that judgments of knowledge are both synthetic and a priori. By synthetic, Kant referred to a synthesis with what is unknown and, therefore, unrepresentable. However, he contradicted this proposition by suggesting that evaluations of new knowledge are also shaped by a priori transcendent principles. As a counterpoint to the *Critique of Pure Reason*, Kant's *Critique of Judgment* (1790) investigates what the experience of synthesis and the unrepresentable is like (see chapter 1). Regarding judgments of beauty, Kant toys with the idea that there are experiences that exceed cognition, only to assert a fundamental correspondence between cognition and the senses via a concord between the faculties of understanding and imagination. However, Kant's theory of the sublime is more extreme: it proposes that experience exceeds thought, and that there is no adequate concept in the subject's understanding for a synthesis with the unrepresentable. This marks a significant moment in philosophy and points to the dissolution of the subject whose understanding is overwhelmed by experience. Subsequently, Kant attempted to curb his radical conclusion about the sublime by declaring that this experience expands the mind beyond the grasp of space and time and, therefore, into infinity such that it is governed by a pure state of Reason. Despite his attempts to legitimize this experience and give it a metaphysical inflection, the fact is that Kant opened up the possibility of thinking the unrepresentable in absolute terms beyond dialectics. This has had a lasting legacy within Continental philosophy and aesthetics.

NIETZSCHE AND THE "OVERCOMING OF METAPHYSICS"

In sections 5 and 6 of "History of an Error," Nietzsche proposes getting rid of dialectical oppositions altogether since their effect is prejudicial and repressive. This does not mean getting rid of the terms themselves, but of

the line drawn between them. So, in removing the opposition between truth and falsity, falsity becomes of value, having the status of truth and, in turn, truth attains the status of a dissimulating falsity. This collapsing of opposites, so that what is true is false devoid of any prejudice, is known as the simulacrum,[13] a term that stems originally from Plato's account of Sophism.

Nietzsche recognized that in metaphysics dialectical oppositions define and overdetermine each other, always to the detriment of the repressed term: falsity, illusion, and simulation, with which images are traditionally associated, are seen to lack truth; zero and nothing are seen as absences of presence, lacking in matter and meaningfulness. Following Nietzsche's strategy of withdrawing the traditional divisions between oppositions, even the notions of zero and nothing are no longer defined as they were. As Nietzsche shows in "History of an Error," while they remain indefinable and unrepresentable, they cannot be seen in terms of a lack or as the negative of their conceptual opposites, since this still involves defining them contrapositively. This revaluation of "no-thing"—of what is unrepresentable—is of crucial importance for understanding Nietzsche's philosophy and provides the context, for instance, for his writings in "The Will to Power as Art" (see chapter 3; for further discussion, see chapters 7 and 14).

With falsity and change unleashed, art became the central point of Nietzsche's philosophy. Since Plato, art had been negatively associated not just with artifice, illusion, and dissimulation but also, more widely, with ephemerality and transience. Now that art was no longer dominated by a negative approach toward falsity, it became the paradigm by which to describe a new philosophy or attitude capable of superseding moral agendas and their reliance upon truth. As his notebooks reveal, Nietzsche christened this philosophy "the will to power as art" as a way of referring to a desire for change coupled with an acknowledgment that change is, by definition, unrepresentable (since it can be understood only retrospectively). For Nietzsche, the concept of beauty had a similar meaning as the will to power as art, signaling the collapse of all conceptually and morally determined oppositions. As he writes in "The Will to Power as Art," "Beauty exists outside all orders of rank, because in beauty opposites are tamed; moreover without tension: —that violence is no longer needed" (see chapter 3)

Nietzsche's revised conception of beauty shows just how far aesthetics had come since its inception in the eighteenth century. Beauty no longer consisted of a harmonious synthesis between sensibility and understanding, as Kant had proposed; rather, it signaled the breakdown of truth integrated within an overall conception of desire situated at the threshold

between representation and its disappearance. As Alain Badiou has pointed out, this shift in conceptualization draws upon an entirely different understanding of Being from that of metaphysics: "It is not 'to be or not to be,' it is 'to be and not to be.' "[14]

DIALECTICS AND MODERN PHILOSOPHY

In the light of Nietzsche's critique and revaluation of metaphysics, one of the key determinants of Continental philosophy has been a desire to overcome or, possibly, to outwit dialectical forms of thinking, particularly as they construct and maintain essentialist ideals of transcendence and unified subjectivity. At this point it is appropriate to highlight briefly some of the ongoing debates in philosophy about the persistence of dialectical forms of thinking in its various guises—but, above all, in the way these relate to the analysis and interpretation of art, ranging across Hegel, the Marxist intellectual tradition, Heidegger, psychoanalysis, "Deconstruction," and Nietzsche himself. As will be seen, in all these cases the issue of dialectics revolves around the problematic desire on the part of the respective philosopher to subsume what is not categorizable—that is, "art"—within a bounded project or purposeful thesis concerning its meaning or social role. Circumscribing art in this way may occur even in modern and postmodern philosophy, where a conscious awareness of this problematic has developed.

Hegel

Both Hegel and the Marxist intellectual tradition employ a consciously dialectical method of thinking, albeit with different purposes in mind. In Hegel's case, this was related to his idea that the history of mankind would culminate in the eventual realization of Spirit as ultimate consciousness. As Hegel discussed in his lectures on aesthetics (1820–1829), the tendency toward this realization is marked by successive periods of art, culminating in the romantic era, which ostensibly marks "the end of art" and the beginning of the conclusive historical era when philosophy makes the transition to the realization of Spirit (see chapter 2). Stated in this way, Hegel's philosophy seems to be clearly based upon a dialectic between the infinite (Spirit) and the finite (mankind's history), in which the latter strives after the former in a historical process of lack but ultimate reunification, or what Hegel terms "synthesis." And yet, according to Jean-Luc Nancy, Hegel did not separate metaphysical essence from the processes of appearing and becoming in

his conception of "the Idea" (the kinship between the human mind and the divine): "The Idea is the presentation to itself of being or the thing. It is thus its internal conformation and its visibility"[15] (see chapter 18).

Through the Idea, and by means of it, art in its separate historical phases gradually unfolds the truth of the relationship between the mind and the divine. Capitalizing on this Hegelian schema of unfolding (rather than its teleological schema), Nancy suggests that the Idea is always already divided from itself and that it is *both* essence and representation at the same time. This applies to Nancy's conception of art, too, revising, for him, in its wake any literal assumption of the "end" or "death" of art in Hegel's philosophy: " 'It [the image] withdraws therefore as image *of*, image of something or someone. . . . In a world without image in this sense, a profusion, a whirlwind of imageries unfolds in which one gets utterly lost, no longer finds oneself again, in which art no longer finds itself again. It is a proliferation of views [*vues*], the visible or the sensible itself in multiple brilliant slivers [*éclat*] which refer to nothing. Views that give nothing to be seen or that see nothing: views without *vision*."[16]

In Nancy's thinking, Hegel's idea of "the end of art" may be understood better as the dissolution of a traditional definition of art as a form of representation within which there lay the notion of an absent or concealed referent. In a similar vein, Julia Kristeva has referred to Hegel's conception of synthesis not as a conclusive resolution but rather as the end of a desire to represent the (lacked) object (see chapter 13). For Kristeva, Hegel's philosophy steps into an "abyss" in which the opposition between representation and the referent is dissolved.

Adorno and Benjamin

Writing in his book *Aesthetic Theory* (1970; see chapter 10), Theodor Adorno offers a cautionary note to those who might hope for an art that exceeds its present circumstances under the domination of capitalist relations:

> If today art has become the ideological complement of a world not at peace, it is possible that the art of the past will someday devolve upon society at peace; it would, however, amount to the sacrifice of its freedom were new art to return to peace and order, to affirmative replication and harmony. Nor is it possible to sketch the form of art in a changed society. In comparison with past art and the art of the present it will probably again be something else; but it would be preferable that some fine day art vanish altogether than

that it forget the suffering that is its expression and in which form has its substance.[17]

In this statement, Adorno situates modern art firmly within a history of ideology and alienated suffering. Adorno's refusal to conjecture over art's possible future is understandably cautious, given the historical circumstances of "a world not at peace" to which he refers (the text was written during the 1960s). Like his contemporaries, Heidegger and Benjamin, Adorno views alienation and the present sufferings of mankind as a correlative of modernity itself. As such, they are subject to the unfolding of (historical) time; in other words, Adorno and his contemporaries believed that the present predicament in which humankind finds itself would change fundamentally once the presuppositions underpinning modernity were superseded or overcome. According to Adorno, within this oppressive context art has an oppositional, or negational, function. However, Adorno, a past master in dialectics, often pushes his arguments into a maze of contradictions. Thus, in one sentence from "Aesthetic Theory": art "willfully" refuses "to drown out its entrapment," but "by virtue of its form, art transcends the impoverished, entrapped subject."[18] Employing a style of dense and mesmerizing argumentation, Adorno rejected clear answers, hanging on to the idea that "the zone of indeterminacy between the unreachable and what has been realized constitutes their [the artworks'] enigma. They have truth content and they do not have it."[19] Such a paradoxical form of thinking was influenced, in part, by Hegel, whom Adorno was fond of quoting concerning the reasons behind this approach: "The life of the mind only attains its truth when discovering itself in absolute desolation. The mind is not this power as a positive which turns away from the negative, as when we say of something that it is null, or false, so much for that and now for something else; it is this power only when looking the negative in the face, dwelling upon it."[20]

Given this close engagement with "the negative," Adorno spurned any utopian ideas about the work of art's objectives. Nevertheless, Adorno maintained the idea that art opens onto complex and nuanced senses of experience (even if these experiences are, in part, destructive in character) that can be considered as commensurate with an end to ideology and alienation. While Adorno's work is often compared to that of his friend and compatriot Walter Benjamin, it actually follows a very different line of thinking insofar as it goes farther in viewing art as a propositional model of freedom from the repressive violence of capitalist ideology.

Benjamin's materialist approach to history was inflected by Judaic thought, and this led him to cast modernity in terms of a profane world. For Benjamin, the sacred—that which is opposed to the profane—is not divine in any orthodox sense of the term, rather it signifies the (non)human potential to exceed the coercive violence of the law that imposes its will upon subjects. Since, according to the logic of this conflict between the sacred and the profane, the causes of modernity's end must come from a mystical idea of that which is beyond human calculation and control (of which the law is a fundamental part), Benjamin is doubtful whether they can be fully identified and theorized (as models of liberation) from within the profane world.[21] This did not prevent Benjamin from engaging in an extensive and substantial study of revolutionary praxis and experience; however, at every turn his writing encourages contradictions and, with these contradictions, there emerges a particularly melancholic tenor to his ideas and thoughts. For Benjamin, it is not just that revolutionary events are already a matter of history: even his own identification of such revolutionary moments and their liberating potential are already overtaken by time: "The good tidings which the historian of the past brings with throbbing heart may be lost in a void the very moment he opens his mouth."[22] Such a profound sense of yearning and loss meant that Benjamin's views of art as a catalyst of radical experience remained thoroughly ambivalent and hedged in by a sense of the complexity of meaning (see, for instance, his discussion of the notion of aura in "A Small History of Photography" [chapter 6]). This complexity of meaning is reflected further in the fragmentary nature of Benjamin's work and projects: his idea that "the past can be seized only as an image which flashes up at the instant when it can be recognized and is never seen again"[23] applies equally as much to the question of history as to his own writing, which has a powerfully imagistic yet fugitive quality.

Heidegger

In his lectures of 1936–37 on Nietzsche's "The Will to Power As Art" (see chapter 7), Martin Heidegger recognized the nondialectical nature of Nietzsche's thought, particularly as this applies to "The History of an Error" (see chapter 3). As Heidegger demonstrates through a step-by-step analysis of each of the six parts of this text, the "overcoming" or "twisting free" of metaphysics does not involve abolishing the terms of oppositional thinking, nor does it mean inverting the original hierarchy of the dialectic by valuing, for instance, the notion of the sensuous over the nonsensuous in reverse

manner to tradition. Rather, it amounts to an entire rethinking of the rela-
tionship between such oppositions:

> A path must be cleared for a new interpretation of the sensuous on
> the basis of a new hierarchy of the sensuous and nonsensuous.
> The new hierarchy does not simply wish to reverse matters within
> the old structural order, now reverencing the sensuous and scorn-
> ing the nonsensuous. It does not wish to put what was at the very
> bottom on the very top. A new hierarchy and new valuation mean
> that the ordering *structure* must be changed.[24]

Heidegger's interest in conjoining the sensuous and the supersensu-
ous lies in his desire to foreground the issue of Dasein (or Being-there) as
the precondition for every epochal form of human understanding. As such,
it alone is the vehicle for historical change capable of leading to a new
epoch beyond the domination of Cartesian thinking. (It should be noted
that the emphasis which Heidegger places upon Dasein involves him in dif-
ferent conclusions about the interpretation of the concluding sections of
Nietzsche's "History of an Error" from the one offered earlier, and in the
reading of Nietzsche's writings in this book.) For Heidegger, Dasein (a pre-
subjective space that precedes predication yet also is the precondition for
every episteme of language and understanding) occurs through *alétheia*—
that is, via disclosure and unconcealment. And yet, even in unconcealment
there is a limit to possibilities, a horizon that bounds the space of clearing
and disclosure. The consequence of this is that the end of a new historical
episteme is always already contained in its beginning, and that every epis-
teme contains the potentiality for fixity—which, according to Heidegger, is
what has come to afflict modernity with such disastrous consequences.
Heidegger believed that modernity needed to realize its own end through
which a new, creative episteme could be inaugurated subject to the same
founding principles of Dasein. Despite these affirmative ideas of openness/
limit and ultimate ending connected with Dasein, there is perhaps a dan-
ger in Heidegger's thought of interpreting art too literally in relation to his
concept of Dasein. In the section in "The Origin of the Work of Art" where
the function of the temple in Greek civilization is discussed, Heidegger
suggests that the temple stands as an iconic sign signaling to the com-
munity, through its own temporal existence, the meaning of Dasein and
the necessity for change (see chapter 7). In this desire for the work of art
to serve the purposes of Dasein, Heidegger overlooks the very sense of

limit and of hiddenness that he suggests is an essential aspect of the truth of Dasein. That the work of art might function as a vehicle of true consciousness or enlightenment reflects upon Heidegger's own desire not simply for an unfolding of history, but for the work of art to serve as a means to an end in this process. (For further discussion of Heidegger's aesthetics in this regard, see Alain Badiou's "Art and Philosophy" [chapter 19].)

Approaches to Freud and Psychoanalysis

Freud's extensive inquiries into neurosis revolve around a dialectic between presence (the symptom or psychic manifestation) and absence (the object of desire to which the symptom alludes). This dialectic, based upon an elusive object of desire, is evidenced in Freud's analysis of the beginnings of representation in *Beyond the Pleasure Principle* (see chapter 4). In this text Freud describes a game of *fort/da* (here-there) in which a child of eighteen months repeatedly throws away and retrieves a cotton reel as a way of fantasizing a sense of control over the painful experiences of his mother's departures and leavings. Significantly, Freud's analysis of the *fort/da* game occurs in the context of a wider discussion of trauma and its affects. From his observation of shell-shocked soldiers in the First World War suffering from trauma, Freud notes that they repeatedly return in their dreams to the calamitous and disturbing events behind their suffering. One of the conclusions he draws from this is that, like the child in the *fort/da* game, they are seeking to explain these events to themselves. And yet as Freud points out, such events are by definition without meaning or sense. However, this does not imply that trauma cannot be treated psychoanalytically or that trauma's original relationship with the Oedipal complex and the prohibition of incest cannot be worked through into a conscious emotional life. For Freud, representation is integrally linked to trauma because it functions through a dialectic in which absence is structured as a potentially traumatic lack of presence. Representation offers the means by which to misrepresent and thereby repress trauma, as in the *fort/da* game, but also, alternatively, through sublimation to touch, and bring into consciousness, the emotions and feelings of loss and bereavement attached to it; paradoxically, this is also a feature of the *fort/da* game, which, as Freud says, denotes "the child's first great cultural achievement" of representation.

Art, in Freud's philosophy, depicts conflictual and often aggressive feelings arising from the subject's experience of separation, since this accompanies the establishment of the Oedipus complex and the beginnings of language and representation. However, art also has the capacity to make

the subject conscious of his or her interdependence with language and representation and how he or she is constructed by these constituents. In art, as in dreams and fantasies, repressed feelings and desires originating from the Oedipus complex can come to the surface, where they may be interpreted and understood as an inherent part of the Oedipal formation of the subject. Freud takes up this argument in his analysis of Leonardo da Vinci's psychic, emotional life (see chapter 4). Freud connects Leonardo's misogyny to the artist's repressed feelings of Oedipal desire and goes on to show how these feelings, through their representation in the painting *Saint Anne with Two Others* (ca. 1510), are transformed. While the figures in this painting of the Madonna and her mother, St. Anne, are highly idealized, they also have a sense of individuality and, in comparison to the cartoon image, a separateness from each other. For Freud, Leonardo's ability to give the two women individual identities is an indication of the artist's growing awareness of his Oedipal relationship to his parents and, in turn, demonstrates how Leonardo is in the process of replacing his repressed desire for maternal women with feelings of mourning and loss. Subject to actual conscious interpretation, this is tantamount to a recognition by Leonardo that his misogynistic feelings are structured by the Oedipal complex as rooted in the dialectics of representation. A similar outcome is at stake in Freud's account of the *Mona Lisa* (1503–6), where the effect of ambivalence is so uncanny that the idea of a referent underlying the painting, and to which it refers, is exceeded by a profound sense of loss: as Sarah Kofman argues, the famous smile of the *Mona Lisa* is not a substitute for another's, but rather a simulacrum, "a translation neither of the smile of Leonardo's model, nor of his mother's real smile, nor of Leonardo's fantasy of his mother's smile . . . a smile that everyone longs for because it has never existed"[25] (see chapter 11).

Kofman's reading of Freud proposes that the image is essentially lacunary: an image of loss. The image of loss does not possess a referent—the object of (repressed and envied) desire, such as that of the Oedipal Mother—since signification is composed of an infinite series of substitutions between one signifier and another. Such a proposition takes its cue from Saussure's theory of signification, but it exceeds a dialectical reading of this theory, as outlined earlier in this introduction. In Kofman's interpretation of Freud, the referent does not haunt representation in absentia, since it exists only as an outcome of the structure of representation. In other words, the fiction of a referent is understood outside of a dialectical relationship to truth or idealism, a position traditionally occupied by the Oedipal Mother.

Kofman's approach to the image as an image of loss relates closely to Lacan's ideas about the gaze as *objet a*. However, Kofman believes that the language of representation inevitably reveals its own structure through the processes of condensation and displacement that, as Freud proposed, primarily work through fantasies, dreams, slips of the tongue, jokes, and works of art. Lacan, who was influenced by surrealist aesthetics, including those of Bataille (see chapter 5), tends to stress the idea that the experience of "the Real" (of the referent's fictional status) connected with the gaze involves a violent disturbance within the subject's customary, ego-determined relationship (see chapter 8). Thus, the contradictory and irresolvable pictorial spaces of Hans Holbein's *The Ambassadors* (1533) echo and repeat the affect of the very formation of the unconscious through representation. While this may appear traumatic—the anamorphic skull of Holbein's painting is, after all, a memento mori—in fact, there is no consistent subject position offered by the painting by which this "trauma" might be determined.

Deconstruction

Finally, in this section on dialectics, comes a cautionary note by Derrida, warning against the very identification of the idea of the "overcoming of metaphysics." In his lectures on Nietzsche, Heidegger pinpointed the thought of the overturning or twisting free of metaphysics in the passage of writing in "The History of an Error." And yet, as Derrida queries in his book *Spurs: Nietzsche's Styles*, if the overcoming of metaphysics exceeds representation's dialectic between presence and absence, then how can it be located within a specific text or, indeed, a body of texts? (See chapter 14.) This thought of exceeding metaphysics spells the end of the subject, including not only Heidegger himself in his capacity as the interpreter of Nietzsche, but also Nietzsche, who, even though he is the author of *Twilight of the Idols*, does not possess complete self-knowledge of his ideas and their import: "Perhaps it must simply be admitted that Nietzsche himself did not see his way too clearly there. Nor could he. . . . Nietzsche might be a little lost in the web of his text, lost much as a spider who finds he is unequal to the web he has spun."[26]

POSTMODERNISM AND ART
◼◼◼◼

Derrida's deconstruction of the writings of philosophers such as Nietzsche and Heidegger highlights a potentially problematic issue for philosophy as

to how the notion of unrepresentability, and as we will see, multiplicity can be approached. In its modern, nonmetaphysical formulation, this is a problematic that goes back to Kant who referred to a series of transcendent Ideas composed of, among other things, human freedom and the immeasurability of creation (that is, infinity). By implication, this problematic of representation and unrepresentability also raises the concepts of finitude and singularity as the binary terms opposed to, and thereby defining, the Ideas of infinity and multiplicity associated with unrepresentability. These issues acquired a greater urgency for philosophy at the end of the twentieth century in conjunction with a desire both to foreground, yet also interrogate, the modernist idea of a postmetaphysical condition of thinking wherein binary oppositions are overcome. This situation owed a great deal to the legacy of post-Kantian philosophy, but also to an increased desire among philosophers to engage with the (Kantian) Idea of human freedom provoked by, among other things, the radical political events of 1968 in the west as well the changed global outlook following the fall of the iron curtain. With these events and changes in mind, the philosopher Jean-François Lyotard adopted the term "the Event" (*l'Événement*) to invoke a postmodern sense of experience that reflects humanity's inhumanity. For Lyotard, this inhumanity is the experience of infinity designated by Kant as an "Idea" of which no presentation is possible (see chapter 16). Lyotard advocated a postmodern condition of knowledge based in experience rather than as a quantifiable object. This was part of a strategy intended to define the essence of modernism rather than as a way of invoking an epistemological break or rupture with the past. For Lyotard, the essence of the (post)modern Event lies in Kant's conception of the sublime (see chapter 1):

> It takes place . . . when the imagination fails to present an object which might, if only, in principle come to match a concept. We have the Idea of the world (the totality of what is), but we do not have the capacity to show an example of it. We have the Idea of the simple (that which cannot be broken down, decomposed), but we cannot illustrate it with a sensible object which would be the "case" of it. We can conceive the infinitely great, the infinitely powerful, but every presentation of an object destined to "make visible" this absolute greatness or power appears to us painfully inadequate. Those are Ideas of which no presentation is possible. Therefore, they impart no knowledge about reality (experience); they also prevent the free union of the faculties which gives rise to the sentiment of the

beautiful; and they prevent the formation and stabilization of taste. They can be said to be unpresentable.[27]

While the sublime may lead to a painful sense of the powerlessness of thought and of the mind's inability to represent the infinite, Lyotard suggests that "the emphasis can be placed, rather, on the power of the faculty to conceive, on its 'inhumanity' so to speak (it was the quality Apollinaire demanded of modern artists), since it is not the business of our understanding whether or not human sensibility or imagination can match what it conceives. The emphasis can also be placed on the increase of being and the jubilation which result from the invention of new rules of the game, be it pictorial, artistic, or any other."[28]

Like Kant, therefore, Lyotard believes that thinking—which might be formulated in this context in terms of the remembering of forgetting—is integrally connected to infinity, albeit through its own "failure" to form a concept through the understanding. This results in a "negative presentation." For Lyotard, this affirmative sense of failure is what is at issue in modernism: "Postmodernism . . . is not modernism at its end but in the nascent state, and this state is constant."[29]

Both Jacques Rancière and Alain Badiou differ from Lyotard's conception of the Event and his corresponding formulation of the relationship between representation and infinity. Badiou thinks of an Event in terms of a revolutionary break with the past that is like a void in human understanding and experience. According to Badiou, the major "Events" shaping art have been those of Greek tragedy, the classical style of music, the novel, the twelve-tone system of music, modernist poetry, and the rupture of figurative art in the modern period. For Badiou, the Event is both singular and plural: singular because it is fundamentally different from anything else, plural because its legacy is potentially infinite. It is owing to the lasting, infinite impression of the Event's finitude and disappearance—its vanishing—that axioms are formed and configurations and traces (including works of art) are created. Thus, for instance, the work of Aeschylus is a configuration or trace of the Event of Greek tragedy, in the same way as Malevich's Suprematist paintings are configurations of the Event of nonfigurative art (see chapter 19).

Rancière is skeptical of any idea of an art form or representation referring, or having a relation, to an Idea or Event, as in Lyotard's and Badiou's theories of art. Despite their complexity, Rancière feels that Lyotard's and Badiou's theories have not fully overcome metaphysics as they would

seem to depend upon a dichotomy between a representation or a trace and an absent referent—in Badiou, this is the Event, and in Lyotard it is the infinity that cannot be represented except by the failure to do so. However, it could be argued that both Badiou's Event as revolution and Lyotard's Event as failure to present the Idea are more like sublime voids leaving in their wake representations that no longer even have an absent referent.[30] Rancière's own philosophy of art adopts a historical purview, arguing that the major cultural issue today as inherited from modernism—or, as he terms it, "the aesthetic regime"—is the problem of meaning. This is because today there no longer exist fixed hierarchies of agreed forms and conventions pertaining to subjects and genres by which art might achieve a universal identity. Rancière responds to this impasse by positing thinking in terms of "positive contradictions" that recognize the desire for singularity even while seeking a universal sense of experience. For Rancière, the resulting heterogeneity arising from such a contradiction is what is at stake in modernist art and literature (see chapter 20).[31]

Lyotard adopted the term *postmodernism* in his later writings as a way of disengaging it from the clutches of liberalism, where it was used to denote the rise of a new era of choice and freedom as supposedly exemplified by the eclecticism and heterogeneity of late-twentieth-century art and culture. (Similarly, Rancière's philosophy can be seen as an intervention in this liberal tendency. Rancière underlines the fact that eclecticism and its corresponding sense of equalization are traits that are already evident in nineteenth-century literature.) In addition, Lyotard took up the banner of postmodernism as a way of signaling an end to modernity's metanarratives and its utopic hopes of human emancipation as these had been constructed through various dominant philosophical, political, and aesthetic discourses, including those of technological progress, communism (insofar as it claimed to transcend capitalist repression), and modernism (exemplified especially by its claim that aesthetic experience is autonomous and, therefore, pure and free). For many of the Continental philosophers today, a major issue is whether the idea of a shared, universal sense of experience and community can be maintained in the face of their own questioning of the metanarratives of progress and emancipation underlying modernity as outlined by Lyotard. These philosophers are concerned to guard against any tendency that might lead toward an inversion of binary terms in which the interests of repressed or marginal groups are simply incorporated into, and thereby become part of, the dominant powers—totalitarian and capitalist—that embraced notions of universal progress under modernity. As Badiou explains,

this desire to seize power and, in so doing, establish a determinate "place" or political state is what characterizes the problematic of the classic revolutionary project:

> Classically, politics, revolutionary politics, is a description with places. You have social places, classes, racial and national places, minorities, foreigners and so on; you have dominant places, wealth, power. . . . And a political process is a sort of totalization of different objective places. For example, you organize a political party as the expression of some social places, with the aim of seizing the state power.[32]

The writings of philosophers such as Agamben, Badiou, Nancy, and Rancière are informed by their roots in the radical politics of the 1960s, so that the ideas of universal freedom and equality are not abjured but, on the contrary, remain of paramount importance as founding principles. Badiou makes this point clear when taking up the train of his foregoing thoughts on the relationship between politics and power: "But today, maybe, we have to create a new trend of politics, beyond the domination of the places, beyond social, national, racial places, beyond gender and religions. A purely displaced politics, with absolute equality as its fundamental concept."[33] However, in Badiou's philosophy, and in that of his peers, the idea of a fundamental or founding concept is not thought about in the same ontological terms as it was once in metaphysics and during the period of the domination of modernity's metanarratives. For these philosophers, the universal is created—and simultaneously decreated—through singularity: singular events and experiences that have no predetermined end or purpose but that compose a world and a community out of (their) displacement. Aesthetic experience is an important means by which to locate and understand this idea of the singular as it interacts with the universal. As Kant argued, the aesthetic experience of the sublime elides the categories of understanding and is tantamount to an experience of loss. In Nietzsche's philosophy, this experience of loss, conceived of beyond metaphysical dualities, is not viewed negatively or in terms of lack. The consequence of this is that notions such as those of becoming, change, and loss are envisaged as ends in themselves or, as Nancy says, "perfect"—without a sense of a desired ideal or lack attached to them. In "The Vestige of Art" (see chapter 18), an aptly titled essay on the *post*-modern condition of art, Jean-Luc Nancy explores these ideas through a revaluation of Hegel's account of historical development, showing how the universal in the form of history itself is composed out of the singularity of art:

Art has a history, it is perhaps history in a radical sense, that is, not progress but passage, succession, appearance, disappearance, event. But *each time* it offers *perfection*, completion. Not perfection as final goal and term toward which one advances, but the perfection that has to do with the coming and presentation of a single thing inasmuch as it is formed, inasmuch as it is completely conformed to its being, in its *entelechy*, to use a term from Aristotle that means "a being completed in its end, perfect." Thus it is a perfection that is always *in progress*, but which admits no progression from one entelechy to another.

Therefore, the history of art is a history that withdraws at the outset and always from the history or the historicity that is represented as process or as "progress." One could say: art is each time radically *another art* (not only another form, another style, but another "essence" of "art"), according to its "response" to another world, to another *polis*; but it is at the same time each time *all* that it is, *all art* such as in itself finally.[34]

1

Critique of Judgment

Immanuel Kant

Immanuel Kant's *Critique of Judgment* (1790) is one of the founding texts of aesthetics, representing a crosscurrent of ideas springing from the metaphysical tradition of philosophy and the growth of Romantic thought in the eighteenth century. Its importance lies in its consideration of the ways in which certain aesthetic experiences (of the beautiful and the sublime) cannot be classified as objects of knowledge.

The framework for Kant's consideration of aesthetics was established in the earlier critical philosophy—the *Critique of Pure Reason* (1781) and the *Critique of Practical Reason* (1788)—in which he referred to a tripartite network of three interacting "faculties" responsible for structuring and organizing the mind and experience. These are the faculties of imagination, understanding, and reason. The faculty of imagination is a kind of sensory organ apprehending manifold experience that normally "presents" the raw data for the faculty of understanding to shape into concepts based upon ideas of space and time. Thus, the imagination is concerned with perception, "apprehension," and "intuition," whereas understanding is the faculty of cognition. Kant equates the faculty of reason with the "the supersensible," which is composed of a related series of transcendent "ideas": namely, human freedom, God, immortality, and the immeasurability of creation. In the *Critique of Reason*, this last faculty legitimizes the understanding's use of concepts.

In the *Critique of Judgment*, Kant sets out to establish a universal law-fulness (which is confirmed in the form of a judgment) governing the imagi-nation, even when it is seemingly not in the service of the understanding (see the sections on the beautiful) or when it fails in terms of any function at all (see the sections on the sublime). In the sections on the beautiful, Kant acknowledges that there are experiences that are not organized through concepts by means of the understanding (§1 and §16). However, in assert-ing a lawfulness to the imagination's independence from understanding, Kant states that this is congruent with the experience of what is beautiful. Thus, this experience is governed by what Kant terms an aesthetic "judg-ment," which involves "taste" and "pleasure" and is "subjective." An aesthetic judgment differs fundamentally from personal taste (not to be confused with "subjective taste"), which Kant believes operates simply at the level of what is "agreeable" and charming; it also differs from moral ("practical") judgments about "the good" (§16).

Kant goes on to suggest that concerning beauty the imagination is never *entirely* independent from the understanding. While the imagination does not perform any task on behalf of the understanding in the experi-ence of the beautiful, nevertheless, this experience is composed out of "an accord" or a "harmony" between the imagination and understanding: the mind becomes conscious of its "presentational power" (§1) as it recog-nizes that the imagination can present its faculty to the understanding and that the two can work together through a sense of "play" and a "quicken-ing" as the "freedom" and openness of the former is brought into contact with the "lawfulness" of the latter (§9). Thus, the experience of the beautiful is an experience of form arising from first the fact that the two faculties of the imagination and understanding are formally in accord with one another, and second that both are perfectly designed to correspond with nature and to seek out its laws. Hence, Kant's four defining characteristics (or, as he terms them, "moments") of the beautiful are disinterested liking and plea-sure, universality apart from concepts, purposiveness without purpose, and the necessity of a subjective judgment gaining universal assent. While these "moments" appear to be a series of contradictory statements (or, as Kant terms them, "antinomies"), in fact, they are designed as a summary of the lawful role of the imagination. In the first moment, Kant separates the experience of the beautiful from "interested" feeling while maintaining a pleasure at the heart of the experience. The remaining three moments refer to the imagination's apparent independence from the understanding, since it lacks concepts, is without purpose, and is entirely subjective. And yet, as

this "independence" is actually an accord, the experience of the beautiful possesses three related characteristics composing a law: universality, purposiveness, and the sense of a necessary objectivity. (The idea of universality is based upon Kant's idea of a "common sense," which he refers to elsewhere in the *Critique of Judgment* as a "*sensus communis*.")[1] Thus, Kant allows the experience of beauty to contain a series of contradictory qualities.

Kant argues that in order for art to be art it should be like experiencing beauty in nature. Thus, what is at stake in art is the same principle as for the beautiful in nature: that is, the relationship of the imagination in its freedom with the lawfulness of the understanding.[2] Kant argues that the figure of the genius unites nature with art. Through genius, whose "foremost property must be *originality*" (§46), "nature gives the rule to art" (§46).[3]

With respect to visual art,[4] design—by which Kant means the sense of shape or play of shapes and sensations—is what is essential (§14). This idea of design fits with Kant's idea of form, the basis of both the imagination and understanding. This is taken up in the text with the Pompeian inspired "designs *à la grecque*, the foliage on borders or on wallpaper etc." (§16). These examples have a sense of shape, so they are not alien to the understanding, but their designs are incommensurate with a consistent reading of space as might be supplied by a concept. The section "On the Division of the Fine Arts" (§51) classifies the arts in terms of "word, gesture, and tone (articulation, gesticulation, and modulation)." The phrase "arts of the word" refers to rhetoric and poetry; those of gesture to painting, sculpture, and architecture; and tonal art is essentially music.

In the sublime (§23, §26, and §28), the imagination is overwhelmed and rendered inadequate, unable to absorb the manifold experience. In addition, the understanding is bypassed, since there is no determinate concept that can be brought to bear upon the sublime (§23 and §26). Kant identifies two kinds of experience of the sublime: the mathematically and dynamic sublime. The former is an experience of intellectual limitation in relation to infinity, and the latter a sense of physical vulnerability in relation to nature. Both involve a presentation of quantity (in contrast to a presentation of quality in the beautiful) and a feeling of "negative pleasure" (§23). Kant offers various examples of the sublime. In relation to the mathematically sublime, Kant speaks about standing in a certain position from one of the pyramids, where the observer is unable to see the top and bottom of the edifice at the same time; he also refers to the bewilderment and perplexity seizing the spectator upon entering St. Peter's Basilica in Rome for the first time (§26). In connection with the

dynamic sublime, Kant discusses a series of Romantic-influenced extremes of Nature's power (§28).

Because the sublime is formless, it is unrepresentable: the sublime does not make reference to nature, nor can it be represented in art.[5] However, the experience of the sublime is evidence of the fact that we are never just experiential beings, but that there exists a supersensible power governing experience: the faculty of reason (§23). For Kant, an aesthetic judgment concerning the sublime is a judgment that we are rational and moral beings.

How, then, are these ideas to be interpreted? Running throughout both the sections on the beautiful and the sublime is the problematic of the imagination and, by implication, how to theorize the senses, perception, and feeling. Specifically, there is the question whether the imagination can be assigned a legitimate role and purpose and, if so, what these might be. Kant grants that the imagination in relation to the beautiful and the sublime has no utilitarian purpose: there is no determinate concept at stake in the beautiful, and in the sublime the imagination is unable to perform its usual task in connection with the understanding. Nevertheless, Kant asserts that with respect to the beautiful there exists a deep correspondence between the imagination and understanding and, in relation to the sublime, the imagination is sanctioned by the transcendent ideas of reason. In this last case, this means that the mind's faculties—including that of the imagination—are timeless and transcendentally pregiven. Kant's recourse to reason counters a perceived excess within Romantic thought concerning the overwhelming power of the emotions. While Kant develops a notion of unrepresentability with respect to the sublime, he withdraws from this conclusion, proposing instead that the unrepresentability of the sublime overwhelming the imagination is, in fact, an affect of reason. As such, Kant's interpretation of the sublime can be read in terms of an economy of surplus profit, assuring the subject that any relationship to, or exchange with, the Other is certain to be advantageous, since reason is infinite.

And yet, it is possible to interpret the arguments of the *Critique of Judgment* differently. Within the constraints of a rationalist discourse and a somewhat unwieldy set of separate, differentiated faculties, Kant's ideas may be more nuanced than at first appears. Within the accord existing between the imagination and the understanding in which no determinate concept is involved in an aesthetic judgment of the beautiful, it is possible to see that Kant is suggesting that the imagination, and its related processes of perception, intuition, and feeling, are *themselves* forms of understanding that are, by nature, unquantifiable and without utilitarian purpose.

The fact that Kant emphasizes the unrepresentability of the sublime is also important; the implications of this theory exceed Kant's own attempt to control them (see the introduction to this book).

Several passages of writing in the sections on the beautiful warrant particular attention, especially in the light of subsequent philosophical concerns. Although much of Kant's writing about genius appears typically Romantic, in which the (male) artist is identified with nature as a primal force of creativity, his statement that the genius "does not know how he came by the ideas for [the art product]" (§46) anticipates later philosophers who theorized the unconscious, such as Freud and Nietzsche. There is also a connection here with the theory of "the death of the author" expounded by, among others, Roland Barthes.[6] In §51, Kant seems to envisage a type of *gesamtkunstwerk* (total work of art) combining all modes of communication: "Only when these three ways of expressing himself are combined does the speaker communicate completely." This may carry with it shades of cultivated perfection, but Kant's inclusion of gesture and tone as intrinsic elements of communication, alongside that of the word, could be seen to open up ideas about the potentiality of meaning and understanding.

CRITIQUE OF JUDGMENT

First Moment of a Judgment of Taste, as to Its Quality

§1 A Judgment of Taste Is Aesthetic If we wish to decide whether something is beautiful or not, we do not use understanding to refer the presentation[7] to the object so as to give rise to cognition;[8] rather, we use imagination (perhaps in connection with understanding) to refer the presentation to the subject and his feeling of pleasure or displeasure. Hence a judgment of taste[9] is not a cognitive judgment and so is not a logical judgment but an aesthetic one, by which we mean a judgment whose determining basis *cannot be other* than *subjective.* But any reference of presentations, even of sensations, can be objective (in which case it signifies what is real [I rather than formal I] in an empirical presentation); excepted is a reference to the feeling of pleasure and displeasure—this reference designates nothing whatsoever in the object, but here the subject feels himself, [namely] how he is affected by the presentation.

To apprehend a regular, purposive building with one's cognitive power (whether the presentation is distinct or confused) is very different from being

conscious of this presentation with a sensation of liking. Here the presenta-
tion is referred only to the subject, namely to his feeling of life, under the
name feeling of pleasure or displeasure, and this forms the basis of a very
special power of discriminating and judging.[10] This power does not contrib-
ute anything to cognition, but merely compares the given presentation in
the subject with the entire presentational power, of which the mind be-
comes conscious when it feels its own state. The presentations given in a
judgment may be empirical (and hence aesthetic),[11] but if we refer them to
the object, the judgment we make by means of them is logical. On the other
hand, even if the given presentations were rational, they would still be aes-
thetic if, and to the extent that, the subject referred them, in his judgment,
solely to himself (to his feeling).

§2 The Liking That Determines a Judgment of Taste Is Devoid of All
Interest Interest is what we call the liking we connect with the presenta-
tion of an object's existence. Hence such a liking always refers at once to
our power of desire, either as the basis that determines it, or at any rate as
necessarily connected with that determining basis. But if the question is
whether something is beautiful, what we want to know is not whether we or
anyone cares, or so much as might care, in any way, about the thing's ex-
istence, but rather how we judge it in our mere contemplation of it (intuition
or reflection). Suppose someone asks me whether I consider the palace I
see before me beautiful. I might reply that I am not fond of things of that
sort, made merely to be gaped at. Or I might reply like that Iroquois *sachem*
who said that he liked nothing better in Paris than the eating-houses.[12] I
might even go on, as *Rousseau* would, to rebuke the vanity of the great
who spend the people's sweat on such superfluous things. I might, finally,
quite easily convince myself that, if I were on some uninhabited island with
no hope of ever again coming among people, and could conjure up such a
splendid edifice by a mere wish, I would not even take that much trouble for
it if I already had a sufficiently comfortable hut. The questioner may grant all
this and approve of it: but it is not to the point. All he wants to know is
whether my mere presentation of the object is accompanied by a liking, no
matter how indifferent I may be about the existence of the object of this pre-
sentation. We can easily see that, in order for me to say that an object is
beautiful, and to prove that I have taste, what matters is what I do with this
presentation within myself, and not the [respect] in which I depend on the
object's existence. Everyone has to admit that if a judgment about beauty is
mingled with the least interest then it is very partial and not a pure judgment

of taste. In order to play the judge in matters of taste, we must not be in the least biased in favor of the thing's existence but must be wholly indifferent about it.

Explication of the Beautiful Inferred from the First Moment

Taste is the ability to judge an object, or a way of presenting it, by means of a liking or disliking *devoid of all interest*. The object of such a liking is called *beautiful*.

Second Moment of a Judgment of Taste, as to Its Quantity

§6 The Beautiful Is What Is Presented Without Concepts as the Object of a *Universal* Liking This explication of the beautiful can be inferred from the preceding explication of it as object of a liking devoid of all interest. For if someone likes something and is conscious that he himself does so without any interest, then he cannot help judging that it must contain a basis for being liked [that holds] for everyone. He must believe that he is justified in requiring a similar liking from everyone because he cannot discover, underlying this liking, any private conditions, on which only he might be dependent, so that he must regard it as based on what he can presuppose in everyone else as well. He cannot discover such private conditions because his liking is not based on any inclination he has (nor on any other considered interest whatever): rather, the judging person feels completely *free* as regards the liking he accords the object. Hence he will talk about the beautiful as if beauty were a characteristic of the object and the judgment were logical (namely, a cognition of the object through concepts of it), even though in fact the judgment is only aesthetic and refers the object's presentation merely to the subject. He will talk in this way because the judgment does resemble a logical judgment inasmuch as we may presuppose it to be valid for everyone. On the other hand, this universality cannot arise from concepts. For from concepts there is no transition to the feeling of pleasure, or displeasure (except in pure practical laws; but these carry an interest with them, while none is connected with pure judgments of taste). It follows that, since a judgment of taste involves the consciousness that all interest is kept out of it, it must also involve a claim to being valid for everyone, but without having a universality based on concepts. In other words, a judgment of taste must involve a claim to subjective universality.

§7 Comparison of the Beautiful with the Agreeable . . . in Terms of the Above Characteristic As regards the agreeable, everyone acknowledges

that his judgment, which he bases on a private feeling and by which he says that he likes some object, is by the same token confined to his own person. Hence, if he says that canary wine is agreeable he is quite content if someone else corrects his terms and reminds him to say instead: It is agreeable to me. This holds moreover not only for the taste of the tongue, palate, and throat, but also for what may be agreeable to any one's eyes and ears. To one person the color violet is gentle and lovely, to another life-less and faded. One person loves the sound of wind instruments, another that of string instruments.[13] It would be foolish if we disputed about such differences with the intention of censuring another's judgment as incorrect if it differs from ours, as if the two were opposed logically. Hence about the agreeable the following principle holds: *Everyone has his own taste* (of sense).[14]

It is quite different (exactly the other way round) with the beautiful. It would be ridiculous if someone who prided himself on his taste tried to justify [it] by saying: This object (the building we are looking at, the garment that man is wearing, the concert we are listening to, the poem put up to be judged) is beautiful *for me.* For he must not call it *beautiful* if [he means] only [that] he[15] likes it. Many things may be charming and agreeable to him; no one cares about that. But if he proclaims something to be beautiful, then he requires the same liking from others; he then judges not just for himself but for everyone, and speaks of beauty as if it were a property of things. That is why he says: The *thing* is beautiful, and does not count on other people to agree with his judgment of liking on the ground that he has repeatedly found them agreeing with him; rather, he *demands* that they agree. He reproaches them if they judge differently, and denies that they have taste, which he nev-ertheless demands of them, as something they ought to have. In view of this [*sofern*], we cannot say that everyone has his own particular taste. That would amount to saying that there is no such thing as taste at all, no aes-thetic judgment that could rightfully lay claim to everyone's assent.

§9 Investigation of the Question Whether in a Judgment of Taste the Feeling of Pleasure Precedes the Judging of the Object or the Judging Precedes the Pleasure The solution of this problem is the key to the cri-tique of taste and hence deserves full attention.

If the pleasure in the given object came first, and our judgment of taste were to attribute only the pleasure's universal communicability to the pre-sentation of the object, then this procedure would be self-contradictory. For that kind of pleasure would be none other than mere agreeableness in

the sensation, so that by its very nature it could have only private validity, because it would depend directly on the presentation by which the object *is given.*

Hence it must be the universal communicability of the mental state, in the given presentation, which underlies the judgment of taste as its subjective condition, and the pleasure in the object must be its consequence. Nothing, however, can be communicated universally except cognition, as well as presentation insofar as it pertains to cognition; for presentation is objective only insofar as it pertains to cognition, and only through this does it have a universal reference point with which everyone's presentational power is compelled to harmonize. If, then, we are to think that the judgment about this universal communicability of the presentation has a merely subjective determining basis, i.e., one that does not involve a concept of the object, then this basis can be nothing other than the mental state that we find in the relation between the presentational powers [imagination and understanding] insofar as they refer a given presentation to *cognition in general.*

When this happens, the cognitive powers brought into play by this presentation are in free play, because no determinate concept restricts them to a particular rule of cognition. Hence the mental state in this presentation must be a feeling, accompanying the given presentation, of a free play of the presentational powers directed to cognition in general. Now if a presentation by which an object is given is, in general, to become cognition, we need *imagination* to combine the manifold of intuition, and *understanding* to provide the unity of the concept uniting the [component] presentations. This state of *free play* of the cognitive powers, accompanying a presentation by which an object is given, must be universally communicable; for cognition, the determination of the object with which given presentations are to harmonize (in any subject whatever) is the only way of presenting that holds for everyone.

But the way of presenting [which occurs] in a judgment of taste is to have subjective universal communicability without presupposing a determinate concept; hence this subjective universal communicability can be nothing but [that of] the mental state in which we are when imagination and understanding are in free play (insofar as they harmonize with each other as required for *cognition in general*). For we are conscious that this subjective relation suitable for cognition in general must hold just as much for everyone, and hence be just as universally communicable, as any determinate cognition, since cognition always rests on that relation as its subjective condition.

Now this merely subjective (aesthetic) judging of the object, or of the presentation by which it is given, precedes the pleasure in the object and is the basis of this pleasure, [a pleasure] in the harmony of the cognitive powers. But the universal subjective validity of this liking, the liking we connect with the presentation of the object we call beautiful, is based solely on the mentioned universality of the subjective conditions for judging objects.

Explication of the Beautiful Inferred from the Second Moment

Beautiful is what, without a concept, is liked universally.

Third Moment of Judgments of Taste, as to the Relation of Purposes That Is Taken Into Consideration in Them

§13 A Pure Judgment of Taste Is Independent of Charm and Emotion

§14 Elucidation by Examples In painting, in sculpture, indeed in all the visual arts, including architecture and horticulture insofar as they are fine arts, *design is* what is essential; in design the basis for any involvement of taste is not what gratifies us in sensation, but merely what we like because of its form. The colors that illuminate the outline belong to charm. Though they can indeed make the object itself vivid to sense, they cannot make it beautiful and worthy of being beheld. Rather, usually the requirement of beautiful form severely restricts [what] colors [may be used], and even where the charm [of colors] is admitted it is still only the form that refines the colors.

All form of objects of the senses (the outer senses or, indirectly, the inner sense as well) is either *shape* or *play;* if the latter, it is either play of shapes (in space, namely, mimetic art and dance), or mere play of sensations (in time). The *charm* of colors or of the agreeable tone of an instrument may be added, but it is the *design* in the first case and the *composition* in the second that constitute the proper object of a pure judgment of taste; that the purity of the colors and of the tones, or for that matter their variety and contrast, seem to contribute to the beauty, does not mean that, because they themselves are agreeable, they furnish us, as it were, with a supplement to, and one of the same kind as, our liking for the form. For all they do is to make the form intuitable more precisely, determinately, and completely, while they also enliven the presentation by means of their charm, by arousing and sustaining the attention we direct toward the object itself.

Even what we call *ornaments* (*parerga*), i.e., what does not belong to the whole presentation of the object as an intrinsic constituent, but [is] only an

extrinsic addition, does indeed increase our taste's liking, and yet it too does so only by its form, as in the case of picture frames, or drapery on statues, or colonnades around magnificent buildings. On the other hand, if the ornament itself does not consist in beautiful form but is merely attached, as a gold frame is to a painting so that its charm may commend the painting for our approval, then it impairs genuine beauty and is called *finery*.

§16 A Judgment of Taste by Which We Declare an Object Beautiful Under the Condition of a Determinate Concept Is Not Pure There are two kinds of beauty, free beauty (*pulchritude vaga*) and merely accessory beauty (*pulchritude adhaerens*). Free beauty does not presuppose a concept of what the object is [meant] to be. Accessory beauty does presuppose such a concept, as well as the object's perfection in terms of that concept. The free kinds of beauty are called (self-subsistent) beauties of this or that thing. The other kind of beauty is accessory to a concept (i.e., it is conditioned beauty) and as such is attributed to objects that fall under the concept of a particular purpose.

Flowers are free natural beauties. Hardly anyone apart from the botanist knows what sort of thing a flower is [meant] to be; and even he, while recognizing it as the reproductive organ of a plant, pays no attention to this natural purpose when he judges the flower by taste. Hence the judgment is based on no perfection of any kind, no intrinsic purposiveness to which the combination of the manifold might refer. Many birds (the parrot, the humming-bird, the bird of paradise) and a lot of crustaceans in the sea are [free] beauties themselves [and] belong to no object determined by concepts as to its purpose, but we like them freely and on their own account. Thus designs *à la grecque*,[16] the foliage on borders or on wallpaper, etc., mean nothing on their own: they represent [*vorstellen*] nothing, no object under a determinate concept, and are free beauties. What we call fantasias in music (namely, music without a topic [*Thema*]), indeed all music not set to words, may also be included in the same class.

When we judge free beauty (according to mere form) then our judgment of taste is pure. Here we presuppose no concept of any purpose for which the manifold is to serve the given object, and hence no concept [as to] what the object is [meant] to represent; our imagination is playing, as it were, while it contemplates the shape, and such a concept would only restrict its freedom.

But the beauty of a human being (and, as kinds subordinate to a human being, the beauty of a man or woman or child), or the beauty of a horse or

of a building (such as a church, palace, armory, or summer-house) does presuppose the concept of the purpose that determines what the thing is [meant] to be, and hence a concept of its perfection, and so it is merely adherent beauty. Now just as a connection of beauty, which properly concerns only form, with the agreeable (the sensation) prevented the judgment of taste from being pure, so does a connection of beauty with the good (i.e., as to how, in terms of the thing's purpose, the manifold is good for the thing itself) impair the purity of a judgment of taste.

Explication of the Beautiful Inferred from the Third Moment

Beauty is an object's form of *purposiveness* insofar as it is perceived in the object *without the presentation of a purpose.*[17]

Fourth Moment of a Judgment of Taste, as to the Modality of the Liking for the Object

§18 What the Modality of a Judgment of Taste Is About any presentation I can say at least that there is a *possibility* for it (as a cognition) to be connected with a pleasure. About that which I call *agreeable* I say that it *actually* gives rise to pleasure in me. But we think of the *beautiful* as having a *necessary*[18] reference to liking. This necessity is of a special kind. It is not a theoretical objective necessity, allowing us to cognize a priori that everyone *will feel* this liking for the object I call beautiful. Nor is it a practical objective necessity, where, through concepts of a pure rational will that serves freely acting beings as a rule, this liking is the necessary consequence of an objective law and means nothing other than that one absolutely (without any further aim) ought to act in a certain way. Rather, as a necessity that is thought in an aesthetic judgment, it can only be called *exemplary, i.e.,* a necessity of the assent of *everyone* to a judgment that is regarded as an example of a universal rule that we are unable to state. Since an aesthetic judgment is not an objective and cognitive one, this necessity cannot be derived from determinate concepts and hence is not apodeictic. Still less can it be inferred from the universality of experience (from a thorough agreement among judgments about the beauty of a certain object). For not only would experience hardly furnish a sufficient amount of evidence for this, but a concept of the necessity of these judgments cannot be based on empirical judgments.

Explication of the Beautiful Inferred from the Fourth Moment

Beautiful is what without a concept is cognized as the object of a *necessary* liking. . . .

§23 Transition from the Power of Judging the Beautiful to That of Judging the Sublime The beautiful and the sublime[19] are similar in some respects. We like both for their own sake, and both presuppose that we make a judgment of reflection rather than either a judgment of sense or a logically determinative one. Hence in neither of them does our liking depend on a sensation, such as that of the agreeable, nor on a determinate concept, as does our liking for the good; yet we do refer the liking to concepts, though it is indeterminate which concepts these are. Hence the liking is connected with the mere exhibition or power of exhibition, i.e., the imagination, with the result that we regard this power, when an intuition is given us, as harmonizing with the power of concepts, i.e., the understanding or reason, this harmony furthering [the aims of] these. That is also why both kinds of judgment are singular ones that nonetheless proclaim themselves universally valid for all subjects, though what they lay claim to is merely the feeling of pleasure, and not any cognition of the object.

But some significant differences between the beautiful and the sublime are also readily apparent. The beautiful in nature concerns the form of the object, which consists in [the object's] being bounded. But the sublime can also be found in a formless object, insofar as we present unboundedness, either [as] in the object or because the object prompts us to present it, while yet we add to this unboundedness the thought of its totality. So it seems that we regard the beautiful as the exhibition of an indeterminate concept of the understanding, and the sublime as the exhibition of an indeterminate concept of reason. Hence in the case of the beautiful our liking is connected with the presentation of quality, but in the case of the sublime with the presentation of quantity. The two likings are also very different in kind. For the one liking ([that for] the beautiful) carries with it directly a feeling of life's being furthered, and hence is compatible with charms and with an imagination at play. But the other liking (the feeling of the sublime) is a pleasure that arises only indirectly: it is produced by the feeling of a momentary inhibition of the vital forces followed immediately by an outpouring of them that is all the stronger. Hence[20] it is an emotion,[21] and so it seems to be seriousness, rather than play, in the imagination's activity. Hence, too, this liking is incompatible with charms, and, since the mind is not just attracted by the object but is alternately always repelled as well, the liking for the sublime contains not so much a positive pleasure as rather admiration and respect, and so should be called a negative pleasure.[22]

But the intrinsic and most important distinction between the sublime and the beautiful is presumably the following. If, as is permissible, we start

here by considering only the sublime in natural objects (since the sublime in art is always confined to the conditions that [art] must meet to be in harmony with nature), then the distinction in question comes to this: (Independent) natural beauty carries with it a purposiveness in its form, by which the object seems as it were predetermined for our power of judgment, so that this beauty constitutes in itself an object of our liking. On the other hand, if something arouses in us, merely in apprehension and without any reasoning on our part, a feeling of the sublime, then it may indeed appear, in its form, contrapurposive for our power of judgment, incommensurate with our power of exhibition, and as it were violent to our imagination, and yet we judge it all the more sublime for that.

We see from this at once that we express ourselves entirely incorrectly when we call this or that *object of nature* sublime, even though we may quite correctly call a great many natural objects beautiful; for how can we call something by a term of approval if we apprehend it as in itself contrapurposive? Instead, all we are entitled to say is that the object is suitable for exhibiting a sublimity that can be found in the mind. For what is sublime, in the proper meaning of the term, cannot be contained in any sensible form but concerns only ideas of reason, which, though they cannot be exhibited adequately, are aroused and called to mind by this very inadequacy, which can be exhibited in sensibility. Thus the vast ocean heaved up by storms cannot be called sublime. The sight of it is horrible; and one must already have filled one's mind with all sorts of ideas if such an intuition is to attune it to a feeling that is itself sublime, inasmuch as the mind is induced to abandon sensibility and occupy itself with ideas containing a higher purposiveness.

§ 26 On Estimating the Magnitude of Natural Things, as We Must for the Idea of the Sublime In order for the imagination to take in a quantum intuitively, so that we can then use it as a measure or unity in estimating magnitude by numbers, the imagination must perform two acts: *apprehension* (*apprehensio*), and *comprehension*[23] (*comprehensio*). Apprehension involves no problem, for it may progress to infinity. But comprehension becomes more and more difficult the farther apprehension progresses, and it soon reaches its maximum, namely, the aesthetically largest basic measure for an estimation of magnitude. For when apprehension has reached the point where the partial presentations of sensible intuition that were first apprehended are already beginning to be extinguished in the imagination, as it proceeds to apprehend further ones, the imagination

then loses as much on the one side as it gains on the other; and so there is a maximum in comprehension that it cannot exceed.

This serves to explain a comment made by Savary in his report on Egypt:[24] that in order to get the full emotional effect from the magnitude of the pyramids one must neither get too close to them nor stay too far away. For if one stays too far away, then the apprehended parts (the stones on top of one another) are presented only obscurely, and hence their presentation has no effect on the subject's aesthetic judgment; and if one gets too close, then the eye needs some time to complete the apprehension from the base to the peak, but during that time some of the earlier parts are invariably extinguished in the imagination before it has apprehended the later ones, and hence the comprehension is never complete. Perhaps the same observation can explain the bewilderment or kind of perplexity that is said to seize the spectator who for the first time enters St. Peter's Basilica in Rome. For he has the feeling that his imagination is inadequate for exhibiting the idea of a whole, [a feeling] in which imagination reaches its maximum, and as it strives to expand that maximum, it sinks back into itself, but consequently comes to feel a liking [that amounts to an] emotion [*rührendes Wohlgefallen*].[25]

§28 On Nature as a Might

Might is an ability that is superior to great obstacles. It is called dominance [*Gewalt*] if it is superior even to the resistance of something that itself possesses might. When in an aesthetic judgment we consider nature as a might that has no dominance over us, then it is *dynamically*[26] sublime.

If we are to judge nature as sublime dynamically, we must present it as arousing fear. (But the reverse does not hold: not every object that arouses fear is found sublime when we judge it aesthetically.) For when we judge [something] aesthetically (without a concept), the only way we can judge a superiority over obstacles is by the magnitude of the resistance. But whatever we strive to resist is an evil, and it is an object of fear if we find that our ability [to resist it] is no match for it. Hence nature can count as a might, and so as dynamically sublime, for aesthetic judgment only insofar as we consider it as an object of fear.

We can, however, consider an object *fearful* without being afraid *of* it, namely, if we judge it in such a way that we merely *think* of the case where we might possibly want to put up resistance against it, and that any resistance would in that case be utterly futile. Thus a virtuous person fears God without being afraid of him. For he does not think of wanting to resist God

and his commandments as a possibility that should worry *him*. But for every such case, which he thinks of as not impossible intrinsically, he recognizes God as fearful.

Just as we cannot pass judgment on the beautiful if we are seized by inclination and appetite, so we cannot pass judgment at all on the sublime in nature if we are afraid. For we flee from the sight of an object that scares us, and it is impossible to like terror that we take seriously. That is why the agreeableness that arises from the cessation of a hardship is *gladness*. But since this gladness involves our liberation from a danger, it is accompanied by our resolve never to expose ourselves to that danger again. Indeed, we do not even like to think back on that sensation, let alone actively seek out an opportunity for it.

On the other hand, consider bold, overhanging and, as it were, threatening rocks, thunderclouds piling- up in the sky and moving about accompanied by lightning and thunderclaps, volcanoes with all their destructive power, hurricanes with all the devastation they leave behind, the boundless ocean heaved up, the high waterfall of a mighty river, and so on. Compared to the might of any of these, our ability to resist becomes an insignificant trifle. Yet the sight of them becomes all the more attractive the more fearful it is, provided we are in a safe place. And we like to call these objects sublime because they raise the soul's fortitude above its usual middle range and allow us to discover in ourselves an ability to resist which is of a quite different kind, and which gives us the courage [to believe] that we could be a match for nature's seeming omnipotence.

For although we found our own limitation when we considered the immensity of nature and the inadequacy of our ability to adopt a standard proportionate to estimating aesthetically the magnitude of nature's *domain*, yet we also found, in our power of reason, a different and nonsensible standard that has this infinity itself under it as a unit; and since in contrast to this standard everything in nature is small, we found in our mind a superiority over nature itself in its immensity. In the same way, though the irresistibility of nature's might makes us, considered as natural beings, recognize our physical impotence, it reveals in us at the same time an ability to judge ourselves independent of nature, and reveals in us a superiority over nature that is the basis of a self-preservation quite different in kind from the one that can be assailed and endangered by nature outside us. This keeps the humanity in our person from being degraded, even though a human being would have to succumb to that dominance [of nature]. Hence if in judging nature aesthetically we call it sublime, we do so not because nature arouses fear, but

because it calls forth our strength (which does not belong to nature [within us]), to regard as small the [objects] of our [natural] concerns: property, health, and life, and because of this we regard nature's might (to which we are indeed subjected in these [natural] concerns) as yet not having such dominance over us, as persons, that we should have to bow to it if our highest principles were at stake and we had to choose between upholding or abandoning them. Hence nature is here called sublime [*erhaben*] merely because it elevates [*erhebt*] our imagination, [making] it exhibit those cases where the mind can come to feel its own sublimity, which lies in its vocation and elevates it even above nature.

This self-estimation loses nothing from the fact that we must find ourselves safe in order to feel this exciting liking, so that (as it might seem), since the danger is not genuine, the sublimity of our intellectual ability might also not be genuine. For here the liking concerns only our ability's *vocation,* revealed in such cases, insofar as the predisposition to this ability is part of our nature, whereas it remains up to us, as our obligation, to develop and exercise this ability. And there is truth in this, no matter how conscious of his actual present impotence man may be when he extends his reflection thus far.

§45 Fine Art Is an Art Insofar as It Seems at the Same Time to Be Nature In [dealing with] a product of fine art we must become conscious that it is art rather than nature, and yet the purposiveness in its form must seem as free from all constraint of chosen rules as if it were a product of mere nature. It is this feeling of freedom in the play of our cognitive powers, a play that yet must also be purposive, which underlies that pleasure which alone is universally communicable although not based on concepts. Nature, we say, is beautiful [*schön*] if it also looks like art; and art can be called fine [*schön*] art only if we are conscious that it is art while yet it looks to us like nature.

For we may say universally, whether it concerns beauty in nature or in art: *beautiful is what we like in merely judging it* (rather than either in sensation proper or through a concept). Now art always has a determinate intention to produce something. But if this something were mere sensation (something merely subjective), to be accompanied by pleasure, then we would [indeed] like this product in judging it, [but] only by means of the feeling of sense. If the intention were directed at producing a determinate object and were achieved by the art, then we would like the object only through concepts. In neither case, then, would we like the art in *merely judging it*, i.e., we would like it not as fine but only as mechanical art.

Therefore, even though the purposiveness in a product of fine art is intentional, it must still not seem intentional; i.e., fine art must have the *look* of nature even though we are conscious of it as art. And a product of art appears like nature if, though we find it to agree quite *punctiliously* with the rules that have to be followed for the product to become what it is intended to be, it does not do so *painstakingly*. In other words, the academic form must not show; there must be no hint that the rule was hovering before the artist's eyes and putting fetters on his mental powers.

§46 Fine Art Is the Art of Genius

Genius is the talent (natural endowment) that gives the rule to art. Since talent is an innate productive ability of the artist and as such belongs itself to nature, we could also put it this way: Genius is the *innate mental predisposition (ingenium)* through which nature gives the rule to art.

Whatever the status of this definition may be, and whether or not it is merely arbitrary, or rather adequate to the concept that we usually connect with the word genius . . . still we can prove even now that, in terms of the meaning of the word genius adopted here, fine arts must necessarily be considered arts of genius.

For every art presupposes rules, which serve as the foundation on which a product, if it is to be called artistic, is thought of as possible in the first place. On the other hand, the concept of fine art does not permit a judgment about the beauty of its product to be derived from any rule whatsoever that has a concept as its determining basis, i.e., the judgment must not be based on a concept of the way in which the product is possible. Hence fine art cannot itself devise the rule by which it is to bring about its product. Since, however, a product can never be called art unless it is preceded by a rule, it must be nature in the subject (and through the attunement of his powers) that gives the rule to art; in other words, fine art is possible only as the product of genius.

What this shows is the following: (1) Genius is a *talent* for producing something for which no determinate rule can be given, not a predisposition consisting of a skill for something that can be learned by following some rule or other; hence the foremost property of genius must be *originality*. (2) Since nonsense too can be original, the products of genius must also be models, i.e., they must be *exemplary*; hence, though they do not themselves arise through imitation, still they must serve others for this, i.e., as a standard or rule by which to judge. (3) Genius itself cannot describe or indicate scientifically how it brings about its products, and it is rather as *nature*

that it gives the rule. That is why, if an author owes a product to his genius, he himself does not know how he came by the ideas for it; nor is it in his power [*Gewalt*] to devise such products at his pleasure, or by following a plan, and to communicate [his procedure] to others in precepts that would enable them to bring about like products. (Indeed, that is presumably why the word genius is derived from [Latin] *genius,* [which means] the guardian and guiding spirit that each person is given as his own at birth,[27] and to whose inspiration [*Eingebung*] those original ideas are due.) (4) Nature, through genius, prescribes the rule not to science but to art, and this also only insofar as the art is to be fine art. . . .

§ 51 On the Division of the Fine Arts We may in general call beauty (whether natural or artistic) the *expression* of aesthetic ideas; the difference is that in the case of beautiful [*schön*] art the aesthetic idea must be prompted by a concept of the object, whereas in the case of beautiful nature, mere reflection on a given intuition, without a concept of what the object is [meant] to be, is sufficient for arousing and communicating the idea of which that object is regarded as the *expression.*

Accordingly, if we wish to divide the fine [*schön*] arts, we can choose for this, at least tentatively, no more convenient principle than the analogy between the arts and the way people express themselves in speech so as to communicate with one another as perfectly as possible, namely, not merely as regards their concepts but also as regards their sensations.[28] Such expression consists in *word*, *gesture*, and *tone* (articulation, gesticulation, and modulation). Only when these three ways of expressing himself are combined does the speaker communicate completely. For in this way thought, intuition, and sensation are conveyed to others simultaneously and in unison.

Hence there are only three kinds of fine arts: the art *of speech, visual* art, and the art *of the play of sensations* (as outer sense impressions). This division could also be arranged as a dichotomy: we could divide fine art into the art of expressing thoughts and that of expressing intuitions, and then divide the latter according to whether it deals merely with form, or with matter (sensation). But in that case the division would look too abstract, and less in keeping with ordinary concepts.

—Translated by Werner S. Pluhar

2

Introductory Lectures on Aesthetics

Georg Wilhelm Friedrich Hegel

Influenced by rationalist ideas concerning the primacy of the mind, Georg Wilhelm Friedrich Hegel (1770–1831) developed a teleological account of the history of humankind's awakening consciousness and realization of Spirit (*Geist*). Hegel's reputation and influence rest upon four published books—*The Phenomenology of Spirit* (1807), *The Science of Logic* (1812–16), *The Encyclopedia of the Philosophical Sciences* (1817), and *The Philosophy of Right* (1821)—and the numerous series of lectures he gave at the University of Berlin, where he was professor of philosophy between 1818 and 1831. Many of these lectures were compiled posthumously. Included in them was an important series on the philosophy of art, delivered between 1818 and 1829 and published in 1835, outlining the significance of art for the understanding of humankind's progressive striving for spiritual attainment.

Hegel posits spirit and historical process in terms of a dialectic in which the former, alienated from itself by crude nature, will be reconciled through a series of evolutionary developments in mankind's history. In this context, Spirit is equated with the transcendental Idea of absolute consciousness toward which mankind advances in moving beyond nature in order to achieve reunification. Here, Hegel's theory can be understood as part of a wider attempt to supersede and, in the process, reconcile the opposition

within metaphysics and Christian theology between the transcendental essence of the Godhead and the realm of phenomena and appearances. His answer to this conundrum was to develop Kant's idea of a speculative but ultimately rationalist mind as the fount of the Universe within a historical process dedicated to fulfilling its own destiny. Unlike Kant, Hegel did not believe that reason exists in transcendental concepts a priori, but that it develops in history as humankind becomes more conscious of Spirit. Hegel argued that God and humans are mutually dependent upon each other as they strive for a consciousness of their shared divinity. By implication, humankind is superior to a nature that is largely unconscious of itself. As evidence of the interdependence between God and humankind, Hegel stressed the fact that divine love became incarnate in the physical person of Jesus Christ and that the universal unity of the Christian godhead is manifested paradoxically through the particularity of the Trinity, which consists of three individual elements: the Father, the Son, and the Holy Spirit (xcvi). This provides the context for Hegel's approach to art, which he views as an external product of the mind consciously reflecting, and thereby contributing to, the mind's awareness of its intrinsic relation to spirit (xxi). As Hegel states, it is a "misconception that God does *not* work in man and through man. . . . This false opinion is to be entirely abandoned if we mean to penetrate the true conception of art."[1] Hegel argues that "the spiritual and the sensuous side must in artistic production be as one"[2] and that the common thread running between spiritual content and sensuous representation is art. As such, art possesses the "character of concreteness," a capacity for realizing the spiritual in both content and form and for combining them together (xcvii).

Hegel argues that because art is essentially sensuous, it is not ultimately fully up to the task of representing the Idea (the unity between God and the human mind) (xvi, xcviii, and cvii). Classical art can only achieve a latent, unconscious sense of the unity between humankind and the divine and, although Romantic art advances toward a more conscious, "inward" sense of this, it does not transcend history, itself. Hegel proposes that the consciousness achieved by art eventually will be transcended by thought or "inward knowledge" (xcviii). Speaking of his own times, Hegel believes that philosophy, science and religion, and the inward knowledge and thought that they possess have already exceeded art (xvi–xviii). Such a "reflective culture" developed by these inquiries cultivate general truths ("laws, duties, rights, maxims") in more abstract terms than art is capable of representing (xvii). As

a consequence, Hegel goes so far as to suggest that "art is, and remains for us, on the side of its highest destiny, a thing of the past" (xviii). This much-quoted statement is associated with the idea, which is often attributed to Hegel, of the end or death of art. Somewhat in contradiction to this idea Hegel suggests that his own times may yet not be sufficiently ready to appreciate the truth of art (xvi).

Humankind's progress toward the realization of consciousness that is Spirit and mind encompasses the historical task of art and the definition of beauty as the Idea (ciii). With this in view, Hegel divided the history of art into three major phases involving a process in which the Idea increasingly reveals itself; eventually, these phases culminate in a consciousness that the relationship between God and the mind is not a matter of an external-ization in a visible form but of "intellectual inwardness" and "spiritual knowl-edge." The first stage is symbolic art, which points toward spirit without being adequate to it (cv). Such inadequacy is due to Hegel's belief that at this stage of development the Idea still seems abstract and indeterminate, so that either art operates at the level of crude symbolism, "as when a lion is used to mean strength," or its sensory shape is distorted, with the effect that the Idea is suggested by default (cv). Hegel classifies Hindu and Egyp-tian art and Judaic poetry as symbolic art.[3] The next stage is classical art, by which Hegel specifically means Greek sculpture (cvi). Classical art ex-presses the Idea through the human form, although this form is necessarily "purified" in order to render the Idea appropriately. The final stage is roman-tic art, which encompasses art from the Greeks to Hegel's own day, but the essence of which is an inward feeling of human and divine unity that in effect begins to leave behind the necessity for a visualization of this unity. Thus, "romantic art must be considered as art transcending itself, while remaining within the artistic sphere and in artistic form" (cvii).[4]

Spirit, as defined by Hegel, is actually a combination of several levels of consciousness at once. First, Spirit is a consciousness of the codepen-dency of humanity and the divine, and of the interrelationship between the sensual side of humankind and the mind. Second, it is a consciousness of the historical evolution of reason toward the Idea. Third, it is a conscious-ness of this historical development itself, as a bounded, finite entity. And fi-nally, Spirit is the transcendence of the finite process of history. Through the death of history (and within it, art) Spirit attains its own transcendence and so resolves the metaphysical split between humans and God. Thus, the Idea is made manifest as an absolute mind or consciousness shaping and, finally, reflecting upon history and finitude.

INTRODUCTORY LECTURES ON AESTHETICS
■■■■■■■

The Range of Aesthetic Defined, and Some Objections Against the Philosophy of Art Refuted

Chapter I [xi] That art is in the abstract capable of serving other aims, and of being a mere pastime, is moreover a relation which it shares with thought. For, on the one hand, science, in the shape of the subservient understanding, submits to be used for finite purposes, and as an accidental means, and in that case is not self-determined, but determined by alien objects and relations; but, on the other hand, science liberates itself from this service to rise in free independence to the attainment of truth, in which medium, free from all interference, it fulfils itself in conformity with its proper aims.

[xii] Fine art is not real art till it is in this sense free, and only achieves its highest task when it has taken its place in the same sphere with religion and philosophy, and has become simply a mode of revealing to consciousness and bringing to utterance the Divine Nature, the deepest interests of humanity, and the most comprehensive truths of the mind. It is in works of art that nations have deposited the profoundest intuitions and ideas of their hearts; and fine art is frequently the key—with many nations there is no other—to the understanding of their wisdom and of their religion.

[xiii] This is an attribute which art shares with religion and philosophy, only in this peculiar mode, that it represents even the highest ideas *in sensuous forms*, thereby bringing them nearer to the character of natural phenomena, to the senses, and to feeling. The world, into whose depths *thought* penetrates, is a supra-sensuous world, which is thus, to begin with, erected as a *beyond* over against immediate consciousness and present sensation; the power which thus rescues itself from the *here*, that consists in the actuality and finiteness of sense, is the freedom of thought in cognition. But the mind is able to heal this schism which its advance creates; it generates out of itself the works of fine art as the first middle term of reconciliation between pure thought and what is external, sensuous, and transitory, between nature with its finite actuality and the infinite freedom of the reason that comprehends.

[xiv] The *element* of art was said to be in its general nature an *unworthy* elemont, as consisting in appearance and deception. The censure would be not devoid of justice, if it were possible to class appearance as something that ought not to exist. An appearance or show, however, is essential to existence. Truth could not be, did it not appear and reveal itself, were it not truth *for*

someone or something, *for* itself as also *for* Mind. Therefore there can be no objection against appearance in general, but, if at all, against the particular mode of appearance in which art gives actuality to what is in itself real and true. If, in this aspect, the *appearance* with which art gives its conceptions life as determinate existences is to be termed a *deception*, this is a criticism which primarily receives its meaning by comparison with the external world of phenomena and its immediate contact with us as *matter*, and in like manner by the standard of our own world of feeling, that is, the inner world of *sense*. These are the two worlds to which, in the life of daily experience, in our own phenomenal life, we are accustomed to attribute the value and the title of actuality, reality, and truth, in contrast to art, which we set down as lacking such reality and truth. Now, this whole sphere of the empirical inner and outer world is just what is not the world of genuine reality, but is to be entitled a mere appearance more strictly than is true of art, and a crueler deception. Genuine reality is only to be found beyond the immediacy of feeling and of external objects. Nothing is genuinely real but that which is actual in its own right, that which is the substance of nature and of mind, fixing itself indeed in present and definite existence, but in this existence still retaining its essential and self-centered being, and thus and no otherwise attaining genuine reality. The dominion of these universal powers is exactly what art accentuates and reveals. The common outer and inner world also no doubt present to us this essence of reality, but in the shape of a chaos of accidental matters, encumbered by the immediateness of sensuous presentation, and by arbitrary states, events, characters, etc. Art liberates the real import of appearances from the semblance and deception of this bad and fleeting world, and imparts to phenomenal semblances a higher reality, born of mind. The appearances of art, therefore, far from being mere semblances, have the higher reality and the more genuine existence in comparison with the realities of common life.

Just as little can the representations of art be called a deceptive semblance in comparison with the representations of historical narrative, as if that had the more genuine truth. For history has not even immediate existence, but only the intellectual presentation of it, for the element of its portrayals, and its content remains burdened with the whole mass of contingent matter formed by common reality with its occurrences, complications, and individualities. But the work of art brings before us the eternal powers that hold dominion in history, without any such superfluity in the way of immediate sensuous presentation and its unstable semblances.

[xv] Again, the mode of appearance of the shapes produced by art may be called a deception in comparison with philosophic thought, with religious

or moral principles. Beyond a doubt the mode of revelation which a content attains in the realm of thought is the truest reality; but in comparison with the show or semblance of immediate sensuous existence or of historical narrative, the artistic semblance has the advantage that in itself it points beyond itself, and refers us away from itself to something spiritual which it is meant to bring before the mind's eye. Whereas immediate appearance does not give itself out to be deceptive, but rather to be real and true, though all the time its truth is contaminated and infected by the immediate sensuous element. The hard rind of nature and the common world gives the mind more trouble in breaking through to the idea than do the products of art.

[xvi] But if, on the one side, we assign this high position to art, we must no less bear in mind, on the other hand, that art is not, either in content or in form, the supreme and absolute mode of bringing the mind's genuine interests into consciousness. The form of art is enough to limit it to a restricted content. Only a certain circle and grade of truth is capable of being represented in the medium of art. Such truth must have in its own nature the capacity to go forth into sensuous form and be adequate to itself therein, if it is to be a genuinely artistic content, as is the case with the gods of Greece. There is, however, a deeper form of truth, in which it is no longer so closely akin and so friendly to sense as to be adequately embraced and expressed by that medium. Of such a kind is the Christian conception of truth; and more especially the spirit of our modern world, or, to come closer, of our religion and our intellectual culture, reveals itself as beyond the stage at which art is the highest mode assumed by man's consciousness of the absolute. The peculiar mode to which artistic production and works of art belong no longer satisfies our supreme need. We are above the level at which works of art can be venerated as divine, and actually worshipped; the impression which they make is of a more considerate kind, and the feelings which they stir within us require a higher test and a further confirmation. Thought and reflection have taken their flight above fine art. Those who delight in grumbling and censure may set down this phenomenon for a corruption, and ascribe it to the predominance of passion and selfish interests, which scare away at once the seriousness and the cheerfulness of art. Or we may accuse the troubles of the present time and the complicated condition of civil and political life as hindering the feelings, entangled in minute preoccupations, from freeing themselves, and rising to the higher aims of art, the intelligence itself being subordinate to petty needs and interests, in sciences which only subserve such purposes and are seduced into making this barren region their home.

[xvii] However all this may be, it certainly is the case that art no longer affords that satisfaction of spiritual wants which earlier epochs and peoples have sought therein, and have found therein only; a satisfaction which, at all events on the religious side, was most intimately and profoundly connected with art. The beautiful days of Greek art, and the golden time of the later Middle Ages are gone by. The reflective culture of our life of today, makes it a necessity for us, in respect of our will no less than of our judgment, to adhere to general points of view, and to regulate particular matters according to them, so that general forms, laws, duties, rights, maxims are what have validity as grounds of determination and are the chief regulative force. But what is required for artistic interest as for artistic production is, speaking generally, a living creation, in which the universal is not present as law and maxim, but acts as if one with the mood and the feelings, just as, in the imagination, the universal and rational is contained only as brought into unity with a concrete sensuous phenomenon. Therefore, our present in its universal condition is not favorable to art. As regards the artist himself, it is not merely that the reflection which finds utterance all round him, and the universal habit of having an opinion and passing judgment about art infect him, and mislead him into putting more abstract thought into his works themselves; but also the whole spiritual culture of the age is of such a kind that he himself stands within this reflective world and its conditions, and it is impossible for him to abstract from it by will and resolve, or to contrive for himself and bring to pass, by means of peculiar education or removal from the relations of life, a peculiar solitude that would replace all that is lost.

[xviii] In all these respects art is, and remains for us, on the side of its highest destiny, a thing of the past. Herein it has further lost for us its genuine truth and life, and rather is transferred into our *ideas* than asserts its former necessity, or assumes its former place, in reality. What is now aroused in us by works of art is over and above our immediate enjoyment, and together with it, our judgment, inasmuch as we subject the content and the means of representation of the work of art and the suitability or unsuitability of the two to our intellectual consideration. Therefore, the *science* of art is a much more pressing need in our day than in times in which art, simply as art, was enough to furnish a full satisfaction. Art invites us to consideration of it by means of thought, not to the end of stimulating art production, but in order to ascertain scientifically what art is.

[xix] As soon as we propose to accept this invitation we are met by the difficulty which has already been touched upon in the suggestion that, though art is a suitable subject for philosophical reflection in the general

sense, yet it is not so for systematic and scientific discussion. In this objec-
tion there lies the false idea that a philosophical consideration may, never-
theless, be unscientific. On this point it can only be remarked here with
brevity that, whatever ideas others may have of philosophy and philoso-
phizing, I regard the pursuit of philosophy as utterly incapable of existing
apart from a scientific procedure. Philosophy has to consider its object in
its necessity, not, indeed, in its subjective necessity or external arrange-
ment, classification, etc., but it has to unfold and demonstrate the object
out of the necessity of its own inner nature. Until this evolution is brought to
pass the scientific element is lacking to the treatment. In as far, however, as
the objective necessity of an object lies essentially in its logical and meta-
physical nature, the isolated treatment of art must be conducted with a
certain relaxation of scientific stringency. For art involves the most complex
presuppositions, partly in reference to its content, partly in respect of its
medium and element, in which art is constantly on the borders of the arbi-
trary or accidental. Thus it is only as regards the essential innermost prog-
ress of its content and of its media of expression that we must call to mind
the outline prescribed by its necessity.

[xx] The objection that works of fine art elude the treatment of scientific
thought because they originate out of the unregulated fancy and out of the
feelings, are of a number and variety that defy the attempt to gain a con-
spectus, and therefore take effect only on feeling and imagination, raises a
problem which appears still to have importance. For the beauty of art does
in fact appear in a form which is expressly contrasted with abstract thought,
and which the latter is forced to destroy in exerting the activity which is its
nature. This idea coheres with the opinion that reality as such, the life of
nature and of mind, is disfigured and slain by comprehension; that, so far
from being brought close to us by the thought which comprehends, it is by
it that such life is absolutely dissociated from us, so that, by the use of
thought as the *means* of grasping what has life, man rather cuts himself off
from this his purpose. We cannot speak fully on this subject in the present
passage, but only indicate the point of view from which the removal of this
difficulty, or impossibility depending on maladaptation, might be effected.

[xxi] It will be admitted, to begin with, that the mind is capable of con-
templating itself, and of possessing a consciousness, and that a *thinking*
consciousness, of itself and all that is generated by itself. Thought—to
think—is precisely that in which the mind has its innermost and essential
nature. In gaining this thinking consciousness concerning itself and its
products, the mind is behaving according to its essential nature, however

much freedom and caprice those products may display, supposing only that in real truth they have mind in them. Now art and its works as generated and created by the mind (spirit) are themselves of a spiritual nature, even if their mode of representation admits into itself the semblance of sensuous being, and pervades what is sensuous with mind. In this respect art is, to begin with, nearer to mind and its thinking activity than is mere external unintelligent nature; in works of art, mind has to do but with its own. And even if artistic works are not abstract thought and notion, but are an evolution of the notion *out of* itself, an alienation from itself towards the sensuous, still the power of the thinking spirit (mind) lies herein, *not merely* to grasp *itself only* in its peculiar form of the self-conscious spirit (mind), but just as much to recognize itself in its alienation in the shape of feeling and the sensuous, in its other form, by transmuting the metamorphosed thought back into definite thoughts, and so restoring it to itself. And in this preoccupation with the other of itself the thinking spirit is not to be held untrue to itself as if forgetting or surrendering itself therein, nor is it so weak as to lack strength to comprehend what is different from itself, but it comprehends both itself and its opposite. For the notion is the universal, which preserves itself in its particularizations, dominates alike itself and its "other," and so becomes the power and activity that consists in undoing the alienation which it had evolved. And thus the work of art in which thought alienates itself belongs, like thought itself, to the realm of comprehending thought, and the mind, in subjecting it to scientific consideration, is thereby but satisfying the want of its own inmost nature. For because thought is its essence and notion, it can in the last resort only be satisfied when it has succeeded in imbuing all the products of its activity with thought, and has thus for the first time made them genuinely its own. But, as we shall see more definitely below, art is far from being the highest form of mind, and receives its true ratification only from science.

[xxii] Just as little does art elude philosophical consideration by unbridled caprice. As has already been indicated, it is its true task to bring to consciousness the highest interests of the mind. Hence it follows at once with respect to the *content* that fine art cannot rove in the wildness of unfettered fancy, for these spiritual interests determine definite bases for its content, how manifold and inexhaustible so ever its forms and shapes may be. The same holds true for the forms themselves. They, again, are not at the mercy of mere chance. Not every plastic shape is capable of being the expression and representation of those spiritual interests, of absorbing and of reproducing them; every definite content determines a form suitable to it.

In this aspect too, then, we are in a position to find our bearings according to the needs of thought in the apparently unmanageable mass of works and types of art.

Thus, I hope, we have begun by defining the content of our science, to which we propose to confine ourselves, and have seen that neither is fine art unworthy of a philosophical consideration, nor is a philosophical consideration incompetent to arrive at a knowledge of the essence of fine art.

Chapter V. Division of the Subject [xciv] 1. After the above introductory remarks, it is now time to pass to the study of our object-matter. But we are still in the introduction, and an introduction cannot do more than lay down, for the sake of explanation, the general sketch of the entire course which will be followed by our subsequent scientific considerations. As, however, we have spoken of art as proceeding from the absolute Idea, and have even assigned as its end the sensuous representation of the absolute itself, we shall have to conduct this review in a way to show, at least in general, how the particular divisions of the subject spring from the conception of artistic beauty as the representation of the absolute. Therefore we must attempt to awaken a very general idea of this conception itself

[xcv] It has already been said that the content of art is the Idea, and that its form lies in the plastic use of images accessible to sense. These two sides art has to reconcile into a full and united totality. The *first* attribution which this involves is the requirement that the content, which is to be offered to artistic representation, shall show itself to be in its nature worthy of such representation. Otherwise we only obtain a bad combination, whereby a content that will not submit to plasticity and to external presentation is forced into that form, and a matter which is in its nature prosaic is expected to find an appropriate mode of manifestation in the form antagonistic to its nature.

[xcvi] The *second* requirement, which is derivable from this first, demands of the content of art that it should not be anything abstract in itself. This does not mean that it must be concrete as the sensuous is concrete in contrast to everything spiritual and intellectual, these being taken as in themselves simple and abstract. For everything that has genuine truth in the mind as well as in nature is concrete in itself, and has, in spite of its universality, nevertheless, both subjectivity and particularity within it. If we say, e.g., of God that he is simply *One*, the supreme Being as such, we have only enunciated a lifeless abstraction of the irrational understanding. Such a God, as he himself is not apprehended in his concrete truth, can afford no material for art, least of all for plastic art. Hence the Jews and the Turks have

not been able to represent their God, who does not even amount to such an abstraction of the understanding, in the positive way in which Christians have done so. For God in Christianity is conceived in His truth, and therefore, as in Himself thoroughly concrete, as a person, as a subject, and more closely determined, as mind or spirit. What He is as spirit unfolds itself to the religious apprehension as the Trinity of Persons, which at the same time in relation with itself is *One*. Here is essentiality, universality, and particularity, together with their reconciled unity; and it is only such unity that constitutes the concrete. Now, as a content in order to possess truth at all must be of this concrete nature, art demands the same concreteness, because a mere abstract universal has not in itself the vocation to advance to particularity and phenomenal manifestation and to unity with itself therein.

[xcvii] If a true and therefore concrete content is to have corresponding to it a sensuous form and modeling, this sensuous form must, in the third place, be no less emphatically something individual, wholly concrete in itself, and one. The character of concreteness as belonging to both elements of art, to the content as to the representation, is precisely the point in which both may coincide and correspond to one another; as, for instance, the natural shape of the human body is such a sensuous concrete as is capable of representing spirit, which is concrete in itself, and of displaying itself in conformity therewith. Therefore we ought to abandon the idea that it is a mere matter of accident that an actual phenomenon of the external world is chosen to furnish a shape thus conformable to truth. Art does not appropriate this form either because it simply finds it existing or because there is no other. The concrete content itself involves the element of external and actual, we may say indeed of sensible manifestation. But in compensation this sensuous concrete, in which a content essentially belonging to mind expresses itself, is in its own nature addressed to the inward being; its external element of shape, whereby the content is made perceptible and imaginable, has the aim of existing purely for the heart and mind. This is the only reason for which content and artistic shape are fashioned in conformity with each other. The *mere* sensuous concrete, external nature as such, has not this purpose for its exclusive ground of origin. The birds' variegated plumage shines unseen, and their song dies away unheard, the *Cereus* which blossoms only for a night withers without having been admired in the wilds of southern forests, and these forests, jungles of the most beautiful and luxuriant vegetation, with the most odorous and aromatic perfumes, perish and decay no less unenjoyed. The work of art has not such a naive self-centered being, but is

essentially a question, an address to the responsive heart, an appeal to affections and to minds.

[xcviii] Although the artistic bestowal of sensuous form is in this respect not accidental, yet on the other hand it is not the highest mode of apprehending the spiritually concrete. Thought is a higher mode than representation by means of the sensuous concrete. Although in a relative sense abstract, yet it must not be one-sided but concrete thinking, in order to be true and rational. Whether a given content has sensuous artistic representation for its adequate form, or in virtue of its nature essentially demands a higher and more spiritual embodiment, is a distinction that displays itself at once, if, for instance, we compare the Greek gods with God as conceived according to Christian ideas. The Greek god is not abstract but individual, and is closely akin to the natural human shape; the Christian God is equally a concrete personality, but in the mode of pure spiritual existence, and is to be known as *mind* and in mind. His medium of existence is therefore essentially inward knowledge and not external natural form, by means of which He can only be represented imperfectly, and not in the whole depth of His idea.

[xcix] But inasmuch as the task of art is to represent the idea to direct perception in sensuous shape, and not in the form of thought or of pure spirituality as such, and seeing that this work of representation has its value and dignity in the correspondence and the unity of the two sides, i.e. of the Idea and its plastic embodiment, it follows that the level and excellency of art in attaining a realization adequate to its idea must depend upon the grade of inwardness and unity with which Idea and Shape display themselves as fused into one.

[c] Thus the higher truth is spiritual being that has attained a shape adequate to the conception of spirit. This is what furnishes the principle of division for the science of art. For before the mind can attain the true notion of its absolute essence, it has to traverse a course of stages whose ground is in this idea itself; and to this evolution of the content with which it supplies itself, there corresponds an evolution, immediately connected therewith, of the plastic forms of art, under the shape of which the mind as artist presents to itself the consciousness of itself.

[ci] This evolution within the art-spirit has again in its own nature two sides. In the *first* place the development itself is a spiritual and universal one, in so far as the graduated series of definite *conceptions of the world* as the definite but comprehensive consciousness of nature, man and God, gives itself artistic shape; and, in the *second* place, this *universal* development of art is obliged to provide itself with external existence and sensuous form, and

the definite modes of the sensuous art-existence are themselves a totality of necessary distinctions in the realm of art—which are *the several arts*. It is true, indeed, that the necessary kinds of artistic representation are on the one hand *qua* spiritual of a very general nature, and not restricted to any one material; while sensuous existence contains manifold varieties of matter. But as this latter, like the mind, has the idea potentially for its inner soul, it follows from this that particular sensuous materials have a close affinity and secret accord with the spiritual distinctions and types of art presentation.

[cii] In its completeness, however, our science divides itself into three principal portions.

First, we obtain a *general part*. It has for its content and object the universal Idea of artistic beauty—this beauty being conceived as the Ideal—together with the nearer relation of the latter both to nature and to subjective artistic production.

Secondly, there develops itself out of the idea of artistic beauty a *particular* part, in as far as the essential differences which this idea contains in itself evolve themselves into a scale of *particular* plastic forms.

In the *third* place there results *a final* part, which has for its subject the individualization of artistic beauty, that consists in the advance of art to the sensuous realization of its shapes and its self-completion as a system of the several arts and their genera and species.

[ciii] With respect to the first part, we must begin by recalling to mind, in order to make the sequel intelligible, that the Idea *qua* the beautiful in art is not the Idea as such, in the mode in which a metaphysical logic apprehends it as the absolute, but the Idea as developed into concrete form fit for reality, and as having entered into immediate and adequate unity with this reality. For the *Idea as such*, although it is the essentially and actually true, is yet the truth only in its generality which has not yet taken objective shape; but the *Idea* as the *beautiful in art* is at once the Idea when specially determined as in its essence individual reality, and also an individual shape of reality essentially destined to embody and reveal the Idea. This amounts to enunciating the requirement that the Idea, and its plastic mould as concrete reality, are to be made completely adequate to one another. When reduced to such form the Idea, as a reality molded in conformity with the conception of the Idea, is the *Ideal*. The problem of this conformity might, to begin with, be understood in the sense that any Idea would serve, so long as the actual shape, it did not matter what shape, represented this particular Idea and no other. But if so, the required truth of the Ideal is confounded with mere correctness, which consists in the expression of any meaning whatever in appropriate fashion

so that its import may be readily recognized in the shape created. The Ideal is not to be thus understood. Any content whatever may attain to being represented quite adequately, judged by the standard of its own nature, but it does not therefore gain the right to claim the artistic beauty of the Ideal. Compared indeed with ideal beauty, even the presentation will in such a case appear defective. From this point of view we must remark to begin with, what cannot be proved till later, that the defects of a work of art are not to be regarded simply as always due, for instance, to individual unskillfulness. *Defectiveness of form* arises from *defectiveness of content*. So, for example, the Chinese, Indians, and Egyptians in their artistic shapes, their forms of deities, and their idols, never got beyond a formless phase, or one of a vicious and false definiteness of form, and were unable to attain genuine beauty; because their mythological ideas, the content and thought of their works of art, were as yet indeterminate in themselves, or of a vicious determinateness, and did not consist in the content that is absolute in itself. The more that works of art excel in true beauty of presentation, the more profound is the inner truth of their content and thought. And in dealing with this point, we have not to think merely perhaps of the greater or lesser skill with which the natural forms as given in external reality are apprehended and imitated. For in certain stages of art-consciousness and of representation, the distortion and disfigurement of natural structures is not unintentional technical inexpertness and want of skill, but intentional alteration, which emanates from the content that is in consciousness, and is required thereby. Thus, from this point of view, there is such a thing as imperfect art, which may be quite perfect, both technically and in other respects, *in its determinate* sphere, yet reveals itself to be defective when compared with the conception of art as such, and with the Ideal. Only in the highest art are the Idea and the representation genuinely adequate to one another, in the sense that the outward shape given to the Idea is in itself essentially and actually the true shape, because the content of the Idea, which that shape expresses, is itself the true and real content. It is a corollary from this, as we indicated above, that the Idea must be defined in and through itself as concrete totality, and thereby possess in itself the principle and standard of its particularization and determination in external appearance. For example, the Christian imagination will be able to represent God only in human form and with man's intellectual expression, because it is herein that God Himself is completely known in Himself as mind. Determinateness is, as it were, the bridge to phenomenal existence. Where this determinateness is not totality derived from the Idea itself, where the Idea is not conceived as self-determining and

self-particularizing, the Idea remains abstract and has its determinateness, and therefore the principle that dictates its particular and exclusively appropriate mode of presentation, not in itself but external to it. Therefore, the Idea when still abstract has even its shape external, and not dictated by itself. The Idea, however, which is concrete in itself bears the principle of its mode of manifestation within itself, and is by that means the free process of giving shape to itself. Thus it is only the truly concrete Idea that can generate the true shape, and this correspondence of the two is the Ideal.

[civ] Now because the Idea is in this fashion concrete unity, it follows that this unity can enter into the art-consciousness only by the expansion and reconciliation of the particularities of the Idea, and it is through this evolution that artistic beauty comes to possess a *totality of particular stages and forms*. Therefore, after we have studied the beauty of art in itself and on its own merits, we must see how beauty as a whole breaks up into its particular determinations. This gives, as our *second part, the doctrine of the types of art*. These forms find their genesis in the different modes of grasping the Idea as artistic content, whereby is conditioned a difference of the form in which it manifests itself. Hence the types of art are nothing but the different relations of content and shape, relations which emanate from the Idea itself, and furnish thereby the true basis of division for this sphere. For the principle of division must always be contained in *that* conception whose particularization and division is in question.

[cv] We have here to consider *three* relations of the Idea to its outward shaping.

(First, the Idea gives rise to the beginning of Art when, being itself still in its indistinctness and obscurity, or in vicious untrue determinateness, it is made the import of artistic creations. As indeterminate it does not yet possess in itself that individuality which the Ideal demands; its abstractness and one-sidedness leave its shape to be outwardly bizarre and defective. The first form of art is therefore rather a mere search after plastic portrayal than a capacity of genuine representation. The Idea has not yet found the true form even within itself, and therefore continues to be merely the struggle and aspiration thereafter. In general terms we may call this form the *Symbolic* form of art. In it the abstract Idea has its outward shape external to itself in natural sensuous matter, with which the process of shaping begins, and from which, *qua* outward expression, it is inseparable.

Natural objects are thus primarily left unaltered, and yet at the same time invested with the substantial Idea as their significance, so that they receive the vocation of expressing it, and claim to be interpreted as though

the Idea itself were present in them. At the root of this is the fact that natural objects have in them an aspect in which they are capable of representing a universal meaning. But as an adequate correspondence is not yet possible, this reference can only concern *an abstract attribute*, as when a lion is used to mean strength.

On the other hand, this abstractness of the relation brings to consciousness no less strongly the foreignness of the Idea to natural phenomena; and the Idea, having no other reality to express it, expatiates in all these shapes, seeks itself in them in all their unrest and disproportion, but nevertheless does not find them adequate to itself. Then it proceeds to exaggerate the natural shapes and the phenomena of reality into indefiniteness and disproportion, to intoxicate itself in them, to seethe and ferment in them, to do violence to them, to distort and explode them into unnatural shapes, and strives by the variety, hugeness, and splendor of the forms employed to exalt the phenomenon to the level of the Idea. For the Idea is here still more or less indeterminate and non-plastic, but the natural objects are in their shape thoroughly determinate.

Hence, in view of the unsuitability of the two elements to each other, the relation of the Idea to objective reality becomes a *negative* one, for the former, as in its nature inward, is unsatisfied with such an externality, and as being its inner universal substance persists in exaltation or *Sublimity* beyond and above all this inadequate abundance of shapes. In virtue of this sublimity the natural phenomena and the human shapes and incidents are accepted, and left as they were, though at the same time understood to be inadequate to their significance, which is exalted far above every earthly content.

These aspects may be pronounced in general terms to constitute the character of the primitive artistic pantheism of the East, which either charges even the meanest objects with the absolute import, or again coerces nature with violence into the expression of its view. By this means it becomes bizarre, grotesque, and tasteless, or turns the infinite but abstract freedom of the substantive Idea disdainfully against all phenomenal being as null and evanescent. By such means the import cannot be completely embodied in the expression, and in spite of all aspiration and endeavor the reciprocal inadequacy of shape and Idea remains insuperable. This may be taken as the first form of art—Symbolic art with its aspiration, its disquiet, its mystery and its sublimity.

[cvi] In the second form of art, which we propose to call *Classical*, the double defect of symbolic art is cancelled. The plastic shape of symbolic art is imperfect, because, in the first place, the Idea in it only enters into

consciousness in *abstract* determinateness or indeterminateness, and, in the second place, this must always make the conformity of shape to import defective, and in its turn merely abstract. The classical form of art is the solution of this double difficulty; it is the free and adequate embodiment of the Idea in the shape that, according to its conception, is peculiarly appropriate to the Idea itself. With it, therefore, the Idea is capable of entering into free and complete accord. Hence, the classical type of art is the first to afford the production and intuition of the completed Ideal, and to establish it as a realized fact.

The conformity, however, of notion and reality in classical art must not be taken in the purely *formal* sense of the agreement of a content with the external shape given to it, any more than this could be the case with the Ideal itself. Otherwise every copy from nature, and every type of countenance, every landscape, flower, or scene, etc., which forms the purport of any representation, would be at once made classical by the agreement which it displays between form and content. On the contrary, in classical art the peculiarity of the content consists in being itself concrete idea, and, as such, the concrete spiritual; for only the spiritual is the truly inner self. To suit such a content, then, we must search out that in Nature which on its own merits belongs to the essence and actuality of the mind. It must be the absolute notion that *invented* the shape appropriate to concrete mind, so that the *subjective* notion—in this case the spirit of art—has merely *found* it, and brought it, as an existence possessing natural shape, into accord with free individual spirituality. This shape, with which the Idea as spiritual—as individually determinate spirituality—invests itself when manifested as a temporal phenomenon, is *the human form*. Personification and anthropomorphism have often been decried as a degradation of the spiritual; but art, in as far as its end is to bring before perception the spiritual in sensuous form, must advance to such anthropomorphism, as it is only in its proper body that mind is adequately revealed to sense. The migration of souls is in this respect a false abstraction, and physiology ought to have made it one of its axioms that life had necessarily in its evolution to attain to the human shape, as the sole sensuous phenomenon that is appropriate to mind. The human form is employed in the classical type of art not as mere sensuous existence, but exclusively as the existence and physical form corresponding to mind, and is therefore exempt from all the deficiencies of what is merely sensuous, and from the contingent finiteness of phenomenal existence. The outer shape must be thus purified in order to express in itself a content adequate to itself; and again, if the conformity of import and con-

tent is to be complete, the spiritual meaning which is the content must be of a particular kind. It must, that is to say, be qualified to express itself completely in the physical form of man, without projecting into another world beyond the scope of such an expression in sensuous and bodily terms. This condition has the effect that Mind is by it at once specified as a particular case of mind, as human mind, and not as simply absolute and eternal, inasmuch as mind in this latter sense is incapable of proclaiming and expressing itself otherwise than as intellectual being.

Out of this latter point arises, in its turn, the defect which brings about the dissolution of classical art, and demands a transition into a third and higher form, viz. into the *Romantic* form of art.

[cvii] The romantic form of art destroys the completed union of the Idea and its reality, and recurs, though in a higher phase, to that difference and antagonism of two aspects which was left unvanquished by symbolic art. The classical type attained the highest excellence, of which the sensuous embodiment of art is capable; and if it is in any way defective, the defect is in art as a whole, i.e. in the limitation of its sphere. This limitation consists in the fact that art as such takes for its object Mind—the conception of which is *infinite* concrete universality—in the shape of *sensuous* concreteness, and in the classical phase sets up the perfect amalgamation of spiritual and sensuous existence as a Conformity of the two. Now, as a matter of fact, in such an amalgamation Mind cannot be represented according to its true notion. For mind is the infinite subjectivity of the Idea, which, as absolute inwardness, is not capable of finding free expansion in its true nature on condition of remaining transposed into a bodily medium as the existence appropriate to it.

As *an escape from such a condition* the romantic form of art in its turn dissolves the inseparable unity of the classical phase, because it has won a significance which goes beyond the classical form of art and its mode of expression. This significance—if we may recall familiar ideas—coincides with what Christianity declares to be true of God as Spirit, in contradistinction to the Greek faith in gods which forms the essential and appropriate content for classical art. In Greek art the concrete import is potentially, but not explicitly, the unity of the human and divine nature; a unity which, just because it is purely *immediate* and *not explicit*, is capable of adequate manifestation in an immediate and sensuous mode. The Greek god is the object of naive intuition and sensuous imagination. His shape is, therefore, the bodily shape of man. The circle of his power and of his being is individual and individually limited. In relation with the subject, he is, therefore, an essence and a power with which the subject's inner being is merely in latent

unity, not itself possessing this unity as inward subjective knowledge. Now the higher stage is the *knowledge* of this *latent* unity, which as latent is the import of the classical form of art, and capable of perfect representation in bodily shape. The elevation of the latent or potential into self-conscious knowledge produces an enormous difference. It is the infinite difference which, e.g., separates man as such from the animals. Man is animal, but even in his animal functions he is not confined within the latent and potential as the animal is, but becomes conscious of them, learns to know them, and raises them—as, for instance, the process of digestion—into self-conscious science. By this means man breaks the boundary of merely potential and immediate consciousness, so that just for the reason that he knows himself to be animal, he ceases to be animal, and, as *mind,* attains to self-knowledge.

If in the above fashion the unity of the human and divine nature, which in the former phase was potential, is raised from an *immediate* to a *conscious* unity, it follows that the true medium for the reality of this content is no longer the sensuous immediate existence of the spiritual, the human bodily shape, but *self-conscious inward intelligence.*

Now, Christianity brings God before our intelligence *as spirit*, or mind—not as particularized individual spirit, but as absolute, in *spirit* and in truth. And for this reason Christianity retires from the sensuousness of imagination into intellectual inwardness, and makes this, not bodily shape, the medium and actual existence of its significance. So, too, the unity of the human and divine nature is a conscious unity, only to be realized by *spiritual* knowledge and in *spirit*. Thus the new content, won by this unity, is not inseparable from sensuous representation, as if that were adequate to it, but is freed from this immediate existence, which has to be posited as negative, absorbed, and reflected into the spiritual unity. In this way romantic art must be considered as art transcending itself, while remaining within the artistic sphere and in artistic form.

Therefore, in short, we may abide by the statement that in this third stage the object (of art) is *free*, concrete intellectual being, which has the function of revealing itself as spiritual existence for the inward world of spirit. In conformity with such an object-matter, art cannot work for sensuous perception. It must address itself to the inward mind, which coalesces with its object simply and as though this were itself, to the subjective inwardness, to the heart, the feeling, which, being spiritual, aspires to freedom within itself, and seeks and finds its reconciliation only in the spirit within. It is this *inner* world that forms the content of the romantic, and must

therefore find its representation as such inward feeling, and in the show or presentation of such feeling. The world of inwardness celebrates its triumph over the outer world, and actually in the sphere of the outer and in its medium manifests this its victory, owing to which the sensuous appearance sinks into worthlessness.

But, on the other hand, this type of Art, like every other, needs an external vehicle of expression. Now the spiritual has withdrawn into itself out of the external and its immediate oneness therewith. For this reason, the sensuous externality of concrete form is accepted and represented, as in symbolic art, as something transient and fugitive. And the same measure is dealt to the subjective finite mind and will, even including the peculiarity or caprice of the individual, of character, action, etc., or of incident and plot. The aspect of external existence is committed to contingency, and left at the mercy of freaks of imagination, whose caprice is no more likely to mirror what is given *as* it is given, than to throw the shapes of the outer world into chance medley, or distort them into grotesqueness. For this external element no longer has its notion and significance, as in classical art, in its own sphere, and in its own medium. It has come to find them in the feelings, the display of which is *in themselves* instead of being in the external and *its* form of reality, and which have the power to preserve or to regain their state of reconciliation with themselves, in every accident, in every unessential circumstance that takes independent shape, in all misfortunes and grief, and even in crime.

Owing to this, the characteristics of symbolic art, in difference, discrepancy, and severance of Idea and plastic shape, are here reproduced, but with an essential difference. In the sphere of the romantic, the Idea, whose defectiveness in the case of the symbol produced the defect of external shape, has to reveal itself in the medium of spirit and feelings as perfected in itself. And it is because of this higher perfection that it withdraws itself from any adequate union with the external element, inasmuch as it can seek and achieve its true reality and revelation nowhere but in itself.

This we may take as in the abstract the character of the symbolic, classical, and romantic forms of art, which represent the three relations of the Idea to its embodiment in the sphere of art. They consist in the aspiration after, and the attainment and transcendence of, the Ideal as the true Idea of beauty.

—Translated by Bornard Rosanquet

3

How the "True World" Finally Became a Fable:
The History of an Error
The Will to Power as Art

Friedrich Nietzsche

The son of a Lutheran minister, Friedrich Nietzsche was born in Röcken bei Lützen, a village in Saxony, in 1844. A brilliant student, he gained a chair in classical philology at the University of Basel, in Switzerland, at the age of only twenty-four. After retiring from academic life in 1879 on account of poor health, Nietzsche concentrated upon writing, and for the next decade he published a succession of books almost annually. Nietzsche suffered a nervous breakdown in 1889, spending the rest of his life in a sanatorium without writing any further, and he died in 1900.

Following Nietzsche's death, his work was promoted by his sister, Elisabeth Förster-Nietzsche, who used her brother's philosophy—particularly the concepts of the "Overman" and "the will to power"—to promote ideas of Aryan supremacy. This association with Nazism, coupled with Adolf Hitler's own admiration of Nietzsche, has inevitably tarnished the philosopher's reputation. But since, and even during, the Nazi period, Nietzsche's philosophy underwent an extensive reappraisal by philosophers from Heidegger and Bataille to Deleuze, Kofman, and Kristeva. The accompanying excerpts from *Twilight of the Idols* (1888)[1] and *The Will to Power* (1883–1888)[2] exemplify Nietzsche's idea that a philosophical consideration of art's status is the key not only to a reappraisal of Western values, as underpinned by metaphysics, but also to a new philosophy of life.

Nietzsche's infamous declaration "God is dead" was not intended simply as a celebration of atheism, but rather as a herald of the end of metaphysics and, with it, the basis for Western systems of moral thought. Nietzsche argued that moral repression is sustained through a type of thinking, stemming from metaphysics, that utilizes dialectically structured conceptual oppositions as its mainstay. In order to overcome this mindset, Nietzsche called for a "revaluation of all values." The specific conceptual operation required to achieve this task is outlined in the passage of writing entitled "How the 'True World' Finally Became a Fable: The History of an Error." This text describes the history of ideas in relation to the traditional binary opposition between truth and falsity. Since Plato, this has been aligned with the oppositions between essence and appearance, as well as the supersensuous and the sensuous. In effect, Nietzsche's text can be understood as a revaluation of the traditional distinctions between the representable and the unrepresentable, the knowable and the unknowable. Initially, in section 1, Nietzsche refers to Plato's confident identification of himself with the truth. There are different ways of interpreting this section. Nietzsche may have in mind his own assertion in his book *The Genealogy of Morals: An Attack* (1887) that Plato's confidence is born from his political ambitions for thinkers and philosophers to succeed the imperialistic warrior caste of Athens.[3] However, Heidegger understands this section to denote an affirmative idea that the supersensuous is integral to the sensuous (see chapter 7). Plato also features in section 2, where he is referred to as "the sage" who, along with Christian ideology, initiates metaphysics. Both Platonic and Christian ideologies are based upon the promise that it is possible to enter "the true world" (meaning, in this case, the divine realm) in return for leading a moral life. For Nietzsche, this places all humankind in a dialectical position of lack and subservience—a position traditionally allotted to women—since the true world is not obtainable until after death. (Nietzsche's use of the trope of femininity to denote dialectics can be seen as problematically sexist, although at the same time it recognizes the position of women under patriarchy as one situated in a dialectic.)[4] In section 3, although Immanuel Kant (who was from Königsberg, Prussia, and thus "Königsbergian") attempted to delimit the study of philosophy by asserting that it is impossible to have any knowledge of the transcendent and unrepresentable noumenon, Nietzsche believes that he maintained its presence in absentia in a dialectic with knowledge in other words, in terms of an opposition between what is knowable and what is

unknowable. Nietzsche implies that it is impossible to delimit the unknowable through contrast with the knowable. In section 4, Nietzsche proposes that positivism (a movement of rationalistic inquiry beginning in the nineteenth century) introduced a valuable sense of doubt into the question of truth by proposing that truth is a relative concept. Nevertheless, this ideology still harbored a sense of inadequacy, even guilt, about this situation since it implied that, because there are only truths in the plural, *the* "truth" is never obtainable. In sections 5 and 6 Nietzsche celebrates his own philosophy, its overcoming of the age-old sense of humankind's inadequacy with respect to the truth and, as a consequence, the birth of a new epoch (symbolized by the persona Zarathustra). In his philosophy, Nietzsche dispensed with binary oppositions—such as those between truth and falsity—altogether; this meant getting rid of not the terms themselves but the line drawn between them. So, in removing the opposition between truth and falsity, everything becomes false since there is no truth. But "falsity" is not a negative value, since there is no truth to measure it against. Similarly, by removing the opposition between the representable and the unrepresentable, the unrepresentable is envisaged not as other than what is representable (see the introduction).

The second extract, taken from Nietzsche's late notebooks, entitled "The Will to Power as Art," expands upon the idea of a new physiology of desire beyond metaphysics in which conceptual oppositions are overcome (see, for instance, section 803). With falsity and unrepresentability being taken seriously as having the status of truth (but not being *the* truth), art became the center point of Nietzsche's thought. Since Plato, art had been associated with artifice, illusion, and dissimulation. Now it became the paradigm by which to describe a new philosophy of affirmation underpinned by the revaluation of the unrepresentable. Nietzsche christened this philosophy "the will to power as art," the vehicle for which is envisaged through the figure of the philosopher-artist.

Nietzsche believed that Greek literature and culture before Plato[5] embraced a combination of two creative tendencies: a Dionysian desire for intoxication and an Apollonian worship of form and images (see sections 798 and 799). The combination of intoxicated energy and love of images provides a fertile ground for humanity itself ("the world") to become both creator and creation—that is, a work of art (see section 796). Nietzsche envisaged this possibility in terms of an experience of continual flux and outpouring of libidinal energy that he attempts to describe through the idea of sensual and amorous desire and, in sections 801 and 811, the economy

underpinning the psyche of the artist. These passages of writing anticipate Georges Bataille's philosophy, encapsulated in his essay "Notion of Expenditure" (1933),[6] in which an economy is envisaged no longer dominated by the wish to "balance the books" between income and expenditure. Instead, the philosopher-artist's psyche is envisaged as consisting of a desire for unadulterated expenditure and loss. At the same time, Nietzsche contrasts this type of exuberant "power" with the decline in libidinal appetite fostered by metaphysics and Christianity. He refers to this decline as a form of "ugliness" and "decadence" (sections 800 and 809) that, among other things, has established a system of aesthetics in which the subject is alienated from the work of art's production (809).

HOW THE "TRUE WORLD" FINALLY BECAME A FABLE

1. The true world—attainable for the sage, the pious, the virtuous man; he lives in it, *he is it*.

(The oldest form of the idea, relatively sensible, simple, and persuasive. A circumlocution for the sentence, "I, Plato, *am* the truth.")

2. The true world—unattainable for now, but promised for the sage, the pious, the virtuous man ("for the sinner who repents").

(Progress of the idea: it becomes more subtle, insidious, incomprehensible—it *becomes female*, it becomes Christian.)

3. The true world—unattainable, indemonstrable, unpromisable; but the very thought of it—a consolation, an obligation, an imperative.

(At bottom, the old sun, but seen through mist and skepticism. The idea has become elusive, pale, Nordic, Königsbergian.)

4. The true world—unattainable? At any rate, unattained. And being unattained, also *unknown*. Consequently, not consoling, redeeming, or obligating: how could something unknown obligate us?

(Gray morning. The first yawn of reason. The cockcrow of positivism.)

5. The "true" world—an idea which is no longer good for anything, not even obligating—an idea which has become useless and superfluous—*consequently*, a refuted idea: let us abolish it!

(Bright day; breakfast; return of *bon sens* and cheerfulness; Plato's embarrassed blush; pandemonium of all free spirits.)

6. The true world—we have abolished. What world has remained? The apparent one perhaps? But no! *With the true world we have also abolished the apparent one.*

(Noon; moment of the briefest shadow; end of the longest error; high point of humanity; INCIPIT ZARATHUSTRA.)

—Translated by Walter Kaufmann

THE WILL TO POWER AS ART

794 (March–June 1888) Our religion, morality, and philosophy are decadence forms of man.

The *countermovement: art.*

795 (1885–1886) The *artist*-philosopher.[7] Higher concept of art. Whether a man can place himself so far distant from other men that he can form them? (—Preliminary exercises: (1) he who forms himself, the hermit; (2) the artist hitherto, as a perfecter on a small scale, working on material.)

796 (1885–1886) The work of art where it appears without an artist, e.g., as body, as organization (Prussian officer corps, Jesuit order). To what extent the artist is only a preliminary stage.

The world as a work of art that gives birth to itself—

797 (1885–1886) The phenomenon "artist" is still the most transparent:—to see through it to the basic instincts of power, nature, etc.! Also those of religion and morality!

"Play," the useless—as the ideal of him who is overfull of strength, as "childlike." The "childlikeness" of God, *pais paizon.*[8]

798 (March–June 1888) *Apollinian—Dionysian.*[9] — There are two conditions in which art appears in man like a force of nature and disposes of him whether he will or no: as the compulsion to have visions and as a compulsion to an orgiastic state. Both conditions are rehearsed in ordinary life, too, but weaker: in dream and in intoxication. But the same antithesis obtains between dream and intoxication: both release artistic powers in us, but different ones: the dream those of vision, association, poetry; intoxication those of gesture, passion, song, dance.

799 (March–June 1888) In the Dionysian intoxication there is sexuality and voluptuousness: they are not lacking in the Apollinian. There must also be a difference in tempo in the two conditions — The extreme calm in certain

sensations of intoxication (more strictly: the retardation of the feelings of time and space) likes to be reflected in a vision of the calmest gestures and types of soul. The classical style is essentially a representation of this calm, simplification, abbreviation, concentration—the *highest feeling of power* is concentrated in the classical type. To react slowly; a great consciousness; no feeling of struggle.

800 (March–June 1888) The feeling of intoxication in fact corresponding to an increase in strength; strongest in the mating season: new organs, new accomplishments, colors, forms; "becoming more beautiful" is a consequence of *enhanced* strength.[10] Becoming more beautiful as the expression of a *victorious* will, of increased co-ordination, of a harmonizing of all the strong desires, of an infallibly perpendicular stress. Logical and geometrical simplification is a consequence of enhancement of strength: conversely the apprehension of such a simplification again enhances the feeling of strength— High point of the development: the grand style.

Ugliness signifies the decadence of a type, contradiction and lack of coordination among the inner desires—signifies a decline in organizing strength, in "will," to speak psychologically.

The condition of pleasure called intoxication is precisely an exalted feeling of *power*—The sensations of space and time are altered: tremendous distances are surveyed and, as it were, for the first time apprehended; the extension of vision over greater masses and expanses; the refinement of the organs for the apprehension of much that is extremely small and fleeting; *divination*, the power of understanding with only the least assistance, at the slightest suggestion: "intelligent" *sensuality*—; strength as a feeling of dominion in the muscles, as suppleness and pleasure in movement, as dance, as levity and *presto*; strength as pleasure in the proof of strength, as bravado, adventure, fearlessness, indifference to life or death — All these climactic moments of life mutually stimulate one another; the world of images and ideas of the one suffices as a suggestion for the others:—in this way, states finally merge into one another though they might perhaps have good reason to remain apart. For example: the feeling of religious intoxication and sexual excitation (—two profound feelings, co-ordinated to an almost amazing degree. What pleases all pious women, old or young? Answer: a saint with beautiful legs, still young, still an idiot). Cruelty in tragedy and sympathy (—also normally coordinated) Spring, dance, music:—all competitions between the sexes—and even that Faustian "infinity in the breast."

Artists, if they are any good, are (physically as well) strong, full of surplus energy, powerful animals, sensual; without a certain overheating of the sexual system a Raphael is unthinkable—Making music is another way of making children; chastity is merely the economy of an artist—and in any event, even with artists fruitfulness ceases when potency ceases— Artists should see nothing as it is, but fuller, simpler, stronger: to that end, their lives must contain a kind of youth and spring, a kind of habitual intoxication.

801 (Spring–Fall 1887; rev. Spring–Fall 1888) The states in which we infuse a transfiguration and fullness into things and poetize about them until they reflect back our fullness and joy in life: sexuality; intoxication; feasting; spring; victory over an enemy, mockery; bravado; cruelty; the ecstasy of religious feeling. *Three* elements principally: *sexuality, intoxication, cruelty*—all belonging to the oldest *festal joys* of mankind, all also preponderate in the early "artist."

Conversely, when we encounter things that display this transfiguration and fullness, the animal responds with an excitation of those spheres in which all those pleasurable states are situated—and a blending of these very delicate nuances of animal wellbeing and desires constitutes the *aesthetic state*. The latter appears only in natures capable of that bestowing and overflowing fullness of bodily vigor; it is this that is always the *primum mobile*. The sober, the weary, the exhausted, the dried-up (e.g., scholars) can receive absolutely nothing from art, because they do not possess the primary artistic force, the pressure of abundance: whoever cannot give, also receives nothing.

"Perfection": in these states (in the case of sexual love especially) there is naively revealed what the deepest instinct recognizes as higher, more desirable, more valuable in general, the upward movement of its type; also toward what status it really aspires. Perfection: that is the extraordinary expansion of its feeling of power, riches, necessary overflowing of all limits.

802 (Spring–Fall 1887) Art reminds us of states of animal vigor; it is on the one hand an excess and overflow of blooming physicality into the world of images and desires; on the other, an excitation of the animal functions through the images and desires of intensified life; —an enhancement of the feeling of life, a stimulant to it.

How can even ugliness possess this power? In so far as it still communicates something of the artist's victorious energy which has become mas-

ter of this ugliness and awfulness; or in so far as it mildly excites in us the pleasure of cruelty (under certain conditions even a desire to harm *ourselves,* self-violation—and thus the feeling of power over ourselves).

803 (1883–1888) "Beauty" is for the artist something outside all orders of rank, because in beauty opposites are tamed; the highest sign of power, namely power over opposites; moreover, without tension:—that violence is no longer needed; that everything follows, obeys, so easily and so pleasantly—that is what delights the artist's will to power.

804 (Spring–Fall 1887) *Origin of the beautiful and ugly.*[11]—Biological value of the *beautiful* and the *ugly.*— That which is instinctively *repugnant* to us, aesthetically, is proved by mankind's longest experience to be harmful, dangerous, worthy of suspicion: the suddenly vocal aesthetic instinct (e.g., in disgust) contains a *judgment.* To this extent the beautiful stands within the general category of the biological values of what is useful, beneficent, life-enhancing—but in such a way that a host of stimuli that are only distantly associated with, and remind us only faintly of, useful things and states give us the feeling of the beautiful, i.e., of the increase of the feeling of power (—not merely things, therefore, but also the sensations that accompany such things, or symbols of them).

Thus the beautiful and the ugly are recognized as *relative* to our most fundamental values of preservation. It is senseless to want to posit anything as beautiful or ugly apart from this. *The* beautiful exists just as little as does *the* good, or *the* true. In every case it is a question of the conditions of preservation of a certain type of man: thus the *herd man* will experience the value feeling of the beautiful in the presence of different things than will the *exceptional* or over-man.

It is the perspective of the foreground, which concerns itself only with immediate consequences, from which the value of the beautiful (also of the good, also of the true) arises.

All instinctive judgments are shortsighted in regard to the chain of consequences: they advise what is to be done immediately. The understanding is essentially a brake upon immediate reactions on the basis of instinctive judgments: it retards, it considers, it looks further along the chain of consequences.

Judgments concerning beauty and ugliness are shortsighted (—they are always opposed by the understanding—) but persuasive in the highest

degree; they appeal to our instincts where they decide most quickly and pronounce their Yes and No before the understanding can speak.

The most habitual affirmations of beauty excite and stimulate each other; once the aesthetic drive is at work, a whole host of other perfections, originating elsewhere, crystallize around "the particular instance of beauty." It is not possible to remain objective, or to suspend the interpretive, additive, interpolating, poetizing power (—the latter is the forging of the chain of affirmations of beauty). The sight of a "beautiful woman"

Thus 1. the judgment of beauty is shortsighted, it sees only the immediate consequences;

2. it lavishes upon the object that inspires it a magic conditioned by the association of various beauty judgments—that are quite alien to the nature of that object. To experience a thing as beautiful means: to experience it necessarily wrongly—(which, incidentally, is why marriage for love is, from the point of view of society, the most unreasonable kind of marriage).

805 (1883–1888) *On the genesis of art.*— That making perfect, seeing as perfect, which characterizes the cerebral system bursting with sexual energy (evening with the beloved, the smallest chance occurrences transfigured, life a succession of sublime things, "the misfortune of the unfortunate lover worth more than anything else"): on the other hand, everything perfect and beautiful works as an unconscious reminder of that enamored condition and its way of seeing—every perfection, all the beauty of things, revives through contiguity[12] this aphrodisiac bliss. (Physiologically: the creative instinct of the artist and the distribution of semen in his blood—) The demand for art and beauty is an indirect demand for the ecstasies of sexuality communicated to the brain. The world become perfect, through "love"—

806 (1883–1888) *Sensuality* in its disguises: (1) as idealism ("Plato"), peculiar to youth, creating the same kind of concave image that the beloved in particular assumes, imposing an encrustation, magnification, transfiguration, infinity upon everything—; (2) in the religion of love: "a handsome young man, a beautiful woman," somehow divine, a bridegroom, a bride of the soul—; (3) in *art,* as the "embellishing" power: as man sees woman and, as it were, makes her a present of everything excellent, so the sensuality of the artist puts into one object everything else that he honors and esteems—in this way he *perfects* an object ("idealizes" it). Woman, conscious of man's feelings concerning women, assists his efforts at idealization by adorning herself, walking beautifully, dancing, expressing delicate thoughts:

in the same way, she practices modesty, reserve, distance—realizing instinctively that in this way the idealizing capacity of the man will grow. (—Given the tremendous subtlety of woman's instinct, modesty remains by no means conscious hypocrisy: she divines that it is precisely an actual naive modesty that most seduces a man and impels him to overestimate her. Therefore woman is naive—from the subtlety of her instinct, which advises her of the utility of innocence. A deliberate *closing of one's eyes to oneself*— Wherever dissembling produces a stronger effect when it is unconscious, it *becomes* unconscious.)

807 (Summer–Fall 1888) What a tremendous amount can be accomplished by that intoxication which is called "love" but which is yet something other than love!— But everyone has his own knowledge of this. The muscular strength of a girl *increases* as soon as a man comes into her vicinity; there are instruments to measure this. When the sexes are in yet closer contact, as, e.g., at dances and other social events, this strength is augmented to such a degree that real feats of strength are possible: in the end one scarcely believes one's own eyes—or one's watch. In such cases, to be sure, we must reckon with the fact that dancing in itself, like every other swift movement, brings with it a kind of intoxication of the whole vascular, nervous, and muscular system. So one has to reckon with the combined effects of a twofold intoxication.— And how wise it is at times to be a little tipsy!

There are realities that one may never admit to oneself; after all, one is a woman; after all, one has a woman's *pudeurs*—Those young creatures dancing over there are obviously beyond all reality: they are dancing with nothing but palpable ideals; what is more, they even see ideals sitting around them: the mothers!—Opportunity to quote *Faust*— They look incomparably better when they are a little tipsy like that, these pretty creatures—oh, how well they know that, too. They actually become amiable *because* they know it.

Finally, they are also inspired by their finery; their finery is their *third* intoxication: they believe in their tailors as they believe in their God—and who would dissuade them from this faith? This faith makes blessed! And self-admiration is healthy! Self admiration protects against colds. Has a pretty woman who knew herself to be well dressed ever caught cold? Never! I am even assuming that she was barely dressed.[13]

808 (March–June 1888) Do you desire the most astonishing proof of how far the transfiguring power of intoxication can go?— "Love" is this proof:

that which is called love in all the languages and silences of the world. In this case, intoxication has done with reality to such a degree that in the consciousness of the lover the cause of it is extinguished and something else seems to have taken its place—a vibration and glittering of all the magic mirrors of Circe—

Here it makes no difference whether one is man or animal; even less whether one has spirit, goodness, integrity. If one is subtle, one is fooled subtly; if one is coarse, one is fooled coarsely: but love, and even the love of God, the saintly love of "redeemed souls," remains the same in its roots: a fever that has good reason to transfigure itself, an intoxication that does well to lie about itself— And in any case, one lies well when one loves, about oneself and to oneself: one seems to oneself transfigured, stronger, richer, more perfect, one *is* more perfect— Here we discover *art* as an organic function: we discover it in the most angelic instinct, "love"; we discover it as the greatest stimulus of life—art thus sublimely expedient even when it lies—

But we should do wrong if we stopped with its power to lie: it does more than merely imagine; it even transposes values. And it is not only that it transposes the *feeling* of values: the lover *is* more valuable, is stronger. In animals this condition produces new weapons, pigments, colors, and forms; above all, new movements, new rhythms, new love calls and seductions. It is no different with man. His whole economy is richer than before, more powerful, more *complete* than in those who do not love. The lover becomes a squanderer: he is rich enough for it. Now he dares, becomes an adventurer, becomes an ass in magnanimity and innocence; he believes in God again, he believes in virtue, because he believes in love; and on the other hand, this happy idiot grows wings and new capabilities, and even the door of art is opened to him. If we subtracted all traces of this intestinal fever from lyricism in sound and word, what would be left of lyrical poetry and music?— *L'art pour l'art* perhaps: the virtuoso croaking of shivering frogs, despairing in their swamp— All the rest was created by love—

809 (March–June 1888) All art exercises the power of suggestion over the muscles and senses, which in the artistic temperament are originally active: it always speaks only to artists—it speaks to this kind of a subtle flexibility of the body. The concept "layman" is an error. The deaf man is not a species of the man with good hearing.

All art works tonically, increases strength, inflames desire (i.e., the feeling of strength), excites all the more subtle recollections of intoxication—

there is a special memory that penetrates such states: a distant and transitory world of sensations here comes back.

The ugly, i.e., the contradiction to art, that which is excluded from art, its No—every time decline, impoverishment of life, impotence, disintegration, degeneration are suggested even faintly, the aesthetic man reacts with his No. The effect of the ugly is depressing: it is the expression of a depression. It takes away strength, it impoverishes, it weighs down

The ugly suggests ugly things; one can use one's states of health to test how variously an indisposition increases the capacity for imagining ugly things. The selection of things, interests, and questions changes. A state closely related to the ugly is encountered in logic, too: heaviness, dimness. Mechanically speaking, equilibrium is lacking: the ugly limps, the ugly stumbles: antithesis to the divine frivolity of the dancer.

The aesthetic state possesses a superabundance of means of communication, together with an extreme receptivity for stimuli and signs. It constitutes the high point of communication and transmission between living creatures—it is the source of languages. This is where languages originate: the languages of tone as well as the languages of gestures and glances. The more complete phenomenon is always the beginning: our faculties are subtilized out of more complete faculties. But even today one still hears with one's muscles, one even reads with one's muscles.

Every mature art has a host of conventions as its basis-in so far as it is‾ a language. Convention is the condition of great art, *not* an obstacle—

Every enhancement of life enhances man's power of communication, as well as his power of understanding. Empathy with the souls of others is originally nothing moral, but a physiologia susceptibility to suggestion: "sympathy," or what is called "altruism," is merely a product of that psychomotor rapport which is reckoned a part of spirituality *(induction psycho-motrice,* Charles Féré thinks). One never communicates thoughts: one communicates movements, mimic signs, which we then trace back to thoughts.

810 (Spring–Fall 1887) Compared with music all communication by words is shameless; words dilute and brutalize; words depersonalize; words make the uncommon common.

811 (March–June 1888) It is exceptional states that condition the artist—all of them profoundly related to and interlaced with morbid phenomena so it seems impossible to be an artist and not to be sick.

Physiological states that are in the artist as it were molded into a "personality" and that characterize men in general to some degree:

1. *intoxication:* the feeling of enhanced power; the inner need to make of things a reflex of one's own fullness and perfection;

2. the *extreme sharpness* of certain senses, so they understand a quite different sign language—and create one—the condition that seems to be a part of many nervous disorders—; extreme mobility that turns into an extreme urge to communicate; the desire to speak on the part of everything that knows how to make signs —; a need to get rid of oneself, as it were, through signs and gestures; ability to speak of oneself through a hundred speech media—an explosive condition. One must first think of this condition as a compulsion and urge to get rid of the exuberance of inner tension through muscular activity and movements of all kinds; then as an involuntary co-ordination between this movement and the processes within (images, thoughts, desires)—as a kind of automatism of the whole muscular system impelled by strong stimuli from within—; inability to prevent reaction; the system of inhibitions suspended, as it were. Every inner movement (feeling, thought, affect) is accompanied by vascular changes and consequently by changes in color, temperature, and secretion. The suggestive power of music, its "*suggestion mentale*"—

3. the *compulsion to imitate*: an extreme irritability through which a given example becomes contagious—a state is divined on the basis of signs and immediately enacted— An image, rising up within, immediately turns into a movement of the limbs—a certain suspension of the will— (Schopenhauer!!!) A kind of deafness and blindness towards the external world—the realm of admitted stimuli is sharply defined.

This is what distinguishes the artist from laymen (those susceptible to art): the latter reach the high point of their susceptibility when they receive; the former as they give—so that an antagonism between these two gifts is not only natural but desirable. The perspectives of these two states are opposite: to demand of the artist that he should practice the perspective of the audience (of the critic—) means to demand that he should impoverish himself and his creative power— It is the same here as with the difference between the sexes: one ought not to demand of the artist, who gives, that he should become a woman—that he should receive.

Our aesthetics hitherto has been a woman's aesthetics to the extent that only the receivers of art have formulated their experience of "what is beautiful?" In all philosophy hitherto the artist is lacking—

This, as the foregoing indicates, is a necessary mistake; for the artist who began to understand himself would misunderstand himself: he ought not to look back, he ought not to look at all, he ought to give. —

It is to the honor of an artist if he is unable to be a critic—otherwise he is half and half, he is "modern."

—Translated by Walter Kaufmann and R. J. Hollingdale

Beyond the Pleasure Principle
Leonardo da Vinci and a Memory of His Childhood

Sigmund Freud

Sigmund Freud (1856–1939) is often credited as "the inventor of the unconscious"—a possibly extravagant claim, notwithstanding the fact that he founded the institution of psychoanalysis and had a seminal influence upon the modern theory of the psyche. During the course of his work, Freud wrote a number of papers on the subjects of creativity and art (including both visual art and literature). These form part of Freud's overall investigation into the psyche, as constituted by the id, the ego, and the superego, and its relationship to neurotic or pathological symptoms and fantasies (which Lacan later referred to as the realm of "the Imaginary") under the aegis of the Oedipus complex. Freud's writings on art propose two related theories: that art is a vehicle for psychical conflicts, and that creativity is a form of sublimation. This latter theory is normally understood to refer to the capacity of the sexual drive to replace its immediate aim with other aims, but there appears a more ambitious conceptualization of this idea in "Leonardo da Vinci and a Memory of His Childhood."

The extract from the essay "Beyond the Pleasure Principle" (1920) considers the issue of the formation and structure of representation in connection with the question of the relationship, or rather the nonrelationship, between pleasure and unpleasure. In this context, pleasure is defined as a desire to avoid excitation by repressing those feelings connected with experiences of loss and Oedipal conflicts upon which difference rests. In view

of this definition, Freud believes that the psyche's predilection for pleasure is governed by the death drive. Freud is curious, therefore, to observe that soldiers traumatized in the First World War repeatedly return in their dreams to the events bound up with their trauma, since it might be assumed that this would be an unpleasurable thing to do. From this Freud is led to several conclusions: first, that there is a (masochistic) pleasure involved in repeatedly reenacting unpleasurable events; and second, contrary to the first conclusion, it is through repetition that the soldiers "work through" and manage consciously their traumatic experiences and psychical conflicts. (This latter idea is related to Freud's analysis of the psychological motivations of Leonardo's art.) Freud's subsequent analysis of the *fort/da* (here-there) game played by an eighteen-month-old child also involves the issue of repetition, about which again he draws seemingly contradictory conclusions.

Representation, as manifested in the *fort/da* game, is based upon a dialectic between presence and absence—wherein presence is always the touchstone by which absence is gauged. Freud asserts that the very substance of this dialectic is formed by the psyche itself, governed by the pleasure principle. By means of this game, the child transforms his unpleasurable experiences of his mother's leavings and absences into a representation through which he can form a fantasy of mastery and control (as if he could direct his mother's comings and goings at will, in the same way as he manipulates the cotton reel in the *fort/da* game). While Freud acknowledges that this game of representation is an egoistic absurdity, he nevertheless acclaims it as "the child's first great cultural achievement." This is because the child's very ability to invent the game reveals the ego's internalization of the mother's love—a process that Freud believed to be of crucial importance for subsequent psychical health.

The essay "Leonardo da Vinci and A Memory of His Childhood" (1910) develops many of the classic Freudian themes, namely those of the Oedipus complex, neurotic ambivalence, and castration anxiety (an anxiety that revolves around the dialectic between a fantasy of phallic presence and the fear of its absence or "lack"). Freud believes that the story told by Leonardo of a vulture landing on the side of his cradle is "phantasmatic" and can be interpreted as an erotic but threatening fantasy constructed through the Oedipal relation to the mother. In this scenario, Leonardo's mother, and women in general, raise the specter of castration anxiety: Leonardo's emotional experience of his mother's overwhelming love as well as his experience of separation and loss from her lead him to fear that women are the

cause of unpleasure (and, ultimately, castration). For Freud, Leonardo's paintings reveal the unconscious sense of threat to the ego in the Imaginary. Thus, the cartoon drawing of *Saint Anne with Two Others* (ca. 1499–1500) represents, for Freud, the two women as monstrous twins. However, Freud argues that the more accomplished and balanced composition of the painting of the same subject (ca. 1510) reveal that Leonardo's fear of women is in process of transformation. What is at stake in this transformation, or sublimation, is developed through analysis of the famous·"smiles" of Leonardo's figures, especially the smile of the *Mona Lisa*. At times, Freud seems to suggest that the Mona Lisa's smile is derived from that of his biological mother, Caterina. But, given Freud's wider discussion of the phantasmatic nature of memory, the conclusion emerges that the painting's smile, like the balanced effect of the composition of *Saint Anne with Two Others*, results from Leonardo's working through and becoming conscious of his fear of castration. By means of this working through, the artist is able to reconnect to feelings of familial love, as well as to those of loss, which are not encapsulated in any specific memory. This conclusion implies that the emotions encompassed by Leonardo's artworks are irreducible to a dialectic of presence (the representation of a remembered yet, supposedly, forgotten, memory) and absence (the forgotten "memory"). For further discussion of these last points in connection with Freud's essay on Leonardo, see Sarah Kofman, "The Work of Art and Fantasy" (chapter 11).

BEYOND THE PLEASURE PRINCIPLE

A condition has long been known and described which occurs after severe mechanical concussions, railway disasters and other accidents involving a risk to life; it has been given the name of "traumatic neurosis." The terrible war which has just ended gave rise to a great number of illnesses of this kind, but it at least put an end to the temptation to attribute the cause of the disorder to organic lesions of the nervous system brought about by mechanical force.[1] The symptomatic picture presented by traumatic neurosis approaches that of hysteria in the wealth of its similar motor symptoms, but surpasses it as a rule in its strongly marked signs of subjective ailment (in which it resembles hypochondria or melancholia) as well as in the evidence it gives of a far more comprehensive general enfeeblement and disturbance of the mental capacities. No complete explanation has yet been reached either of war neuroses or of the traumatic neuroses of peace. In the case of

the war neuroses, the fact that the same symptoms sometimes came about without the intervention of any gross mechanical force seemed at once enlightening and bewildering. In the case of the ordinary traumatic neuroses two characteristics emerge prominently: first, that the chief weight in their causation seems to rest upon the factor of surprise, of fright; and secondly, that a wound or injury inflicted simultaneously works as a rule *against* the development of a neurosis. "Fright," "fear," and "anxiety"[2] are improperly used as synonymous expressions; they are in fact capable of clear distinction in their relation to danger. "Anxiety" describes a particular state of expecting the danger or preparing for it, even though it may be an unknown one. "Fear" requires a definite object of which to be afraid. "Fright," however, is the name we give to the state a person gets into when he has run into danger without being prepared for it; it emphasizes the factor of surprise. I do not believe anxiety can produce a traumatic neurosis. There is something about anxiety that protects its subject against fright and so against fright-neuroses. . . . [3]

The study of dreams may be considered the most trustworthy method of investigating deep mental processes. Now dreams occurring in traumatic neuroses have the characteristic of repeatedly bringing the patient back into the situation of his accident, a situation from which he wakes up in another fright. This astonishes people far too little. They think the fact that the traumatic experience is constantly forcing itself upon the patient even in his sleep is a proof of the strength of that experience: the patient is, as one might say, fixated to his trauma. Fixations to the experience which started the illness have long been familiar to us in hysteria. Breuer and Freud declared in 1893[4] that "hysterics suffer mainly from reminiscences." In the war neuroses, too, observers like Ferenczi and Simmel have been able to explain certain motor symptoms by fixation to the moment at which the trauma occurred.

I am not aware, however, that patients suffering from traumatic neurosis are much occupied in their waking lives with memories of their accident. Perhaps they are more concerned with *not* thinking of it. Anyone who accepts it as something self-evident that their dreams should put them back at night into the situation that caused them to fall ill has misunderstood the nature of dreams. It would be more in harmony with their nature if they showed the patient pictures from his healthy past or of the cure for which he hopes. If we are not to be shaken in our belief in the wish-fulfilling tenor of dreams by the dreams of traumatic neurotics, we still have one resource open to us: we may argue that the function of dreaming, like so much else,

is upset in this condition and diverted from its purposes, or we may be driven to reflect on the mysterious masochistic trends of the ego.[5]

At this point I propose to leave the dark and dismal subject of the traumatic neurosis and pass on to examine the method of working employed by the mental apparatus in one of its earliest *normal* activities—I mean in children's play.

The different theories of children's play have only recently been summarized and discussed from the psychoanalytic point of view by Pfeifer (1919), to whose paper I would refer my readers. These theories attempt to discover the motives which lead children to play, but they fail to bring into the foreground the *economic* motive, the consideration of the yield of pleasure involved. Without wishing to include the whole field covered by these phenomena, I have been able, through a chance opportunity which presented itself, to throw some light upon the first game played by a little boy of one and a half and invented by himself. It was more than a mere fleeting observation, for I lived under the same roof as the child and his parents for some weeks, and it was some time before I discovered the meaning of the puzzling activity which he constantly repeated.

The child was not at all precocious in his intellectual development. At the age of one and a half he could say only a few comprehensible words; he could also make use of a number of sounds which expressed a meaning intelligible to those around him. He was, however, on good terms with his parents and their one servant-girl, and tributes were paid to his being a "good boy." He did not disturb his parents at night, he conscientiously obeyed orders not to touch certain things or go into certain rooms, and above all he never cried when his mother left him for a few hours. At the same time, he was greatly attached to his mother, who had not only fed him herself but had also looked after him without any outside help. This good little boy, however, had an occasional disturbing habit of taking any small objects he could get hold of and throwing them away from him into a comer, under the bed, and so on, so that hunting for his toys and picking them up was often quite a business. As he did this he gave vent to a loud, long-drawn-out "o-o-o-o," accompanied by an expression of interest and satisfaction. His mother and the writer of the present account were agreed in thinking that this was not a mere interjection but represented the German word "*fort*" [gone]. I eventually realized that it was a game and that the only use he made of any of his toys was to play "gone" with them. One day I made an observation which confirmed my view. The child had a wooden reel with a piece of string tied round it. It never occurred to him to pull it

along the floor behind him, for instance, and play at its being a carriage. What he did was to hold the reel by the string and very skillfully throw it over the edge of his curtained cot, so that it disappeared into it, at the same time uttering his expressive "o-o-o-o." He then pulled the reel out of the cot again by the string and hailed its reappearance with a joyful "*da*" [there]. This, then, was the complete game—disappearance and return. As a rule one only witnessed its first act, which was repeated untiringly as a game in itself, though there is no doubt that the greater pleasure was attached to the second act.[6]

The interpretation of the game then became obvious. It was related to the child's great cultural achievement—the instinctual renunciation (that is, the renunciation of instinctual satisfaction) which he had made in allowing his mother to go away without protesting. He compensated himself for this, as it were, by himself staging the disappearance and return of the objects within his reach. It is of course a matter of indifference from the point of view of judging the effective nature of the game whether the child invented it himself or took it over on some outside suggestion. Our interest is directed to another point. The child cannot possibly have felt his mother's departure as something agreeable or even indifferent. How then does his repetition of this distressing experience as a game fit in with the pleasure principle? It may perhaps be said in reply that her departure had to be enacted as a necessary preliminary to her joyful return, and that it was in the latter that lay the true purpose of the game. But against this must be counted the observed fact that the first act, that of departure, was staged as a game in itself and far more frequently than the episode in its entirety, with its pleasurable ending.

No certain decision can be reached from the analysis of a single case like this. On an unprejudiced view one gets an impression that the child turned his experience into a game from another motive. At the outset he was in a *passive* situation—he was overpowered by the experience; but, by repeating it, unpleasurable though it was, as a game, he took on an *active* part. These efforts might be put down to an instinct for mastery that was acting independently of whether the memory was in itself pleasurable or not. But still another interpretation may be attempted. Throwing away the object so that it was "gone" might satisfy an impulse of the child's, which was suppressed in his actual life, to revenge himself on his mother for going away from him. In that case it would have a defiant meaning; "All right, then, go away! I don't need you. I'm sending you away myself." A year later, the same boy whom I had observed at his first game used to take a toy, if he

was angry with it, and throw it on the floor, exclaiming: "Go to the fwont!" He had heard at that time that his absent father was "at the front," and was far from regretting his absence; on the contrary he made it quite clear that he had no desire to be disturbed in his sole possession of his mother.[7] We know of other children who liked to express similar hostile impulses by throwing away objects instead of persons.[8] We are therefore left in doubt as to whether the impulse to work over in the mind some overpowering experience so as to make oneself master of it can find expression as a primary event, and independently of the pleasure principle. For, in the case we have been discussing, the child may, after all, only have been able to repeat his unpleasant experience in play because the repetition carried along with it a yield of pleasure of another sort but none the less a direct one.

Nor shall we be helped in our hesitation between these two views by further considering children's play. It is clear that in their play children repeat everything that has made a great impression on them in real life, and that in doing so they abreact the strength of the impression and, as one might put it, make themselves master of the situation. But on the other hand it is obvious that all their play is influenced by a wish that dominates them the whole time—the wish to be grown-up and to be able to do what grown-up people do. It can also be observed that the unpleasurable nature of an experience does not always unsuit it for play. If the doctor looks down a child's throat or carries out some small operation on him, we may be quite sure that these frightening experiences will be the subject of the next game; but we must not in that connection overlook the fact that there is a yield of pleasure from another source. As the child passes over from the passivity of the experience to the activity of the game, he hands on the disagreeable experience to one of his playmates and in this way revenges himself on a substitute.

Nevertheless, it emerges from this discussion that there is no need to assume the existence of a special imitative instinct in order to provide a motive for play. Finally, a reminder may be added that the artistic play and artistic imitation carried out by adults, which, unlike children's, are aimed at an audience, do not spare the spectators (for instance, in tragedy) the most painful experiences and can yet be felt by them as highly enjoyable.[9] This is convincing proof that, even under the dominance of the pleasure principle, there are ways and means enough of making what is in itself unpleasurable into a subject to be recollected and worked over in the mind. The consideration of these cases and situations, which have a yield of pleasure as their final outcome, should be undertaken by some system of aesthetics with an

economic approach to its subject-matter. They are of no use for *our* pur-
poses, since they presuppose the existence and dominance of the plea-
sure principle; they give no evidence of the operation of tendencies *beyond*
the pleasure principle, that is, of tendencies more primitive than it and inde-
pendent of it.

LEONARDO DA VINCI AND A MEMORY OF HIS CHILDHOOD

There is, so far as I know, only one place in his scientific notebooks where
Leonardo inserts a piece of information about his childhood. In a passage
about the flight of vultures he suddenly interrupts himself to pursue a
memory from very early years which had sprung to his mind:

> It seems that I was always destined to be so deeply concerned with
> vultures; for I recall one of my very earliest memories that while I was
> in my cradle a vulture came down to me, and opened my mouth with
> its tail, and struck me many times with its tail against my lips.[10]

What we have here then is a childhood memory; and certainly one of
the strangest sort. It is strange on account of its content and on account of
the age to which it is assigned. That a person should be able to retain a
memory of his suckling period is perhaps not impossible, but it cannot by
any means be regarded as certain. What, however, this memory of Leon-
ardo's asserts—namely that a vulture opened the child's mouth with its
tail—sounds so improbable, so fabulous, that another view of it, which at a
single stroke puts an end to both difficulties, has more to commend it to our
judgment. On this view the scene with the vulture would not be a memory
of Leonardo's but a fantasy, which he formed at a later date and trans-
posed to his childhood.[11]

This is often the way in which childhood memories originate. Quite un-
like conscious memories from the time of maturity, they are not fixed at the
moment of being experienced and afterwards repeated, but are only elic-
ited at a later age when childhood is already past; in the process they are
altered and falsified, and are put into the service of later trends, so that
generally speaking they cannot be sharply distinguished from fantasies.
Their nature is perhaps best illustrated by a comparison with the way in
which the writing of history originated among the peoples of antiquity. As
long as a nation was small and weak it gave no thought to the writing of its
history. Men tilled the soil of their land, fought for their existence against

their neighbors, and tried to gain territory from them and to acquire wealth. It was an age of heroes, not of historians. Then came another age, an age of reflection: men felt themselves to be rich and powerful, and now felt a need to learn where they had come from and how they had developed. Historical writing, which had begun to keep a continuous record of the present, now also cast a glance back to the past, gathered traditions and legends, interpreted the traces of antiquity that survived in customs and usages, and in this way created a history of the past. It was inevitable that this early history should have been an expression of present beliefs and wishes rather than a true picture of the past; for many things had been dropped from the nation's memory, while others were distorted, and some remains of the past were given a wrong interpretation in order to fit in with contemporary ideas. Moreover people's motive for writing history was not objective curiosity but a desire to influence their contemporaries, to en- courage and inspire them, or to hold a mirror up before them. A man's conscious memory of the events of his maturity is in every way comparable to the first kind of historical writing [which was a chronicle of current events]; while the memories that he has of his childhood correspond, as far as their origins and reliability are concerned, to the history of a nation's earliest days, which was compiled later and for tendentious reasons.[12]

If, then, Leonardo's story about the vulture that visited him in his cradle is only a fantasy from a later period, one might suppose it could hardly be worthwhile spending much time on it. One might be satisfied with explain- ing it on the basis of his inclination, of which he makes no secret, to regard his preoccupation with the flight of birds as preordained by destiny. Yet in underrating this story one would be committing just as great an injustice as if one were carelessly to reject the body of legends, traditions and interpre- tations found in a nation's early history. In spite of all distortions and misun- derstandings, they still represent the reality of the past: they are what a people forms out of the experience of its early days and under the domi- nance of motives that were once powerful and still operate today; and if it were only possible, by a knowledge of all forces at work, to undo these distortions, there would be no difficulty in disclosing the historical truth lying behind the legendary material. The same holds good for the childhood memories or fantasies of an individual. What someone thinks he remem- bers from his childhood is not a matter of indifference; as a rule the residual memories—which he himself does not understand—cloak priceless pieces of evidence about the most important features in his mental development.[13] As we now possess in the techniques of psychoanalysis excellent meth-

ods for helping us to bring this concealed material to light, we may venture to fill in the gap in Leonardo's life story by analyzing his childhood fantasy. And if in doing so we remain dissatisfied with the degree of certainty which we achieve, we shall have to console ourselves with the reflection that so many other studies of this great and enigmatic man have met with no better fate.

If we examine with the eyes of a psychoanalyst Leonardo's fantasy of the vulture, it does not appear strange for long. We seem to recall we have come across the same sort of thing in many places, for example in dreams; so that we may venture to translate the fantasy from its own special language into words that are generally understood. The translation is then seen to point to an erotic content. A tail, "*coda*," is one of the most familiar symbols and substitutive expressions for the male organ, in Italian no less than in other languages;[14] the situation in the fantasy, of a vulture opening the child's mouth and beating about inside it[15] vigorously with its tail, corresponds to the idea of an act of *fellatio*, a sexual act in which the penis is put into the mouth of the person involved. It is strange that this fantasy is so completely passive in character; moreover it resembles certain dreams and fantasies found in women or passive homosexuals (who play the part of the woman in sexual relations).

I hope the reader will restrain himself and not allow a surge of indignation to prevent his following psycho-analysis any further because it leads to an unpardonable aspersion on the memory of a great and pure man the very first time it is applied to his case. Such indignation, it is clear, will never be able to tell us the significance of Leonardo's childhood fantasy; at the same time Leonardo has acknowledged the fantasy in the most unambiguous fashion, and we cannot abandon our expectation—or, if it sounds better, our prejudice—that a fantasy of this kind must have *some* meaning, in the same way as any other psychical creation: a dream, a vision or a delirium. Let us rather therefore give a fair hearing for a while to the work of analysis, which indeed has not yet spoken its last word.

The inclination to take a man's sexual organ into the mouth and suck at it, which in respectable society is considered a loathsome sexual perversion, is nevertheless found with great frequency among women of today—and of earlier times as well, as ancient sculptures show—and in the state of being in love it appears completely to lose its repulsive character. Fantasies derived from this inclination are found by doctors even in women who have not become aware of the possibilities of obtaining sexual satisfaction in this way by reading Krafft-Ebing's *Psychopathia Sexualis* or from other sources of information. Women, it seems, find no difficulty in producing this kind of

wishful fantasy spontaneously.[16] Further investigation informs us that this situation, which morality condemns with such severity, may be traced to an origin of the most innocent kind. It only repeats in a different form a situation in which we all once felt comfortable—when we were still in our suckling days ("*essendo io in culla*")[17] and took our mother's (or wet-nurse's) nipple into our mouth and sucked at it. The organic impression of this experience— the first source of pleasure in our life—doubtless remains indelibly printed on us; and when at a later date the child becomes familiar with the cow's udder whose function is that of a nipple, but whose shape and position under the belly make it resemble a penis, the preliminary stage has been reached which will later enable him to form the repellent sexual fantasy.[18]

Now we understand why Leonardo assigned the memory of his supposed experience with the vulture to his suckling period. What the fantasy conceals is merely a reminiscence of sucking —or being suckled—at his mother's breast, a scene of human beauty that he, like so many artists, undertook to depict with his brush, in the guise of the mother of God and her child. There is indeed another point which we do not yet understand and which we must not lose sight of: this reminiscence, which has the same importance for both sexes, has been transformed by the man Leonardo into a passive homosexual fantasy. For the time being we shall put aside the question of what there may be to connect homosexuality with sucking at the mother's breast, merely recalling that tradition does in fact represent Leonardo as a man with homosexual feelings. In this connection, it is irrelevant to our purpose whether the charge brought against the young Leonardo[19] was justified or not. What decides whether we describe someone as an invert[20] is not his actual behavior, but his emotional attitude.

Our interest is next claimed by another unintelligible feature of Leonardo's childhood fantasy. We interpret the fantasy as one of being suckled by his mother, and we find his mother replaced by—a vulture. Where does this vulture come from and how does it happen to be found in its present place?

At this point a thought comes to the mind from such a remote quarter that it would be tempting to set it aside. In the hieroglyphics of the ancient Egyptians the mother is represented by a picture of a vulture.[21] The Egyptians also worshipped a Mother Goddess, who was represented as having a vulture's head, or else several heads, of which at least one was a vulture's.[22] This goddess's name was pronounced *Mut*. Can the similarity to the sound of our word *Mutter* [mother] be merely a coincidence? There is, then, some real connection between vulture and mother—but what

help is that to us? For have we any right to expect Leonardo to know of it, seeing that the first man who succeeded in reading hieroglyphics was François Champollion (1790–1832)?[23]

It would be interesting to enquire how it could be that the ancient Egyptians came to choose the vulture as a symbol of motherhood. Now the religion and civilization of the Egyptians were objects of scientific curiosity even to the Greeks and the Romans: and long before we ourselves were able to read the monuments of Egypt we had at our disposal certain pieces of information about them derived from the extant writings of classical antiquity. Some of these writings were by well-known authors, such as Strabo, Plutarch, and Ammianus Marcellinus; while others bear unfamiliar names and are uncertain in their source of origin and their date of composition, like the *Hieroglyphica* of Horapollo Nilous and the book of oriental priestly wisdom which has come down to us under the name of the god Hermes Trismegistos. We learn from these sources that the vulture was regarded as a symbol of motherhood because only female vultures were believed to exist; there were, it was thought, no males of this species.[24] A counterpart to this restriction to one sex was also known to the natural history of antiquity: in the case of the scarabaeus [scarab] beetle, which the Egyptians worshipped as divine, it was thought that only males existed.[25]

How then were vultures supposed to be impregnated if all of them were female? This is a point fully explained in a passage in Horapollo.[26] At a certain time these birds pause in mid-flight, open their vagina and are impregnated by the wind.

We have now unexpectedly reached a position where we can take something as very probable which only a short time before we had to reject as absurd. It is quite possible that Leonardo was familiar with the scientific fable which was responsible for the vulture being used by the Egyptians as a pictorial representation of the idea of mother. He was a wide reader and his interest embraced all branches of literature and learning. In the Codex Atlanticus we find a catalogue of all the books he possessed at a particular date,[27] and in addition numerous jottings on other books that he had borrowed from friends; and if we may judge by the extracts from his notes by Richter [1883],[28] the extent of his reading can hardly be overestimated. Early works on natural history were well represented among them in addition to contemporary books; and all them were already in print at the time. Milan was in fact the leading city in Italy for the new art of printing.

On proceeding further we come across a piece of information which can turn the probability that Leonardo knew the fable of the vulture into a

certainty. The learned editor and commentator on Horapollo has the follow-
ing note on the text already quoted above [Leemans 1835, 172]: "Caeterum
hanc fabulam de vulturibus cupide amplexi sunt Patres Ecclesiastici, ut ita
argumento ex rerum natura petito refutarent eos, qui Virginis partum nega-
bant; itaque apud omnes fere hujus rei mentio occurrit."[29]

So the fable of the single sex of vultures and their mode of conception
remained something very far from an unimportant anecdote like the analo-
gous tale of the scarabaeus beetle; it had been seized on by the Fathers of
the Church so that they could have at their disposal a proof drawn from
natural history to confront those who doubted sacred history. If vultures
were described in the best accounts of antiquity as depending on the wind
for impregnation, why could not the same thing have also happened on
one occasion with a human female? Since the fable of the vulture could be
turned to this account "almost all" the Fathers of the Church made a prac-
tice of telling it, and thus it can hardly be doubted that Leonardo too came
to know of it through its being favored by so wide a patronage.

We can now reconstruct the origin of Leonardo's vulture fantasy. He
once happened to read in one of the Fathers or in a book on natural history
the statement that all vultures were females and could reproduce their kind
without any assistance from a male: and at that point a memory sprang to
his mind, which was transformed into the fantasy we have been discussing,
but which meant to signify that he also had been such a vulture-child—he
had had a mother, but no father. With this memory was associated, in the
only way in which impressions of so great an age can find expression, an
echo of the pleasure he had had at his mother's breast. The allusion made
by the Fathers of the Church to the idea of the Blessed Virgin and her
child—an idea cherished by every artist—must have played its part in help-
ing the fantasy to appear valuable and important to him. Indeed in this way
he was able to identify himself with the child Christ, the comforter and sav-
ior not of this one woman alone.

Our aim in dissecting a childhood fantasy is to separate the real mem-
ory that it contains from the later motives that modify and distort it. In Leon-
ardo's case we believe that we now know the real content of the fantasy:
the replacement of his mother by the vulture indicates that the child was
aware of his father's absence and found himself alone with his mother The
fact of Leonardo's illegitimate birth is in harmony with his vulture fantasy; it
was only on this account that he could compare himself to a vulture child.
But the next reliable fact that we possess about his youth is that by the time
he was five he had been received into his father's household. We are com-

pletely ignorant when that happened—whether it was a few months after his birth or whether it was a few weeks before the drawing-up of the land-register.[30] It is here that the interpretation of the vulture fantasy comes in: Leonardo, it seems to tell us, spent the critical first years of his life not by the side of his father and stepmother, but with his poor, forsaken, real mother, so that he had time to feel the absence of his father. This seems a slender and yet a somewhat daring conclusion to have emerged from our psychoanalytic efforts, but its significance will increase as we continue our investigation. Its certainty is reinforced when we consider the circumstances that did in fact operate in Leonardo's childhood. In the same year that Leonardo was born, the sources tell us, his father, Ser Piero da Vinci, married Donna Albiera, a lady of good birth; it was to the childlessness of this marriage that the boy owed his reception into his father's (or rather his grandfather's) house—an event which had taken place by the time he was five years old, as the document attests. Now it is not usual at the start of a marriage to put an illegitimate offspring into the care of the young bride who still expects to be blessed with children of her own. Years of disappointment must surely first have elapsed before it was decided to adopt the illegitimate child—who had probably grown up an attractive young boy—as a compensation for the absence of the legitimate children that had been hoped for. It fits in best with the interpretation of the vulture fantasy if at least three years of Leonardo's life, and perhaps five, had elapsed before he could exchange the solitary person of his mother for a parental couple. And by then it was too late. In the first three or four years of life certain impressions become fixed and ways of reacting to the outside world are established which can never be deprived of their importance by later experiences.

If it is true that the unintelligible memories of a person's childhood and the fantasies that are built on them invariably emphasize the most important elements in his mental development, then it follows that the fact which the vulture fantasy confirms, namely that Leonardo spent the first years of his life alone with his mother, will have been of decisive influence in the formation of his inner life. An inevitable effect of this state of affairs was that the child—who was confronted in his early life with one problem more than other children—began to brood on this riddle with special intensity, and so at a tender age became a researcher, tormented as he was by the great question of where babies come from and what the father has to do with their origin.[31] It was a vague suspicion that his researches and the history of his childhood were connected in this way which later prompted him to ex-

claim that he had been destined from the first to investigate the problem of the flight of birds since he had been visited by a vulture as he lay in his cradle. Later on it will not be difficult to show how his curiosity about the flight of birds was derived from the sexual researches of his childhood.

In Leonardo's childhood fantasy we have taken the element of the vulture to represent the real content of his memory, while the context in which Leonardo himself placed his fantasy has thrown a bright light on the importance which that content had for his later life. In proceeding with our work of interpretation we now come up against the strange problem of why this content has been recast into a homosexual situation. The mother who suckles her child—or to put it better, at whose breast the child sucks—has been turned into a vulture that puts its tail into the child's mouth. We have asserted that, according to the usual way in which language makes use of substitutes, the vulture's *"coda"* cannot possibly signify anything other than a male genital, a penis. But we do not understand how imaginative activity can have succeeded in endowing precisely this bird which is a mother with the distinguishing mark of masculinity; and in view of this absurdity we are at a loss how to reduce this creation of Leonardo's fantasy to any rational meaning. . . .

Infantile sexual theories provide the explanation. There was once a time when the male genital was found compatible with the picture of the mother.[32] When a male child first turns his curiosity to the riddles of sexual life, he is dominated by his interest in his own genital. He finds that part of his body too valuable and too important for him to be able to believe that it could be missing in other people whom he feels he resembles so much. As he cannot guess that there exists another type of genital structure of equal worth, he is forced to make the assumption that all human beings, women as well men, possess a penis like his own. This preconception is so firmly planted in the youthful investigator that it is not destroyed even when he first observes the genitals of little girls. His perception tells him, it is true, that there is something different from what there is in him, but he is incapable of admitting to himself that the content of this perception is that he cannot find a penis in girls. That the penis could be missing strikes him as an uncanny and intolerable idea, and so in an attempt at a compromise he comes to the conclusion that little girls have a penis as well, only it is still very small; it will grow later.[33] If it seems from later observations that this expectation is not realized, he has another remedy at his disposal: little girls too had a penis, but it was cut off and in its place was left a wound. This

theoretical advance already makes use of personal experiences of a dis-
tressing kind: the boy in the meantime has heard the threat that the organ
which is so dear to him will be taken away from him if he shows his interest
in it too plainly. Under the influence of this threat of castration he now sees
the notion he has gained of the female genitals in a new light; henceforth he
will tremble for his masculinity, but at the same time he will despise the
unhappy creatures on whom the cruel punishment has, as he supposes,
already fallen.[34]

We have not yet done with Leonardo's vulture fantasy. In words which only
too plainly recall a description of a sexual act ("and struck me many times
with its tail against[35] my lips"), Leonardo stresses the intensity of the erotic
relations between mother and child. From this linking of his mother's (the
vulture's) activity with the prominence of the mouth zone it is not difficult to
guess that a second memory is contained in the fantasy. This may be
translated: "My mother pressed innumerable passionate kisses on my
mouth." The fantasy is compounded from the memory of being suckled
and being kissed by his mother.

Kindly nature has given the artist the ability to express most secret men-
tal impulses, which are hidden even from himself, by means of the works
that he creates; and these works have a powerful effect on others who are
strangers to the artist, and who are themselves unaware of the source of
their emotion. Can it be that there is nothing in Leonardo's life work to bear
witness to what his memory preserved as the strongest impression of his
childhood? One would certainly expect there to be something. Yet if one
considers the profound transformations through which an impression in an
artist's life has to pass before it is allowed to make its contribution to a work
of art, one will be bound to keep any claim to certainty in one's demonstra-
tion within very modest limits; and this is especially so in Leonardo's case.

Anyone who thinks of Leonardo's paintings will be reminded of a re-
markable smile, at once fascinating and puzzling, which he conjured up on
the lips of his female subjects. It is an unchanging smile, on long, curved
lips; it has become a mark of his style and the name "Leonardesque" has
been chosen for it.[36] In the strangely beautiful face of the Florentine Mona
Lisa del Giocondo it has produced the most powerful and confusing effect
on whoever looks at it. This smile has called for an interpretation, and it has
met with many of the most varied kinds, none of which has been satisfac-
tory. "Voilà quatre siècles bientôt que Monna Lisa fait perdre la tête à tour
ceux qui parlent d'elle, après l'avoir longtemps regardée."[37]

Muther (1909, 1, 314) writes: "What especially casts a spell on the spectator is the daemonic magic of this smile. Hundreds of poets and authors have written about this woman who now appears to smile on us so seductively, and now to stare coldly and without soul into space; and no one has solved the riddle of her smile, no one has read the meaning of her thoughts. Everything, even the landscape, is mysteriously dream-like, and seems to be trembling in a kind of sultry sensuality."

The idea that two distinct elements are combined in Mona Lisa's smile is one that has struck several critics. They accordingly find in the beautiful Florentine's expression the most perfect representation of the contrasts which dominate the erotic life of women; the contrast between reserve and seduction, and between the most devoted tenderness and a sensuality that is ruthlessly demanding—consuming men as if they were alien beings. This is the view of Müntz (1899, 417): "On sait quelle énigme indéchiffrable et passionnante Monna Lisa Gioconda ne cesse depuis bientôt quatre siècles de proposer aux admirateurs pressés devant elle. Jamais artiste (j'emprunte la plume du délicat écrivain qui se cache sous le pseudonyme de Pierre de Corlay) "a-t-il traduit ainsi l'essence même de la fémininité: tendresse et coquetterie, pudeur et sourde volupté, tout le mystère d'un Coeur qui se réserve, d'un cerveau qui réfléchit, d'une personnalité qui se garde et ne livre d'elle-même que son rayonnement."[38] The Italian writer Angelo Conti (1910, 93) saw the picture in the Louvre brought to *life* by a ray of sunshine. "La donna sorrideva in una calma regale: i suoi istinti di conquista, di ferocia, tutta l'eredità della specie, la volontà dells seduzione e dell' agguato, la grazia del inganno, la bontà che cela un proposito crudele, tutto ciò appariva alternativamente e scompariva dietro il velo ridente e si fondeva nel poema del suo sorriso. . . . Buona e malvagia, crudele e compassionevole, graziosa e felina, ella rideva."[39]

Leonardo spent four years painting at this picture, perhaps from 1503 to 1507, during his second period of residence in Florence, when he was over fifty. According to Vasari he employed the most elaborate artifices to keep the lady amused during the sittings and to retain the famous smile on her features. In its present condition the picture has preserved but little of all delicate details which his brush reproduced on the canvas at that time; while it was being painted it was considered to be the highest that art could achieve, but it is certain that Leonardo himself was not satisfied with it, declaring it to be incomplete, and did not deliver it to the person who had commissioned it, but took it to France with him, where his patron, Francis I, acquired it from him for the Louvre.

Let us leave unsolved the riddle of the expression on Mona Lisa's face, and note the indisputable fact that her smile exercised no less powerful a

fascination on the artist than on all who have looked at it for the last four hundred years. From that date the captivating smile reappears in all his pictures and in those of his pupils. As Leonardo's Mona Lisa is a portrait, we cannot assume that he added on his own account such an expressive feature to her face—a feature that she did not herself possess. The conclusion seems hardly to be avoided that he found this smile in his model and fell so strongly under its spell that from then on he bestowed it on the free creations of his fantasy. This interpretation, which cannot be called far-fetched, is put forward, for example, by Konstantinowa (1907, 44):

> During the long period in which the artist was occupied with the portrait of Mona Lisa del Giocondo, he had entered into the subtle details of the features on this lady's face with such sympathetic feeling that he transferred its traits—in particular the mysterious smile and the strange gaze—to all the faces that he painted or drew afterwards. The Gioconda's peculiar facial expression can even be perceived in the picture of John the Baptist in the Louvre; but above all it may be clearly recognized in the expression on Mary's face in the "Madonna and Child with St. Anne."[40]

Yet this situation may also have come about in another way. The need for a deeper reason behind the attraction of La Gioconda's smile, which so moved the artist that he was never again free from it, has been felt by more than one of his biographers. Walter Pater, who sees in the picture of Mona Lisa a "presence . . . expressive of what in the ways of a thousand years men had come to desire" [1873, 118], and who writes very sensitively of "the unfathomable smile, always with a touch of something sinister in it, which plays over all Leonardo's work" [ibid., 117], leads us to another clue when he declares (loc. cit.):

> Besides, the picture is a portrait. From childhood we see this image defining itself on the fabric of his dreams; and but for express historical testimony, we might fancy that this was but his ideal lady, embodied and beheld at last . . .

Marie Herzfeld (1906, 88) has no doubt something very similar in mind when she declares that in the Mona Lisa Leonardo encountered his own self and for this reason was able to put so much of his own nature into the picture "whose features had lain all along in mysterious sympathy within Leonardo's mind."

Let us attempt to clarify what is suggested here. It may very well have been that Leonardo was fascinated by Mona Lisa's smile for the reason that

it awoke something in him which had for long lain dormant in his mind—probably an old memory. This memory was of sufficient importance for him never to get free of it when it had once been aroused; he was continually forced to give it new expression. Pater's confident assertion that we can see, from childhood, a face like Mona Lisa's defining itself on the fabric of his dreams, seems convincing and deserves to be taken literally.

Vasari mentions that "teste di femmine, che ridono"[41] formed the subject of Leonardo's first artistic endeavors. The passage—which, since it is not intended to prove anything, is quite beyond suspicion—runs more fully according to Schorn's translation (1843, 3, 6): "In his youth he made some heads of laughing women out of clay, which were reproduced in plaster, and some children's heads which were as beautiful as if they had been modeled by the hand of a master."

Thus we learn that he began his artistic career by portraying two kinds of objects; and these cannot fail to remind us of the two kinds of sexual objects that we have inferred from the analysis of his vulture-fantasy. If the beautiful children's heads were reproductions of his own person as it was in his childhood, then the smiling women are nothing other than repetitions of his mother Caterina, and we begin to suspect the possibility that it was his mother who possessed the mysterious smile—the smile that he had lost and that fascinated him so much when he found it again in the Florentine lady.[42]

The painting of Leonardo's which stands nearest to the Mona Lisa in point of time is the so-called "St. Anne with Two Others," St. Anne with the Madonna and child. In it the Leonardesque smile is most beautifully and markedly portrayed on both the women's faces. It is not possible to discover how long before or after the painting of the Mona Lisa Leonardo began to paint this picture. As both works extended over years, it may, I think, be assumed that the artist was engaged on them at the same time. It would best agree with our expectations if it was the intensity of Leonardo's preoccupation with the features of Mona Lisa which stimulated him to create the composition of St. Anne out of his fantasy. For if the Gioconda's smile called up in his mind the memory of his mother, it is easy to understand how it drove him at once to create a glorification of motherhood, and to give back to his mother the smile he had found in the noble lady. We may therefore permit our interest to pass from Mona Lisa's portrait to this other picture—one which is hardly less beautiful, and which today also hangs in the Louvre.

St. Anne with her daughter and her grandchild is a subject that is rarely handled in Italian painting. At all events Leonardo's treatment of it differs widely from all other known versions. Muther (1909, 1, 309) writes: "Some

artists, like Hans Fries, the elder Holbein and Girolamo dai Libri, made Anne sit beside Mary and put the child between them. Others, like Jakob Cornelisz in his Berlin picture, painted what was truly a 'St. Anne with Two Others';[43] in other words, they represented her as holding in her arms the small figure of Mary upon which the still smaller figure of the child Christ is sitting." In Leonardo's picture Mary is sitting on her mother's lap, leaning forward, and is stretching out both arms towards the boy, who is playing with a young lamb and perhaps treating it a little unkindly. The grandmother rests on her hip the arm that is not concealed and gazes down on the pair with a blissful smile. The grouping is certainly not entirely unconstrained. But although the smile that plays on the lips of the two women is unmistakably the same as that in the picture of Mona Lisa, it has lost its uncanny and mysterious character; what it expresses is inward feeling and quiet blissfulness.[44]

After we have studied this picture for some time, it suddenly dawns on us that only Leonardo could have painted it, just as only he could have created the fantasy of the vulture. The picture contains the synthesis of the history of his childhood: its details are to be explained by reference to the most personal impressions in Leonardo's life. In his father's house he found not only his kind stepmother, Donna Albiera, but also his grandmother, his father's mother, Monna Lucia, who—so we will assume—was no less tender to him than grandmothers usually are. These circumstances might well suggest to him a picture representing childhood watched over by mother and grandmother. Another striking feature of the picture assumes even greater significance. St. Anne, Mary's mother and the boy's grandmother, who must have been a matron, is here portrayed as being perhaps a little more mature and serious than the Virgin Mary, but as still being a young woman of unfaded beauty. In point of fact Leonardo has given the boy two mothers, one who stretches her arms out to him, and another in the background; and both are endowed with the blissful peculiarity of the picture smile of the joy of motherhood. This peculiarity of the picture has not failed to surprise those who have written about it: Muther, for example, is of the opinion that Leonardo could not bring himself to paint old age, lines and wrinkles, and for this reason made Anne too into a woman of radiant beauty. But can we be satisfied with this explanation? Others have had recourse to denying that there is any similarity in age between the mother and daughter.[45] But Muther's attempt at an explanation is surely enough to prove that the impression that St. Anne has been made more youthful derives from the picture and is not an invention for an ulterior purpose.

Leonardo's childhood was remarkable in precisely the same way as this picture. He had had two mothers: first, his true mother Caterina, from whom he was torn away when he was between three and five, and then a young and tender stepmother, his father's wife, Donna Albiera. By his combining this fact about his childhood with the one mentioned above (the presence of his mother and grandmother)[46] and by his condensing them into a composite unity, the design of "St. Anne with Two Others" took shape for him. The maternal figure that is further away from the boy—the grandmother—corresponds to the earlier and true mother, Caterina, in its appearance and in its special relation to the boy. The artist seems to have used the blissful smile of St. Anne to disavow and to cloak the envy which the unfortunate woman felt when she was forced to give up her son to her better-born rival, as she had once given up his father as well.[47]

We thus find a confirmation in another of Leonardo's works of our suspicion that the smile of Mona Lisa del Giocondo had awakened in him as a grown man the memory of the mother of his earliest childhood. From that time onward, madonnas and aristocratic ladies were depicted in Italian painting humbly bowing their heads and smiling the strange, blissful smile of Caterina, the poor peasant girl who had brought into the world the splendid son who was destined to paint, to search and to suffer.

If Leonardo was successful in reproducing on Mona Lisa's face the double meaning which this smile contained, the promise of unbounded tenderness and at the same time sinister menace (to quote Pater's phrase, then here too he had remained true to the content of his earliest memory. For his mother's tenderness was fateful for him; it determined his destiny and the privations that were in store for him. The violence of the caresses, to which his fantasy of the vulture points, was only too natural. In her love for her child the poor forsaken mother had to give vent to all her memories of the caresses she had enjoyed as well as her longing for new ones; and she was forced to do so not only to compensate herself for having no husband, but also to compensate her child for having no father to fondle him. So, like all unsatisfied mothers, she took her little son in place of her husband, and by the too early maturing of his erotism robbed him of a part of his masculinity. A mother's love for the infant she suckles and cares for is something far more profound than her later affection for the growing child. It is in the nature of a completely satisfying love-relation, which not only fulfils every mental wish but also every physical need; and if it represents one of the forms of attainable human happiness, that is in no little measure due to the possibility it offers of satisfying, without reproach, wishful im-

pulses which have long been repressed and which must be called perverse.[48] In the happiest young marriage the father is aware that the baby, especially if he is a baby son, has become his rival, and this is the starting-point of an antagonism towards the favorite which is deeply rooted in the unconscious.

When, in the prime of life, Leonardo once more encountered the smile of bliss and rapture which had once played on his mother's lips as she fondled him, he had for long been under the dominance of an inhibition which forbade him ever again to desire such caresses from the lips of women. But he had become a painter, and therefore he strove to reproduce the smile with his brush, giving it to all his pictures (whether he in fact executed them himself or had them done by his pupils under his direction)—to Leda, to John the Baptist and to Bacchus. The last two are variants of the same type. "Leonardo has turned the locust-eater of the Bible," says Muther [1909, 1, 314], "into a Bacchus, a young Apollo, who, with a mysterious smile on his lips, and with his smooth legs crossed, gazes at us with eyes that intoxicate the senses." These pictures breathe a mystical air into whose secret one dares not penetrate; at the very most one can attempt to establish their connection with Leonardo's earlier creations. The figures are still androgynous, but no longer in the sense of the vulture-fantasy. They are beautiful youths of feminine delicacy and with effeminate forms; they do not cast their eyes down, but gaze in mysterious triumph, as if they knew of a great achievement of happiness, about which silence must be kept. The familiar smile of fascination leads one to guess that it is a secret of love. It is possible that in these figures Leonardo has denied the unhappiness of his erotic life and has triumphed over it in his art, by representing the wishes of the boy, infatuated with his mother, as fulfilled in this blissful union of the male and female natures.

5

The Lugubrious Game

Georges Bataille

Friedrich Nietzsche's vision of a Dionysian energy of libidinal intoxication had a profound effect upon a number of disaffected surrealist intellectuals and social scientists in France in the 1920s and 1930s, including Georges Bataille (1897–1962). Bataille's day job until 1942 was in the Bibliothèque Nationale in Paris. He was also involved in a number of factious organizations and projects, among which was the publication, beginning in 1929, of the short-lived journal *Documents*, from which the following text is taken.

Bataille developed Nietzsche's ideas of excess through his own theory of the universe's solar energy as an economy of consumption and uninhibited waste.[1] In a deliberate swipe at both capitalist and Marxist economic theories, Bataille argued that a libidinal economy founded upon desire functions not through a careful balancing of books, in which income is offset by expenditure, but through unmitigated expenditure and loss.[2] In the preface to his short story "Madame Edwarda" (1941), Bataille advocated: "We must seek for [our sense of Being] in the feeling of dying, in those unbearable moments when it seems to us that we are dying because the existence in us, during these interludes, exists through nothing but a sustaining and ruinous excess, when the fullness of horror and that of joy coincide."[3]

Bataille believed that excess, the conjoining of "horror and joy," is the essence of desire. By "horror," Bataille meant experiences that the subject might envisage as a threat, in the form of a loss of control, to his or her ego and

sense of identity. As a riposte to the surrealist leader André Breton's earnest ideas of revolutionary communism, Bataille often explored this idea of loss through ideas of mass hysteria and feelings of violent physical revulsion. In a footnote to "The Lugubrious Game" (1929), Bataille refers to the sequence of enucleation by a razor blade in Luis Buñuel's film *An Andalusian Dog* (1929) and the horror of emasculation, which he understands to be the central theme of Salvador Dali's painting *The Lugubrious Game*. Elsewhere in his essay, Bataille mentions the antics of the Marquis de Sade, whose unstable personality is marked by self-obsession and depraved cruelty. While these ideas may seem simply to invert the Enlightenment ideal of rationalism and self-control, they represent Bataille's concern to overcome Oedipal feelings of guilt and shame and, above all, to override any sense of limit to desire. In the body of the text of "The Lugubrious Game," this results in a form of writing that is indulgently random while also being self-consciously provocative.

THE LUGUBRIOUS GAME

Intellectual despair results in neither weakness nor dreams, but in violence. Thus abandoning certain investigations is out of the question. It is only a matter of knowing how to give vent to one's rage; whether one only wants to wander like madmen around prisons, or whether one wants to overturn them.[4]

To halfheartedness, to loopholes and deliria that reveal a great poetic impotence, one can only oppose a black rage and even an incontestable bestiality; it is impossible to get worked up other than as a pig who rummages in manure and mud uprooting everything with his snout—and whose repugnant voracity is unstoppable.

If the forms brought together by a painter on a canvas had no repercussion, and for example, since we are speaking of voracity—even in the intellectual order—if horrible shadows that collide in the head, if jaws with hideous teeth had not come out of Picasso's skull to terrify those who still have the impudence to think honestly, then painting at the very most would be good for distracting people from their rage, as do bars or American films. But why hesitate to write that when Picasso paints, the dislocation of forms leads to that of thought, in other words that the immediate intellectual movement, which in other cases leads to the idea, aborts. We cannot ignore that flowers are aphrodisiacs, that a single burst of laughter can traverse and stir up a crowd, that an equally obstinate abortion is the shrill and incendiary blast of

the *non serviam* that the human brute opposes to the idea. And the idea has over man the same degrading power that a harness has over a horse; I can snort and gasp: I go, no less, right and left, my head bridled and pulled by the idea that brutalizes all men and causes them to be docile—the idea in the form of, among other things, a piece of paper adorned with the arms of the State. Taking into account trickery, human life always more or less conforms to the image of a soldier obeying commands in his drill. But sudden cataclysms, great popular manifestations of madness, riots, enormous revolutionary slaughters—all these show the extent of the inevitable backlash.

This leads me to state, almost without introduction, that the paintings of Picasso are hideous, that those of Dali are frighteningly ugly.[5] One is a victim of the awkwardness of words, or even of an evil spell resulting from the practices of black magic, when one attempts to believe otherwise. All it takes is to imagine suddenly the charming little girl whose soul would be Dali's abominable mirror, to measure the extent of the evil. The tongue of this little girl is not a tongue but a she-rat. And if she still appears admirably beautiful, it is, as they say, because black blood is beautiful, flowing on the hide of a cow or on the throat of a woman. (If violent movements manage to rescue a being from profound boredom, it is because they can lead—through some obscure error—to a ghastly satiating ugliness. It must be said, moreover, that ugliness can be hateful without any recourse and, as it were, through misfortune, but nothing is more common than the equivocal ugliness that gives, in a provocative way, the illusion of the opposite. As for irrevocable ugliness, it is exactly as detestable as certain beauties: the beauty that conceals nothing, the beauty that is not the mask of ruined immodesty, the beauty that never contradicts itself and remains eternally at attention like a coward.)

Little by little the contradictory signs of servitude and revolt are revealed in all things. The great constructions of the intellect are, finally, prisons: that is why they are obstinately overturned. Dreams and illusory Cimmerii remain within reach of the zealously irresolute, whose unconscious calculations are not so clumsy since they innocently shelter revolt from laws. Besides, how could one not admire the loss of will, the blind manner, the drifting uncertainty ranging from willful distraction to attentiveness? It is true that I am speaking here of what already sinks into oblivion when Dali's razors carve into our faces the grimaces of horror that probably risk making us vomit like drunkards this servile nobility, this idiotic idealism that leaves us under the spell of a few comical prison bosses.

Dogs, vaguely sick from having so long licked the fingers of their masters, howl themselves to death in the countryside, in the middle of the night.

These frightening howls are answered—as thunder is answered by the racket of rain—by cries so extreme that one cannot even talk of them without excitement.

A few days before July 14, 1789, the Marquis de Sade, for years doomed to rage in his cell in the Bastille, excited the crowd around the prison by screaming insanely into the pipe that was used to carry off his filthy water—an insane cry that was doubtless the most far-reaching ever to strain a larynx. This scream is reported historically as follows: "People of Paris." shouted Sade, "they are killing the prisoners!" Practically the scream of an old rentière with her throat slashed at night in a suburb. It is known that Governor Launay, justifiably frightened by the riot that was starting to explode, had the frenzied prisoner transferred to another prison; this however did not prevent his head, only a few hours later, from terrifying the town on the end of a pike.

But if one wants explicitly to account for the excessive character of this scream, it is necessary to refer to the deposition of Rose Keller, which accuses Sade of inflicting cruelties upon her. This deposition, recently discovered by M. Maurice Heine,[6] is categorical. The young woman recounts that, after being tortured with a whip, she tried to move, with her tears and entreaties, a man both so pleasing and so evil; and as she invoked everything in the world that was saintly and touching, Sade, suddenly gone wild and hearing nothing, let out horrifying and perfectly nauseating screams. . . .

It is well known that a long-standing uneasiness, going back a number of years, has no other meaning than the feeling that something is missing from existence; it is hardly useful to insist upon the fact that it is for want of the power to let out or hear such screams that, on all sides, restless people have plainly lost their heads, condemning human life to boredom and disgust, while pretending at that very instant to conserve and even to defend it, at the first opportunity, heroically, against stains that seem to them ignoble.

This is said without any critical intention, for it is evident that violence, even when one is beside oneself with it, is most often of sufficient brutal hilarity to exceed questions about people. My only desire here—even if by pushing this bestial hilarity to its furthest point I must nauseate Dali—is to squeal like a pig before his canvases.

For reasons which, out of consideration for him, I put off explaining,[7] Dali has refused to allow the reproduction of his paintings in this article, thus doing me an honor that was as unexpected as I may believe it was persistently sought. I am not unaware of the cowardice and the poverty of spirit reflected, by and large, in the attention paid to his recent productions,

Psychoanalytic Schema of the Contradictory Representations of the Subject in "Lugubrious Game" of Salvador Dali.

A. Representation of the subject at the moment of emasculation. The emasculation is expressed by the laceration of the upper part of the body.

B. The subject's desires expressed by a winged ascension of the objects of desire. The burlesque and provocative character of this expression indicates the voluntary pursuit of punishment.

C. Representation of the soiled subject escaping emasculation through an ignominious and nauseating posture. The stain is both original cause and remedy.

D. Representation of the subject contemplating with complacency his own emasculation and giving a poetic amplification.

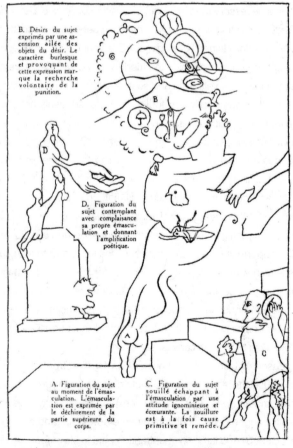

B. Désirs du sujet exprimés par une ascension ailée des objets du désir. Le caractère burlesque et provoquant de cette expression marque la recherche volontaire de la punition.

D. Figuration du sujet contemplant avec complaisance sa propre émasculation et donnant l'amplification poétique.

A. Figuration du sujet au moment de l'émasculation. L'émasculation est exprimée par le déchirement de la partie supérieure du corps.

C. Figuration du sujet souillé échappant à l'émasculation par une attitude ignominieuse et écœurante. La souillure est à la fois cause primitive et remède.

SCHÉMA PSYCHANALYTIQUE DES FIGURATIONS CONTRADICTOIRES DU SUJET DANS "LE JEU LUGUBRE" DE SALVADOR DALI.

to minor and major discoveries. Having gotten caught up in the game, I at least have the good fortune to speak of a man who will necessarily take this article as a provocation and not as a traditional bit of flattery, who will hate me, as I am well aware, as a *provocateur.*

Nowhere, no doubt, from one end to the other of the regions inhabited by the bourgeoisie, is there anything going on that is noticeably different from the rest, from the past, from political traditions, from literary traditions; nevertheless, and moreover without attaching any other importance to it, I can say that from now on it is impossible to retreat and hide in the "wonder-land" of Poetry without being publicly condemned as a coward.

—Translated by Allan Stoekl

6

A Small History of Photography

Walter Benjamin

Opposed equally to capitalist and totalitarian ideologies, Walter Benjamin (1892–1940) made a series of important contributions to debates in the 1930s about art's political efficacy in the context of a wider investigation into the historical origins and telos of modernity. As such, his writings bear comparison with those of his compatriots Martin Heidegger and Theodor Adorno.

As a Marxist, Benjamin focused his aesthetic concerns upon media that he believed would best suit the revolutionary purposes of the prole-tariat. As a consequence, he rejected the aesthetic experience associated with the contemplation of art—owing to its auratic character—concentrating instead upon the reproductive technologies of photography and film. In "A Small History of Photography" (1931), Benjamin claims that photography is the revolutionary medium par excellence and, furthermore, is capable of redeeming art's failed efficacy by making it available through reproduction to the masses. In a reworking of this essay, "The Work of Art in the Epoch of Its Technical Reproducibility" (1935–1939),[1] film replaces photography and supplants art altogether as the most appropriate medium for the pur-poses of revolutionary consciousness.

"A Small History of Photography" exemplifies Benjamin's belief that the major shift in capitalist ideology within the history of modernity is towards the aestheticization of politics, a fundamental part of which is the mobilization of

an auratic tendency. In the first instance, aura refers to the fetishization of art within culture, based upon the fact that the work of art exists in one place and can be seen only in that place at any one time. (In the essay, Benjamin describes this aspect of the auratic effect by referring to a restful and contemplative experience of nature). Through its uniqueness in space and time, the work of art resists becoming available to the masses. In contrast to this foregoing connotation of aura, and yet sometimes almost in the same breath, Benjamin uses the term to explore what is inassimilable to ideology. Thus, his account of the aura in terms of the expansion and contraction of spatiotemporal relationships ("A strange weave of space and time") resembles certain Proustian as well as psychoanalytic ideas about these subjects in relation to the experience of the unconscious. For Benjamin, the early daguerreotypes illustrate the radical auratic potential lying dormant within technology that came to the fore at the moment of photography's invention. That is, at a time when the applications and purposes of photography were not yet resolved and put to particular uses. Benjamin's interest in the early daguerreotypes arose in part from the fact that the sitters did not yet know how to strike a conventional pose in front of the camera. The sitters' openness to representation reveals that their sense of themselves is also open and independent of the structures of identity imposed upon society by the class power of the bourgeoisie.

The daguerreotypes referred to in the essay present a contingency that amounts to a form of communication across time. Because these portraits are sensitive to the subject's privacy, they convey a sense of intimate yet mysterious distance that, in turn, offers the possibility for a direct emotional encounter with the viewer's desiring unconscious.[2] Benjamin expands on this point by referring to an observation about the way in which the faces in Dauthendey's daguerreotypes seem to "see us." The idea of the observer's gaze being returned may have connotations of superstition. Alternatively, it might be understood as an experience of the self beheld through its own unconscious (which in this case might be described in terms of the gaze of another). Notably, however, Benjamin's discussion of the early daguerreotypes is suffused with melancholy. This is because Benjamin's encounter with their aura cannot be reproduced for the revolutionary purposes of the present (as well as because he wishes to respect the elusiveness of the aesthotic experience). Thus, the revolutionary function of photography in Benjamin's day is significantly different to that of the original daguerreotypes: whereas they possess an aura, albeit one of radical affect, contemporary photography is intent upon dispelling aura. Benjamin cites the

French photographer Eugène Atget (1857–1927) as an example of this latter tendency. Atget's photographs achieve an uncanny sense of indeterminacy that, Benjamin argues, offers a potentially new use-value for photography: a way of making and understanding photography as a form of evidence. August Sander's photographs seem to prove this contentious point, exemplifying what Benjamin sees as a new, "delicate" scientism in photography. Such photography may work for the "politically educated eye," but Benjamin concludes the essay by arguing that context is everything and that the political potential of photography may depend upon the accompanying text or caption by which it is framed.

A SMALL HISTORY OF PHOTOGRAPHY

The fog that surrounds the beginnings of photography is not as thick as that which shrouds the early days of printing; more obviously than in the case of the printing press, perhaps, the time was ripe for the invention, and was sensed by more than one—by men who strove independently for the same objective: to capture the images in the camera obscura, which had been known at least since Leonardo's time. When, after about five years of effort, both Niepce and Daguerre simultaneously succeeded in doing this, the state, aided by the patent difficulties encountered by the inventors, assumed control of the enterprise and made it public, with compensation to the pioneers. This paved the way for a rapid ongoing development which long precluded any backward glance. Thus it is that the historical or, if you like, philosophical questions suggested by the rise and fall of photography have gone unheeded for decades. And if people are starting to be aware of them today, there is a definite reason for it. The latest writings on the subject point up the fact that the flowering of photography—the work of Hill and Cameron, Hugo and Nadar—came in its first decade. But this was the decade which preceded its industrialization. Not that hucksters and charlatans did not appropriate the new techniques for gain, even in that early period; indeed, they did so *en masse*. But that was closer to the arts of the fairground, where photography is at home to this day, than to industry. Industry made its first real inroads with the visiting card picture, whose first manufacturer significantly became a millionaire. It would not be surprising if the photographic methods which today, for the first time, are harking back to the pre-industrial heyday of photography had an underground connection with the crisis of capitalist industry. But that does not make it any easier to

use the charm of old photographs, available in fine recent publications,[3] for real insights into their nature. Attempts at theoretical mastery of the subject have so far been entirely rudimentary. And no matter how extensively it may have been debated in the last century, basically the discussion never got away from the ludicrous stereotype which a chauvinistic rag, the *Leipziger Stadtanzeiger*, felt it must offer in timely opposition to this black art from France. "To try to capture fleeting mirror images," it said, "is not just an impossible undertaking, as has been established after thorough German investigation; the very wish to do such a thing is blasphemous. Man is made in the image of God, and God's image cannot be captured by any machine of human devising. The utmost the artist may venture, borne on the wings of divine inspiration, is to reproduce man's God-given features without the help of any machine, in the moment of highest dedication, at the higher bidding of his genius." Here we have the philistine notion of *art* in all its overweening obtuseness, a stranger to all technical considerations, which feels that its end is nigh with the alarming appearance of the new technology. Nevertheless, it was this fetishistic and fundamentally anti-technical concept of art with which the theoreticians of photography sought to grapple for almost a hundred years, naturally without the smallest success. For they undertook nothing less than to legitimize the photographer before the very tribunal he was in the process of overturning. Far different is the tone of the address which the physicist Arago, speaking on behalf of Daguerre's invention, gave in the Chamber of Deputies on 3 July 1839. The beautiful thing about this speech is the connections it makes with all aspects of human activity. The panorama it sketches is broad enough not only to make the dubious project of authenticating photography in terms of painting—which it does anyway—seem beside the point; more important, it offers an insight into the real scope of the invention. "When inventors of a new instrument," says Arago, "apply it to the observation of nature, what they expect of it always turns out to be a trifle compared with the succession of subsequent discoveries of which the instrument was the origin." In a great arc Arago's speech spans the field of new technologies, from astrophysics to philology: alongside the prospects for stellar photography we find the idea of establishing a photographic record of the Egyptian hieroglyphs.

Daguerre's photographs were iodized silver plates exposed in the camera obscura, which had to be turned this way and that until, in the proper light, a pale grey image could be discerned. They were one of a kind; in 1839 a plate cost an average of 25 gold francs. They were not infrequently kept in a case, like jewelry. In the hands of many a painter, though, they

became a technical adjunct just as 70 years later Utrillo painted his fascinating views of Paris not from life but from picture postcards, so did the highly regarded English portrait painter David Octavius Hill base his fresco of the first general synod of the Church of Scotland in 1843 on a long series of portrait photographs. But these pictures he took himself. And it is they, unpretentious makeshifts meant for internal use that gave his name a place in history, while as a painter he is forgotten. Admittedly a number of his studies lead even deeper into the new technology than this series of portraits: anonymous images, not posed subjects. Such figures had long been known in painting. Where the painting remained in the possession of a particular family, now and then someone would ask after the originals. But after two or three generations this interest fades; the pictures, if they last, do so only as testimony to the art of the painter. With photography, however, we encounter something new and strange: in Hill's Newhaven fishwife, her eyes cast down in such indolent, seductive modesty, there remains something that goes beyond testimony to the photographer's art, something that cannot be silenced, that fills you with an unruly desire to know what her name was, the woman who was alive there, who even now is still real and will never consent to be wholly absorbed in *art*. "And I ask: how did the beauty of that hair, those eyes, beguile our forebears: how did that mouth kiss, to which desire curls up senseless as smoke without fire." Or you turn up the picture of Dauthendey the photographer, the father of the poet, from the time of his engagement to that woman whom he then found one day, shortly after the birth of her sixth child, lying in the bedroom of his Moscow house with her arteries severed. Here she can be seen with him, he seems to be holding her; but her gaze passes him by, absorbed in an ominous distance. Immerse yourself in such a picture long enough and you will recognize how alive the contradictions are, here too: the most precise technology can give its products a magical value, such as a painted picture can never again have for us. No matter how artful the photographer, no matter how carefully posed his subject, the beholder feels an irresistible urge to search such a picture for the tiny spark of contingency, of the Here and Now, with which reality has so to speak seared the subject, to find the inconspicuous spot where in the immediacy of that long-forgotten moment the future subsists so eloquently that we, looking back, may rediscover it. For it is another nature that speaks to the camera than to the eye: other in the sense that a space informed by human consciousness gives way to a space informed by the unconscious. Whereas it is a commonplace that, for example, we have some idea what is involved in the act of walking, if only in

general terms, we have no idea at all what happens during the fraction of a second when a person *steps out*. Photography, with its devices of slow motion and enlargement, reveals the secret. It is through photography that we first discover the existence of this optical unconscious, just as we discover the instinctual unconscious through psychoanalysis. Details of structure, cellular tissue, with which technology and medicine are normally concerned—all this is in its origins more native to the camera than the atmospheric landscape or the soulful portrait. Yet at the same time photography reveals in this material the physiognomic aspects of visual worlds which dwell in the smallest things, meaningful yet covert enough to find a hiding place in waking dreams, but which, enlarged and capable of formulation, make the difference between technology and magic visible as a thoroughly historical variable. Thus Blossfeldt with his astonishing plant photographs[4] reveals the forms of ancient columns in horse willow, a bishop's crosier in the ostrich fern, totem poles in tenfold enlargements of chestnut and maple shoots, and gothic tracery in the fuller's thistle. Hill's subjects, too, were probably not far from the truth when they described "the phenomenon of photography" as still being "a great and mysterious experience"; even if for them this was no more than the consciousness of "standing before a device which in the briefest time could produce a picture of the visible environment that seemed as real and alive as nature itself." It has been said of Hill's camera that it kept a discreet distance. But his subjects, for their part, are no less reserved; they maintain a certain shyness before the camera, and the watchword of a later photographer from the heyday of the art, "Don't look at the camera," could be derived from their attitude. But that did not mean the "they're looking at you" of animals, people, and babies, that so distastefully implicates the buyer and to which there is no better counter than the way old Dauthendey talks about daguerreotypes: "We didn't trust ourselves at first," so he reported, "to look long at the first pictures he developed. We were abashed by the distinctness of these human images, and believed that the little tiny faces in the picture could see *us*, so powerfully was everyone affected by the unaccustomed clarity and the unaccustomed truth to nature of the first daguerreotypes."

The first people to be reproduced entered the visual space of photography with their innocence intact, uncompromised captions. Newspapers were still a luxury item, which people seldom bought, preferring to consult them in the coffee house; photography had not yet become a journalistic tool, and ordinary people had yet to see their names in print. The human

countenance had a silence about it in which the gaze rested. In short, the portraiture of this period owes its effect to the absence of contact between actuality and photography. Many of Hill's portraits were made in the Edinburgh Greyfriars cemetery— nothing is more characteristic of this early period than the way his subjects were at home there. And indeed the cemetery itself, in one of Hill's pictures, looks like an interior, a separate closed-off space where the gravestones propped against gable walls rise up from the grass, hollowed out like chimney-pieces, with inscriptions inside instead of flames. But this setting could never have been so effective if it had not been chosen on technical grounds. The low light-sensitivity of the early plates made prolonged exposure outdoors a necessity. This in turn made it desirable to take the subject to some out-of-the-way spot where there was no obstacle to quiet concentration. "The expressive coherence due to the length of time the subject had to remain still," says Orlik of early photography, "is the main reason why these photographs, apart from their simplicity, resemble well drawn or painted pictures and produce a more vivid and lasting impression on the beholder than more recent photographs." The procedure itself caused the subject to focus his life in the moment rather than hurrying on past it; during the considerable period of the exposure, the subject as it were grew into the picture, in the sharpest contrast with appearances in a snap-shot—which is appropriate to that changed environment where, as Kracauer has aptly noted, the split second of the exposure determines "whether a sportsman becomes so famous that photographers start taking his picture for the illustrated papers." Everything about these early pictures was built to last; not only the incomparable groups in which people came together—and whose disappearance was surely one of the most telling symptoms of what was happening in society in the second half of the century—but the very creases in people's clothes have an air of permanence. Just consider Schelling's coat; its immortality, too, rests assured; the shape it has borrowed from its wearer is not unworthy of the creases in his face. In short, everything suggests that Bernhard von Brentano was right in his view "that a photographer of 1850 was on a par with his instrument"— for the first time, and for a long while the last.

To appreciate the full impact made by the daguerreotype in the age of its discovery, one should also bear in mind that entirely new vistas were then being opened up in landscape painting by the most advanced painters. Conscious that in this very area photography had to take over where painting left off, even Arago, in his historical review of the early attempts of Giovanni Battista Porta, explicitly commented: "As regards the effect produced by

the imperfect transparency of our atmosphere (which has been loosely termed 'degradation'), not even experienced painters expect the camera obscura"—i.e. the copying of images appearing in it—"to help them to render it accurately." At the moment when Daguerre succeeded in fixing the images of the camera obscura, the painters parted company on this point with the technician. The real victim of photography, however, was not landscape painting, but the portrait miniature. Things developed so rapidly that by 1840 most of the innumerable miniaturists had already become professional photographers, at first only as a sideline, but before long exclusively. Here the experience of their original livelihood stood them in good stead, and it is not their artistic background so much as their training as craftsmen that we have to thank for the high level of their photographic achievement. This transitional generation disappeared very gradually; indeed, there seems to have been a kind of Biblical blessing on those first photographers: the Nadars, Stelzners, Pierson, Bayards all lived well into their eighties and nineties. In the end, though, businessmen invaded professional photography from every side, and when later on the retouched negative, which was the bad painter's revenge on photography became ubiquitous, a sharp decline in taste set in. This was the time photograph albums came into vogue. They were most at home in the chilliest spots, on occasional tables or little stands in the drawing room: leather-bound tomes with ugly metal clasps and those gilt-edged pages as thick as your finger, where foolishly draped or corseted figures were displayed: Uncle Alex and Aunt Riekchen, little Trudi when she was still a baby, Papa in his first term at university . . . and finally, to make our shame complete, we selves: as a parlor Tyrolean, yodeling, waving our hat against a painted snowscape, or as a smartly turned-out sailor, standing leg and trailing leg, as is proper, leaning against a polished door jamb. The accessories used in these portraits, the pedestals and balustrades and little oval tables, are still reminiscent of the period when because of the long exposure time the subjects had to be given supports so that they wouldn't move. And if at first *head-holders* or *knee-braces* were felt to be sufficient, further impedimenta were soon added, such as were to be seen in famous paintings and must therefore be *artistic.* First it was pillars, or curtains. The most capable started resisting this nonsense as early as the sixties. As an English trade journal of the time put it, "in painting the pillar has some plausibility, but the way it is used in photography is absurd, since it usually stands on a carpet. But anyone can see that pillars of marble or stone are not erected on a foundation of carpeting." This was the period of those studios, with their draperies and palm trees, their tapestries

and easels, which occupied so ambiguous a place between execution and representation, between torture chamber and throne room, and to which an early portrait of Kafka bears pathetic witness. There the boy stands, perhaps six years old, dressed up in a humiliatingly tight child's suit overloaded with trimming, in a sort of conservatory landscape. The background is thick with palm fronds. And as if to make these upholstered tropics even stuffier and more oppressive, the subject holds in his left hand an inordinately large broad-brimmed hat, such as Spaniards wear. He would surely be lost in this setting were it not for the immensely sad eyes, which dominate this landscape predestined for them.

This picture in its infinite sadness forms a pendant to the early photographs in which people did not yet look out at the world in so excluded and god-forsaken a manner as this boy. There was an aura about them, an atmospheric medium, that lent fullness and security to their gaze even as it penetrated that medium. And once again the technical equivalent is obvious; it consists in the absolute continuum from brightest light to darkest shadow. Here too we see in operation the law that new advances are prefigured in older techniques, for the earlier art of portrait painting had produced the strange flower of the mezzotint before its disappearance. The mezzotint process was of course a technique of reproduction, which was only later combined with the new photographic reproduction. The way light struggles out of darkness in the work of a Hill is reminiscent of mezzotint: Orlik talks about the "coherent illumination" brought about by the long exposure times, which "gives these early photographs their greatness." And among the invention's contemporaries, Delaroche already noted the "unprecedented and exquisite" general impression, "in which nothing disturbs the tranquility of the composition." So much for the technical considerations behind the atmospheric appearances. Many group photos in particular still preserve an air of animated conviviality for a brief space on the plate, before being ruined by the print. It was this atmosphere that was sometimes captured with delicacy and depth by the now old-fashioned oval frame. That is why it would be a misreading of these incunabula of photography to make too much of their *artistic perfection* or their *taste*. These pictures were made in rooms where every client was confronted, in the photographer, with a technician of the latest school; whereas the photographer was confronted, in every client, with a member of a rising class equipped with an aura that had seeped into the very folds of the man's frock coat or floppy cravat. For that aura was by no means the mere product of a primitive camera. Rather, in that early period subject

and technique were as exactly congruent as they become incongruent in the period of decline that immediately followed. For soon advances in optics made instruments available that put darkness entirely to flight and recorded appearances as faithfully as any mirror. After 1880, though, photographers made it their business to simulate with all the arts of retouching, especially the so-called rubber print, the aura which had been banished from the picture with the rout of darkness through faster lenses, exactly as it was banished from reality by the deepening degeneration of the imperialist bourgeoisie. Thus, especially in *Jugendstil*, a penumbral tone, interrupted by artificial highlights came into vogue; notwithstanding this fashionable twilight, however, a pose was more and more clearly in evidence, whose rigidity betrayed the impotence of that generation in the face of technical progress.

And yet, what is again and again decisive for photography is the photographer's attitude to his techniques. Camille Recht has found an apt metaphor: "The violinist," he says, "must first produce the note, must seek it out, find it in an instant; the pianist strikes the key and the note rings out. The painter and the photographer both have an instrument at their disposal. Drawing and coloring, for the painter, correspond to the violinist's production of sound; the photographer, like the pianist, has the advantage of a mechanical device that is subject to restrictive laws, while the violinist is under no such restraint. No Paderewski will ever reap the fame, ever cast the almost fabulous spell, that Paganini did." There is, however—to continue the metaphor—a Busoni of photography, and that is Atget. Both were virtuosi, but at the same time precursors. The combination of unparalleled absorption in their work and extreme precision is common to both. There was even a facial resemblance. Atget was an actor who, disgusted with the profession, wiped off the mask and then set about removing the make-up from reality too. He lived in Paris poor and unknown, selling his pictures for a trifle to photographic enthusiasts scarcely less eccentric than himself; he died recently, leaving behind an *oeuvre* of more than 4,000 pictures. Berenice Abbot from New York has gathered these together, and a selection has just appeared in an exceptionally beautiful volume published by Camille Recht.[5] The contemporary journals "knew nothing of the man who for the most part hawked his pictures round the studios, sold them off for next to nothing, often for the price of one of those picture postcards which, around 1900, showed such pretty town views, bathed in midnight blue, complete with touched-up moon. He reached the pole of utmost mastery; but with the bitter mastery of a great craftsman who always lives in the shadows, he

neglected to plant his flag there. Therefore many are able to flatter them-
selves that they have discovered the pole, when Atget was there before
them." Indeed, Atget's Paris photos are the forerunners of surrealist pho-
tography; an advance party of the only really broad column surrealism man-
aged to set in motion. He was the first to disinfect the stifling atmosphere
generated by conventional portrait photography in the age of decline. He
cleanses this atmosphere, indeed he dispels it altogether: he initiates the
emancipation of object from aura which is the most signal achievement of
the latest school of photography. When avant-garde periodicals like *Bifur* or
Variété publish pictures captioned *Westminster, Lille, Antwerp,* or *Breslau*
but showing only details, here a piece of balustrade, there a tree-top whose
bare branches crisscross a gas lamp, or a gable wall, or a lamp-post with a
lifebuoy bearing the name of the town—this is nothing but a literary refine-
ment of themes that Atget discovered. He looked for what was unre-
marked, forgotten, cast adrift, and thus such pictures too work against the
exotic, romantically sonorous names of the cities; they pump the aura out
of reality like water from a sinking ship. What is aura, actually? A strange
weave of space and time: the unique appearance or semblance of dis-
tance, no matter how close the object may be. While resting on a summer's
noon, to trace a range of mountains on the horizon, or a branch that throws
its shadow on the observer, until the moment or the hour become part of
their appearance—that is what it means to breathe the aura of those
mountains, that branch. Now, to bring things *closer* to us, or rather to the
masses, is just as passionate an inclination in our day as the overcoming
of whatever is unique in every situation by means of its reproduction. Ev-
ery day the need to possess the object in close-up in the form of a picture,
or rather a copy, becomes more imperative. And the difference between
the copy, which illustrated papers and newsreels keep in readiness, and
the picture is unmistakable. Uniqueness and duration are as intimately
conjoined in the latter as are transience and reproducibility in the former.
The stripping bare of the object, the destruction of the aura, is the mark of
a perception whose sense of the sameness of things has grown to the
point where even the singular, the unique, is divested of its uniqueness—by
means of is reproduction. Atget almost always passed by the "great sights
and the so-called landmarks"; what he did not pass by was a long row of
boot lasts; or the Paris courtyards, where from night to morning the hand-
carts stand in serried ranks; or the tables after people have finished eating
and left, the dishes not yet cleared away—as they exist in their hundreds
of thousands at the same hour; or the brothel at Rue . . . No 5, whose

street number appears, gigantic, at four different places on the building's façade. Remarkably, however, almost all these pictures are empty. Empty the Porte d'Arceuil by the Fortifications, empty the triumphal steps, empty the courtyards, empty, as it should be, the Place du Tertre. They are not lonely, merely without mood; the city in these pictures looks cleared out, like a lodging that has not yet found a new tenant. It is in these achievements that surrealist photography sets the scene for a salutary estrangement between man and his surroundings. It gives free play to the politically educated eye, under whose gaze all intimacies are sacrificed to the illumination of detail.

It is obvious that this new way of seeing stands to gain least in an area where there was the greatest self-indulgence: commercial portrait photography. On the other hand, to do without people is for photography the most impossible of renunciations. And anyone who did not know it was taught by the best of the Russian films that milieu and landscape, too, reveal themselves most readily to those photographers who succeed in capturing their anonymous physiognomy, as it were presenting them at face value. Whether this is possible, however, depends very much on the subject. The generation that was not obsessed with going down to posterity in photographs, rather shyly drawing back into their private space in the face of such proceedings—the way Schopenhauer withdrew into the depths of his chair in the Frankfurt picture, taken about 1850—for that very reason allowed that space, the space where they lived, to get onto the plate with them. That generation did not pass on its virtues. So the Russian feature film was the first opportunity in decades to put people before the camera who had no use for their photographs. And immediately the human face appeared on film with new and immeasurable significance. But it was no longer a portrait. What was it? It is the outstanding service of a German photographer to have answered this question. August Sander[6] has compiled a series of faces that is in no way inferior to the tremendous physiognomic gallery mounted by an Eisenstein or a Pudovkin, and he has done it from a scientific viewpoint. "His complete work comprises seven groups which correspond to the existing social order, and is to be published in some 45 folios containing 12 photographs each." So far we have a sample volume containing 60 reproductions, which offer inexhaustible material for study. "Sander starts off with the peasant, the earth-bound man, takes the observer through every social stratum and even walk of life up to the highest representatives of civilization, and then back down all the way to the idiot." The author did not approach this enormous undertaking as a scholar,

or with the advice of ethnographers and sociologists, but, as the publisher says "from direct observation." It was assuredly a very impartial indeed bold sort of observation, but delicate too, very much in the spirit of Goethe's remark: "There is a delicate empiricism which so, intimately involves itself with the object that it becomes true theory." So it was quite in order for an observer like Döblin to have hit on precisely the scientific aspects of this work, commenting "Just as there is comparative anatomy, which helps us to understand the nature and history of organs, so this photographer is doing comparative photography, adopting a scientific standpoint superior to the photographer of detail." It would be a pity if economic considerations should prevent the continuing publication of this extraordinary body of work. Apart from this basic encouragement, there is a more specific incentive one might offer the publisher. Work like Sander's could overnight assume unlooked-for topicality. Sudden shifts of power such as are now overdue in our society can make the ability to read facial types a matter of vital importance. Whether one is of the left or right, one will have to get used to being looked at in terms of one's provenance. And one will have to look at others the same way. Sander's work is more than a picture book. It is a training manual.

"In our age there is no work of art that is looked at so closely as a photograph of oneself, one's closest relatives and friends, ones sweetheart," wrote Lichtwark back in 1907, thereby moving the inquiry out of the realm of aesthetic distinctions into that of social functions. Only from this vantage point can it be carried further. It is indeed significant that the debate has raged most fiercely around the aesthetics of *photography as art*, whereas the far less questionable social fact of *art as photography* was given scarcely a glance. And yet the impact of the photographic reproduction of art works is of very much greater importance for the function of art than the greater or lesser artistry of a photography that regards all experience as fair game for the camera. The amateur who returns home with great piles of artistic shots is in fact no more appealing a figure than the hunter who comes back with quantities of game of no use to anyone but the dealer. And the day does indeed seem to be at hand when there will be more illustrated magazines than game merchants. So much for the *snapshot*. But the emphasis changes completely if we turn from photography-as-art to art-as-photography. Everyone will have noticed how much easier it is to get hold of a picture, more particularly a piece of sculpture, not to mention architecture, in a photograph than in reality. It is all too tempting to blame this squarely on the decline of artistic appreciation, on a failure of contemporary

sensibility. But one is brought up short by the way the understanding of great works was transformed at about the same time the techniques of reproduction were being developed. They can no longer be regarded as the work of individuals; they have become a collective creation, a corpus so vast it can be assimilated only through miniaturization. In the final analysis, mechanical reproduction is a technique of diminution that helps men to achieve a control over works of art without whose aid they could no longer be used.

If one thing typifies present-day relations between art and photography, it is the unresolved tension between the two introduced by the photography of works of art. Many of those who, as photographers, determine the present face of this technology started out as painters. They turned their back on painting after attempts to bring its expressive resources into a living and unequivocal relationship with modern life. The keener their feel for the temper of the times, the more problematic their starting point became for them. For once again, as eighty years before, photography was taking over from painting. "The creative potential of the new," says Moholy-Nagy, "is for the most part slowly revealed through old forms, old instruments and areas of design that in their essence have already been superseded by the new, but which under pressure from the new as it takes shape are driven to a euphoric efflorescence. Thus, for example, futurist (structural) painting brought forth the clearly defined *Problematik* of the simultaneity of motion, the representation of the instant, which was later to destroy it—and this at a time when film was already known but far from being understood . . . Similarly, some of the painters (neoclassicists and verists) today using representational-objective methods can be regarded—with caution—as forerunners of a new representational optical form which will soon be making use only of mechanical, technical methods." And Tristan Tzara, 1922: "When everything that called itself art was stricken with palsy, the photographer switched on his thousand candle-power lamp and gradually the light-sensitive paper absorbed the darkness of a few everyday objects. He had discovered what could be done by a pure and sensitive flash of light that was more important than all the constellations arranged for the eye's pleasure." The photographers who went over from figurative art to photography not on opportunistic grounds, not by chance, not out of sheer laziness, today constitute the avant-garde among their colleagues, because they are to some extent protected by their background against the greatest danger facing photography today, the touch of the commercial artist. "Photography as art," says Sasha Stone, "is a very dangerous field."

Where photography takes itself out of context, severing the connections illustrated by Sander, Blossfeldt or Germaine Krull, where it frees itself from physiognomic, political and scientific interest, then it becomes *creative*. The lens now looks for interesting juxtapositions; photography turns into a sort of arty journalism. "The spirit that overcomes mechanics translates exact findings into parables of life." The more far-reaching the crisis of the present social order, the more rigidly its individual components are locked together in their death struggle, the more has the creative—in its deepest essence a sport, by contradiction out of imitation — become a fetish, whose lineaments live only in the fitful illumination of changing fashion. The creative in photography is its capitulation to fashion. *The world is beautiful*—that is its watchword. Therein is unmasked the posture of a photography that can endow any soup can with cosmic significance but cannot grasp a single one of the human connections in which it exists, even where most far-fetched subjects are more concerned with salability than with insight. But because the true face of this kind of photographic creativity is the advertisement or association, its logical counterpart is the act of unmasking or construction. As Brecht says: "the situation is complicated by the fact that less than ever does the mere reflection of reality reveal anything about reality. A photograph of the Krupp works or the A.E.G. tells us next to nothing about these institutions. Actual reality has slipped into the functional. The reification of human relations – the factory, say—means that they are no longer explicit. So something must in fact be *built up,* something artificial, posed." We owe it to the surrealists that they trained the pioneers of such a constructivist photography. A further stage in this contest between creative and constructivist photography is typified by the Russian film. It is not too much to say that the great achievements of the Russian directors were only possible in a country where photography does not set out to charm or persuade, but to experiment and instruct. In this sense, and in this only, there is still some meaning in the grandiloquent salute offered to photography in 1855 by the uncouth painter of ideas, Antoine Wiertz. "For some years now the glory of our age has been a machine which daily amazes the mind and startles the eye. Before another century is out, this machine will be the brush, the palette, the colors, the craft, the experience, the patience, the dexterity, the sureness of touch, the atmosphere, the luster, the exemplar, the perfection, the very essence of painting . . . Let no one suppose that daguerreotype photography will be the death of art . . . When the daguerreotype, that infant prodigy, has grown to its full stature, when all its art and its strength have been revealed, then will

Genius seize it by the scruff of the neck and shout: Come with me, you are mine now! We shall work together!" How sober, indeed pessimistic by contrast are the words in which Baudelaire announced the new technology to his readers, two years later, in the *Salon of 1857.* Like the preceding quotation, they can be read today only with a subtle shift of emphasis. But as a counterpart to the above they still make sense as a violent reaction to the encroachments of artistic photography. "In these sorry days a new industry has arisen that has done not a little to strengthen the asinine belief . . . that art is and can be nothing other than the accurate reflection of nature . . . A vengeful god has hearkened to the voice of this multitude. Daguerre is his Messiah." And: "If photography is permitted to supplement some of art's functions, they will forthwith be usurped and corrupted by it, thanks to photography's natural alliance with the mob. It must therefore revert to its proper duty, which is to serve as the handmaiden of science and the arts."

One thing, however, both Wiertz and Baudelaire failed to grasp: the lessons inherent in the authenticity of the photograph. These cannot be forever circumvented by a commentary whose clichés merely establish verbal associations in the viewer. The camera is getting smaller and smaller, ever readier to capture fleeting and secret moments whose images paralyze the associative mechanism in the beholder. This is where the caption comes in, whereby photography turns all life's relationships into literature, and without which all constructivist photography must remain arrested in the approximate. Not for nothing have Atget's photographs been likened to those of the scene of a crime. But is not every square inch of our cities the scene of a crime? Every passer-by a culprit? Is it not the task of the photographer—descendant of the augurs and haruspices—to reveal guilt and to point out the guilty in his pictures? "The illiteracy of the future," someone has said, "will be ignorance not of reading or writing, but of photography." But must not a photographer who cannot read his own pictures be no less accounted an illiterate? Will not the caption become the most important part of the photograph? Such are the questions in which the interval of ninety years that separate us from the age of the daguerreotype discharges its historical tension. It is in the illumination of these sparks that the first photographs emerge, beautiful and unapproachable, from the darkness of our grandfathers' day.

—Translated by Edmund Jephcott and Kingsley Shorter

7

Nietzsche's Overturning of Platonism
The Origin of the Work of Art

Martin Heidegger

Martin Heidegger (1889–1976) is one of the most famous of twentieth-century philosophers. His book *Being and Time* (1927) is a landmark in philosophical thought, raising the issue of a crisis in modernity that can be resolved only by a wholesale rethinking of contemporary humankind's thought and very existence. Inevitably, Heidegger's reputation has been colored by his association with National Socialism, beginning during his appointment as rector of the University of Freiburg from 1933 to 1934. After the Second World War, Heidegger was prohibited from teaching owing to his support of the Nazis, although he resumed lecturing at Freiburg in 1951.

Heidegger saw the rise of National Socialism as an event bringing into focus the central problem of modernity as he had identified it in *Being and Time*: the problematic of a prevailing Cartesian approach to technological progress whereby objects and things in the world are understood through a priori forms of assumed knowledge. Heidegger was not against modernity per se, but he was worried about its historical persistence and the way in which it prevents change—which, for him, always occurs as a rupture with previously prevailing values and systems of understanding. Heidegger divided history into three historical epistemes: pre-Socratic philosophy, Christian thought, and modern Cartesian thinking. Much of Heidegger's philosophy, including the essay "The Origin of the Work of Art,"[1] is dedicated to advancing the beginning of a new historical epoch of thinking. In

this respect, Heidegger believes that Nietzsche is involved in the same task, as he writes in "Nietzsche's Overturning of Platonism."[2] And yet, however much Heidegger affirms Nietzsche's philosophy, he remains concerned that it may simply serve as a way of extending (the end of) modernity rather than as a means of inaugurating a new beginning. In his later work after the war, Heidegger became increasingly pessimistic about the possible emergence of a new historical epoch.

Drawing for inspiration upon the philosophical fragments of the pre-Socratic philosopher Heraclitus and the writings of the German Romantic poet Friedrich Hölderlin, Heidegger's philosophy is concerned with a pre-subjective space that precedes predication but nevertheless is the precondition for language enabling predication and understanding to occur. Heidegger refers to this space as that of Dasein, the identity of which is always outside of itself, since it is essentially receptive and affectable. Like all of the interconnected terms in Heidegger's writing, including those of Being, essence, existence, and truth, Dasein functions as both a noun and a verb: Dasein is a state of being (as the precondition for language and thought) and a process of becoming that occurs over history and time. Whereas Cartesianism is a philosophy based upon the desire for certainty, in contrast, Heidegger's philosophy embraces uncertainty, since the process of emergence and what emerges through Dasein cannot be fixed in advance. Having said this, Heidegger believes Dasein is always circumscribed by a limited horizon of possibilities: each historical epoch contains its own ending in its beginning and is always potentially a form of fixity and repression if it endures for too long (which Heidegger believes is what has happened with modernity). In "The Origin of the Work of Art," Heidegger explores this process of emergence and limit through various yet synonymous terms or sets of terms: *alétheia* (meaning disclosure and concealment), world (an open region) and earth (connected to world yet self-secluding), and (the space of) clearing. Whereas unconcealment (*alétheia*) is a process of opening, change, and disclosure, the pervasive sense of veiling and self-seclusion (*léthe*) that is part of unconcealment refers to what cannot be said or thought within a respective historical epoch. Thus, "Truth, in its essence, is un-truth." For Heidegger, the fact that there is much that cannot be said within any episteme of understanding is an indication that there is a limit to all such epistemes.

For Heidegger, there emerges in Nietzsche's passage of writing, "How the 'True World' Finally Became A Fable: The History of an Error" (1888; see chapter 3) a renewed relationship with Dasein. In this context, Dasein is

equated with the "true world" and the supersensuous. According to Heidegger, the mistake of Platonism, Christianity, and Kant (sections 2 and 3) is to cast the supersensuous in a realm separate from mankind and phenomena, while positivism (section 4) attempts in myopic fashion to ignore the issue of the supersensuous altogether. Heidegger believes that Nietzsche's conjoining of the sensuous and supersensuous worlds represents a "twisting free" of metaphysics and, as a consequence, returns to Plato's idea that our understanding of the world and our sense of being is conditioned by Dasein (sections 1, 5 and 6). (For further discussion of this passage of writing, see the introduction and Jacques Derrida, "Spurs: Nietzsche's Styles," chapter 16).

"The Origin of the Work of Art" inquires into the function and significance of the work of art with respect to Dasein. Through the examples of a painting of shoes by Van Gogh and the Greek temple, Heidegger proposes that the work of art has two functions that are distinct from one another. With respect to Van Gogh's painting,[3] Heidegger argues that the work of art's function is to disclose or reveal what is usually not acknowledged and so taken for granted that it remains unconscious (in the realm of "reliability"): this is the truth of the essence of tools and products. Techné (as an aspect of Dasein) brings forth the essence of tools and products, but the role of representing this belongs to the work of art, and not techné. In this context, the work of art is a "happening of truth." Thus, it is not the tool or "equipment" that determines the truth in the final instance, but the work of art. In the example of the Greek temple, Heidegger makes more ambitious claims for the role of the work of art. In almost tautological fashion, Heidegger claims that the temple is both a setting of Dasein into the work of art and a disclosure of an epoch's temporal existence. Thus, the temple is both an effect of Dasein as well as its iconic presence within a community. In this latter role, the work of art serves as a reminder, and even an imperative, to the community to effect change by drawing to an end the historical epoch of which it is a part. Heidegger underlies this role by pointing out that the temple's living condition is only "as long as the god has not fled from it." For Heidegger, it was necessary for the survival of humanity that "the god" and, along with it, the community's most cherished values, departed from Greek civilization. Their departure made way for a new origin and beginning, which Heidegger wishes to reaffirm as a sign for his own times.

NIETZSCHE'S OVERTURNING OF PLATONISM
████

We conducted an examination of the relation of truth and beauty in Plato in order to sharpen our view of things. For we are attempting to locate the place and context in Nietzsche's conception of art and truth where the severance of the two must occur, and in such a way that it is experienced as a discordance that arouses dread.

Both beauty and truth are related to Being, indeed by way of unveiling the Being of beings. Truth is the immediate way in which Being is revealed in the thought of philosophy; it does not enter into the sensuous, but from the outset is averted from it. Juxtaposed to it is beauty, penetrating the sensuous and then moving beyond it, liberating in the direction of Being. If beauty and truth in Nietzsche's view enter into discordance, they must previously belong together in one. That one can only be Being and the relation to Being.

Nietzsche defines the basic character of beings, hence Being, as will to power. Accordingly, an original conjunction of beauty and truth must result from the essence of will to power, a conjunction which simultaneously must become a discordance. When we try to discern and grasp the discordance we cast a glance toward the unified essence of will to power. Nietzsche's philosophy, according to his own testimony, is inverted Platonism. We ask: in what sense does the relation of beauty and truth which is peculiar to Platonism become a different sort of relation through the overturning?

The question can easily be answered by a simple recalculation, if "overturning" Platonism may be equated with the procedure of standing all of Plato's statements on their heads, as it were. To be sure, Nietzsche himself often expresses the state of affairs in that way, not only in order to make clear what he means in a rough and ready fashion, but also because he himself often thinks that way, although he is aiming at something else.

Only late in his life, shortly before the cessation of his labors in thinking, does the full scope required by such an inversion of Platonism become clear to him. That clarity waxes as Nietzsche grasps the necessity of the overturning, which is demanded by the task of overcoming nihilism. For that reason, when we elucidate the overturning of Platonism we must take the structure of Platonism as our point of departure. For Plato the supersensuous is the true world. It stands over all, as what sets the standard. The sensuous lies below, as the world of appearances. What stands over all is alone and from the start what sets the standard; it is therefore what is desired. After the inversion—that is easy to calculate in a formal way—the

sensuous, the world of appearances, stands above; the supersensuous, the true world, lies below. With a glance back to what we have already presented, however, we must keep a firm hold on the realization that the very talk of a "true world" and "world of appearances" no longer speaks the language of Plato.

But what does that mean—the sensuous stands above all? It means that it is the true, it is genuine being. If we take the inversion strictly in this sense, then the vacant niches of the "above and below" are preserved, suffering only a change in occupancy, as it were. But as long as the "above and below" define the formal structure of Platonism, Platonism in its essence perdures. The inversion does not achieve what it must, as an overcoming of nihilism, namely, an overcoming of Platonism in its very foundations. Such overcoming succeeds only when the "above" in general is set aside as such, when the former positing of something true and desirable no longer arises, when the true world—in the sense of the ideal—is expunged. What happens when the true world is expunged? Does the apparent world still remain? No. For the apparent world can be what it is only as a counterpart of the true. If the true world collapses, so must the world of appearances. Only then is Platonism overcome, which is to say, inverted in such a way that philosophical thinking twists free of it. But then where does such thinking wind up?

During the time the overturning of Platonism became for Nietzsche a twisting free of it, madness befell him. Heretofore no one at all has recognized this reversal as Nietzsche's final step; neither has anyone perceived that the step is clearly taken only in his final creative year (1888). Insight into these important connections is quite difficult on the basis of the book *The Will to Power* as it lies before us in its present form, since the textual fragments assembled here have been removed from a great number of manuscripts written during the years 1882 to 1888. An altogether different picture results from the examination of Nietzsche's original manuscripts. But even without reference to these, there is a section of the treatise *Twilight of the Idols*, composed in just a few days during that final year of creative work (in September of 1888, although the book did not appear until 1889), a section which is very striking, because its basic position differs from the one we are already familiar with. The section is entitled "How the 'True World' Finally Became a Fable: The History of an Error" (VIII, 82–83; cf. WM,[4] 567 and 568, from the year 1888.)

The section encompasses a little more than one page. (Nietzsche's handwritten manuscript, the one sent to the printer, is extant.) It belongs to

those pieces the style and structure of which betray the fact that here, in a magnificent moment of vision, the entire realm of Nietzsche's thought is permeated by a new and singular brilliance. The title, "How the 'True World' Finally Became a Fable," says that here a history is to be recounted in the course of which the supersensuous, posited by Plato as true being, not only is reduced from the higher to the lower rank but also collapses into the unreal and nugatory. Nietzsche divides the history into six parts, which can be readily recognized as the most important epochs of Western thought, and which lead directly to the doorstep of Nietzsche's philosophy proper.

For the sake of our own inquiry we want to trace that history in all brevity, so that we can see how Nietzsche, in spite of his will to subvert, preserved a luminous knowledge concerning what had occurred prior to him.

The more clearly and simply a decisive inquiry traces the history of Western thought back to its few essential stages, the more that history's power to reach forward, seize, and commit grows. This is especially the case where it is a matter of overcoming such history. Whoever believes that philosophical thought can dispense with its history by means of a simple proclamation will, without his knowing it, be dispensed with by history; he will be struck a blow from which he can never recover, one that will blind him utterly. He will think he is being original when he is merely rehashing what has been transmitted and mixing together traditional interpretations into something ostensibly new. The greater a revolution is to be, the more profoundly must it plunge into its history.

We must measure Nietzsche's brief portrayal of the history of Platonism and its overcoming by this standard. Why do we emphasize here things that are evident? Because the form in which Nietzsche relates the history might easily tempt us to take it all as a mere joke, whereas something very different is at stake here (cf. *Beyond Good and Evil*, no. 213, "What a philosopher is," VII, 164 ff.).

The six divisions of the history of Platonism, culminating in emergence from Platonism, are as follows.

"1. The true world, attainable for the wise, the pious, the virtuous man—he lives in it, *he is it*."

Here the founding of the doctrine by Plato is established. To all appearances, the true world itself is not handled at all, but only how man adopts a stance toward it and to what extent it is attainable. And the essential definition of the true world consists in the fact that it is attainable here and now for man, although not for any and every man, and not without further ado. It is attainable for the virtuous; it is the supersensuous. The implication is

that virtue consists in repudiation of the sensuous, since denial of the world that is closest to us, the sensuous world, is proper to the Being of beings. Here the "true world" is not yet anything "Platonic," that is, not something unattainable, merely desirable, merely "ideal." Plato himself is who he is by virtue of the fact that he unquestioningly and straightforwardly functions on the basis of the world of Ideas as the essence of Being. The supersensuous is the *idea*. What is here envisioned in the eyes of Greek thought and existence is truly seen, and experienced in such simple vision, as what makes possible every being, as that which becomes present to itself (see *Vom Wesen des Grundes*, 1929, part two).[5] Therefore, Nietzsche adds the following commentary in parentheses: "(Oldest form of the idea, relatively sensible, simple, convincing. Circumlocution for the sentence 'I, Plato, *am* the truth.')" The thought of the Ideas and the interpretation of Being posited here are creative in and of themselves. Plato's work is not yet Platonism. The "true world" is not yet the object of a doctrine; it is the power of Dasein; it is what lights up in becoming present; it is pure radiance without cover.

"2. The true world, unattainable for now, but promised for the wise, the pious, the virtuous man ('for the sinner who repents')."

With the positing of the supersensuous as true being, the break with the sensuous is now expressly ordained, although here again not straightaway: the true world is unattainable only in this life, for the duration of earthly existence. In that way earthly existence is denigrated and yet receives its proper tension, since the supersensuous is promised as the "beyond." Earth becomes the "earthly." The essence and existence of man are now fractured, but that makes a certain ambiguity possible. The possibility of "yes and no," of "this world as well as that one," begins; the apparent affirmation of this world, but with a reservation; the ability to go along with what goes on in this world, but keeping that remote back door ajar. In place of the unbroken essence of the Greek, which while unbroken was not without hazard but was passionate, which grounded itself in what was attainable, which drew its definitive boundaries here, which not only bore the intractability of fate but in its affirmation struggled for victory—in place of that essence begins something insidious. In Plato's stead, Platonism now rules. Thus: "(Progress of the idea: it becomes more subtle, insidious, ungraspable —*it becomes woman*, it becomes Christian . . .)." The supersensuous is no longer present within the scope of human existence, present for it and for its sensuous nature. Rather, the whole of human existence becomes this-worldly to the extent that the supersensuous is interpreted as the "beyond." In that way the true world now becomes even truer, by being dis-

placed ever farther beyond and away from this world; it grows ever stronger in being, the more it becomes what is promised and the more zealously it is embraced, i.e., believed in, as what is promised. If we compare the second part of the history with the first, we see how Nietzsche in his description of the first part consciously sets Plato apart from all Platonism, protecting him from it.

"3. The true world, unattainable, indemonstrable, unpromisable, but even as thought, a consolation, an obligation, an imperative."

This division designates the form of Platonism that is achieved by the Kantian philosophy. The supersensuous is now a postulate of practical reason; even outside the scope of all experience and demonstration it is demanded as what is necessarily existent, in order to salvage adequate grounds for the lawfulness of reason. To be sure, the accessibility of the supersensuous by way of cognition is subjected to critical doubt, but only in order to make room for belief in the requisition of reason. Nothing of the substance and structure of the Christian view of the world changes by virtue of Kant; it is only that all the light of knowledge is cast on experience, that is, on the mathematical-scientific interpretation of the "world." Whatever lies outside of the knowledge possessed by the sciences of nature is not denied as to its existence but is relegated to the indeterminateness of the unknowable. Therefore: "(The old sun, basically, but seen through haze and skepticism; the idea ratified, grown pallid, Nordic, Konigsbergian.)" A transformed world—in contrast to the simple clarity by which Plato dwelled in direct contact with the supersensuous, as discernible Being. Because he sees through the unmistakable Platonism of Kant, Nietzsche at the same time perceives the essential difference between Plato and Kant. In that way he distinguishes himself fundamentally from his contemporaries, who, not accidentally, equate Kant and Plato—if they don't interpret Plato as a Kantian who didn't quite make it.

"4. The true world—unattainable? In any case, unattained. And as unattained also *unknown*. Consequently, also, not consolatory, redemptive, obligating: to what could something unknown obligate us? . . ."

With the fourth division, the form to which Platonism commits itself as a consequence of the bygone Kantian philosophy is historically attained, although without an originally creative overcoming. It is the age following the dominance of German Idealism, at about the middle of the last century. With the help of its own chief principle, the theoretical unknowability of the supersensuous, the Kantian system is unmasked and exploded. If the supersensuous world is altogether unattainable for cognition, then nothing

can be known about it, nothing can be decided for or against it. It becomes manifest that the supersensuous does not come on the scene as a part of the Kantian philosophy on the grounds of basic philosophical principles of knowledge but as a consequence of uneradicated Christian-theological presuppositions.[6] In that regard Nietzsche on one occasion observes of Leibniz, Kant, Fichte, Schelling, Hegel, and Schopenhauer, "They are all mere Schleiermachers" (XV, 112). The observation has two edges: it means not only that these men are at bottom camouflaged theologians but also that they are what that name suggests—Schleier-macher, makers of veils, men who veil things. In opposition to them stands the somewhat half-hearted rejection of the supersensuous as something unknown, to which, after Kant, no cognition can in principle attain. Such rejection is a kind of first glimmer of "probity" of meditation amid the captiousness and "coun-terfeiting" that came to prevail with Platonism. Therefore: "(Gray morning. First yawnings of reason. Cockcrow of positivism.)" Nietzsche descries the rise of a new day. Reason, which here means man's knowing and inquiring, awakens and comes to its senses.

"5. The 'true world'—an idea which is of use for nothing, which is no lon-ger even obligating—an idea become useless, superfluous, consequently, a refuted idea: let us abolish it!"

With this division Nietzsche designates the first segment of his own way in philosophy. The "true world" he now sets in quotation marks. It is no longer his own word, the content of which he himself could still affirm. The "true world" is abolished. But notice the reason: because it has become useless, superfluous. In the shimmering twilight a new standard of mea-sure comes to light: whatever does not in any way at any time involve man's Dasein can make no claim to be affirmed. Therefore: "(Bright day; break-fast; return of bon sens and of cheerfulness; Plato's embarrassed blush; pandemonium of all free spirits.)" Here Nietzsche thinks back on the years of his own metamorphosis, which is intimated clearly enough in the very ti-tles of the books he wrote during that time: Human, All Too Human (1878), The Wanderer and His Shadow (1880), The Dawn (1881), and The Gay Sci-ence (1882). Platonism is overcome inasmuch as the supersensuous world, as the true world, is abolished; but by way of compensation the sensuous world remains, and positivism occupies it. What is now required is a con-frontation with the latter. For Nietzsche does not wish to tarry in the dawn of morning; neither will he rest content with mere forenoon. In spite of the fact that the supersensuous world as the true world has been cast aside, the vacant niche of the higher world remains, and so does the blueprint of

an "above and below," which is to say, so does Platonism. The inquiry must go one step farther.

"6. The true world we abolished: which world was left? the apparent one perhaps? . . . But no! along with the true world we have also abolished the apparent one!"

That Nietzsche appends a sixth division here shows that, and how, he must advance beyond himself and beyond sheer abolition of the supersensuous. We sense it directly from the animation of the style and manner of composition—how the clarity of this step conducts him for the first time into the brilliance of full daylight, where all shadows dwindle. Therefore: "(Midday; moment of the shortest shadow; end of the longest error; highpoint of humanity; INCIPIT ZARATHUSTRA.)" Thus the onset of the final stage of his own philosophy.

The portrayal of all six divisions of the history of Platonism is so arranged that the "true world," the existence and legitimacy of which is under consideration, is in each division brought into connection with the type of man who comports himself to that world. Consequently, the overturning of Platonism and the ultimate twist out of it imply a metamorphosis of man. At the end of Platonism stands a decision concerning the transformation of man. That is how the phrase "high-point of humanity" is to be understood, as the peak of decision, namely, decision as to whether with the end of Platonism man as he has been hitherto is to come to an end, whether he is to become that kind of man Nietzsche characterized as the "last man," or whether that type of man can be overcome and the "overman" can begin: "Incipit Zarathustra." By the word "overman" Nietzsche does not mean some miraculous, fabulous being, but the man who surpasses former man. But man as he has been hitherto is the one whose Dasein and relation to Being have been determined by Platonism in one of its forms or by a mixture of several of these. The last man is the necessary consequence of unsubdued nihilism. The great danger Nietzsche sees is that it will all culminate in the last man, that it will peter out in the spread of the increasingly insipid last man. "The opposite of the overman is the *last man:* I created him at the same time I created the former" (XIV, 262). That suggests that the end first becomes visible as an end on the basis of the new beginning. To put it the other way round, overman's identity first becomes clear when the last man is perceived as such.

Now all we must do is bring into view the extreme counterposition to Plato and Platonism and then ascertain how Nietzsche successfully adopts a stance within it. What results when, along with the true world, the apparent world too is abolished?

The "true world," the supersensuous, and the apparent world, the sensuous, together make out what stands opposed to pure nothingness; they constitute beings as a whole. When both are abolished everything collapses into the vacuous nothing. That cannot be what Nietzsche means. For he desires to overcome nihilism in all its forms. When we recall that, and how, Nietzsche wishes to ground art upon embodying life by means of his physiological aesthetics, we note that this implies an affirmation of the sensuous world, not its abolition. However, according to the express wording of the final division of the history of Platonism, "the apparent world is abolished." Certainly. But the sensuous world is the "apparent world" only according to the interpretation of Platonism. With the abolition of Platonism the way first opens for the affirmation of the sensuous, and along with it, the nonsensuous world of the spirit as well. It suffices to recall the following statement from *The Will to Power*, no. 820:

> For myself and for all those who live—are *permitted* to live—without the anxieties of a puritanical conscience, I wish an ever greater spiritualization and augmentation of the senses. Yes, we ought to be grateful to our senses for their subtlety, fullness, and force; and we ought to offer them in return the very best of spirit we possess.

What is needed is neither abolition of the sensuous nor abolition of the nonsensuous. On the contrary, what must be cast aside is the misinterpretation, the deprecation, of the sensuous, as well as the extravagant elevation of the supersensuous. A path must be cleared for a new interpretation of the sensuous on the basis of a new hierarchy of the sensuous and nonsensuous. The new hierarchy does not simply wish to reverse matters within the old structural order, now reverencing the sensuous and scorning the nonsensuous. It does not wish to put what was at the very bottom on the very top. A new hierarchy and new valuation mean that the ordering *structure* must be changed. To that extent, overturning Platonism must become a twisting free of it. How far the latter extends with Nietzsche, how far it can go, to what extent it comes to an overcoming of Platonism and to what extent not—those are necessary critical questions. But they should be posed only when we have reflected in accordance with the thought that Nietzsche most intrinsically willed—beyond everything captious, ambiguous, and deficient which we might very easily ascribe to him here.

—Translated by David Farrell Krell

THE ORIGIN OF THE WORK OF ART

Origin here means that from which and by which something is what it is and as it is. What something is, as it is, we call its essence. The origin of something is the source of its essence. The question concerning the origin of the work of art asks about its essential source. On the usual view, the work arises out of and by means of the activity of the artist. But by what and whence is the artist what he is? By the work; for to say that the work does credit to the master means that it is the work that first lets the artist emerge as a master of his art. The artist is the origin of the work. The work is the origin of the artist. Neither is without the other. Nevertheless, neither is the sole support of the other. In themselves and in their interrelations artist and work *are* each of them by virtue of a third thing which is prior to both, namely, that which also gives artist and work of art their names—art.

As necessarily as the artist is the origin of the work in a different way than the work is the origin of the artist, so it is equally certain that, in a still different way, art is the origin of both artist and work. But can art be an origin at all? Where and how does art occur? Art—this is nothing more than a word to which nothing actual any longer corresponds. It may pass for a collective idea under which we find a place for that which alone is actual in art: works and artists. Even if the word *art* were taken to signify more than a collective notion, what is meant by the word could exist only on the basis of the actuality of works and artists. Or is the converse the case? Do works and artists exist only because art exists as their origin?

Whatever the decision may be, the question of the origin of the work of art becomes a question about the essence of art. Since the question whether and how art in general exists must still remain open, we shall attempt to discover the essence of art in the place where art undoubtedly prevails in an actual way. Art essentially unfolds in the artwork. But what and how is a work of art?

What art is should be inferable from the work. What the work of art is we can come to know only from the essence of art. Anyone can easily see that we are moving in a circle. Ordinary understanding demands that this circle be avoided because it violates logic. What art is can be gathered from a comparative examination of actual artworks. But how are we to be certain that we are indeed basing such an examination on artworks if we do not know beforehand what art is? And the essence of art can no more be arrived at by a derivation from higher concepts than by a collection of characteristics of actual artworks. For such a derivation, too, already has in

view the definitions that must suffice to establish that what we in advance take to be an artwork is one in fact. But selecting characteristics from among given objects, and deriving concepts from principles, are equally impossible here, and where these procedures are practiced they are a self-deception.

Thus we are compelled to follow the circle. This is neither a makeshift nor a defect. To enter upon this path is the strength of thought, to continue on it is the feast of thought, assuming that thinking is a craft. Not only is the main step from work to art a circle like the step from art to work, but every separate step that we attempt circles in this circle.

In order to discover the essence of the art that actually prevails in the work, let us go to the actual work and ask the work what and how it is.

Works of art are familiar to everyone. Architectural and sculptural works can be seen installed in public places, in churches, and in dwellings. Artworks of the most diverse periods and peoples are housed in collections and exhibitions. If we consider the works in their untouched actuality and do not deceive ourselves, the result is that the works are as naturally present as are things. The picture hangs on the wall like a rifle or a hat. A painting, e.g., the one by Van Gogh that represents a pair of peasant shoes, travels from one exhibition to another. Works of art are shipped like coal from the Ruhr and logs from the Black Forest. During the First World War Hölderlin's hymns were packed in the soldier's knapsack together with cleaning gear. Beethoven's quartets lie in the storerooms of the publishing house like potatoes in a cellar.

All works have this thingly character. What would they be without it? But perhaps this rather crude and external view of the work is objectionable to us. Shippers or charwomen in museums may operate with such conceptions of the work of art. We, however, have to take works as they are encountered by those who experience and enjoy them. But even the much-vaunted aesthetic experience cannot get around the thingly aspect of the artwork. There is something stony in a work of architecture, wooden in a carving, colored in a painting, spoken in a linguistic work, sonorous in a musical composition. The thingly element is so irremovably present in the artwork that we are compelled rather to say conversely that the architectural work is in stone, the carving is in wood, the painting in color, the linguistic work in speech, the musical composition in sound. "Obviously," it will be replied. No doubt. But what is this self-evident thingly element in the work of art?

Presumably it becomes superfluous and confusing to inquire into this feature, since the artwork is something else over and above the thingly

element. This something else in the work constitutes its artistic nature. The artwork is, to be sure, a thing that is made, but it says something other than what the mere thing itself is, *allo agoreuei*. The work makes public something other than itself; it manifests something other; it is an allegory. In the work of art something other is brought together with the thing that is made. To bring together is, in Greek, *symballein*. The work is a symbol.

Allegory and symbol provide the conceptual frame within whose channel of vision the artwork has long been characterized. But this one element in a work that manifests another, this one element that joins with another, is the thingly feature in the artwork. It seems almost as though the thingly element in the artwork is like the substructure into and upon which the other, proper element is built. And is it not this thingly feature in the work that the artist properly makes by his handicraft?

Our aim is to arrive at the immediate and full actuality of the work of art, for only in this way shall we discover actual art also within it. Hence we must first bring to view the thingly element of the work. To this end it is necessary that we should know with sufficient clarity what a thing is. Only then can we say whether the artwork is a thing, but a thing to which something else adheres: only then can we decide whether the work is at bottom something else and not a thing at all.

Thing and Work

We choose as example a common sort of equipment—a pair of peasant shoes. We do not even need to exhibit actual pieces of this sort of useful article in order to describe them. Everyone is acquainted with them. But since it is a matter here of direct description, it may be well to facilitate the visual realization of them. For this purpose a pictorial representation suffices. We shall choose a well-known painting by Van Gogh, who painted such shoes several times. But what is there to see here? Everyone knows what shoes consist of. If they are not wooden or bast shoes, there will be leather soles and uppers, joined together by thread and nails. Such gear serves to clothe the feet. Depending on the use to which the shoes are to be put, whether for work in the field or for dancing, matter and form will differ.

Such statements, no doubt correct, only explicate what we already know. The equipmental quality of equipment consists in its usefulness. But what about this usefulness itself? In conceiving it, do we already conceive along with it the equipmental character of equipment? In order to succeed in doing this, must we not look out for useful equipment in its use? The

peasant woman wears her shoes in the field. Only here are they what they are. They are all the more genuinely so, the less the peasant woman thinks about the shoes while she is at work, or looks at them at all, or is even aware of them. She stands and walks in them. That is how shoes actually serve. It is in this process of the use of equipment that we must actually encounter the character of equipment.

As long as we only imagine a pair of shoes in general, or simply look at the empty, unused shoes as they merely stand there in the picture, we shall never discover what the equipmental being of the equipment in truth is. From Van Gogh's painting we cannot even tell where these shoes stand. There is nothing surrounding this pair of peasant shoes in or to which they might belong—only an undefined space. There are not even clods of soil from the field or the field-path sticking to them, which would at least hint at their use. A pair of peasant shoes and nothing more. And yet.

From the dark opening of the worn insides of the shoes the toilsome tread of the worker stares forth. In the stiffly rugged heaviness of the shoes there is the accumulated tenacity of her slow trudge through the far-spreading and ever-uniform furrows of the field swept by a raw wind. On the leather lie the dampness and richness of the soil. Under the soles stretches the loneliness of the field-path as evening falls. In the shoes vibrates the silent call of the earth, its quiet gift of the ripening grain and its unexplained self-refusal in the fallow desolation of the wintry field. This equipment is pervaded by uncomplaining worry as to the certainty of bread, the wordless joy of having once more withstood want, the trembling before the impending childbed and shivering at the surrounding menace of death. This equipment belongs to the *earth,* and it is protected in the *world* of the peasant woman. From out of this protected belonging the equipment itself rises to its resting-within-itself.

But perhaps it is only in the picture that we notice all this about the shoes. The peasant woman, on the other hand, simply wears them. If only this simple wearing were so simple. When she takes off her shoes late in the evening, in deep but healthy fatigue, and reaches out for them again in the still dim dawn, or passes them by on the day of rest, she knows all this without noticing or reflecting. The equipmental being of the equipment consists indeed in its usefulness. But this usefulness itself rests in the abundance of an essential Being of the equipment. We call it reliability. By virtue of this reliability the peasant woman is made privy to the silent call of the earth; by virtue of the reliability of the equipment she is sure of her world. World and earth exist for her, and for those who are with her in her

mode of being, only thus—in the equipment. We say "only" and therewith fall into error; for the reliability of the equipment first gives to the simple world its security and assures to the earth the freedom of its steady thrust.

The equipmental being of equipment, reliability, keeps gathered within itself all things according to their manner and extent. The usefulness of equipment is nevertheless only the essential consequence of reliability. The former vibrates in the latter and would be nothing without it. A single piece of equipment is worn out and used up; but at the same time the use itself also falls into disuse, wears away, and becomes usual. Thus equipmentality wastes away, sinks into mere stuff. In such wasting, reliability vanishes. This dwindling, however, to which use-things owe their boringly obtrusive usualness, is only one more testimony to the original essence of equipmental being. The worn-out usualness of the equipment then obtrudes itself as the sole mode of being, apparently peculiar to it exclusively. Only blank usefulness now remains visible. It awakens the impression that the origin of equipment lies in a mere fabricating that impresses a form upon some matter. Nevertheless, in its genuinely equipmental being, equipment stems from a more distant source. Matter and form and their distinction have a deeper origin.

The repose of equipment resting within itself consists in its reliability. Only in this reliability do we discern what equipment in truth is. But we still know nothing of what we first sought: the thing's thingly character. And we know nothing at all of what we really and solely seek: the workly character of the work in the sense of the work of art.

Or have we already learned something unwittingly—in passing, so to speak—about the work-being of the work?

The equipmental quality of equipment was discovered. But how? Not by a description and explanation of a pair of shoes actually present; not by a report about the process of making shoes; and also not by the observation of the actual use of shoes occurring here and there; but only by bringing ourselves before Van Gogh's painting. This painting spoke. In the nearness of the work we were suddenly somewhere else than we usually tend to be.

The artwork lets us know what shoes are in truth. It would be the worst self-deception to think that our description, as a subjective action, had first depicted everything thus and then projected it into the painting. If anything is questionable here, it is rather that we experienced too little in the nearness of the work and that we expressed the experience too crudely and too literally. But above all, the work did not, as it might seem at first, serve

merely for a better visualizing of what a piece of equipment is. Rather, the equipmentality of equipment first expressly comes to the fore through the work and only in the work.

What happens here? What is at work in the work? Van Gogh's painting is the disclosure of what the equipment, the pair of peasant shoes, *is* in truth. This being emerges into the unconcealment of its Being. The Greeks called the unconcealment of beings *alétheia.* We say "truth" and think little enough in using this word. If there occurs in the work a disclosure of a particular being, disclosing what and how it is, then there is here an occurring, a happening of truth at work.

In the work of art the truth of beings has set itself to work. "To set" means here "to bring to stand." Some particular being, a pair of peasant shoes, comes in the work to stand in the light of its Being. The Being of beings comes into the steadiness of its shining.

The essence of art would then be this: the truth of beings setting itself to work. But until now art presumably has had to do with the beautiful and beauty, and not with truth. The arts that produce such works are called the fine arts, in contrast with the applied or industrial arts that manufacture equipment. In fine art the art itself is not beautiful, but is called so because it produces the beautiful. Truth, in contrast, belongs to logic. Beauty, however, is reserved for aesthetics.

But perhaps the proposition that art is truth setting itself to work intends to revive the fortunately obsolete view that art is an imitation and depiction of something actual? The reproduction of something at hand requires, to be sure, agreement with the actual being, adaptation to it; the Middle Ages called it *adaequatio*; Aristotle already spoke of *homoiosis.* Agreement with what *is* has long been taken to be the essence of truth. But then, is it our opinion that this painting by Van Gogh depicts a pair of peasant shoes somewhere at hand, and is a work of art because it does so successfully? Is it our opinion that the painting draws a likeness from something actual and transposes it into a product of artistic—production? By no means.

The work, therefore, is not the reproduction of some particular entity that happens to be at hand at any given time; it is, on the contrary, the reproduction of things' general essence. But then where and how is this general essence, so that artworks are able to agree with it? With what essence of what thing should a Greek temple agree? Who could maintain the impossible view that the Idea of Temple is represented in the building? And yet, truth is set to work in such a work, if it is a work. Or let us think of Hölderlin's hymn, "The Rhine." What is pregiven to the poet, and how is it

given, so that it can then be regiven in the poem? And if in the case of this hymn and similar poems the idea of a copy-relation between something already actual and the artwork clearly fails, the view that the work is a copy is confirmed in the best possible way by a work of the kind presented in C. F. Meyer's poem "Roman Fountain."

Roman Fountain

The jet ascends and falling fills
The marble basin circling round;
This, veiling itself over, spills
Into a second basin's ground.
The second in such plenty lives,
Its bubbling flood a third invests,
And each at once receives and gives
And streams and rests.

This is neither a poetic painting of a fountain actually present nor a reproduction of the general essence of a Roman fountain. Yet truth is set into the work.

The Work and Truth

We now ask the question of truth with a view to the work. But in order to become more familiar with what the question involves, it is necessary to make visible once more the happening of truth in the work. For this attempt let us deliberately select a work that cannot be ranked as representational art.

A building, a Greek temple, portrays nothing. It simply stands there in the middle of the rock-cleft valley. The building encloses the figure of the god, and in this concealment lets it stand out into the holy precinct through the open portico. By means of the temple, the god is present in the temple. This presence of the god is in itself the extension and delimitation of the precinct as a holy precinct. The temple and its precinct, however, do not fade away into the indefinite. It is the temple-work that first fits together and at the same time gathers around itself the unity of those paths and relations in which birth and death, disaster and blessing, victory and disgrace, endurance and decline acquire the shape of destiny for human being. The all-governing expanse of this open relational context is the world of this historical people. Only from and in this expanse does the nation first return to itself for the fulfillment of its vocation.

Standing there, the building rests on the rocky ground. This resting of the work draws up out of the rock the obscurity of that rock's bulky yet spontaneous support. Standing there, the building holds its ground against the storm raging above it and so first makes the storm itself manifest in its violence. The luster and gleam of the stone, though itself apparently glowing only by the grace of the sun, first brings to radiance the light of the day, the breadth of the sky, the darkness of the night. The temple's firm towering makes visible the invisible space of air. The steadfastness of the work contrasts with the surge of the surf, and its own repose brings out the raging of the sea. Tree and grass, eagle and bull, snake and cricket first enter into their distinctive shapes and thus come to appear as what they are. The Greeks early called this emerging and rising in itself and in all things *physis*. It illuminates also that on which and in which man bases his dwelling. We call this ground the *earth*. What this word says is not to be associated with the idea of a mass of matter deposited somewhere, or with the merely astronomical idea of a planet. Earth is that whence the arising brings back and shelters everything that arises as such. In the things that arise, earth occurs essentially as the sheltering agent.

The temple-work, standing there, opens up a world and at the same time sets this world back again on earth, which itself only thus emerges as native ground. But men and animals, plants and things, are never present and familiar as unchangeable objects, only to represent incidentally also a fitting environment for the temple, which one fine day is added to what is already there. We shall get closer to what *is*, rather, if we think of all this in reverse order, assuming of course that we have, to begin with, an eye for how differently everything then faces us. Mere reversing, done for its own sake, reveals nothing.

The temple, in its standing there, first gives to things their look and to men their outlook on themselves. This view remains open as long as the work is a work, as long as the god has not fled from it. It is the same with the sculpture of the god, a votive offering of the victor in the athletic games. It is not a portrait whose purpose is to make it easier to realize how the god looks; rather, it is a work that lets the god himself be present and thus *is* the god himself. The same holds for the linguistic work. In the tragedy nothing is staged or displayed theatrically, but the battle of the new gods against the old is being fought. The linguistic work, originating in the speech of the people, does not refer to this battle; it transforms the people's saying so that now every living word fights the battle and puts up for decision what is holy and what unholy, what great and what small, what brave and what

cowardly, what lofty and what flighty, what master and what slave (see Heraclitus, Fragment 53).

In what, then, does the work-being of the work consist? Keeping steadily in view the points just crudely enough indicated, two essential features of the work may for the moment be brought out more distinctly. We set out here, from the long familiar foreground of the work's being, the thingly character which gives support to our customary attitude toward the work.

When a work is brought into a collection or placed in an exhibition we say also that it is "set up." But this setting up differs essentially from setting up in the sense of erecting a building, raising a statue, presenting a tragedy at a holy festival. The latter setting up is erecting in the sense of dedication and praise. Here "setting up" no longer means a bare placing. To dedicate means to consecrate, in the sense that in setting up the work the holy is opened up as holy and the god is invoked into the openness of his presence. Praise belongs to dedication as doing honor to the dignity and splendor of the god. Dignity and splendor are not properties beside and behind which the god, too, stands as something distinct, but it is rather in the dignity, in the splendor that the god comes to presence. In the reflected glory of this splendor there glows, i.e., there clarifies, what we called the world. To erect means: to open the right in the sense of a guiding measure, a form in which what is essential gives guidance. But why is the setting up of a work an erecting that consecrates and praises? Because the work, in its work-being, demands it. How is it that the work comes to demand such a setting up? Because it itself, in its own work-being, is something that sets up. What does the work, as work, set up? Towering up within itself, the work opens up a *world* and keeps it abidingly in force.

To be a work means to set up a world. But what is it to be a world? The answer was hinted at when we referred to the temple. On the path we must follow here, the essence of world can only be indicated. What is more, this indication limits itself to warding off anything that might at first distort our view of the essential.

The world is not the mere collection of the countable or uncountable, familiar and unfamiliar things that are at hand. But neither is it a merely imagined framework added by our representation to the sum of such given things. The *world worlds*, and is more fully in being than the tangible and perceptible realm in which we believe ourselves to be at home. World is never an object that stands before us and can be seen. World is the ever-nonobjective to which we are subject as long as the paths of birth and

death, blessing and curse keep us transported into Being. Wherever those utterly essential decisions of our history are made, are taken up and abandoned by us, go unrecognized and are rediscovered by new inquiry, there the world worlds. A stone is worldless. Plant and animal likewise have no world; but they belong to the covert throng of a surrounding into which they are linked. The peasant woman, on the other hand, has a world because she dwells in the overtness of beings. Her equipment, in its reliability, gives to this world a necessity and nearness of its own. By the opening up of a world, all things gain their lingering and hastening, their remoteness and nearness, their scope and limits. In a world's worlding is gathered that spaciousness out of which the protective grace of the gods is granted or withheld. Even this doom, of the god remaining absent, is a way in which world worlds.

A work, by being a work, makes space for that spaciousness. "To make space for" means here especially to liberate the free space of the open region and to establish it in its structure. This installing occurs through the erecting mentioned earlier. The work as work sets up a world. The work holds open the open region of the world. But the setting up of a world is only the first essential feature in the work-being of a work to be referred to here. Starting again from the foreground of the work, we shall attempt to make clear in the same way the second essential feature that belongs with the first.

When a work is created, brought forth out of this or that work material— stone, wood, metal, color, language, tone—we say also that it is made, set forth out of it. But just as the work requires a setting up in the sense of a consecrating-praising erection, because the work's work-being consists in the setting up of a world, so a setting forth is needed because the work-being of the work itself has the character of setting forth. The work as work, in its essence, is a setting forth. But what does the work set forth? We come to know about this only when we explore what comes to the fore and is customarily spoken of as the production [*Herstellung*, literally, "setting forth"] of works.

To work-being there belongs the setting up of a world. Thinking of it within this perspective, what is the essence of that in the work which is usually called the work material? Because it is determined by usefulness and serviceability, equipment takes into its service that of which it consists: the matter. In fabricating equipment—e.g., an ax—stone is used, and used up. It disappears into usefulness. The material is all the better and more suitable the less it resists vanishing in the equipmental being of the equipment. By

contrast the temple-work, in setting up a world, does not cause the material to disappear, but rather causes it to come forth for the very first time and to come into the open region of the work's world. The rock comes to bear and rest and so first becomes rock; metals come to glitter and shimmer, colors to glow, tones to sing, the word to say. All this comes forth as the work sets itself back into the massiveness and heaviness of stone, into the firmness and pliancy of wood, into the hardness and luster of metal, into the brightening and darkening of color, into the clang of tone, and into the naming power of the word.

That into which the work sets itself back and which it causes to come forth in this setting back of itself we called the earth. Earth is that which comes forth and shelters. Earth, irreducibly spontaneous, is effortless and untiring. Upon the earth and in it, historical man grounds his dwelling in the world. In setting up a world, the work sets forth the earth. This setting forth must be thought here in the strict sense of the word. The work moves the earth itself into the open region of a world and keeps it there. *The work lets the earth be an earth.*

But why must this setting forth of the earth happen in such a way that the work sets itself back into it? What is the earth that it attains to the unconcealed in just such a manner? A stone presses downward and manifests its heaviness. But while this heaviness exerts an opposing pressure upon us it denies us any penetration into it. If we attempt such a penetration by breaking open the rock, it still does not display in its fragments anything inward that has been opened up. The stone has instantly withdrawn again into the same dull pressure and bulk of its fragments. If we try to lay hold of the stone's heaviness in another way, by placing the stone on a balance, we merely bring the heaviness into the form of a calculated weight. This perhaps very precise determination of the stone remains a number, but the weight's burden has escaped us. Color shines and wants only to shine. When we analyze it in rational terms by measuring its wavelengths, it is gone. It shows itself only when it remains undisclosed and unexplained. Earth thus shatters every attempt to penetrate it. It causes every merely calculating importunity upon it to turn into a destruction. This destruction may herald itself under the appearance of mastery and of progress in the form of the technical-scientific objectivation of nature, but this mastery nevertheless remains an impotence of will. The earth appears openly cleared as itself only when it is perceived and preserved as that which is essentially undisclosable, that which shrinks from every disclosure and constantly keeps itself closed up. All things of earth, and the earth itself

as a whole, flow together into a reciprocal accord. But this confluence is not a blurring of their outlines. Here there flows the bordering stream, restful within itself, which delimits everything present in its presenting. Thus in each of the selfsecluding things there is the same not-knowing-of-one-another. The earth is essentially self-secluding. To set forth the earth means to bring it into the open region as the self-secluding.

This setting forth of the earth is achieved by the work as it sets itself back into the earth. The self-seclusion of earth, however, is not a uniform, inflexible staying under cover, but unfolds itself in an inexhaustible variety of simple modes and shapes. To be sure, the sculptor uses stone just as the mason uses it, in his own way. But he does not use it up. That happens in a certain way only where the work miscarries. To be sure, the painter also uses pigment, but in such a way that color is not used up but rather only now comes to shine forth. To be sure, the poet also uses the word—not, however, like ordinary speakers and writers who have to use them up, but rather in such a way that the word only now becomes and remains truly a word.

Nowhere in the work is there any trace of a work material. It even remains doubtful whether, in the essential definition of equipment, what the equipment consists of is properly described in its equip-mental essence as matter.

The setting up of a world and the setting forth of earth are two essential features in the work-being of the work. They belong together, however, in the unity of work-being. This is the unity we seek when we ponder the self-subsistence of the work and try to tell of this closed, unitary repose of self-support.

However, in the essential features just mentioned, if our account has any validity at all, we have indicated in the work rather a happening and in no sense a repose. For what is rest if not the opposite of motion? It is at any rate not an opposite that excludes motion from itself, but rather includes it. Only what is in motion can rest. The mode of rest varies with the kind of motion. In motion as the mere displacement of a physical body, rest is, to be sure, only the limiting case of motion. Where rest includes motion, there can exist a repose which is an inner concentration of motion, hence supreme agitation, assuming that the mode of motion requires such a rest. Now, the repose of the work that rests in itself is of this·sort. We shall therefore come nearer to this repose if we can succeed in grasping the state of movement of the happening in work-being in its unity. We ask: What relation

do the setting up of a world and the setting forth of the earth exhibit in the work itself?

The world is the self-opening openness of the broad paths of the simple and essential decisions in the destiny of a historical people. The earth is the spontaneous forthcoming of that which is continually self-secluding and to that extent sheltering and concealing. World and earth are essentially different from one another and yet are never separated. The world grounds itself on the earth, and earth juts through world. Yet the relation between world and earth does not wither away into the empty unity of opposites unconcerned with one another. The world, in resting upon the earth, strives to surmount it. As self-opening it cannot endure anything closed. The earth, however, as sheltering and concealing, tends always to draw the world into itself and keep it there.

The opposition of world and earth is strife. But we would surely all too easily falsify its essence if we were to confound strife with discord and dispute, and thus see it only as disorder and destruction. In essential strife, rather, the opponents raise each other into the self-assertion of their essential natures. Self-assertion of essence, however, is never a rigid insistence upon some contingent state, but surrender to the concealed originality of the provenance of one's own Being. In strife, each opponent carries the other beyond itself. Thus the strife becomes ever more intense as striving, and more properly what it is. The more strife, for its part, outdoes itself, the more inflexibly do the opponents let themselves go into the intimacy of simple belonging to one another. The earth cannot dispense with the open region of the world if it itself is to appear as earth in the liberated surge of its self-seclusion. The world in turn cannot soar out of the earth's sight if, as the governing breadth and path of all essential destiny, it is to ground itself on something decisive.

In setting up a world and setting forth the earth, the work is an instigating of this strife. This does not happen so that the work should at the same time settle and put an end to strife by an insipid agreement, but so that the strife may remain a strife. Setting up a world and setting forth the earth, the work accomplishes this strife. The work-being of the work consists in the instigation of strife between world and earth. It is because the strife arrives at its high point in the simplicity of intimacy that the unity of the work comes about in the instigation of strife. The latter is the continually self-overreaching gathering of the work's agitation. The repose of the work that rests in itself thus has its essence in the intimacy of strife.

From this repose of the work we can now first see what is at work in the work. Until now it was a merely provisional assertion that in an artwork truth is set to work. In what way does truth happen in the work-being of the work, which now means to say, how does truth happen in the instigation of strife between world and earth? What is truth?

How slight and stunted our knowledge of the essence of truth is, is shown by the laxity we permit ourselves in using this basic word. By truth is usually meant this or that particular truth. That means: something true. A cognition articulated in a proposition can be of this sort. However, we call not only a proposition true, but also a thing, true gold in contrast with sham gold. True here means genuine, actual gold. What does the expression "actual" mean here? To us it is what is in truth. The true is what corresponds to the actual, and the actual is what is in truth. The circle has closed again.

What does "in truth" mean? Truth is the essence of the true. What do we have in mind when speaking of essence? Usually it is thought to be those features held in common by everything that is true. The essence is discovered in the generic and universal concept, which represents the one feature that holds indifferently for many things. This indifferent essence (essentiality in the sense of *essentia*) *is*, however, only the unessential essence. What does the essential essence of something consist in? Presumably it lies in what the entity *is* in truth. The true essence of a thing is determined by way of its true Being, by way of the truth of the given being. But we are now seeking not the truth of essence but the essence of truth. There thus appears a curious tangle. Is it only a curiosity or even merely the empty sophistry of a conceptual game, or is it—an abyss?

Truth means the essence of the true. We think this essence in recollecting the Greek word *alétheia*, the unconcealment of beings. Yet is this enough to define the essence of truth? Are we not passing off a mere change of word usage—unconcealment instead of truth—as a characterization of the matter at issue? Certainly we do not get beyond an interchange of names as long as we do not come to know what must have happened in order to be compelled to say the *essence* of truth in the word "unconcealment."

Does this require a revival of Greek philosophy? Not at all. A revival, even if such an impossibility were possible, would be of no help to us; for the hidden history of Greek philosophy consists from its beginning in this, that it does not remain in conformity with the essence of truth that flashes out in the word *alétheia*, and has to misdirect its knowing and its speaking about the essence of truth more and more into the discussion of a derivative

essence of truth. The essence of truth as *alétheia* was not thought out in the thinking of the Greeks, and certainly not in the philosophy that followed after. Unconcealment is, for thought, the most concealed thing in Greek existence, although from early times it determines the presencing of every-thing present.

Yet why should we not be satisfied with the essence of truth that has by now been familiar to us for centuries? Truth means today and has long meant the conformity of knowledge with the matter. However, the matter must show itself to be such if knowledge and the proposition that forms and expresses knowledge are to be able to conform to it; otherwise the matter cannot become binding on the proposition. How can the matter show itself if it cannot itself stand forth out of concealment, if it does not itself stand in the unconcealed? A proposition is true by conforming to the unconcealed, to what is true. Propositional truth is always, and always exclusively, this correctness. The critical concepts of truth which, since Descartes, start out from truth as certainty, are merely variations of the definition of truth as correctness. The essence of truth which is familiar to us—correctness in representation—stands and falls with truth as uncon-cealment of beings.

If here and elsewhere we conceive of truth as unconcealment, we are not merely taking refuge in a more literal translation of a Greek word. We are reminding ourselves of what, unexperienced and unthought, underlies our familiar and therefore outworn essence of truth in the sense of correct-ness. We do, of course, occasionally take the trouble to concede that natu-rally, in order to understand and verify the correctness (truth) of a proposi-tion, one really should go back to something that is already evident, and that this presupposition is indeed unavoidable. As long as we talk and be-lieve in this way, we always understand truth merely as correctness, which of course still requires a further presupposition, that we ourselves just hap-pen to make, heaven knows how or why.

But it is not we who presuppose the unconcealment of beings; rather, the unconcealment of beings (Being) puts us into such a condition of being that in our representation we always remain installed within and in atten-dance upon unconcealment. Not only must that in *conformity* with which a cognition orders itself be already in some way unconcealed. The entire *realm* in which this "conforming to something" goes on must already occur as a whole in the unconcealed; and this holds equally of that *for* which the conformity of a proposition to a matter becomes manifest. With all our cor-rect representations we would get nowhere, we could not even presuppose

that there already is manifest something to which we can conform our-
selves, unless the unconcealment of beings had already exposed us to,
placed us in that cleared realm in which every being stands for us and from
which it withdraws.

But how does this take place? How does truth happen as this uncon-
cealment? First, however, we must say more clearly what this unconceal-
ment itself is.

Things are, and human beings, gifts, and sacrifices are, animals and
plants are, equipment and works are. The particular being stands in Being.
Through Being there passes a veiled fatality that is ordained between the
godly and the countergodly. There is much in being that man cannot mas-
ter. There is but little that comes to be known. What is known remains inex-
act, what is mastered insecure. Beings are never of our making, or even
merely our representations, as it might all too easily seem. When we con-
template this whole as one, then we apprehend, so it appears, all that is—
though we grasp it crudely enough.

And yet—beyond beings, not away from them but before them, there is
still something else that happens. In the midst of beings as a whole an
open place occurs. There is a clearing. Thought of in reference to beings,
this clearing is more in being than are beings. This open center is therefore
not surrounded by beings; rather, the clearing center itself encircles all that
is, as does the nothing, which we scarcely know.

Beings can be as beings only if they stand within and stand out within
what is cleared in this clearing. Only this clearing grants and guarantees to us
humans a passage to those beings that we ourselves are not, and access to
the being that we ourselves are. Thanks to this clearing, beings are uncon-
cealed in certain changing degrees. And yet a being can be *concealed*, as
well, only within the sphere of what is cleared. Each being we encounter and
which encounters us keeps to this curious opposition of presencing, in that it
always withholds itself at the same time in a concealment. The clearing in
which beings stand is in itself at the same time concealment. Concealment,
however, prevails in the midst of beings in a twofold way.

Beings refuse themselves to us down to that one and seemingly least
feature which we touch upon most readily when we can say no more of
beings than that they are. Concealment as refusal is not simply and only
the limit of knowledge in any given circumstance, but the beginning of the
clearing of what is cleared. But concealment, though of another sort, to be
sure, at the same time also occurs within what is cleared. One being places

itself in front of another being, the one helps to hide the other, the former obscures the latter, a few obstruct many, one denies all. Here concealment is not simple refusal. Rather, a being appears, but presents itself as other than it is.

This concealment is dissembling. If one being did not simulate another, we could not make mistakes or act mistakenly in regard to beings; we could not go astray and transgress, and especially could never overreach ourselves. That a being should be able to deceive as semblance is the condition for our being able to be deceived, not conversely.

Concealment can be a refusal or merely a dissembling. We are never fully certain whether it is the one or the other. Concealment conceals and dissembles itself. This means that the open place in the midst of beings, the clearing, is never a rigid stage with a permanently raised curtain on which the play of beings runs its course. Rather, the clearing happens only as this double concealment. The unconcealment of beings—this is never a merely existent state, but a happening. Unconcealment (truth) is neither an attribute of matters in the sense of beings, nor one of propositions.

We believe we are at home in the immediate circle of beings. Beings are familiar, reliable, ordinary. Nevertheless, the clearing is pervaded by a constant concealment in the double form of refusal and dissembling. At bottom, the ordinary is not ordinary; it is extraordinary. The essence of truth, that is, of unconcealment, is dominated throughout by a denial. Yet this denial is not a defect or a fault, as though truth were an unalloyed unconcealment that has rid itself of everything concealed. If truth could accomplish this, it would no longer be itself. *This denial, in the form of a double concealment, belongs to the essence of truth as unconcealment.* Truth, in its essence, is un-truth. We put the matter this way in order to serve notice, with a possibly surprising trenchancy, that denial in the manner of concealment belongs to unconcealment as clearing. The proposition "the essence of truth is un-truth" is not, however, intended to state that truth is at bottom falsehood. Nor does it mean that truth is never itself but, viewed dialectically, is also its opposite.

Truth occurs precisely as itself in that the concealing denial, as refusal, provides the steady provenance of all clearing, and yet, as dissembling, metes out to all clearing the indefeasible severity of error. Concealing denial is intended to denote that opposition in the essence of truth which subsists between clearing and concealing. It is the opposition of the original strife. The essence of truth is, in itself, the primal strife in which that open center

is won within which beings stand and from which they set themselves back into themselves.

This open region happens in the midst of beings. It exhibits an essential feature that we have already mentioned. To the open region there belongs a world and the earth. But the world is not simply the open region that corresponds to clearing, and the earth is not simply the closed region that corresponds to concealment. Rather, the world is the clearing of the paths of the essential guiding directions with which all decision complies. Every decision, however, bases itself on something not mastered, something concealed, confusing; else it would never be a decision. The earth is not simply the closed region but rather that which rises up as self-closing. World and earth are always intrinsically and essentially in conflict, belligerent by nature. Only as such do they enter into the strife of clearing and concealing.

Earth juts through the world and world grounds itself on the earth only so far as truth happens as the primal strife between clearing and concealing. But how does this happen? We answer: it happens in a few essential ways. One of these ways in which truth happens is the work-being of the work. Setting up a world and setting forth the earth, the work is the instigation of the strife in which the unconcealment of beings as a whole, or truth, is won.

Truth happens in the temple's standing where it is. This does not mean that something is correctly represented and rendered here, but that beings as a whole are brought into unconcealment and held therein. To hold [halten] originally means to take into protective heed [hüten]. Truth happens in Van Gogh's painting. This does not mean that something at hand is correctly portrayed, but rather that in the revelation of the equipmental being of the shoes beings as a whole—world and earth in their counterplay—attain to unconcealment.

Thus in the work it is truth, not merely something true, that is at work. The picture that shows the peasant shoes, the poem that says the Roman fountain, do not simply make manifest what these isolated beings as such are—if indeed they manifest anything at all; rather, they make unconcealment as such happen in regard to beings as a whole. The more simply and essentially the shoes are engrossed in their essence, the more directly and engagingly do all beings attain a greater degree of being along with them. That is how self-concealing Being is cleared. Light of this kind joins its shining to and into the work. This shining, joined in the work, is the beautiful. *Beauty is one way in which truth essentially occurs as unconcealment.*

Truth and Art

A genuine beginning, as a leap, is always a head start, in which everything to come is already leaped over, even if as something still veiled. The beginning already contains the end latent within itself. A genuine beginning, however, has nothing of the neophyte character of the primitive. The primitive, because it lacks the bestowing, grounding leap and head start, is always futureless. It is not capable of releasing anything more from itself because it contains nothing more than that in which it is caught.

A beginning, on the contrary, always contains the undisclosed abundance of the awesome, which means that it also contains strife with the familiar and ordinary. Art as poetry is founding, in the third sense of instigation of the strife of truth: founding as beginning. Always when beings as a whole, as beings themselves, demand a grounding in openness, art attains to its historical essence as foundation. This foundation happened in the West for the first time in Greece. What was in the future to be called Being was set into work, setting the standard. The realm of beings thus opened up was then transformed into a being in the sense of God's creation. This happened in the Middle Ages. This kind of being was again transformed at the beginning and during the course of the modern age. Beings became objects that could be controlled and penetrated by calculation. At each time a new and essential world irrupted. At each time the openness of beings had to be established in beings themselves by the fixing in place of truth in figure. At each time there happened unconcealment of beings. Unconcealment sets itself into work, a setting which is accomplished by art.

Whenever art happens—that is, whenever there is a beginning—a thrust enters history; history either begins or starts over again. History here means not a sequence in time of events, of whatever sort, however important. History is the transporting of a people into its appointed task as entry into that people's endowment.

Art is the setting-into-work of truth. In this proposition an essential ambiguity lies hidden, in which truth is at once the subject and the object of the setting. But subject and object are unsuitable names here. They keep us from thinking precisely this ambiguous essence, a task that no longer belongs to the present consideration. Art is historical, and as historical it is the creative preserving of truth in the work. Art happens as poetry. Poetry is founding in the triple sense of bestowing, grounding, and beginning. Art, as founding, is essentially historical. This means not simply that art has a history in the extrinsic sense that in the course of time it, too, appears along

with many other things, and in the process changes and passes away and offers changing aspects for historiology. Art is history in the essential sense that it grounds history.

Art lets truth originate. Art, founding preserving, is the spring that leaps to the truth of beings in the work. To originate something by a leap, to bring something into being from out of its essential source in a founding leap— this is what the word "origin" [*Ursprung*, literally, primal leap] means.

The origin of the work of art—that is, the origin of both the creators and the preservers, which is to say of a people's historical existence—is art. This is so because art is in its essence an origin: a distinctive way in which truth comes into being, that is, becomes historical.

We inquire into the essence of art. Why do we inquire in this way? We inquire in this way in order to be able to ask more properly whether art is or is not an origin in our historical existence, whether and under what conditions it can and must be an origin.

Such reflection cannot force art and its coming-to-be. But this reflective knowledge is the preliminary and therefore indispensable preparation for the becoming of art. Only such knowledge prepares its space for art, their way for the creators, their location for the preservers.

In such knowledge, which can only grow slowly, the question is decided whether art can be an origin and then must be a forward spring, or whether it is to remain a mere appendix and then can only be carried along as a routine cultural phenomenon.

Are we in our existence historically at the origin? Do we know, which means do we give heed to, the essence of the origin? Or, in our relation to art, do we still merely make appeal to a cultivated acquaintance with the past?

For this either-or and its decision there is an infallible sign. Hölderlin, the poet—whose work still confronts the Germans as a test to be stood— named it in saying:

> *Schwer verlässt*
> *was nahe dem Ursprung wohnet, den Ort.*

> Reluctantly
> that which dwells near its origin abandons the site.

—"The Journey," verses 18–19

—Translated by Albert Hofstadter

8

The Mirror Stage as Formative of the Function of the *I*
Of the Gaze as *Objet Petit a*

Jacques Lacan

Jacques Lacan (1901–1981) was one of the leading interpreters of Freudian psychoanalysis in the twentieth century. His seminars and papers have been highly influential upon the development of theories of subjectivity and visual representation. Lacan described his psychoanalytic project as "a return to Freud." Ferdinand de Saussure, whose influence is felt in Lacan's famous dictum, "the unconscious is structured like a language," closely informed this "return." The phrase is intended to stress the idea that the psyche, with its conscious and unconscious minds, is formed together with language. The psyche's dependence upon language underpins Lacan's approach to the image and its role in constructing the self.

In his paper "The Mirror Stage as Formative of the Function of the *I*" (1949),[1] Lacan argues that the subject's contradictory and phantasmatic position within language (the symbolic order) is anticipated in the biological urge of the human species to identify mimetically with an ideal "imago" reflected, for instance, in a mirror image. Such identification may aid motor development, but simultaneously it constructs the fantasy of an autonomous, independent being. Given this fantasy, the subject is lodged within a dialectic composed of a yearning for the ideal image contrasted with a sense of "lack" that is born of an inevitable failure to obtain and become this ideal. (This dialectic takes its cue from Freud's conception of the Oedipal subject whose desire for the Father and the place he occupies within the

family is beset by an impending threat of castration.) Lacan proposes that Hieronymus Bosch's paintings of hell as well as certain stereotypical dreams of fortresses and enclosures reveal the dialectic of unity and fragmentation which besets the ego as this is constituted through the misrecognition (*méconnaissance*) engendered, initially, by the mirror stage and, subsequently, language. He suggests that the disenchantment of existential philosophy with "the self-sufficiency of consciousness" is overdetermined by a similar dialectic, and that hysteria may be understood as an outcome of the overbearing strain of this dialectic in its hold upon the subject.

As a repost to the idealism inherent within the position of the subject Lacan's story in "Of the Gaze as *Objet Petit a*" (1964)[2] concerning the sardine can—"You see that can? . . . well, it doesn't see you!"—is to negate any residual notion of individual controlling agency with respect to language and meaning (upon which representing, in this case, a sardine can depends), and to assign it to the realm of fantasy. Arguing against Jean-Paul Sartre's idea of sight as that which the (voyeuristic) subject does not possess but is afraid of losing,[3] and inspired by Maurice Merleau-Ponty's phenomenology, Lacan discusses the concepts of vision and visuality in terms of the relationship between the unconscious and signification. To further this discussion, Lacan cites Hans Holbein's *The Ambassadors* (1533), which, in its use of perspective, constructs a subject-viewer situated outside the painting in command of the visual field ("the sovereign subject"). The anamorphic object in the form of the (distorted) skull in the foreground of the painting, however, reveals the signifying structure or symbolic order (space constructed through the use of perspective) in which the subject participates. In other words, the subject sees the fantasy of sovereignty constructed by the symbolic order that is also to see his own—blind—participation in this construction. For Lacan this experience is identified with the unconscious and desire, itself, which he names as the *objet petit a*. Since the anamorphic object is "a stain, a spot," it lies in the realm of the visual field and yet it is also indefinable, a blind spot in vision. Thus, the anamorphic object is phallic, but also like one of Dali's soft watches. As such, sight is no longer conditioned by "the gaze" as a function of the subject in which the I/eye seeks, but also fears, to behold the—unobtainable—object of desire. Instead, the gaze—both in its "triumph" and in its "laying down"—is visionary: "pulsatile, dazzling, and spread out." Finally, as a way of underlining the contradictory nature of visuality in relation to the *objet petit a*, Lacan narrates the classical tale of Zeuxis and Parrhasius, the purpose of

which is to highlight the idea that dissimulation is the nature of truth, and vice versa.

THE MIRROR STAGE AS FORMATIVE OF THE FUNCTION OF THE *I*
█████

The conception of the mirror stage that I introduced at our last congress, thirteen years ago, has since become more or less established in the practice of the French group. However, I think it worthwhile to bring it again to your attention, especially today, for the light it sheds—the formation of the I as we experience it in psychoanalysis. It is an experience that leads us to oppose any philosophy directly issuing from the *Cogito*.

Some of you may recall that this conception originated in a feature of human behavior illuminated by a fact of comparative psychology. The child, at an age when he is for a time, however short, outdone by the chimpanzee in instrumental intelligence, can nevertheless already recognize as such his own image in a mirror. This recognition is indicated in the illuminative mimicry of the *Aha-Erlebnis*, which Köhler sees the expression of situational apperception, an essential stage of the act of intelligence.

This act, far from exhausting itself, as in the case of the monkey, once the image has been mastered and found empty, immediately rebounds in the case of the child in a series of gestures in which he experiences in play the relation between the movements assumed in the image and the reflected environment, and between this virtual complex and the reality it reduplicates – the child's own body, and the persons and things around him.

This event can take place, as we have known since Baldwin, from the age of six months, and its repetition has often made me reflect upon the startling spectacle of the infant in front of the mirror. Unable as yet to walk, or even to stand up, and held tightly as he is by some support, human or artificial (what, in France, we call a "*trotte-bébé*"), he nevertheless overcomes, in a flutter of jubilant activity, the obstructions of his support and, fixing his attitude in a slightly leaning-forward position, in order to hold it in his gaze, brings back an instantaneous aspect of the image.

For me, this activity retains the meaning I have given it up to the age of eighteen months. This meaning discloses a libidinal dynamism, which has hitherto remained problematic, as well as an ontological structure of the human world that accords with my reflections on paranoiac knowledge.

We have only to understand the mirror stage *as an identification*, in the full sense that analysis gives to the term: namely, the transformation that takes place in the subject when he assumes an image—whose predestination to this phase-effect is sufficiently indicated by the use, in analytic theory, of the ancient term *imago*.

This jubilant assumption of his specular image by the child at the *infans* stage, still sunk in his motor incapacity and nursling dependence, would seem to exhibit in an exemplary situation the symbolic matrix in which the I is precipitated in a primordial form, before it is objectified in the dialectic of identification with the other, and before language restores to it, in the uni-versal, its function as subject.

This form would have to be called the Ideal-I,[4] if we wished to incorporate it into our usual register, in the sense that it will also be the source of secondary identifications, under which term I would place the functions of libidinal normalization. But the important point is that this form situates the agency of the ego, before its social determination, in a fictional direction, which will always remain irreducible for the individual alone, or rather, which will only rejoin the coming-intobeing (*le devenir*) of the subject asymptotically, whatever the success of the dialectical syntheses by which he must resolve as I his discordance with his own reality.

The fact is that the total form of the body by which the subject anticipates in a mirage the maturation of his power is given to him only as *Gestalt*, that is to say, in an exteriority in which this form is certainly more constituent than constituted, but in which it appears to him above all in a contrasting size (*un relief de stature*) that fixes it and in a symmetry that inverts it, in contrast with the turbulent movements that the subject feels are animating him. Thus, this *Gestalt*—whose pregnancy should be regarded as bound up with the species, though its motor style remains scarcely recognizable—by these two aspects of its appearance, symbolizes the mental permanence of the I, at the same time as it prefigures its alienating destination; it is still pregnant with *the* correspondences that unite the I with the statue in which man projects himself, with the phantoms that dominate him, or with the automaton in which, in an ambiguous relation, the world of his own making tends to find completion.

Indeed, for the *imagos*—whose veiled faces it is our privilege to see in outline in our daily experience and in the penumbra of symbolic efficacity[5]—the mirror-image would seem to be the threshold of the visible world, if we go by the mirror disposition that the *imago of one's own body* presents in hallucinations or dreams, whether it concerns its individual features, or

even its infirmities, or its object-projections; or if we observe the role of the mirror apparatus in the appearances of the *double*, in which psychical realities, however heterogeneous, are manifested.

That a *Gestalt* should be capable of formative effects in the organism is attested by a piece of biological experimentation that is itself so alien to the idea of psychical causality that it cannot bring itself to formulate its results in these terms. It nevertheless recognizes that it is a necessary condition for the maturation of the gonad of the female pigeon that it should see another member of its species, of either sex; so sufficient in itself is this condition that the desired effect may be obtained merely by placing the individual within reach of the field of reflection of a mirror. Similarly, in the case of the migratory locust, the transition within a generation from the solitary to the gregarious form can be obtained by exposing the individual, at a certain stage, to the exclusively visual action of a similar image, provided it is animated by movements of a style sufficiently close to that characteristic of the species. Such facts are inscribed in an order of homeomorphic identification that would itself fall within the larger question of the meaning of beauty as both formative and erogenic.

But the facts of mimicry are no less instructive when conceived as cases of heteromorphic identification, in as much as they raise the problem of the signification of space for the living organism—psychological concepts hardly seem less appropriate for shedding light on these matters than ridiculous attempts to reduce them to the supposedly supreme law of adaptation. We have only to recall how Roger Caillois (who was then very young, and still fresh from his breach with the sociological school in which he was trained) illuminated the subject by using the term *"legendary psychasthenia"* to classify morphological mimicry as an obsession with space in its derealizing effect.

I have myself shown in the social dialectic that structures human knowledge as paranoiac[6] why human knowledge has greater autonomy than animal knowledge in relation to the field of force of desire, but also why human knowledge is determined in that "little reality" (*ce peu de réalité*), which the Surrealists, in their restless way, saw as its limitation. These reflections lead me to recognize in the spatial captation manifested in the mirror-stage, even before the social dialectic, the effect in man of an organic insufficiency in his natural reality—in so far as any meaning can be given to the word "nature."

I am led, therefore, to regard the function of the mirror-stage as a particular case of the function of the *imago*, which is to establish a relation

between the organism and its reality—or, as they say, between the *Innen-welt* and the *Umwelt*.

In man, however, this relation to nature is altered by a certain dehis-cence at the heart of the organism, a primordial Discord betrayed by the signs of uneasiness and motor uncoordination of the neonatal months. The objective notion of the anatomical incompleteness of the pyramidal system and likewise the presence of certain humoral residues of the maternal or-ganism confirm the view I have formulated as the fact of a real *specific prematurity of birth* in man.

It is worth noting, incidentally, that this is a fact recognized as such by embryologists, by the term *fetalization*, which determines the prevalence of the so-called superior apparatus of the neurax, and especially of the cor-tex, which psychosurgical operations lead us to regard as the intraorganic mirror.

This development is experienced as a temporal dialectic that deci-sively projects the formation of the individual into history. The *mirror stage* is a drama whose internal thrust is precipitated from insufficiency to anticipation—and which manufactures for the subject, caught up in the lure of spatial identification, the succession of fantasies that extends from a fragmented body-image to a form of its totality that I shall call orthopedic—and, lastly, to the assumption of the armor of an alienating identity, which will mark with its rigid structure the subject's entire mental development. Thus, to break out of the circle of the *Innenwelt* into the *Umwelt* generates the inexhaustible quadrature of the ego's verifications.

This fragmented body—which term I have also introduced into our sys-tem of theoretical references—usually manifests itself in dreams when the movement of the analysis encounters a certain level of aggressive disinte-gration in the individual. It then appears in the form of disjointed limbs, or of those organs represented in exoscopy, growing wings and taking up arms for intestinal persecutions—the very same that the visionary Hieronymus Bosch has fixed, for all time, in painting, in their ascent from the fifteenth century to the imaginary zenith of modern man. But this form is even tangi-bly revealed at the organic level, in the lines of "fragilization" that define the anatomy of fantasy, as exhibited in the schizoid and spasmodic symptoms of hysteria.

Correlatively, the formation of the I is symbolized in dreams by a for-tress, or a stadium—its inner arena and enclosure, surrounded by marshes and rubbish-tips, dividing it into two opposed fields of contest where the subject flounders in quest of the lofty, remote inner castle whose form

(sometimes juxtaposed in the same scenario) symbolizes the id in a quite startling way. Similarly, on the mental plane, we find realized the structures of fortified works, the metaphor of which arises spontaneously, as if issuing from the symptoms themselves, to designate the mechanisms of obsessional neurosis—inversion, isolation, reduplication, cancellation, and displacement.

But if we were to build on these subjective givens alone—however little we free them from the condition of experience that makes us see them as partaking of the nature of a linguistic technique—our theoretical attempts would remain exposed to the charge of projecting themselves into the unthinkable of an absolute subject. This is why I have sought in the present hypothesis, grounded in a conjunction of objective data, the guiding grid for a *method of symbolic reduction.*

It establishes in the *defenses of the ego* a genetic order, in accordance with the wish formulated by Miss Anna Freud, in the first part of her great work, and situates (as against a frequently expressed prejudice) hysterical repression and its returns at a more archaic stage than obsessional inversion and its isolating processes, and the latter in turn as preliminary to paranoiac alienation, which dates from the deflection of the specular I into the social I.

This moment in which the mirror-stage comes to an end inaugurates, by the identification with the *imago* of the counterpart and the drama of primordial jealousy (so well brought out by the school of Charlotte Bühler in the phenomenon of infantile *transitivism*), the dialectic that will henceforth link the I to socially elaborated situations.

It is this moment that decisively tips the whole of human knowledge into mediatization through the desire of the other, constitutes its objects in an abstract equivalence by the cooperation of others, and turns the I into that apparatus for which every instinctual thrust constitutes a danger, even though it should correspond to a natural maturation—the very normalization of this maturation being henceforth dependent, in man, on a cultural mediation as exemplified, in the case of the sexual object, by the Oedipus complex.

In the light of this conception, the term primary narcissism, by which analytic doctrine designates the libidinal investment characteristic of that moment, reveals in those who invented it the most profound awareness of semantic latencies. But it also throws light on the dynamic opposition between this libido and the sexual libido, which the first analysts tried to define when they invoked destructive and, indeed, death instincts, in order to

explain the evident connection between the narcissistic libido and the alienating function of the I, the aggressivity it releases in any relation to the other, even in a relation involving the most Samaritan of aid.

In fact, they were encountering that existential negativity whose reality is so vigorously proclaimed by the contemporary philosophy of being and nothingness.

But unfortunately that philosophy grasps negativity only within the limits of a self-sufficiency of consciousness, which, as one of its premises, links to the *méconnaissances* [misrecognitions] that constitute the ego, the illusion of autonomy to which it entrusts itself. This flight of fancy, for all that it draws to an unusual extent, on borrowings from psychoanalytic experience, culminates in the pretension of providing an existential psychoanalysis.

At the culmination of the historical effort of a society to refuse to *recognize* that it has any function other than the utilitarian one, and in the anxiety of the individual confronting the "concentrational"[7] form of the social bond that seems to arise to crown this effort, existentialism must be judged by the explanations it gives of the subjective impasses that have indeed resulted from it; a freedom that is never more authentic that when it is within the walls of a prison; a demand for commitment, expressing the impotence of a pure consciousness to master any situation; a voyeuristic-sadistic idealization of the sexual relation; a personality that realizes itself only in suicide; a consciousness of the other than can be satisfied only by Hegelian murder.

These propositions are opposed by all our experience, in so far as it teaches us not to regard the ego as centered on the *perception-consciousness* or as organized by the "reality principle"—a principle that is the expression of a scientific prejudice most hostile to the dialectic of knowledge. Our experience shows that we should start instead from the *function of méconnaissance* that characterizes the ego in all its structures, so markedly articulated by Miss Anna Freud. For, if the *Verneinung* represents the patent form of that function, its effects will, for the most part, remain latent, so long as they are not illuminated by some light reflected on to the level of fatality, which is where the id manifests itself.

We can thus understand the inertia characteristic of the formations of the *I*, and find there the most extensive definition of neurosis—just as the captation of the subject by the situation gives us the most general formula for madness, not only the madness that lies behind the walls of asylums, but also the madness that deafens the world with its sound and fury.

The sufferings of neurosis and psychosis are for us a schooling in the passions of the soul, just as the beam of the psychoanalytic scales, when we calculate the tilt of its threat to entire communities, provides us with an indication of the deadening of the passions in society.

At this junction of nature and culture, so persistently examined by modern anthropology, psychoanalysis alone recognizes this knot of imaginary servitude that love must always undo again, or sever.

For such a task, we place no trust in altruistic feeling, we who lay bare the aggressivity that underlies the activity of the philanthropist, the idealist, the pedagogue, and even the reformer.

In the recourse of subject to subject that we preserve, psychoanalysis may accompany the patient to the ecstatic limit of the *"Thou art that,"* in which is revealed to him the cipher of his mortal destiny, but it is not in our mere power as practitioners to bring him to that point where the real journey begins.

OF THE GAZE AS *OBJET PETIT A*

Anamorphosis

II But what is the gaze?

I shall set out from this first point of annihilation in which is marked, in the field of the reduction of the subject, a break—which warns us of the need to introduce another reference, that which analysis assumes in reducing the privileges of the consciousness.

Psychoanalysis regards the consciousness as irremediably limited, and institutes it as a principle, not only of idealization, but of *méconnaissance*, as—using a term that takes on new value by being referred to a visible domain—*scotoma*. The term was introduced into the psychoanalytic vocabulary by the French School. Is it simply a metaphor? We find here once again the ambiguity that affects anything that is inscribed in the register of the scopic drive.

For us, consciousness matters only in its relation to what, for propaedeutic reasons, I have tried to show you in the fiction of the incomplete text—on the basis of which it is a question of recentering the subject as speaking in the very lacunae of that in which, at first sight, it presents itself as speaking. But I am stating here only the relation of the preconscious to the unconscious. The dynamic that is attached to the consciousness as

such, the attention the subject brings to his own text, remains up to this point, as Freud has stressed, outside theory and, strictly speaking, not yet articulated.

It is here that I propose that the interest the subject takes in his own split is bound up with that which determines it—namely, a privileged object, which has emerged from some primal separation, from some self-mutilation induced by the very approach of the real, whose name, in our algebra, is the *objet a*.

In the scopic relation, the object on which depends the fantasy from which the subject is suspended in an essential vacillation is the gaze. Its privilege—and also that by which the subject for so long has been misunderstood as being in its dependence—derives from its very structure.

Let us schematize at once what we mean. From the moment that this gaze appears, the subject tries to adapt himself to it, he becomes that punctiform object, that point of vanishing being with which the subject confuses his own failure. Furthermore, of all the objects in which the subject may recognize his dependence in the register of desire, the gaze is specified as unapprehensible. That is why it is, more than any other object, misunderstood (*méconnu*), and it is perhaps for this reason, too, that the subject manages, fortunately, to symbolize his own vanishing and punctiform bar (*trait*) in the illusion of the consciousness of *seeing oneself see oneself*, in which the gaze is elided.

If, then, the gaze is that underside of consciousness, how shall we try to imagine it?

The expression is not inapt, for we can give body to the gaze. Sartre, in one of the most brilliant passages of *L'Être et le Néant*, brings it into function in the dimension of the existence of others. Others would remain suspended in the same, partially derealizing, conditions that are, in Sartre's definition, those of objectivity, were it not for the gaze. The gaze, as conceived by Sartre, is the gaze by which I am surprised—surprised in so far as it changes all the perspectives, the lines of force, of my world, orders it, from the point of nothingness where I am, in a sort of radiated reticulation of the organisms. As the locus of the relation between me, the annihilating subject, and that which surrounds me, the gaze seems to possess such a privilege that it goes so far as to have me scotomized, I who look, the eye of him who sees me as object. In so far as I am under the gaze, Sartre writes, I no longer see the eye that looks at me and, if I see the eye, the gaze disappears.

Is this a correct phenomenological analysis? No. It is not true that, when I am under the gaze, when I solicit a gaze, when I obtain it, I do not

see it as a gaze. Painters, above all, have grasped this gaze as such in the mask and I have only to remind you of Goya, for example, for you to realize this.

The gaze sees itself—to be precise, the gaze of which Sartre speaks, the gaze that surprises me and reduces me to shame, since this is the feeling he regards as the most dominant. The gaze I encounter—you can find this in Sartre's own writing—is, not a seen gaze, but a gaze imagined by me in the field of the Other.

If you turn to Sartre's own text, you will see that, far from speaking of the emergence of this gaze as of something that concerns the organ of sight, he refers to the sound of rustling leaves, suddenly heard while out hunting, to a footstep heard in a corridor. And when are these sounds heard? At the moment when he has presented himself in the action of looking through a keyhole. A gaze surprises him in the function of voyeur, disturbs him, overwhelms him and reduces him to a feeling of shame. The gaze in question is certainly the presence of others as such. But does this mean that originally it is in the relation of subject to subject, in the function of the existence of others as looking at me, that we apprehend what the gaze really is? Is it not clear that the gaze intervenes here only in as much as it is not the annihilating subject, correlative of the world of objectivity, who feels himself surprised, but the subject sustaining himself in a function of desire?

Is it not precisely because desire is established here in the domain of seeing that we can make it vanish?

III We can apprehend this privilege of the gaze in the function of desire, by pouring ourselves, as it were, along the veins through which the domain of vision has been integrated into the field of desire.

It is not for nothing that it was at the very period when the Cartesian meditation inaugurated in all its purity the function of the subject that the dimension of optics that I shall distinguish here by calling "geometral" or "flat" (as opposed to perspective) optics was developed.

I shall illustrate for you, by one object among others, what seems to me exemplary in a function that so curiously attracted so much reflection at the time.

One reference, for those who would like to carry further what I tried to convey to you today, is Baltrusaitis's book, *Anamorphoses*.

In my seminar, I have made great use of the function of anamorphosis, in so far as it is an exemplary structure. What does a simple, noncylindrical

anamorphosis consist of? Suppose there is a portrait on this flat piece of paper that I am holding. By chance, you see the blackboard, in an oblique position in relation to the piece of paper. Suppose that, by means of a series of ideal threads or lines, I reproduce on the oblique surface each point of the image drawn on my sheet of paper. You can easily imagine what the result would be—you would obtain a figure enlarged and distorted according to the lines of what may be called a perspective. One supposes that—if I take away that which has helped in the construction, namely, the image placed in my own visual field—the impression I will retain, while remaining in that place, will be more or less the same. At least, I will recognize the general outlines of the image—at best, I will an identical impression.

I will now pass around something that dates from a hundred years earlier, from 1533, a reproduction of a painting that, I think, you all know—Hans Holbein's *The Ambassadors*. It will serve to refresh the memories of those who know the picture well. Those who do not should examine it attentively. I shall come back to it shortly.

Vision is ordered according to a mode that may generally be called the function of images. This function is defined by a point-by-point correspondence of two unities in space. Whatever optical intermediaries may be used to establish their relation, whether their image is virtual, or real, the point-by-point correspondence is essential. That which is of the mode of the image in the field of vision is therefore reducible to the simple schema that enables us to establish anamorphosis, that is to say, to the relation of an image, in so far as it is linked to a surface, with a certain point that we shall call the "geometral" point. Anything that is determined by this method, in which the straight line plays its role of being the path of light, can be called an image.

Art is mingled with science here. Leonardo da Vinci is both a scientist, on account of his dioptric constructions, and an artist. Vitruvius's treatise on architecture is not far away. It is in Vignola and in Alberti that we find the progressive interrogation of the geometral laws of perspective, and it is around research on perspective that is centered a privileged interest for the domain of vision—whose relation with the institution of the Cartesian subject, which is itself a sort of geometral point, a point of perspective, we cannot fail to see. And, around the geometral perspective, the picture—this is a very important function to which we shall return—is organized in a way that is quite new in the history of painting.

I should now like to refer you to Diderot. The *Lettre sur les aveugles à l'usage de ceux qui voient* (Letter on the Blind for the use of those who see)

will show you that this construction allows that which concerns vision to escape totally. For the geometral space of vision—even if we include those imaginary parts in the virtual space of the mirror, of which, as you know, I have spoken at length—is perfectly reconstructible, imaginable, by a blind man.

What is at issue in geometral perspective is simply the mapping of space, not sight. The blind man may perfectly well conceive that the field of space that he knows, and which he knows as real, may be perceived at a distance, and as a simultaneous act. For him, it is a question of apprehending a temporal function, instantaneity. In Descartes, dioptrics, the action of the eyes, is represented as the conjugated action of two sticks. The geometral dimension of vision does not exhaust, therefore, far from it, what the field of vision as such offers us as the original subjectifying relation.

This is why it is so important to acknowledge the inverted use of perspective in the structure of anamorphosis.

It was Dürer himself who invented the apparatus to establish perspective. Dürer's *lucinda* is comparable to what, a little while ago, I placed between that blackboard and myself, namely, a certain image, or more exactly a canvas, a trellis that will be traversed by straight lines—which are not necessarily rays, but also threads—which will link each point that I have to see in the world to a point at which the canvas will, by this line, be traversed.

It was to establish a correct perspective image, therefore, that the *lucinda* was introduced. If I reverse its use, I will have the pleasure of obtaining not the restoration of the world that lies at the end, but the distortion, on another surface, of the image that I would have obtained on the first, and I will dwell, as on some delicious game, on this method that makes anything appear at will in a particular stretching.

I would ask you to believe that such an enchantment took place in its time. Baltrusaitis's book will tell you of the furious polemics that these practices gave rise to, and which culminated in works of considerable length. The convent of the Minims, now destroyed, which once stood near the rue des Tournelles, carried on the very long wall of one of its galleries and representing as if by chance St John at Patmos a picture that had to be looked at through a hole, so that its distorting value could be appreciated to its full extent.

Distortion may lend itself—this was not the case for this particular fresco—to all the paranoiac ambiguities, and every possible use has been made of it, from Arcimboldi to Salvador Dali. I will go so far as to say that

this fascination complements what geometral researches into perspective allow to escape from vision.

How is it that nobody has ever thought of connecting this with . . . the effect of an erection? Imagine a tattoo traced on the sexual organ *ad hoc* in the state of repose and assuming its, if I may say so, developed form in another state.

How can we not see here, immanent in the geometral dimension—a partial dimension in the field of the gaze, a dimension that has nothing to do with vision as such—something symbolic of the function of the lack, of the appearance of the phallic ghost?

Now, in *The Ambassadors*—I hope everyone has had time now to look at the reproduction—what do you see? What is this strange, suspended, oblique object in the foreground in front of these two figures?

The two figures are frozen, stiffened in their showy adornments. Between them is a series of objects that represent in the painting of the period the symbols of *vanitas*. At the same period, Cornelius Agrippa wrote his *De Vanitate scientiarum*, aimed as much at the arts as the sciences, and these objects are all symbolic of the sciences and arts as they were grouped at the time in the *trivium* and *quadrivium*. What, then, before this *display* of the domain of appearance in all its most fascinating forms, is this object, which from some angles appears to be flying through the air, at others to be tilted? You cannot know—for you turn away, thus escaping the fascination of the picture.

Begin by walking out of the room in which no doubt it has long held your attention. It is then that, turning round as you leave—as the author of the *Anamorphoses* describes it—you apprehend in this form . . . What? A skull.

This is not how it is presented at first—that figure, which the author compares to a cuttlebone and which for me suggests rather that loaf composed of two books which Dali was once pleased to place on the head of an old woman, chosen deliberately for her wretched, filthy appearance and, indeed, because she seems to be unaware of the fact, or, again, Dali's soft watches, whose signification is obviously less phallic than that of the object depicted in a flying position in the foreground of this picture.

All this shows that at the very heart of the period in which the subject emerged and geometral optics was an object of research, Holbein makes visible for us here something that is simply the subject as annihilated— annihilated in the form that is, strictly speaking, the imaged embodiment of

the *minus-phi* of castration, which for us, centers the whole organization of the desires through the framework of the fundamental drives.

But it is further still that we must seek the function of vision. We shall then see emerging on the basis of vision, not the phallic symbol, the anamorphic ghost, but the gaze as such, in its pulsatile, dazzling and spread out function, as it is in this picture.

This picture is simply what any picture is, a trap for the gaze. In any picture, it is precisely in seeking the gaze in each of its points that you will see it disappear. . . .

The Line and Light

In order to give you some idea of the question posed by this relation between the subject and light, in order to show you that its place is something other than the place of the geometral point defined by geometric optics, I will now tell you a little story.

It's a true story. I was in my early twenties or thereabouts—and at that time, of course, being a young intellectual, I wanted desperately to get away, see something different, throw myself into something practical, something physical, in the country say, or at the sea. One day, I was on a small boat, with a few people from a family of fishermen in a small port. At that time, Brittany was not industrialized as it is now. There were no trawlers. The fisherman went out in his frail craft at his own risk. It was this risk, this danger, that I loved to share. But it all wasn't a danger and excitement—there were also fine days.

One day, then, as we were waiting for the moment to pull in the nets, an individual known as Petit-Jean, that's what we called him—like all his family, he died very young from tuberculosis, which at that time was a constant threat to the whole of that social class—this Petit Jean pointed out to me something floating on the surface of the waves. It was a small can, a sardine can. It floated there in the sun, a witness to the canning industry, which we, in fact, were supposed to supply. It glittered in the sun. And Petit-Jean said to me—*You see that can? Do you see it? Well, it doesn't see you!*

He found this incident highly amusing—I less so. I thought about it. Why did I find it less amusing than he? It's an interesting question.

To begin with, if what Petit-Jean said to me, namely, that the can did not see me, had any meaning, it was because in a sense, It was looking at me, all the same. It was looking at me at the level of the point of light, the

point at which everything that looks at me is situated—and I am not speaking metaphorically.

The point of this little story, as it had occurred to my partner, the fact that he found it so funny and I less so, derives from the fact that, if I am told a story like that one, it is because I, at that moment—as I appeared to those fellows who were earning their livings with great difficulty, in the struggle with what for them was a pitiless nature—looked like nothing on earth. In short, I was rather out of place in the picture. And it was because I felt this that I was not terribly amused at hearing myself addressed in this humorous, ironical way.

I am taking the structure at the level of the subject here, and it reflects something that is already to be found in the natural relation that the eye inscribes with regard to light. I am not simply that punctiform being located at the geometral point from which the perspective is grasped. No doubt, in the depths of my eye, the picture is painted. The picture, certainly, is in my eye. But I am not in the picture.

That which is light looks at me, and by means of that light in the depths of my eye, something is painted—something that is not simply a constructed relation, the object on which the philosopher lingers—but something that is an impression, the shimmering of a surface that is not, in advance, situated for me in its distance. This is something that introduces what was elided in the geometral relation —the depth of field, with all its ambiguity and variability, which is in no way mastered by me. It is rather it that grasps me, solicits me at every moment, and makes of the landscape something other than a landscape, something other than what I have called the picture.

The correlative of the picture, to be situated in the same place as it, that is to say, outside, is the point of gaze, while that which forms the mediation from the one to the other, that which is between the two, is something of another nature than geometral, optical space, something that plays an exactly reverse role, which operates, not because it can be traversed, but on the contrary because it is opaque—I mean the screen.

In what is presented to me as space of light, that which is gaze is always a play of light and opacity. It is always that gleam of light—it lay at the heart of my little story—it is always this which prevents me, at each point, from being a screen, from making the light appear as an iridescence that overflows it. In short, the point of gaze always participates in the ambiguity of the jewel.

And if I am anything in the picture, it is always in the form of the screen, which I earlier called the stain, the spot.

III What is painting? It is obviously not for nothing that we have referred to as picture the function in which the subject has to map himself as such. But when a human subject is engaged in making a picture of himself, in putting into operation that something that has as its center the gaze, what is taking place? In the picture, the artist, we are told by some, wishes to be a subject, and the art of painting is to be distinguished from all others in that, in the work, it is as subject, as gaze, that the artist intends to impose himself on us. To this, others reply by stressing the object-like side of the art product. In both these directions, something more or less appropriate is manifested, which certainly does not exhaust the question.

I shall advance the following thesis—certainly, in the picture, something of the gaze is always manifested. The painter knows this very well—his morality, his search, his quest, his practice is that he should sustain and vary the selection of a certain kind of gaze. Looking at pictures, even those most lacking in what is usually called the gaze, and which is constituted by a pair of eyes, pictures in which any representation of the human figure is absent, like a landscape by a Dutch or a Flemish painter, you will see in the end, as in filigree, something so specific to each of the painters that you will feel the presence of the gaze. But this is merely an object of research, and perhaps merely illusion.

The function of the picture—in relation to the person to whom the painter, literally, offers his picture to be seen—has a relation with the gaze. This relation is not, as it might at first seem, that of being a trap for the gaze. It might be thought that, like the actor, the painter wishes to be looked at. I do not think so. I think there is a relation with the gaze of the spectator, but that it is more complex. The painter gives something to the person who must stand in front of his painting which, in part, at least, of the painting, might be summed up thus—*You want to see? Well, take a look at this!* He gives something for the eye to feed on, but he invites the person to whom this picture is presented to lay down his gaze there as one lays down one's weapons. This is the pacifying, Apollonian effect of painting. Something is given not so much to the gaze as to the eye, something that involves the abandonment, the *laying down*, of the gaze.

The problem is that a whole side of painting—expressionism—is separated from this field. Expressionist painting, and this is its distinguishing

feature, provides something by way of a certain satisfaction—in the sense in which Freud uses the term in relation to the drive—of a certain satisfaction of what is demanded by the gaze.

In other words, we must now pose the question as to the exact status of the eye as organ. The function, it is said, creates the organ. This is quite absurd—function does not even explain the organ. Whatever appears in the organism as an organ is always presented with a large multiplicity of functions. In the eye, it is clear that various functions come together. The discriminatory function is isolated to the maximum degree at the level of the *fovea*, the chosen point of distinct vision. Something quite different occurs over the rest of the surface of the retina, incorrectly distinguished by specialists as the locus of the scotopic function. But here, too, chiasma is to be found, since it is this last field, supposedly created to perceive things in diminished lighting, which provides the maximum possibility of perceiving the effects of light. If you wish to see a star of the fifth or sixth size, do not look straight at it—this is known as the Arago phenomenon. You will be able to see it only if you fix your eye to one side.

These functions of the eye do not exhaust the character of the organ in so far as it emerges on the couch, and in so far as the eye determines there what every organ determines, namely, duties. What is wrong about the reference to instinct, a reference that is so confused, is that one does not realize that instinct is the way in which an organism has of extricating itself in the best possible way from an organ. There are many examples, in the animal kingdom, of cases in which the organism succumbs to an excess, a hyperdevelopment of an organ. The supposed function of instinct in the relation between organism and organ certainly seems to have been defined as a kind of morality. We are astonished by the so-called preadaptations of instinct. The extraordinary thing is that the organism can do anything with its organ at all.

In my reference to the unconscious, I am dealing with the relation to the organ. It is not a question of the relation to sexuality, or even to the sex, if it is possible to give any specific reference to this term. It is a question rather of the relation to the phallus, in as much as it is lacking in the real that might be attained in the sexual goal.

It is in as much as, at the heart of the experience of the unconscious, we are dealing with that organ—determined in the subject by the inadequacy organized in the castration complex—that we can grasp to what extent the eye is caught up in a similar dialectic.

From the outset, we see, in the dialectic of the eye and the gaze, that there is no coincidence, but, on the contrary, a lure. When, in love, I solicit a look, what is profoundly unsatisfying and always missing is that—*You never look at me from the place from which I see you.*

Conversely, *what I look at is never what I wish to see.* And the relation that I mentioned earlier, between the painter and the spectator, is a play, a play of *trompe-l'oeil,* whatever one says. There is no reference here to what is incorrectly called figurative, if by this you mean some reference or other to a subjacent reality.

In the classical tale of Zeuxis and Parrhasius, Zeuxis has the advantage of having made grapes that attracted the birds. The stress is placed not on the fact that these grapes were in any way perfect grapes, but on the fact that even the eye of the birds was taken in by them. This is proved by the fact that his friend Parrhasius triumphs over him for having painted on the wall a veil, a veil so lifelike that Zeuxis, turning towards him said, *Well, and now show us what you have painted behind it.* By this he showed that what was at issue was certainly deceiving the eye (*tromper l'oeil*). A triumph of the gaze over the eye.

—Translated by Alan Sheridan

9

Las Meninas

Michel Foucault

Michel Foucault (1926–1984) described his philosophical project as an "archaeology of knowledge." Ranging over subjects of sexuality, madness, discipline, and punishment, Foucault investigated the network of ideologies, beliefs, and values composing the different "epistemes," or discursive systems, governing knowledge and its formation in the West. As well as mapping out the transition points between these systems, this investigation implicitly demarcated the knowledge bases and ideological limits of each episteme with the effect that each episteme is viewed as singular and discontinuous without any teleological sense of progress or ultimate completion to history. With this approach to history in mind, Foucault's philosophical project is intent upon displacing any notion of an essence to humankind and of opening up thought to a sense of unquantifiable becoming, an idea that is apparent in the accompanying text.

"Las Meninas," the first chapter of Foucault's book *The Order of Things: An Archaeology of the Human Sciences* (*Les Mots et les Choses*, 1966), is an attempt to characterize the underlying values and premises of what he terms the "classical episteme" at a point of representational disclosure. A product of the ideology of absolutism, Foucault suggests that the classical episteme may still persist today despite his proposal that a further, modern episteme may be in process. In keeping with the Christian idea of a supreme being and the absolutist idea of the sovereign king, the classical

episteme posits an ideal of a transcendent, objective mind or sovereign subject. Since the Renaissance, European painting supported the idea of the sovereign subject through the use of perspective that constructs a central viewing space for the observer outside the painting, as its addressee. By means of this method, the observer is placed in a privileged position, situated literally and metaphorically before the carefully proportioned pictured world. Foucault's extended description of Diego Velázquez's painting *Las Meninas* (The Ladies-in-Waiting) (1656–57) shows how this pictorial structure is imaged in the painting's very subject matter. King Philip IV and Queen Mariana of Spain, whose images appear solely as reflections in the mirror at the back of the room, are the perspectival linchpin of the painting, and all the figures in the painting—the artist, the Infanta Margarita Teresa and the various attendant courtiers—are oriented around this point. Therefore, what is normally elided in perspectival painting, the position of the sovereign observer, is included as part of its structure, in the image of the king and his wife.

Foucault is skeptical about the traditional approaches to art, since they have a tendency to treat writing and images "as though they were equivalents" without preserving a sense of their relationship and their difference. Foucault's intention is "to keep the relation of language to vision open . . . and preserve the infinity of the task" by which the relationship of language to images may be understood as both interdependent yet different. The opportunity to do this lies in the attempt to trace the conflation in *Las Meninas* between its subject-matter and its structuring of the sovereign subject. As Foucault's conclusion states, this conflation composes both "an essential void" and a representation.

LAS MENINAS

But perhaps it is time to give a name at last to that image which appears in the depths of the mirror, and which the painter is contemplating in front of the picture. Perhaps it would be better, once and for all, to determine the identities of all the figures presented or indicated here, so as to avoid embroiling ourselves forever in those vague, rather abstract designations, so constantly prone to misunderstanding and duplication, "the painter," "the characters," "the models," "the spectators," "the images." Rather than pursue to infinity a language inevitably inadequate to the visible fact, it would be better to say that Velázquez composed a picture; that in this picture he

represented himself, in his studio or in a room of the Escorial, in the act of painting two figures whom the Infanta Margarita has come there to watch, together with an entourage of duennas, maids of honor, courtiers, and dwarfs; that we can attribute names to this group of people with great precision: tradition recognizes that here we have Doña Maria Agustina Sarmiente, over there Nieto, in the foreground Nicolaso Pertusato, an Italian jester. We could then add that the two personages serving as models to the painter are not visible, at least directly; but that we can see them in a mirror; and that they are, without any doubt, King Philip IV and his wife, Mariana.

These proper names would form useful landmarks and avoid ambiguous designations; they would tell us in any case what the painter is looking at, and the majority of the characters in the picture along with him. But the relation of language to painting is an infinite relation. It is not that words are imperfect, or that, when confronted by the visible, they prove insuperably inadequate. Neither can be reduced to the other's terms: it is in vain that we say what we see; what we see never resides in what we say. And it is in vain that we attempt to show, by the use of images, metaphors, or similes, what we are saying; the space where they achieve their splendor is not that deployed by our eyes but that defined by the sequential elements of syntax. And the proper name, in this particular context, is merely an artifice: it gives us a finger to point with, in other words, to pass surreptitiously from the space where one speaks to the space where one looks; in other words, to fold one over the other as though they were equivalents. But if one wishes to keep the relation of language to vision open, if one wishes to treat their incompatibility as a starting-point for speech instead of as an obstacle to be avoided, so as to stay as close as possible to both, then one must erase those proper names and preserve the infinity of the task. It is perhaps through the medium of this gray, anonymous language, always over-meticulous and repetitive because too broad, that the painting may, little by little, release its illuminations.

We must therefore pretend not to know who is to be reflected in the depths of that mirror, and interrogate that reflection in its own terms.

First, it is the reverse of the great canvas represented on the left. The reverse, or rather the right side, since it displays in full face what the canvas, by its position, is hiding from us. Furthermore, it is both in opposition to the window and a reinforcement of it. Like the window, it provides a ground which is common to the painting and to what lies outside it. But the window operates by the continuous movement of an effusion which, flowing from

right to left, unites the attentive figures, the painter, and the canvas, with the spectacle they are observing; whereas the mirror, on the other hand, by means of a violent, instantaneous movement, a movement of pure surprise, leaps out from the picture in order to reach that which is observed yet invisible in front of it, and then, at the far end of its fictitious depth, to render it visible yet indifferent to every gaze. The compelling tracer line, joining the reflection to that which it is reflecting, cuts perpendicularly through the lateral flood of light. Lastly—and this is the mirror's third function—it stands adjacent to a doorway which forms an opening, like the mirror itself, in the far wall of the room. This doorway too forms a bright and sharply defined rectangle whose soft light does not shine through into the room. It would be nothing but a gilded panel if it were not recessed out from the room by means of one leaf of a carved door, the curve of a curtain, and the shadows of several steps. Beyond the steps, a corridor begins; but instead of losing itself in obscurity, it is dissipated in a yellow dazzle where the light, without coming in, whirls around on itself in dynamic repose. Against this background, at once near and limitless, a man stands out in full-length silhouette; he is seen in profile; with one hand he is holding back the weight of a curtain; his feet are placed on different steps; one knee is bent. He may be about to enter the room; or he may be merely observing what is going on inside it, content to surprise those within without being seen himself. Like the mirror, his eyes are directed towards the other side of the scene; nor is anyone paying any more attention to him than to the mirror. We do not know where he has come from: it could be that by following uncertain corridors he has just made his way around the outside of the room in which these characters are collected and the painter is at work; perhaps he too, a short while ago, was there in the forefront of the scene, in the invisible region still being contemplated by all those eyes in the picture. Like the images perceived in the looking-glass, it is possible that he too is an emissary from that evident yet hidden space. Even so, there is a difference: he is there in flesh and blood; he has appeared from the outside, on the threshold of the area represented; he is indubitable—not a probable reflection but an irruption. The mirror, by making visible, beyond even the walls of the studio itself, what is happening in front of the picture, creates, in its sagittal dimension, an oscillation between the interior and the exterior. One foot only on the lower step, his body entirely in profile, the ambiguous visitor is coming in and going out at the same time, like a pendulum caught at the bottom of its swing. He repeats on the spot, but in the dark reality of his body, the instantaneous movement of those images flashing across the

room, plunging into the mirror, being reflected there, and springing out from it again like visible, new, and identical species. Pale, minuscule, those silhouetted figures in the mirror are challenged by the tall, solid stature of the man appearing in the doorway.

But we must move down again from the back of the picture towards the front of the stage; we must leave that periphery whose volute we have just been following. Starting from the painter's gaze, which constitutes an off-center center to the left, we perceive first of all the back of the canvas, then the paintings hung on the wall, with the mirror in their center, then the open doorway, then more pictures, of which, because of the sharpness of the perspective, we can see no more than the edges of the frames, and finally, at the extreme right, the window, or rather the groove in the wall from which the light is pouring. This spiral shell presents us with the entire cycle of representation: the gaze, the palette and brush, the canvas innocent of signs (these are the material tools of representation), the paintings, the reflections, the real man (the completed representation, but as it were freed from its illusory or truthful contents, which are juxtaposed to it); then the representation dissolves again: we can see only the frames, and the light that is flooding the pictures from outside, but that they, in return, must reconstitute in their own kind, as though it were coming from elsewhere, passing through their dark wooden frames. And we do, in fact, see this light on the painting, apparently welling out from the crack of the frame; and from there it moves over to touch the brow, the cheekbones, the eyes, the gaze of the painter, who is holding a palette in one hand and in the other a fine brush. . . . And so the spiral is closed, or rather, by means of that light, is opened.

This opening is not, like the one in the back wall, made by pulling back a door; it is the whole breadth of the picture itself, and the looks that pass across it are not those of a distant visitor. The frieze that occupies the foreground and the middle ground of the picture represents—if we include the painter—eight characters. Five of these, their heads more or less bent, turned or inclined, are looking straight out at right angles to the surface of the picture. The center of the group is occupied by the little Infanta, with her flared pink and grey dress. The princess is turning her head towards the right side of the picture, while her torso and the big panniers of her dress slant away slightly towards the left; but her gaze is directed absolutely straight towards the spectator standing in front of the painting. A vertical line dividing the canvas into two equal halves would pass between the child's eyes. Her face is a third of the total height of the picture above the

lower frame. So that here, beyond all question, resides the principal theme of the composition; this is the very object of this painting. As though to prove this and to emphasize it even more, Velázquez has made use of a traditional visual device: beside the principal figure he has placed a secondary one, kneeling and looking in towards the central one. Like a donor in prayer, like an angel greeting the Virgin, a maid of honor on her knees is stretching out her hands towards the princess. Her face stands out in perfect profile against the background. It is at the same height as that of the child. This attendant is looking at the princess and only at the princess. A little to the right, there stands another maid of honor, also turned towards the Infanta, leaning slightly over her, but with her eyes clearly directed towards the front, towards the same spot already being gazed at by the painter and the princess. Lastly, two other groups made up of two figures each: one of these groups is further away; the other, made up of the two dwarfs, is right in the foreground. One character in each of these pairs is looking straight out, the other to the left or the right. Because of their positions and their size, these two groups correspond and themselves form a pair: behind, the courtiers (the woman, to the left, looks to the right); in front, the dwarfs (the boy, who is at the extreme right, looks in towards the center of the picture). This group of characters, arranged in this manner, can be taken to constitute, according to the way one looks at the picture and the center of reference chosen, two different figures. The first would be a large X: the top left-hand point of this X would be the painter's eyes; the top right-hand one, the male courtier's eyes; at the bottom left-hand corner there is the corner of the canvas represented with its back towards us (or, more exactly, the foot of the easel); at the bottom right-hand corner, the dwarf (his foot on the dog's back). Where these two lines intersect, at the center of the X, are the eyes of the Infanta. The second figure would be more that of a vast curve, its two ends determined by the painter on the left and the male courtier on the right—both these extremities occurring high up in the picture and set back from its surface; the center of the curve, much nearer to us, would coincide with the princess's face and the look her maid of honor is directing towards her. This curve describes a shallow hollow across the center of the picture which at once contains and sets off the position of the mirror at the back.

There are thus two centers around which the picture may be organized, according to whether the fluttering attention of the spectator decides to settle in this place or in that. The princess is standing upright in the center of a St Andrew's cross, which is revolving around her with its eddies of

courtiers, maids of honor, animals, and fools. But this pivoting movement is frozen. Frozen by a spectacle that would be absolutely invisible if those same characters, suddenly motionless, were not offering us, as though in the hollow of a goblet, the possibility of seeing in the depths of a mirror the unforeseen double of what they are observing. In depth, it is the princess who is superimposed on the mirror; vertically, it is the reflection that is superimposed on the face. But, because of the perspective, they are very close to one another. Moreover, from each of them there springs an ineluctable line: the line issuing from the mirror crosses the whole of the depth represented (and even more, since the mirror forms a hole in the back wall and brings a further space into being behind it); the other line is shorter: it comes from the child's eyes and crosses only the foreground. These two sagittal lines converge at a very sharp angle, and the point where they meet, springing out from the painted surface, occurs in front of the picture, more or less exactly at the spot from which we are observing it. It is an uncertain point because we cannot see it; yet it is an inevitable and perfectly defined point too, since it is determined by those two dominating figures and confirmed further by other, adjacent dotted lines which also have their origin inside the picture and emerge from it in a similar fashion.

What is there, then, we ask at last, in that place which is completely inaccessible because it is exterior to the picture, yet is prescribed by all the lines of its composition? What is the spectacle, what are the faces that are reflected first of all in the depths of the Infanta's eyes, then in the courtiers' and the painter's, and finally in the distant glow of the mirror? But the question immediately becomes a double one: the face reflected in the mirror is also the face that is contemplating it; what all the figures in the picture are looking at are the two figures to whose eyes they too present a scene to be observed. The entire picture is looking out at a scene for which it is itself a scene. A condition of pure reciprocity manifested by the observing and observed mirror, the two stages of which are uncoupled at the two lower corners of the picture: on the left the canvas with its back to us, by means of which the exterior point is made into pure spectacle; to the right the dog lying on the floor, the only element in the picture that is neither looking at anything nor moving, because it is not intended, with its deep reliefs and the light playing on its silky hair, to be anything but an object to be seen.

Our first glance at the painting told us what it is that creates this spectacle-as-observation. It is the two sovereigns. One can sense their presence already in the respectful gaze of the figures in the picture, in the astonishment of the child and the dwarfs. We recognize them, at the far end of the picture,

in the two tiny silhouettes gleaming out from the looking-glass. In the midst of all those attentive faces, all those richly dressed bodies, they are the palest, the most unreal, the most compromised of all the painting's images: a movement, a little light, would be sufficient to eclipse them. Of all these figures represented before us, they are also the most ignored, since no one is paying the slightest attention to that reflection which has slipped into the room behind them all, silently occupying its unsuspected space; in so far as they are visible, they are the frailest and the most distant form of all reality. Inversely, in so far as they stand outside the picture and are therefore withdrawn from it in an essential invisibility, they provide the center around which the entire representation is ordered: it is they who are being faced, it is towards them that everyone is turned, it is to their eyes that the princess is being presented in her holiday clothes; from the canvas with its back to us to the Infanta, and from the Infanta to the dwarf playing on the extreme right, there runs a curve (or again, the lower fork of the X opens) that orders the whole arrangement of the picture to their gaze and thus makes apparent the true center of the composition, to which the Infanta's gaze and the image in the mirror are both finally subject.

In the realm of the anecdote, this center is symbolically sovereign, since it is occupied by King Philip IV and his wife. But it is so above all because of the triple function it fulfills in relation to the picture. For in it there occurs an exact superimposition of the model's gaze as it is being painted, of the spectator's as he contemplates the painting, and of the painter's as he is composing his picture (not the one represented, but the one in front of us which we are discussing). These three "observing" functions come together in a point exterior to the picture: that is, an ideal point in relation to what is represented, but a perfectly real one too, since it is also the starting-point that makes the representation possible. Within that reality itself, it cannot not be invisible. And yet, that reality is projected within the picture—projected and diffracted in three forms which correspond to the three functions of that ideal and real point. They are: on the left, the painter with his palette in his hand (a self-portrait of Velázquez); to the right, the visitor, one foot on the step, ready to enter the room; he is taking in the scene from the back, but he can see the royal couple, who are the spectacle itself, from the front; and lastly, in the center, the reflection of the king and the queen, richly dressed, motionless, in the attitude of patient models.

A reflection that shows us quite simply, and in shadow, what all those in the foreground are looking at. It restores, as if by magic, what is lacking in every gaze: in the painter's, the model, which his represented double is

duplicating over there in the picture; in the king's, his portrait, which is be-
ing finished off on that slope of the canvas that he cannot perceive from
where he stands; in that of the spectator, the real center of the scene,
whose place he himself has taken as though by usurpation. But perhaps
this generosity on the part of the mirror is feigned; perhaps it is hiding as
much as and even more than it reveals. That space where the king and his
wife hold sway belongs equally well the artist and to the spectator: in the
depths of the mirror there could also appear—there ought to appear—the
anonymous face of the passerby and that of Velázquez. For the function of
that reflection is to draw into the interior of the picture what is intimately
foreign to it: the gaze which has organized it and the gaze for which it is
displayed. But because they are present within the picture, to the right and
to the left, the artist and the visitor cannot be given a place in the mirror: just
as the king appears in the depths of the looking-glass precisely because he
does not belong to the picture.

In the great volute that runs around the perimeter of the studio, from the
gaze of the painter, with his motionless hand and palette, right round to the
finished paintings, representation came into being, reached completion,
only to dissolve once more into the light; the cycle was complete. The lines
that run through the depth of the picture, on the other hand, are not com-
plete; they all lack a segment of their trajectories. This gap is caused by
the absence of the king—an absence that is an artifice on the part of the
painter. But this artifice both conceals and indicates another vacancy which
is, on the contrary, immediate: that of the painter and the spectator when
they are looking at or composing the picture. It may be that, in this picture,
as in all the representations of which it is, as it were, the manifest essence,
the profound invisibility of what one sees is inseparable from the invisibility
of the person seeing—despite all mirrors, reflections, imitations, and por-
traits. Around the scene are arranged all the signs and successive forms of
representation; but the double relation of the representation to its model
and to its sovereign, to its author as well as to the person to whom it is be-
ing offered, this relation is necessarily interrupted. It can never be present
without some residuum, even in a representation that offers itself as a
spectacle. In the depth that traverses the picture, hollowing it into a ficti-
tious recess and projecting it forward in front of itself, it is not possible for
the pure felicity of the image ever to present in a full light both the master
who is representing and the sovereign who is being represented.

Perhaps there exists, in this painting by Velázquez, the representation
as it were, of classical representation, and the definition of the space it

opens up to us. And, indeed, representation undertakes to represent itself here in all its elements, with its images, the eyes to which it is offered, the faces it makes visible, the gestures that call it into being. But there, in the midst of this dispersion which it is simultaneously grouping together and spreading out before us, indicated compellingly from every side, is an essential void: the necessary disappearance of that which is its foundation—of the person it resembles and the person in whose eyes it is only a resemblance. This very subject—which is the same—has been elided. And representation, freed finally from the relation that was impeding it, can offer itself as representation in its pure form.

10

Society

Theodor Adorno

Theodor Adorno (1903–1969) was one of the leading Marxist intellectuals of the modern period. In 1931, together with Max Horkheimer, he founded the Institute for Social Research in Frankfurt, which came to be known as the Frankfurt School. In its heyday from its inception through to the 1960s, the philosophers of the Frankfurt School played an important role in interrogating the legacy of Enlightenment rationalism as transmitted through the ideologies of capitalism and totalitarianism.

Adorno developed a methodology of "negative dialectics," the purpose of which was to negate notions of transcendence as perpetuated by ideology while maintaining, at least in principle, the idea of a future world of unalienated freedom. The way in which Adorno considers art as a form of "negative dialectics" is outlined in the accompanying extract from the section entitled "Society" in his posthumously published book *Aesthetic Theory* (1970). The text develops Adorno's idea of art's significance as it emerges through the question of modern art's relationship to "empirical reality," by which is meant the capitalist realm of commodification, alienated labor, and ideology. In a typically dense style of writing (adopted so as to elide simple solutions and respect the subject of art), Adorno weaves together a series of contradictory ideas and tropes that, taken together, argue that what is at stake in modern art is not simply the representation of the experience of alienation but rather the issue of freedom *from* alienation.

As stated at the beginning of *Aesthetic Theory*, Adorno believed that it is only through a complex and nuanced approach to art associated with the tradition of aesthetics that philosophy can hope to approach the significance of both past art and modern art. However, as the accompanying text outlines, there are particular difficulties in theorizing about art, since for Adorno, like Kant, art is not an object of knowledge. Thus, Adorno argues that materialist philosophy cannot treat art in the same way as other forms of social production. Indeed, for Adorno, art reveals a poverty in philosophy, a limit to what can be achieved through knowledge alone. And furthermore, Adorno argues that art requires materialist philosophy to abandon many of its methods of analysis as these might apply to other commodified objects. According to Adorno, modern art ("which extends from the hybridization of the arts to the *happenings*") has made this abundantly clear to philosophy by refusing to function mimetically or illustratively. While modern art, of which montage and Picasso's cubist collages are the paradigmatic examples, draws upon the materials and products of contemporary society, it does this, not to represent anything as such, but rather to absorb these materials for less purposive and, in a sense, more violent, reasons.

Since art has a solipsistic character, it has to be treated as a unique entity. However, Adorno is quick to point out that this does not mean modern art is a reified form of production; rather, it is concerned with reification itself and its effects. These effects are of untold suffering. Hence, the reason why, in "speaking" of this, modern art cannot be considered an object of knowledge: as Adorno says elsewhere in *Aesthetic Theory*, "suffering remains foreign to knowledge."[1] By virtue of this expression of suffering— which is not an object as such—art retains a connection with freedom, even though it is not free, itself. For Adorno, there is no simple opposition between modern art and past art forms, since both can be concerned with freedom. If a difference exists, it is that modern art is bound up with the experience of alienated suffering, something that Adorno feels is necessary to retain in art for as long as freedom is denied.

SOCIETY

It can be said that philosophy, and theoretical thought as a whole, suffers from an idealist prejudice insofar as it disposes solely over concepts; only through them does it treat what they are concerned with, which it itself never has. Its labor of Sisyphus is that it must reflect the untruth and guilt

that it takes on itself, thereby correcting it when possible. It cannot paste its ontic substratum into the text; by speaking of it, philosophy already makes it into what it wants to free itself from. Modern art has registered dissatisfaction with this ever since Picasso disrupted his pictures with scraps of newspaper, an act from which all montage derives. The social element is aesthetically done justice in that it is not imitated, which would effectively make it fit for art, but is, rather, injected into art by an act of sabotage. Art itself explodes the deception of its pure immanence, just as the empirical ruins, divested of their own context, accommodate themselves to the immanent principles of construction. By conspicuously and willfully ceding to crude material, art wants to undo the damage that spirit—thought as well as art—has done to its other, to which it refers and which it wants to make eloquent. This is the determinable meaning of the meaningless intention-alien element of modern art, which extends from the hybridization of the arts to the *happenings*. It is not so much that traditional art is thereby sanctimoniously condemned by an arriviste judgment but that, rather, the effort is made to absorb even the negation of art by its own force. What is no longer socially possible in traditional art does not on that account surrender all truth. Instead it sinks to a historical, geological stratum that is no longer accessible to living consciousness except through negation but without which no art would exist: a stratum of mute reference to what is beautiful, without all that strict a distinction between nature and work. This element is contrary to the disintegrative element into which the truth of art has changed; yet it survives because as the forming force it recognizes the violence of that by which it measures itself. It is through this idea that art is related to peace. Without perspective on peace, art would be as untrue as when it anticipates reconciliation. Beauty in art is the semblance of the truly peaceful. It is this toward which even the repressive violence of form tends in its unification of hostile and divergent elements.

It is false to arrive at aesthetic realism from the premise of philosophical materialism. Certainly, art, as a form of knowledge, implies knowledge of reality, and there is no reality that is not social. Thus truth content and social content are mediated, although art's truth content transcends the knowledge of reality as what exists. Art becomes social knowledge by grasping the essence, not by endlessly talking about it, illustrating it, or somehow imitating it. Through its own figuration, art brings the essence into appearance in opposition to its own semblance. The epistemological critique of idealism, which secures for the object an element of primacy, cannot simply be transposed to art. Object in art and object in empirical reality are

entirely distinct. In art the object is the work produced by art, as much containing elements of empirical reality as displacing, dissolving, and reconstructing them according to the work's own law. Only through such transformation, and not through an ever falsifying photography, does art give empirical reality its due, the epiphany of its shrouded essence and the merited shudder in the face of it as in the face of a monstrosity. The primacy of the object is affirmed aesthetically only in the character of art as the unconscious writing of history, as anamnesis of the vanquished, of the repressed, and perhaps of what is possible. The primacy of the object, as the potential freedom from domination of what is, manifests itself in art as its freedom from objects. If art must grasp its content [*Gehalt*] in its other, this other is not to be imputed to it but falls to it solely in its own immanent nexus. Art negates the negativity in the primacy of the object, negates what is heteronomous and unreconciled in it, which art allows to emerge even through the semblance of the reconciliation of its works.

At first glance one argument of dialectical materialism bears persuasive force. The standpoint of radical modernism, it is claimed, is that of solipsism, that of a monad that obstinately barricades itself against intersubjectivity; the reified division of labor has run amok. This derides the humanity that awaits realization. However, this solipsism—the argument continues—is illusory, as materialistic criticism and long before that great philosophy have demonstrated; it is the delusion of the immediacy of the for-itself that ideologically refuses to admit its own mediations. It is true that theory, through insight into universal social mediation, has conceptually surpassed solipsism. But art, mimesis driven to the point of self-consciousness, is nevertheless bound up with feeling, with the immediacy of experience; otherwise it would be indistinguishable from science, at best an installment plan on its results and usually no more than social reporting. Collective modes of production by small groups are already conceivable, and in some media even requisite; monads are the locus of experience in all existing societies. Because individuation, along with the suffering that it involves, is a social law, society can only be experienced individually. The substruction of an immediately collective subject would be duplicitous and would condemn the artwork to untruth because it would withdraw the single possibility of experience that is open to it today. If on the basis of theoretical insight art orients itself correctively, according to its own mediatedness, and seeks to escape from the monadic character that it has recognized as social semblance, historical truth remains external to it and becomes untruth: The artwork heteronomously sacrifices its immanent determination. According to critical

theory, mere consciousness of society does not in any real sense lead beyond the socially imposed objective structure, any more than the artwork does, which in terms of its own determinations is itself a part of social reality. The capacity that dialectical materialism antimaterialistically ascribes to and demands of the artwork is achieved by that artwork, if at all, when in its objectively imposed monadologically closed structure it pushes its situation so far that it becomes the critique of this situation. The true threshold between art and other knowledge may be that the latter is able to think beyond itself without abdicating, whereas art produces nothing valid that it does not fill out on the basis of the historical standpoint at which it finds itself. The innervation of what is historically possible for it is essential to the artistic form of reaction. In art, substantiality means just this. If for the sake of a higher social truth art wants more than the experience that is accessible to it and that it can form, that experience becomes less, and the objective truth that it posits as its measure collapses as a fiction that patches over the fissure between subject and object. They are so falsely reconciled by a trumped-up realism that the most utopian fantasies of a future art would be unable to conceive of one that would once again be realistic without falling back into unfreedom. Art possesses its other immanently because, like the subject, immanence is socially mediated in itself. It must make its latent social content eloquent: It must go within in order to go beyond itself. It carries out the critique of solipsism through the force of externalization in its own technique as the technique of objectivation. By virtue of its form, art transcends the impoverished, entrapped subject; what wants willfully to drown out its entrapment becomes infantile and makes out of its heteronomy a social-ethical accomplishment. It may be objected here that the various peoples' democracies are still antagonistic and that they therefore preclude any but an alienated standpoint, yet it is to be hoped that an actualized humanism would be blessedly free of the need for modern art and would once again be content with traditional art. This concessional argument, however, is actually not all that distinct from the doctrine of overcoming individualism. To put it bluntly, it is based on the philistine cliché that modern art is as ugly as the world in which it originates, that the world deserves it and nothing else would be possible, yet surely it cannot go on like this forever. In truth, there is nothing to overcome; the word itself is *index falsi*. There is no denying that the antagonistic situation, what the young Marx called alienation and self-alienation, was not the weakest agency in the constitution of modern art. But modern art was certainly no copy, not the reproduction of that situation. In denouncing it, transposing it into the

image, this situation became its other and as free as the situation denies the living to be. If today art has become the ideological complement of a world not at peace, it is possible that the art of the past will someday devolve upon society at peace; it would, however, amount to the sacrifice of its freedom were new art to return to peace and order, to affirmative replication and harmony. Nor is it possible to sketch the form of art in a changed society. In comparison with past art and the art of the present it will probably again be something else; but it would be preferable that some fine day art vanish altogether than that it forget the suffering that is its expression and in which form has its substance. This suffering is the humane content that unfreedom counterfeits as positivity. If in fulfillment of the wish a future art were once again to become positive, then the suspicion that negativity were in actuality persisting would become acute; this suspicion is ever present, regression threatens unremittingly, and freedom—surely freedom from the principle of possession—cannot be possessed. But then what would art be, as the writing of history, if it shook off the memory of accumulated suffering.

—Translated by Robert Hullot-Kentor

11

The Work of Art and Fantasy

Sarah Kofman

The work of the French philosopher Sarah Kofman (1934–1994) represents a cross-current of influences derived from her studies under Gilles Deleuze, who supervised her primary thesis,[1] Jacques Derrida, who she met in 1969 and whose seminars she attended at the École Normale Supérieure, and André Green, a Lacanian psychoanalyst whose seminars she also attended at the Institute for Psychoanalysis in Paris in the late 1960s. Kofman's writings provide a reading of Freud, via Lacan and Derrida, that counters Deleuze's staunch opposition to psychoanalysis but is compatible with his admiration of Nietzsche. Between 1970 and her death, Kofman published a series of books, many of them about Freud and Nietzsche, whom she saw as "fellow unbelievers" dedicated to a philosophy of "creations and decreations."

In the accompanying text, entitled "The Work of Art and Fantasy" (1970), Kofman argues that Freud's interpretations of works of art follow a rigorous logic concerning the role of representation. She emphasizes that, for Freud, insofar as fantasy is an affect of representation, both of these elements are based on the dialectic of presence and absence. Freud treats representation as an independent system of signification in which the signifier is arbitrary and without correspondence to the "real." This means that representation—composed of, for example, discourse, memories, dreams,

works of art, and so on—is composed of signs that are already, themselves, coded. Viewed in this way the work of art, like the *fort/da* game described by Freud (see chapter 4), is "an original memory, the substitute for infantile psychic memory" (by "original," Kofman means a memory that is constructed through a signifier or series of signifiers that do not assume a referent). It is by virtue of the fact that the work of art is a substitute formed within a code, rather than simply a projection of a fantasy, that fantasy is interpretable.

Kofman retraces Freud's analysis of Leonardo's art, emphasizing the fact that his views about both dreams and art are comparable to Saussure's structuralist theory of signification: "One can state that for Freud, every representation substitutes for an originary absence of meaning, for one is always referred from substitute to substitute without ever coming back to an originary signified, the latter being merely fantasized by desire."

Given that the subject is based upon the fantasy of an absent or concealed referent, Kofman believes that desire may "invest" representation in such a way that this fantasy is seen as an affect of representation itself. This is what Kofman means by "the return of the repressed" and which she feels is at stake in the smile of *Mona Lisa* (ca. 1500–1504). Like all signifiers, the "Leonardesque smile" of *Mona Lisa* is a symbol structured with layers of codification rather than a representation based upon a referent whether real or forgotten in memory. As Kofman states, *Mona Lisa* possesses "a smile that everyone longs for because it has never existed." Following Freud, Kofman suggests that works of art, like dreams, are manifested in representation by the operations of combination, condensation, and transformation. These operations work through fantasies and bring them into consciousness. The effect of these operations in the painting of *Saint Anne with Two Others*, by Leonardo, results in a "return of the repressed" whereby the fantasy of uniting with the lost object (the mother) is represented in such a repetitive and insistent way that it becomes manifest and interpretable as an affect of the structure of signification. In turn, this reveals that the subject is also a construction of the dialectic between presence and absence. Leonardo's paintings *Saint John the Baptist* and *Bacchus* underline the fact that works of art are "distortions" that consist of a complex layering and mixing of codes. These distortions are embedded in fantasies that reveal how the subject's desires are themselves linguistic. However, since they are distorted, the meanings of works of art are never transparent; as Kofman emphasizes, "Only the analytic method, taking the work of art as its starting point, can reconstruct the artist's fantasies and their meaning."

THE WORK OF ART AND FANTASY
THE WORK OF ART AND FANTASY

Once Freud has explained his method in detail, what link does he establish between a work of art and an artist's past—a unique past which constitutes a variant of universal archaic experience? Can what Freud said of the epic poem be generalized to include all works of art? Can the relation between memory and fantasy be transposed onto the one between fantasy and the work of art? We have seen that the childhood memory, a phantasmal construction, was not the translation or pictorial representation of a preexisting reality, but rather a substitutive formation supplementing the lack of meaning in lived experience and therefore an originary supplement, the only text constitutive of the past as such. This being so, does the work of art translate memory-fantasies, or is it too a completely original return of the repressed? Is it a substitute for memory, a kind of completely original memory; that is, a text which, far from translating fantasy, makes possible the structuring and constituting of fantasy after the fact?

Indeed, art functions as a specific memory which makes possible the reconstruction of the author's fantasies. The fantasy is an account of the author's history after the fact that can be given through using the analytic method, which uncovers the way in which this history has been structured symbolically in a work of art. Here one must read Freud's texts carefully. For though the texts dealing with the relations between traces of the past and fantasies pose no problem, it sometimes seems that the texts treating the relations between fantasy and the work of art posit an expressive link between the two. A cursory reading reveals three successive moments in the artist's life: the moment of lived experience in early childhood to which no meaning is attached; that of the memory-fantasy which makes the former intelligible; and the point at which the work of art translates or expresses this fantasy. If this reading were correct, Freud would indeed be elaborating a psychogenesis of art which obliterates the specificity of his object. In "Creative Writers and Daydreaming" (literally, "The Poet and His Imagination"),[2] for instance, he does seem to suggest that poetic creation derives either from universal archaic material—distorted vestiges of the wishful fantasies of all peoples, which are always linked to children's sexual theories[3]—or from an individual's unique fantasy material. At the end of his essay, he acknowledges that he has spoken more about fantasy than poetry: "You will say that, although I have put the creative writer first in the title of my paper, I have told you far less about him than about fantasies. . . . All I have been able to do is to throw out some encouragements and suggestions which,

starting from the study of fantasies, lead on to the problem of the writer's choice of his literary material" (9:152).[4]

This derivation must not be understood, however, as a translation or an "expression," because even in a case where the poet finds symbolic material already available, he must rework it: "Even here, the writer keeps a certain amount of independence, which can express itself in the choice of material and in changes in it which are often quite extensive" (p. 152). This holds true all the more in cases where the material being reworked is the author's own.[5] Artistic elaboration is analogous to the elaboration performed by the dream work; the manifest content does not translate the latent content, but is rather the result of a specific type of figurative writing from which alone the text of the latent content can be constituted. Moreover, if Freud emphasizes the importance of childhood memory in the poet's life, it is because poetry is, like daydreaming, "a continuation of, and substitute for, what was once the play of childhood" (p. 152). As Freud shows in his well-known analysis of the *fort-da* game in *Beyond the Pleasure Principle*, the child's game is not the reproduction or repetition of a fantasy (in this case, the fantasy of the mother's presence and absence), but rather a symbolic invention that allows the child to master this absence through an affective discharge (18:14–17). This discharge might have taken a different form—sobbing or shrieking, for example—for another child who found himself in different circumstances. Indeed, to understand this child's play with the spool, one must take account not only of the differential relation between *o* and *a*, but of the way the entire game is staged.[6] It is particularly significant that the child has an excellent relationship with his parents. His symbolic invention makes possible the structuring of his fantasy regarding the mother's presence and absence. The fantasy does not predate the game, for if it did, the child might not have needed to play it. The only element that is repeated is the affective impression—here, a painful one—which, through its very repetition, brings the subject indirect pleasure and also procures for him the more direct pleasure afforded by the discharge of affect and the symbolic mastery over absence.

The same is true for the artist who repeats his childhood play ever-differently. The artist discharges an affect in the course of the creative process and masters it in the work itself. In this connection, Freud and Breuer write that "Goethe did not feel he had dealt with an experience till he had discharged it in creative artistic activity. This was in his case the preformed reflex belonging to affects, and so long as it had not been carried out the distressing increase in his excitation persisted" (2:207).

Once it is created, the work makes possible constitution of one or several fantasies after the fact. If the memory-fantasy is not a repetition of the past but an originary substitute, neither is the work of art a translation of the fantasy; rather, it substitutes for it at the same time that it makes possible its constitution after the fact. The work of art is thus the substitute for a substitute. There are therefore not three moments but two: a past event, affective in character; and the discharge in an art work. The intermediary stage of the fantasy is unconscious, the fantasy being always already presented and distorted in the very play of the work. The unconscious fantasy presumed to be at the source of the work of art is itself a postulate of the analytic method, which infers the fantasy from its reading of the work. As such, it is nothing more than a construction after the fact. In art . . . the artist's fantasies are put into play before they are understood. Thus for Freud, the relation between fantasy and the work of art is not one of expressiveness, in the sense that term has in the traditional logic of the sign. In his treatment of both fantasy and the work of art, Freud introduces no dissymmetry; neither phenomenon is said to "go back" to an originary signifier. So in what he actually *does,* Freud is not caught in the closure of classical representation, although his language is indeed equivocal in this respect. When he writes in the *Introductory Lectures* that "the creative imagination" is incapable of invention and is satisfied to assemble disparate elements, one might think that the work of art, which is satisfied to combine and distort preexisting fantasies, merely "expresses" them. The concepts "derivation" and "source" might also confuse the reader, since they seem to establish a relation of mechanical causality between the work and the artist's past or the collective past. If this were the case, however, the imagination would scarcely be "creative."

Now, though it is true that the work of art bears the traces of the past, these traces are not to be found anywhere else. In other words, the work does not translate memory in distorted form, but rather constitutes it phantasmally; it is an original memory, the substitute for infantile psychic memory. For anyone who has perfect knowledge of his own history, it would seem that the work of art is neither possible nor necessary, even if the work is consciously fantasized. It is an originary inscription, but one that is always already a symbolic substitute. One can state that for Freud, every representation substitutes for an originary absence of meaning, for one is always referred from substitute to substitute without ever coming back to an originary signified, the latter being merely fantasized by desire. Representation, as *Vorstellung*, is originary. But since Freud's language is suspect in

this regard, let us consider once again what Freud *does* in order better to understand what he *says*.

The analysis in "Leonardo da Vinci and a Memory of His Childhood" provides an exemplary case.[7] The Mona Lisa's smile is a translation neither of the smile of Leonardo's model, nor of his mother's real smile, nor of Leonardo's fantasy of his mother's smile. To grasp its meaning one must, paradoxically, refer to the smiles in other paintings by Leonardo or in other works of art, such as Verrocchio's figures, or archaic Greek statues. In this way we can see that the Mona Lisa's smile, more than any other, makes us aware of the universal fantasy of the mother's smile as an expression of both tenderness and sensuality—a smile that everyone longs for because it has never existed. "The mother's smile" as such is an artistic invention that makes possible the constitution of individual fantasies. That is why the "Leonardesque smile" is both characteristic of that artist's style and a norm for other painters; it is a kind of type of which the smiles in other works of art can be read as variants. Thus the Mona Lisa's smile is an original inscription, a symbolic substitute for the meaning of an experience in Leonardo's childhood. Yet the model, Mona Lisa, had to smile in order for the work to be possible. For that smile is what allows the return of the repressed, which is tied to Leonardo's relation to his mother in childhood. Moreover, it is this link to the repressed that explains Leonardo's fascination with his model; the seduction was possible only because every perception is preinvested by desire.

Indeed, the reality of the perception is guaranteed only by the artist's attention and his heightened investment of that perception. As Freud says, the return of the repressed is possible only if three conditions are fulfilled: the force of the counterinvestment must be weakened either by morbid processes affecting the ego, or by a redistribution of energy, as happens for example in sleep; the instinctual drives linked to the repressed must be strengthened, as in puberty; and events in the present must produce impressions so similar to the repressed material that they awaken it. In *Moses and Monotheism* Freud writes, "In the last case the recent experience is reinforced by the latent energy of the repressed, and the repressed comes into operation behind the recent experience and with its help" (23:95). In every case, the repressed material presents itself in distorted form both because resistance has been only partially overcome, and because the material has been modified by recent events.

These conditions seem to have been fulfilled in Leonardo's encounter with Mona Lisa, an encounter that repeats and transforms his affective relationship with his mother, and prompts the sketching of forgotten memory

traces in a work of art. Indeed, he meets Mona Lisa at the age of fifty, when there is a resurgence of libido in all men. In Leonardo this altered the play of affects and brought about a redistribution of the energy devoted to science and art. The reawakening of sexuality stimulated creation and lifted the inhibition that had been attached to it.[8] The spectator's fascination with the smile in Leonardo's paintings, like Leonardo's fascination with his model's smile, is explained by the same originary fantasy of the mother's smile. This smile is always already lost, known only later through the very existence of its lack and through the satisfaction brought by the hallucination, the dream, the fantasy, or the work of art. The lack is ever seeking substitutive expressions from which the universal fantasy is structured.

Leonardo's other paintings are all related to the *Mona Lisa*. Together they form a chain of substitutive signifiers which all refer to the same signified—the mother's smile—which exists only in its inscription in the painter's works. All can be read as identical yet differentially related. Freud explains in the following terms why he moves from the study of Mona Lisa's portrait to that of the painting of St. Anne, which he finds "hardly less beautiful."

It would best agree with our expectations if it was the intensity of Leonardo's preoccupation with the features of Mona Lisa which stimulated him to create the composition of St. Anne out of his fantasy. For if the Gioconda's smile called up in his mind the memory of his mother, it is easy to understand how it drove him at once to create a glorification of motherhood, and to give back (*wiederzugeben*) to his mother the smile he had found in the noble lady (11:111–112).

The term "to give back" is obviously very ambiguous here, and seems to imply that the mother initially possessed the smile. However, the context makes it clear that "to give back" means to give for the second time in a work of art, the *St. Anne*. For St. Anne is but another symbolic substitute for the mother. The "gift" is as unconscious as the memory of his mother sparked by the sight of Mona Lisa. What must be understood is that the production of the first work was the occasion for a return of the repressed, which allowed Leonardo to express clearly the fantasies of his childhood history. That is why the second painting was necessary: it repeats the smile of the first, but with a difference that is symptomatic of the lifting of repression performed by the *Mona Lisa*. "But although the smile that plays on the lips of the two women is unmistakably the same as that in the picture of Mona Lisa, it has lost its uncanny (*unheimliche*) and enigmatic (*rätselhaften*) character; what it expresses is inward feeling and quiet blissfulness" (p. 112).

Now the enigmatic and uncanny quality of the smile indicates the re-turn of the repressed; indeed in this context the two terms are equivalent. These qualities are not inherent in certain works of art, as is thought by professional aestheticians who neglect them, but rather are characteristic of all art. . . . A work which depicts the enigma par excellence, however, the mother, is that much more enigmatic yet the uncanniness of the first painting disappears in the second, in which the smile conveys only "quiet blissfulness." That is why the second painting is closer to Leonardo's "his-torical truth" than the first; it displays the specific form of the fantasy whose structuring took place in the first painting. The composition of the painting of St. Anne, so different from the composition of other painters' treatments of the same theme, is explained by Leonardo's life. Hans Fries, Holbein the Elder, and Girolamo dai Libri seat Anne near Mary and place the child between them. Jacob Cornelisz depicts St. Anne as though in a Trinity. Leonardo's Mary, however, is seated on her mother's knees, lean-ing forward and reaching her arms out toward the child who is playing roughly with a lamb. The grandmother is looking at Mary and Jesus with a happy smile. Freud remarks, "Only Leonardo could have painted it, just as only he could have created the fantasy of the vulture. The picture contains the synthesis of the history of his childhood: its *details* are to be explained by reference to the most personal impressions in Leonardo's life" (p. 112; my emphasis).

What is important here is that the impressions in the artist's life have been postulated from the composition of his painting, for it is only after analyzing the *St. Anne* that Freud writes that "his father's mother, Donna Lucia . . . —so we will assume—was no less tender to him than grand-mothers usually are" (p. 113). The synthesis of his childhood history does not precede its disguised production in a work of art. There is another strik-ing detail in this painting about which the art critics have argued without being able to account for it satisfactorily, and which is all the more signifi-cant since it differs from traditional representations of the theme; that is, the fact that the grandmother is pictured as a young woman. Since Leonardo had had, so to speak, two mothers, he gave two mothers to Jesus. The peculiarity of the position of the two women, like the peculiarity of the grandmother's age, expresses the peculiarity of the life of Leonardo, who was raised by his mother and by his step-mother, who was younger than the mother. The *St. Anne* is analogous to the composite formations in dreams: "By combining this fact about his childhood with the one men-tioned above (the presence of his mother and grandmother) and by his

condensing them into a composite unity, the design of 'St. Anne with Two Others' took shape for him" (p. 113).

St. Anne's "blissful smile" is the product of repression, because it marks the artist's denial of his mother's suffering and masks the jealousy she felt when she was forced to give up her son to her rival, just as she had previously given up her husband to her. Just as unconsciously as does the dream, the artist uses the primary processes of combination, condensation, and transformation. The smile in the St. Anne indeed refers back to the same smile as the one in the Mona Lisa, but reveals more clearly, because of its relation to Mary's smile and to Leonardo's repression, that the mother's smile never existed. Though the St. Anne can be understood only in connection with Leonardo's life, it does not translate his life, but is rather a figurative production which is just as original as the manifest content of a dream. One could even say that it is from this painting that the artist could become aware of his fantasy identifying with each other the two women who raised him. In a footnote added to the Leonardo essay in 1919, Freud remarks that it is difficult to trace the outline of the figures of Anne and Mary because they are like badly condensed figures in a dream. Thus what appears to be a technical defect in composition, and causes the painting to be considered "less beautiful" than the Mona Lisa, is justified by its hidden meaning, decipherable only by means of analysis: the two mothers in Leonardo's childhood have fused in his mind into a single form.

In a 1923 footnote, Freud compares the St. Anne in the Louvre to the celebrated London cartoon, where the same material is used to form a different composition. The forms of the two mothers have fused even more completely, and it is difficult to discern the contours of each. Critics have even said that there appear to be two heads emerging from a single body. The date of the cartoon is not known, and Freud mentions in this regard the disagreement among critics who place it variously before the painting and after it. In Freud's view it could only have preceded the painting, for in the London cartoon, the fantasy of unity is expressed almost as in a dream. The painting on the other hand is closer to the material truth, marking an advance in the lifting of repression and a greater acceptance of the reality of the separation of the two women. One can also see in the painting a kind of counterinvestment of the cartoon's meaning, as if Leonardo's anxiety about his own fantasy had made him want to conceal it in his later work. In the same way, during analytic treatment a gain in awareness may have certain repercussions, such as a renewed outbreak of symptoms. Freud leans toward the first hypothesis, suggesting that between the cartoon and

the painting, Leonardo went from a kind of childhood memory, essentially phantasmal in character, to adult memory as it is constituted in the course of analytic treatment. The cartoon corresponds to the time of fantasy, the painting to that of interpretation.

It would fit in excellently with our arguments if the cartoon were to be much the earlier work. It is also not hard to imagine how the picture in the Louvre arose out of the cartoon, while the reverse course of events would make no sense. If we take the composition shown in the cartoon as our starting point, we can see how Leonardo may have felt the need to undo the dream-like fusion of the two women—a fusion corresponding to his childhood memory—and to separate the two heads in space (p. 115n).

Leonardo's procedure, which consists in dissociation by displacement, resembles that of the dream, where a particular formal expression of one of the dream thoughts can organize the formal structure of the dream as a whole. Likewise in the painting, a single modification results in the transformation of the entire composition. The fact that the Virgin is forced to lean in order to hold back the infant Jesus who is escaping from her arms is a mere rationalization analogous to secondary revision in dreams.[9]

The smiles of *St. John the Baptist* and *Bacchus* are variants of the same type (p. 117). These pictures breathe a mystical air into whose secret one dares not penetrate. Nevertheless, Freud tries to establish their relationship to the other works of Leonardo. In his last paintings, the smiles of these androgynous young men, effeminate in their form and fragility, express a great achievement of happiness. Without being ashamed, they nonetheless seem to want to keep the source of this happiness secret, for it arises from a forbidden, homosexual love; "It is possible that in these figures Leonardo has denied the unhappiness of his erotic life and has triumphed over it in his art, by representing the wishes of the boy, infatuated with his mother, as fulfilled in this blissful union of the male and female natures" (pp. 117–118).

Thus in his last works, Leonardo constructed the meaning of his erotic history. Repression is lifted as far as possible but nonetheless remains, as we see from the transformation of affect, the mysteriousness of the smile, and the disguising of homosexuality, which does not explicitly present itself as such. Moreover, Freud suggests that through art, Leonardo was able to triumph over the unhappiness of his erotic life, and that without it, he would have been neurotic. Art frees the artist from his fantasies, just as "artistic creation" circumvents neurosis and takes the place of psychoanalytic treatment. However, it must be said that the treatment has been played out

without being understood. Only the analytic method, taking the work of art as its starting point, can reconstruct the artist's fantasies and their meaning. In this light it is clear why Freud could not accept Pfister's interpretation—wrongly attributed to Freud—according to which the outline of a vulture was discernable in the folds of St. Anne's drapery.[10] Pfister, who was a great admirer of Rorschach,[11] views the work as a picture-puzzle or a projective test; thus to his mind, Leonardo's fantasy of the vulture was projected directly into the work. Freud's note on the subject is full of humor. Despite the interest he acknowledges in Pfister's remark, he appeals to the reader to verify its validity, taking care not to do so himself. In his interpretation, Pfister seems to forget that there is no projection without distortion, and that his case may actually be weakened by the fact that the vulture is so clearly visible in all its details, with its tail pointed straight at the child's mouth, as in Leonardo's fantasy.

The work of art is not the projection of a fantasy, but, on the contrary, a substitute which makes possible its structuring after the fact, allowing the artist to free himself from it. The artwork is the originary inscription of the analytic method, what Freud in "Dostoevsky and Parricide" calls "a confession of its author," but only for those who know how to read it.[12]

—Translated by Winifred Woodhull

12

Camera Lucida: *Reflections on Photography*

Roland Barthes

Roland Barthes (1915–1980) was born into a Protestant family in Cherbourg, in northern France, and taught in the last part of his life at the École Practique des Hautes Études and the Collège de France in Paris.[1] As Barthes describes in his autobiography, *Roland Barthes by Roland Barthes* (1975),[2] his family was descended from a line of petit-bourgeois notaries whose utilitarian approach to language and meaning came to represent the very antithesis of his own. In the 1960s and 1970s, in the eponymous journal of the Tel Quel group,[3] Barthes propagated the notion of "the death of the author" by likening the writing of literature to the activity of reading in the sense of an associative, intertextual practice connected with the unconscious. It was partly on account of this idea that Barthes distanced himself from the political events of 1968, since he believed that its participants, in prioritizing the activities of speech and oration, neglected the pluralism that he associated with that reading.

Barthes was unusual for his time for embracing both high art and popular culture. Initially, he adopted a structuralist approach to these cultural forms, analyzing them in terms of their coded signification, but later it was the experience of *jouissance* situated at the threshold of signification and disappearance that was of importance for his writing. *Camera Lucida: Reflections on Photography* (1980), Barthes's last book, written not long before his death in a road accident, connects this idea of jouissance with the

concept of the *punctum*, an emotional experience of vulnerability and being wounded. In previous essays on photography, notably "The Photographic Message" (1961) and "Rhetoric of the Image" (1964),[4] Barthes proposed that photography, like all other representations whether linguistic or pictorial, communicates by means of culturally formed signs and symbols belonging to a socially shared image repertoire. (In *Camera Lucida*, Barthes refers to the process of reading that this language engenders as that of the *studium*). However, in "Rhetoric of the Image," Barthes also suggested that analogue photography is ultimately "a message without a code," unlike all other representations—including that of art—by virtue of the fact that the direct, indexical traces of light that pass between the subject and the photographic negative bypass any code or linguistic structure. In *Camera Lucida*, Barthes expanded upon the implications of photography's uncanny power to disarm the viewer through "the stupefying evidence of this is how it was." Barthes uses the term *resurrection* to describe photography's peculiar way of representing the past. In this respect, he does not mean resurrection in the sense of reincarnation or of the Christian idea of the dead coming back to life. Rather, it refers to the way in which the subject—here, Barthes's late mother—"let" herself be photographed: "my mother 'lent' herself to the photograph." In this gesture, Barthes recognizes his mother's essence (which lies in her generosity) and her metaphorical death through giving herself up to the photographic image. The experience of witnessing the altruism that constitutes the death of the subject, and that touches Barthes "like the delayed rays of a star,"[5] is unrepresentable, in the same way as the sublime is unrepresentable (the word *lucida* in the title of the book refers to stellar light). This is one of the reasons why Barthes did not reproduce the Winter Garden photograph of his mother in *Camera Lucida*; it also lies behind his wider discussion of the sublime effect of the punctum— "that accident which pricks, bruises me"[6]—in the experience of looking at certain individual photographs. It has even been suggested that the Winter Garden photograph never existed, an idea that does not necessarily contradict the desire in *Camera Lucida* both to write and to write about the experience of unrepresentability[7]—and to associate this experience with pleasure and love. The outcome of this is a text that, in being based upon the author's taste, is highly singular and provisional in character. Such an approach toward the photographic image elides any conventional idea of an ontology of the image.

CAMERA LUCIDA

Now, one November evening shortly after my mother's death, I was going through some photographs. I had no hope of "finding" her, I expected nothing from these "photographs of a being before which one recalls less of that being than by merely thinking of him or her" (Proust). I had acknowledged that fatality, one of the most agonizing features of mourning, which decreed that however often I might consult such images, I could never recall her features (summon them up as a totality). No, what I wanted—as Valéry wanted, after his mother's death—was "to write a little compilation about her, just for myself" (perhaps I shall write it one day, so that, printed, her memory will last at least the time of my own notoriety). Further, I could not even say about these photographs, if we except the one I had already published (which shows my mother as a young woman on a beach of Les Landes, and in which I "recognized" her gait, her health, her glow—but not her face, which is too far away), I could not even say that I loved them: I was not sitting down to contemplate them, I was not engulfing myself in them. I was sorting them, but none seemed to me really "right": neither as a photographic performance nor as a living resurrection of the beloved face. If I were ever to show them to friends I could doubt that these photographs would *speak*.

With regard to many of these photographs, it was History which separated me from them. Is History not simply that time when we were not born? I could read my nonexistence in the clothes my mother had worn before I can remember her. There is a kind of stupefaction in seeing a familiar being dressed *differently*. Here, around 1913, is my mother dressed up—hat with a feather, gloves, delicate linen at wrists and throat, her "chic" belied by the sweetness and simplicity of her expression. This is the only time I have seen her like this, caught in a History (of tastes, fashions, fabrics): my attention is distracted from her by accessories which have perished; for clothing is perishable, it makes a second grave for the loved being. In order to "find" my mother, fugitively alas, and without ever being able to hold on to this resurrection for long, I must, much later, discover in several photographs the objects she kept on her dressing table, an ivory powder box (I loved the sound of its lid), a cut-crystal flagon, or else a low chair, which is now near my own bed, or again, the raffia panels she arranged above the divan, the large bags she loved (whose comfortable shapes belied the bourgeois notion of the "handbag").

Thus the life of someone whose existence has somewhat preceded our own encloses in its particularity the very tension of History, its division.

History is hysterical: it is constituted only if we consider it, only if we look at it—and in order to look at it, we must be excluded from it. As a living soul, I am the very contrary of History, I am what belies it, destroys it for the sake of my own history (impossible for me to believe in "witnesses"; impossible, at least, to be one; Michelet was able to write virtually nothing about his own time). That is what the time when my mother was alive before me is—History (moreover, it is the period which interests me most, historically). No anamnesis could ever make me glimpse this time starting from myself (this is the definition of anamnesis)—whereas, contemplating a photograph in which she is hugging me, a child, against her, I can waken in myself the rumpled softness of her crepe de Chine and the perfume of her rice powder.

And here the essential question first appeared: did I *recognize* her?

According to these photographs, sometimes I recognized a region of her face, a certain relation of nose and forehead, the movement of her arms, her hands. I never recognized her except in fragments, which is to say that I missed her being, and that therefore I missed her altogether. It was not she, and yet it was no one else. I would have recognized her among thousands of other women, yet I did not "find" her. I recognized her differentially, not essentially. Photography thereby compelled me to perform a painful labor; straining toward the essence of her identity, I was struggling among images partially true, and therefore totally false. To say, confronted with a certain photograph, "That's almost the way she was!" was more distressing than to say, confronted with another, "That's not the way she was at all." The almost: love's dreadful regime, but also the dream's disappointing status—which is why I hate dreams. For I often dream about her (I dream only about her), but it is never quite my mother: sometimes, in the dream, there is something misplaced, something excessive: for example, something playful or casual—which she never was; or again I know it is she, but I do not see her features (but do we see, in dreams, or do we know?): I dream about her, I do not dream her. And confronted with the photograph, as in the dream, it is the same effort, the same Sisyphean labor: to reascend, straining toward the essence, to climb back down without having seen it, and to begin all over again.

Yet in these photographs of my mother there was always a place set apart, reserved and preserved: the brightness of her eyes. For the moment it was a quite physical luminosity, the photographic trace of a color, the blue-green of her pupils. But this light was already a kind of mediation which led me toward an essential identity, the genius of the beloved face.

And then, however imperfect, each of these photographs manifested the very feeling she must have experienced each time she "let" herself be photographed: my mother "lent" herself to the photograph, fearing that refusal would turn to "attitude"; she triumphed over this ordeal of placing herself in front of the lens (an inevitable action) with discretion (but without a touch of the tense theatricalism of humility or sulkiness); for she was always able to replace a moral value with a higher one—a civil value. She did not struggle with her image, as I do with mine: she did not suppose herself.

There I was, alone in the apartment where she had died, looking at these pictures of my mother, one by one, under the lamp, gradually moving back in time with her, looking for the truth of the face I had loved. And I found it.

The photograph was very old. The corners were blunted from having been pasted into an album, the sepia print had faded, and the picture just managed to show two children standing together at the end of a little wooden bridge in a glassed-in conservatory, what was called a Winter Garden in those days. My mother was five at the time (1898), her brother seven. He was leaning against the bridge railing, along which he had extended one arm; she, shorter than he, was standing a little back, facing the camera; you could tell that the photographer had said, "Step forward a little so we can see you"; she was holding one finger in the other hand, as children often do, in an awkward gesture. The brother and sister, united, as I knew, by the discord of their parents, who were soon to divorce, had posed side by side, alone, under the palms of the Winter Garden (it was the house where my mother was born, in Chennevières-sur-Marne).

I studied the little girl and at last rediscovered my mother. The distinctness of her face, the naive attitude of her hands, the place she had docilely taken without either showing or hiding herself, and finally her expression, which distinguished her, like Good from Evil, from the hysterical little girl, from the simpering doll who plays at being a grownup—all this constituted the figure of a sovereign innocence (if you will take this word according to its etymology, which is: "I do no harm"), all this had transformed the photographic pose into that untenable paradox which she had nonetheless maintained all her life: the assertion of a gentleness. In this little girl's image I saw the kindness which had formed her being immediately and forever, without her having inherited it from anyone; how could this kindness have proceeded from the imperfect parents who had loved her so badly—in short: from a family? Her kindness was specifically out-of-play, it belonged to no system, or at least it was located at the limits of a morality (evangelical,

for instance); I could not define it better than by this feature (among others): that during the whole of our life together, she never made a single "observation." This extreme and particular circumstance, so abstract in relation to an image, was nonetheless present in the face revealed in the photograph I had just discovered. "Not a just image, just an image," Godard says. But my grief wanted a just image, an image which would be both justice and accuracy—*justesse*: just an image, but a just image. Such, for me, was the Winter Garden Photograph.

For once, photography gave me a sentiment as certain as remembrance, just as Proust experienced it one day when, leaning over to take off his boots, there suddenly came to him his grandmother's true face, "whose living reality I was experiencing for the first time, in an involuntary and complete memory." The unknown photographer of Chennevières-sur-Marne had been the mediator of a truth, as much as Nadar making of his mother (or of his wife—no one knows for certain) one of the loveliest photographs in the world; he had produced a supererogatory photograph which contained more than what the technical being of photography can reasonably offer. Or again (for I am trying to express this truth) this Winter Garden Photograph was for me like the last music Schumann wrote before collapsing, that first Gesang der Frühe which accords with both my mother's being and my grief at her death; I could not express this accord except by an infinite series of adjectives, which I omit, convinced however that this photograph collected all the possible predicates from which my mother's being was constituted and whose suppression or partial alteration, conversely, had sent me back to these photographs of her which had left me so unsatisfied. These same photographs, which phenomenology would call "ordinary" objects, were merely analogical, provoking only her identity, not her truth; but the Winter Garden Photograph was indeed essential, it achieved for me, utopically, *the impossible science of the unique being.*

Nor could I omit this from my reflection: that I had discovered this photograph by moving back through Time. The Greeks entered into Death backward: what they had before them was their past. In the same way I worked back through a life, not my own, but the life of someone I love. Starting from her latest image, taken the summer before her death (so tired, so noble, sitting in front of the door of our house, surrounded by my friends), I arrived, traversing three-quarters of a century, at the image of a child: I stare intensely at the Sovereign Good of childhood, of the mother, of the mother-as-child. Of course I was then losing her twice over, in her final fatigue and

in her first photograph, for me the last; but it was also at this moment that everything turned around and I discovered her *as into herself* (*eternity changes her*, to complete Mallarmé's verse).

This movement of the Photograph (of the order of photographs) I have experienced in reality. At the end of her life, shortly before the moment when I looked through her pictures and discovered the Winter Garden Photograph, my mother was weak, very weak. I lived in her weakness (it was impossible for me to participate in a world of strength, to go out in the evenings; all social life appalled me). During her illness, I nursed her, held the bowl of tea she liked because it was easier to drink from than from a cup; she had become my little girl, uniting for me with that essential child she was in her first photograph. In Brecht, by a reversal I used to admire a good deal, it is the son who (politically) educates the mother; yet I never educated my mother, never converted her to anything at all; in a sense I never "spoke" to her, never "discoursed" in her presence, for her; we supposed, without saying anything of the kind to each other, that the frivolous insignificance of language, the suspension of images must be the very space of love, its music. Ultimately I experienced her, strong as she had been, my inner law, as my feminine child. Which was my way of resolving Death. If, as so many philosophers have said, Death is the harsh victory of the race, if the particular dies for the satisfaction of the universal, if after having been reproduced as other than himself, the individual dies, having thereby denied and transcended himself, I who had not procreated, I had, in her very illness, engendered my mother. Once she was dead I no longer had any reason to attune myself to the progress of the superior Life Force (the race, the species). My particularity could never again universalize itself (unless, utopically, by writing, whose project hence forth would become the unique goal of my life). From now on I could do no more than await my total, undialectical death.

That is what I read in the Winter Garden Photograph.

Something like an essence of the Photograph floated in this particular picture. I therefore decided to "derive" all Photography (its "nature") from the only photograph which assuredly existed for me, and to take it somehow as a guide for my last investigation. All the world's photographs formed a Labyrinth I knew that at the center of this Labyrinth I would find nothing but this sole picture, fulfilling Nietzsche's prophecy: "A labyrinthine man never seeks the truth, but only his Ariadne." The Winter Garden Photograph was my Ariadne, not because it would help me discover a secret thing (monster

or treasure), but because it would tell me what constituted that thread which drew me toward Photography. I had understood that henceforth I must interrogate the evidence of Photography, not from the viewpoint of pleasure, but in relation to what we romantically call love and death.

(I cannot reproduce the Winter Garden Photograph. It exists only for me. For you, it would be nothing but an indifferent picture, one of the thousand manifestations of the "ordinary"; it cannot in any way constitute the visible object of a science; it cannot establish an objectivity, in the positive sense of the term; at most it would interest your *studium:* period, clothes, photogeny; but in it, for you, no wound.)

From the beginning, I had determined on a principle for myself: never to reduce myself-as-subject, confronting certain photographs, to the disincarnated, disaffected socius which science is concerned with. This principle obliged me to "forget" two institutions: the Family, the Mother.

An unknown person has written me: "I hear you are preparing an album of family photographs" (rumor's extravagant progress). No: neither album nor family. For a long time, the family, for me, was my mother and, at my side, my brother; beyond that, nothing (except the memory of grandparents); no "cousin," that unit so necessary to the constitution of the family group. Besides, how opposed I am to that scientific way of treating the family as if it were uniquely a fabric of constraints and rites: either we code it as a group of immediate allegiances or else we make it into a knot of conflicts and repressions. As if our experts cannot conceive that there are families "whose members love one another."

And no more than I would reduce my family to the Family, would I reduce my mother to the Mother. Reading certain general studies, I saw that they might apply quite convincingly to my situation: commenting on Freud (Moses and Monotheism), J. J. Goux explains that Judaism rejected the image in order to protect itself from the risk of worshipping the Mother; and that Christianity, by making possible the representation of the maternal feminine, transcended the rigor of the Law for the sake of the Image-Repertoire. Although growing up in a religion without-images where the Mother is not worshipped (Protestantism) but doubtless formed culturally by Catholic art, when I confronted the Winter Garden Photograph I gave myself up to the Image, to the Image-Repertoire. Thus I could understand my generality; but having understood it, invincibly I escaped from it. In the Mother, there was a radiant, irreducible core: my mother. It is always maintained that I should suffer more because I have spent my whole life with

her; but my suffering proceeds from *who she was*; and it is because she was who she was that I lived with her. To the Mother-as-Good, she had added that grace of being an individual soul. I might say, like the Proustian Narrator at his grandmother's death: "I did not insist only upon suffering, but upon respecting the originality of my suffering"; for this originality was the reflection of what was absolutely irreducible in her, and thereby lost forever. It is said that mourning, by its gradual labor, slowly erases pain; I could not, I cannot believe this; because for me, Time eliminates the emotion of loss (I do not weep), that is all. For the rest, everything has remained motionless. For what I have lost is not a Figure (the Mother), but a being; and not a being, but a *quality* (a soul): not the indispensable, but the irreplaceable. I could live without the Mother (as we all do, sooner or later); but what life remained would be absolutely and entirely *unqualifiable* (without quality).

What I had noted at the beginning, in a free and easy manner, under cover of method, i.e., that every photograph is somehow co-natural with its referent, I was rediscovering, overwhelmed by the truth of the image. Henceforth I would have to consent to combine two voices: the voice of banality (to say what everyone sees and knows) and the voice of singularity (to replenish such banality with all the élan of an emotion which belonged only to myself). It was as if I were seeking the nature of a verb which had no infinitive, only tense and mode.

First of all I had to conceive, and therefore if possible express properly (even if it is a simple thing) how photography's referent is not the same as the referent of other systems of representation. I call "photographic referent" not the *optionally* real thing to which an image or a sign refers but the *necessarily* real thing which has been placed before the lens, without which there would be no photograph. Painting can feign reality without having seen it. Discourse combines signs which have referents, of course, but these referents can be and are most often "chimeras." Contrary to these imitations, in Photography I can never deny that *the thing has been there*. There is a superimposition here: of reality and of the past. And since this constraint exists only for Photography, we must consider it, by reduction, as the very essence, the *noeme* of Photography. What I intentionalize in a photograph (we are not yet speaking of film) is neither Art nor Communication, it is Reference, which is the founding order of Photography.

The name of Photography's *noeme* will therefore be: "That-has-been," or again: the Intractable. In Latin (a pedantry necessary because it illuminates

certain nuances), this would doubtless be said: *interfuit*: what I see has been here, in this place which extends between infinity and the subject (*operator* or *spectator*); it has been here, and yet immediately separated; it has been absolutely, irrefutably present, and yet already deferred. It is all this which the verb *intersum* means.

In the daily flood of photographs, in the thousand forms of interest they seem to provoke, it may be that the *noeme "That-has-been"* is not re-pressed (a *noeme* cannot be repressed) but experienced with indifference, as a feature which goes without saying. It is this indifference which the Winter Garden Photograph had just roused me from. According to a para-doxical order—since usually we verify things before declaring them "true"—under the effect of a new experience, that of intensity, I had induced the truth of the image, the reality of its origin; I had identified truth and reality in a unique emotion, in which I henceforth placed the nature—the genius—of Photography, since no painted portrait, supposing that it seemed "true" to me, could compel me to believe its referent had really existed.

13

Giotto's Joy
Holbein's Dead Christ

———————

Julia Kristeva

Julia Kristeva was born in 1941 in Bulgaria but left the Soviet-dominated state in 1965 and settled in Paris, where she continues to work as a psychoanalyst and academic at the University of Paris VII. She was a member of the leftist intellectual group associated with the literary journal *Tel Quel* in the 1960s and 1970s, when she developed a poststructuralist approach to semiology as a radical challenge to patriarchal notions of identity and representation.

In much of her work, including the accompanying passages of writing, "Giotto's Joy,"[1] Kristeva investigates experience beyond patriarchal representation—"something that is more-than-speech"—through Barthes's and Lacan's idea of a sublime conjoining of pain and pleasure termed *jouissance*. In French, jouissance means, variously ecstasy, orgasm, and an extreme, even violent kind of joy; Kristeva's use of the term encompasses these meanings while also indicating an experience of loss in excess of the subject. Kristeva situates the origins of jouissance in the child's formative sentient experiences in the womb and in the relationship of the mother and child prior to the Freudian "law of the Father," imparted through the acquisition of language and the dialectical position of the subject as outlined by Jacques Lacan in his essay "The Mirror Stage as Formative of the Function of the *I*" (chapter 8). As a way of indicating a new understanding of semiology, Kristeva refers to the constitutive space of experience beyond patriarchal law as a semiotic space.

In the visual arts, Giotto's fresco cycles of the lives of the Virgin Mary and Christ at Padua (ca. 1306) exemplify Kristeva's notion of the semiotic and, as such, offer a reading that contrasts with standard art historical interpretations of the artist's work. The overlapping, fragmented blocks of the frescoes' scenery at Padua (fields, landscape, architecture) creates an antagonistic space. The dominant color in the chapel is blue, but it is mixed with subtle complementary tones that create harmony and transition across the fragmented scenery. Kristeva describes how a sense of depth is achieved through the "treatment and juxtapositions of masses of color" that ultimately exceed any basis in perspective (the invention of which Giotto is often credited). Kristeva associates perspective and the idea of a centered viewing subject situated outside the image with a patriarchal desire to circumscribe space. However, in Giotto's frescoes, "color tears these figures away from the wall's plane, giving them a depth related to, but also distinct from, a search for perspective." Jouissance characterizes the overthrow of paternal authority through fragmentation and dissolution conveyed in the color and rhythm of Giotto's art as this merges with the viewing subject in the chapel.

In other writings, Kristeva's exploration of jouissance gives way to different kinds of experience beyond patriarchal representation: for instance, that of abjection in *Powers of Horror: An Essay on Abjection* (1980)[2] and, in *Black Sun: Depression and Melancholia* (1987), an abyssal melancholy encountered in writers such as Dostoyevsky and Marguerite Duras and the artist Hans Holbein. Utterly austere and lacking in any sense of Christian hope for life after death, Holbein's painting *The Body of the Dead Christ in the Tomb* (1522), Kristeva argues, is unrelated to contemporary pictorial traditions and is not even comparable to the artist's own ironic images of the *danse macabre*. The painting is not a representation, as such, more a blank or discontinuity: "the deepest abyss of severance," says Kristeva, quoting Hegel. Kristeva believes that the void exemplified by Holbein's painting is derived from the unconscious, where language and sense are overwhelmed by a profound sorrow originating from the child's conflicts with, and separation from, the Mother.

GIOTTO'S JOY

How can we find our way through what separates words from what is both without a name and more than a name: a painting? What is it that we are

trying to go through? The space of the very act of naming? At any rate, it is not the space of "first naming," or of the incipient naming of the *infans*; nor is it the one that arranges into signs what the subject perceives as separate reality. In the present instance, the painting is already there. A particular "sign" has already come into being. It has organized "something" into a painting with no hopelessly *separate* referent; or rather, the painting is its own reality. There is also an "I" speaking, and any number of "I's" speaking differently before the "same" painting. The question, then, is to insert the signs of language into this already-produced reality-sign—the painting; we must open out, release, and set side by side what is compact, condensed, and meshed. We must then find our way through what separates the place where "I" speak, reason, and understand from the one where something functions in addition to my speech: something that is more-than-speech, a meaning to which space and color have been added. We must develop, then, a second-stage naming in order to name an excess of names, a more-than-name become space and color—a painting. We must retrace the speaking thread, put back into words that from which words have withdrawn.

My choice, my desire to speak of Giotto (1267–1336)—if justification be needed—relates to his experiments in architecture and color (his translation of instinctual drives into colored surface) as much as to his place within the history of Western painting. (He lived at a time when the die had not yet been cast, when it was far from sure that all lines would lead toward the unifying, fixed center of perspective.)

Padua's Blue

Blue is the first color to strike the visitor as he enters into the semidarkness of the Arena Chapel. Unusual in Giotto's time because of its brilliance, it contrasts strongly with the somber coloring of Byzantine mosaics as well as with the colors of Cimabue or the Sienese frescoes.[3]

The delicate, chromatic nuances of the Padua frescoes barely stand out against this luminous blue. One's first impression of Giotto's painting is of a colored substance, rather than form or architecture; one is struck by the light that is generated, catching the eye because of the color blue. Such a blue takes hold of the viewer at the extreme limit of visual perception.

In fact, Johannes Purkinje's law states that in dim light, short wavelengths prevail over long ones; thus, before sunrise, blue is the first color to appear. Under these conditions, one perceives the color blue through the rods of the retina's periphery (the serrated margin), while the central element

containing the cones (the fovea) fixes the object's image and identifies its form. A possible hypothesis, following André Broca's paradox,[4] would be that the perception of blue entails not identifying the object; that blue is, precisely, on this side of or beyond the object's fixed form; that it is the zone where phenomenal identity vanishes. It has also been shown that the fovea is indeed that part of the eye developed latest in human beings (sixteen months after birth)[5] This most likely indicates that centered vision—the identification of objects, including one's own image (the "self" perceived at the mirror stage between the sixth and eighteenth month)—comes into play after color perceptions. The earliest appear to be those with short wavelengths, and therefore the color blue. Thus all colors, but blue in particular, would have a noncentered or decentering effect, lessening both object identification and phenomenal fixation. They thereby return the subject to the archaic moment of its dialectic, that is, before the fixed, specular "I," but while in the process of becoming this "I" by breaking away from instinctual, biological (and also maternal) dependence. On the other hand, the chromatic experience can then be interpreted as a repetition of the specular subject's emergence in the already constructed space of the understanding (speaking) subject; as a reminder of the subject's conflictual constitution, not yet alienated into the set image facing him, not yet able to distinguish the contours of others or his own other in the mirror. Rather, the subject is caught in the acute contradiction between the instincts of self-preservation and the destructive ones, within a limitless pseudoself, the conflictual scene of primary narcissism and autoerotism[6] whose clashes could follow any concatenation of phonic, visual, or spectral differences.

Oblique Constructions and Chromatic Harmony

The massive irruption of bright color into the Arena Chapel frescoes, arranged in soft but contrasting hues, gives a sculptural *volume* to Giotto's figures, often leading to comparisons with Andrea Pisano. That is, color tears these figures away from the wall's plane, giving them a depth related to, but also distinct from, a search for perspective. The treatment and juxtaposition of masses of color, transforming surface into volume, is of capital importance to the architectonics of the Padua frescoes; the surface is cut into prisms whose edges clash but, avoiding the axial point of perspective, are articulated as obliquely positioned, suspended blocks.

This conflictual aspect of Giotto's pictorial space has already been noted.[7] In fact, 75 percent of the Padua frescoes display obliquely set blocks: a room viewed from an angle, a building depicted from outside at a given angle, a

profile of a mountain, the diagonal arrangement of characters, and so on. These examples attest to Giotto's geometric investigations on the properties of squares and rectangles. Frontal settings are relatively rare, whereas oblique spatial constructions dominate the entire narrative cycle, although to varying degrees, frequently tending to merge with the plane of the wall (as in *The Last Supper*).

In short, Giotto avoids frontal settings as well as vanishing points: conflicting oblique lines indicate that the central viewpoint is not in any fresco, but rather in the space of the building where the painter or viewer is standing. These frescoes, with evanescent or exterior centers, articulated by means of the orthogonals' *aggressive patterns*, reveal a spatial organization very unlike the one adopted by perspective-dominated "realist" art. According to John White, this conflictual organization of pictorial space appears only in Islamic or Chinese art—and there only rarely—in the form of "carpets" or "tables" seen from above, the normal viewpoint being avoided within such "spatial" organizations.[8] On the other hand, Giotto's oblique compositions are sustained by the subject's axial point outside of the image. The fresco is thus without autonomy, impossible to isolate from the narrative series; but neither can it be separated from the building's volume, or severed from the hand tracing it. Each fresco, therefore, is the transposition of this volume and subject into an act that is not yet alienated to the facing facet, within the image in perspective. . . .

How do colors participate in this both antagonistic and harmonized space?

Two workings of color may easily be distinguished at Padua: first, in the scenery (field, landscape, architecture); and second, in the make up of human figures and interiors.

The blue field dominates the scenery. The oblique or frontal planes of the blocks stand out from this background either through the use of colors close to blue (green, grayish-green: for example, in *The Annunciation to Anna*) or contrasting with it (rose and pinkish gray, for example, in *The Meeting at the Golden Gate*; or gold and golden-rose in *The Betrothal of the Virgin*). Interiors that are set frontally are surrounded by square or lateral planes painted rose or yellow (*The Mocking of Christ*). The blue-green relation dominates the upper frescoes, whereas the blue-rose or blue-gold one appears more frequently in the lower registers. Once again, Giotto seemingly wants to facilitate the natural perception of a viewer standing at the center of the somber church. The less visible upper registers are consequently done in blue-green, while the lower ones, more accessible to daylight, accentuate

gilded-rose colors, which are, in fact, the first perceived under increased lighting.

In every case, however, the antagonistic space of the overlapping, fragmented blocks is achieved through the confrontation of colored surfaces: either through colors of the same hue with the addition of complementary tones (for example, the pink roof in *The Annunciation to Anna*), or directly through complementary chromatic scales.

What is important is that, except for the basic blues, all other hues are particularly refined and *very light*. It seems as if the distribution of colored masses reflected a search for the *smallest possible difference* capable of shattering a homogeneous background. Such a difference is precisely what causes spatial conflictivity to be perceived without violence—as harmony and transition.

This becomes even more evident in the treatment of human figures.

On the one hand, each mass of color is unfolded into its variants. For example, the colors of clothing are opened out through the realistic effect of drapery folds into variations of pink absorbing gray, white, and green, thus molding a cape. These variants are infinitesimal differentials within the already subtly different light hues of Giotto's palette. In some instances they recall the subdued colorings of Chinese prints, where a text supports the signified, while color seeks out barely perceptible differences, minute retinal sensations charged with the least "semantic latency." These "folds of color" are confrontations between one color and the complete chromatic scale: while each color remains dominant in its various mixtures, it is also *differently* and *indefinitely attenuated*. The conflict within a color moving toward white—an effect of pure brilliance—provides each color and, therefore, each framed surface, with a sense of volume. This rounded, sculptural aspect of Giotto's figures strikes one immediately. The curves of the drawing (oval shape of the heads, rounded fullness of the bodies) repeat the oval-shaped, colored masses (deformed and drawn out spheres and cylinders). Roundness becomes chromatic and independent of the curved drawing itself. The line seems guided by unfolding color and merely follows it, accentuates it, settles it, identifies it when color defies fixed objects, and in short, distinguishes it from adjoining spheres and colors. These masses of color become spherical through their own self-differentiation; set within an angular space of blocks and squares, they serve as transition between clashing surfaces. In fact, and more effectively than the clashing surfaces, these masses of color generate the volume of the painted surface. The colors of colliding surfaces thus delineate the edges of such cubed space,

while the colors of each figure give volume to and round out this conflict between blocks. Color thus succeeds in shaping a space of conflicts, a space of noncentered, unbordered and unfixed transitions, but a space turned inward.

In addition and at the same time, these voluminous colors, as they come into being by intermixing and detaching themselves from the entire spectrum, become articulated with one another either by close contrast (at the same end of the spectrum) or by truly diverging contrast (complementary colors). Thus, in *The Massacre of the Innocents* at Assisi we have the following sequence: brick red–pink–bordeaux–green–white–lavender–white–green–red–pink–lavender–blue (like the field) –red–gold. To simplify, if we designate red by A, blue by B, and yellow by C, the following arrangement may be seen.

Relatively limited differences appear at the beginning (red–pink): A; there is then a jump to the other end of the spectrum (green): B; an echo of the beginning (lavender): A_1; again, a return to the opposite side (green): B_1; its opposite (red): A_2 will be varied until it reaches only a slight difference in hue (pink-lavender): $A_3 = B_3$ before another return to the opposite (blue): B_4 (=field) opposed in turn by red: A_4 before the final C.

Thus, we have: $A–B–A_1–B_2–A_2–A_3=B_3–B_4–A_4–C$.

The arrangement, whose "model" could very well be a multi-faceted gem, is both conflictual and serial. In fact, the geometry represented in the same fresco includes two prismatic towers with their facets obliquely set.

The chromatic treatment of characters produces a plastic effect confirming this geometry. It also adds a harmonization of delineated surfaces and an impression of volume within the colored surfaces themselves. This is done solely by virtue of the colors' own resources, without recourse to geometric determination. Volume is produced by juxtaposing unfolding chromatic differences alone without the assistance of rigid contours. The painter uses drawings and lines, but he coats them, suffuses them with colored matter so that they break away from strictly chromatic differentiation.

By overflowing, softening, and dialecticizing lines, color emerges inevitably as the "device" by which painting gets away from identification of objects and therefore from realism. As a consequence, Giotto's chromatic experiments prefigure a pictorial practice that his immediate followers did not pursue. This practice aspires not to figural representation, but rather, to the resources of the chromatic scale, which then extrapolate, as we have suggested, the instinctual and signifying resources of the speaking subject. For this chromatic system—so crowded with figures, landscape, and

mythical scenes—appears void of figuration if viewed at length and atten-
tively. It is like a setting side by side of chromatic differences that throb into
a third dimension. Such a chromatic working, therefore, erases angles, con-
tours, limits, placements, and figurations, but reproduces the *movement* of
their confrontation.

Color, arranged in this manner, is a compact and plurifunctional ele-
ment, not conforming to the localization-identification-placement of phe-
nomena and/or their (or any) ultimate meaning; it acts upon the subject's
station point outside of the painting rather than projecting him into it. This
painting, then, reaches completion within the viewer. It steers the subject
towards a systematic cutting through its foreclosure, because it has been
set in motion starting from "retinal sensation," their instinctual basis, and
the superimposed signifying apparatus. Is this not precisely the "mecha-
nism" of jouissance whose economy Freud locates in the process of re-
moving prohibition by making one's way through it (in his studies on
another phenomenon of "bewilderment": witticism, in *Jokes and Their
Relation to the Unconscious*)?

Let me emphasize, in summing up, that this working one's way through
is rigorously regulated by a juxtaposition of differences in volume that oper-
ates along two converging paths. On the one hand, it brings into play the
geometric possibilities of squares and blocks (their conflict); on the other, it
explores the infinitesimal chromatic difference that produces a three-
dimensional effect from a colored surface and the opposing or serial alter-
nation of such volumes due to an "element" already indicating volume: the
triple register of color (as suggested above) in relation to the sign.

—Translated by Thomas Gora, Alice Jardine, and Leon S. Roudiez

HOLBEIN'S DEAD CHRIST

A Composition in Loneliness

Italian iconography embellishes, or at least ennobles, Christ's face during
the Passion but especially surrounds it with figures that are immersed in
grief as well as in the certainty of the Resurrection, as if to suggest the atti-
tude we should ourselves adopt facing the Passion. Holbein, on the con-
trary, leaves the corpse strangely alone. It is perhaps that isolation—an *act
of composition*—that endows the painting with its major melancholy burden,
more so than delineation and coloring. To be sure, Christ's suffering is ex-

pressed through three components inherent in lines and colors: the head bent backwards, the contortion of the right hand bearing the stigmata, the position of the feet—the whole being bonded by means of a dark palette of grays, greens, and browns. Nevertheless, such realism, harrowing on account of its very parsimony, is emphasized to the utmost through the painting's composition and location: a body stretched out alone, situated above the viewers, and separated from them.

Cut off from us by its base but without any prospect toward heaven, for the ceiling in the recess comes down low, Holbein's *Dead Christ* is inaccessible, distant, but without a beyond. It is a way of looking at mankind from afar, even in death—just as Erasmus saw folly from a distance. It is a vision that opens out not on glory but on endurance. Another, a new morality resides in this painting.

Christ's dereliction is here at its worst: forsaken by the Father, he is apart from all of us. Unless Holbein, whose mind, pungent as it was, does not appear to have lead him across the threshold of atheism, wanted to include us, humans, foreigners, spectators that we are, forthrightly in this crucial moment of Christ's life. With no intermediary, suggestion, or indoctrination, whether pictorial or theological, other than our ability to imagine death, we are led to collapse in the horror of the caesura constituted by death or to dream of an invisible beyond. Does Holbein forsake us, as Christ, for an instant, had imagined himself forsaken? Or does he, on the contrary, invite us to change the Christly tomb into a living tomb, to participate in the painted death and thus include it in our own life, in order to live with it and make it live? For if the living body, in opposition to the rigid corpse, is a dancing body, doesn't our life, through identification with death, become a "danse macabre," in keeping with Holbein's other well-known depiction?

This enclosed recess, this well-isolated coffin simultaneously rejects us and invites us. Indeed, the corpse fills the entire field of the painting, without any labored reference to the Passion. Our gaze follows the slightest physical detail, it is, as it were, nailed, crucified, and is riveted to the hand placed at the center of the composition. Should it attempt to flee it quickly stops, locked in at the distressed face or the feet propped against the black stone. And yet such walling in allows two prospects.

On the one hand, there is the insertion of date and signature, *MDXXII H. H.,* at Christ's feet. Placing the painter's name, to which was often added that of the donor, in that position was common at the time. It is nevertheless possible that in abiding by that code Holbein inserted himself into the drama of the Dead body. A sign of humility: the artist throwing himself at

God's feet? or a sign of equality? The painter's name is not lower than Christ's body—they are both at the same level, jammed into the recess, united in man's death, in death as the essential sign of humanity, of which the only surviving evidence is the ephemeral creation of a picture drawn here and now in 1521 and 1522!

We have, on the other hand, this hair and this hand that extend beyond the base as if they might slide over toward us, as if the frame could not hold back the corpse. The frame, precisely, dates from the end of the sixteenth century and includes a narrow edging bearing the inscription *Jesus Nazarenus Rex Judaeorum*, which encroaches upon the painting. The edging, which seems nonetheless always to have been part of Holbein's painting, includes, between the words of the inscription, five angels bearing the instruments of the martyrdom: the shaft, the crown of thorns, the scourge, the flogging column, the cross. Integrated afterwards in that symbolic framework, Holbein's painting recovers the evangelical meaning that it did not insistently contain in itself, and which probably legitimized it in the eyes of its purchasers.

Even if Holbein's painting had originally been conceived as a predella for an altarpiece, it remained alone; no other panel was added to it. Such isolation, as splendid as it is gloomy, avoided Christian symbolism as much as the surfeit of German Gothic style, which would combine painting and sculpture but also add wings to altarpieces, aiming for syncretism and the imparting of motion to figures. In the face of that tradition, which directly preceded him, Holbein isolated, pruned, condensed, reduced.

Holbein's originality lies then in a vision of Christly death devoid of pathos and Intimist on account of its very banality. Humanization thus reached its highest point: the point at which glory is obliterated by means of graphics. When the dismal brushes against the nondescript, the most disturbing sign is the most ordinary one. Contrasting with Gothic enthusiasm, humanism and parsimony were the inverted products of melancholia. . . .

Representing "Severance"

Hegel brought to the fore the dual action of death in Christianity: on the one hand there is a natural death of the natural body; on the other, death is "infinite love," the "supreme renunciation of self for the sake of the Other." He sees in it a victory over the tomb, the *sheol*, a "death of death," and emphasizes the dialectic that is peculiar to such a logic. "This negative movement, which belongs to Spirit only as Spirit, is inner conversion and change . . . the end being resolved in splendor, in the feast honoring the reception of the

human being into the divine Idea."[9] Hegel stresses the consequences of this action for representation. Since death is represented as being natural but realized only on condition that it be identified with its otherness, that is, divine Idea, one witnesses "a marvellous union of these absolute extremes," "a supreme alienation of the divine Idea. . . . 'God is dead, God himself is dead' is a marvellous, fearsome representation, which offers to representation the deepest abyss of severance."[10]

Leading representation to the heart of that severance (natural death *and* divine love) is a wager that one could not make without slipping into one or the other of two tendencies: Gothic art, under Dominican influence, favored a pathetic representation of natural death; Italian art, under Franciscan influence, exalted, through the sexual beauty of luminous bodies and harmonious compositions, the glory of the beyond made visible through the glory of the sublime. Holbein's *Body of the Dead Christ in the Tomb* is one of the rare if not a unique realization located at the very place of the severance of representation of which Hegel spoke. The Gothic eroticism of paroxysmal pain is missing, just as the promise of the beyond or the renascent exaltation of nature are lacking. What remains is the tightrope—as the represented body—of an economical, sparing graphic rendition of pain held back within the solitary meditation of artist and viewer. To such a serene, disenchanted sadness, reading the limits of the insignificant, corresponds a painterly art of utmost sobriety and austerity. It presents no chromatic or compositional exultation but rather a mastery of harmony and measure.

Is it still possible to paint when the bonds that tie us to body and meaning are severed? Is it still possible to paint when *desire*, which is a bond, disintegrates? Is it still possible to paint when one identifies not with desire but with *severance*, which is the truth of human psychic life, a severance that is represented by death in the imagination and that melancholia conveys as symptom? Holbein's answer is affirmative. Between classicism and mannerism his minimalism is the metaphor of severance: between life and death, meaning and nonmeaning, it is an intimate, slender response of our melancholia.

Pascal confirmed, before Hegel and Freud, the sepulchre's invisibility. For him, the tomb would be Christ's hidden abode. Everyone looks at him on the cross but in the tomb he hides from his enemies' eyes, and the saints alone see him in order to keep him company in an agony that is peace.

Christ was dead, but seen on the cross. He is dead and hidden in the sepulchre.

Christ has been shrouded only by saints.

Christ did not perform a single miracle in the sepulchre.

Saints alone enter there.

That is where Christ assumes a new life, not on the cross.

It is the final mystery of the Passion and the Redemption.

On earth Christ was able to rest nowhere but in the sepulchre.

His enemies ceased working on him only in the sepulchre.[11]

Seeing the death of Christ is thus a way to give it meaning, to bring him back to life. But in the tomb at Basel Holbein's Christ is alone. Who sees him? There are no saints. There is of course the painter. And ourselves. To be swallowed up by death, or perhaps to see it in its slightest, dreadful beauty, as the limit inherent in life. "Christ in grief . . . Christ being in agony and in the greatest sorrow, let us pray longer."[12]

Painting as a substitute for prayer? Contemplating the painting might perhaps replace prayer at the critical place of its appearance—where the nonmeaning becomes significant, while death seems visible and livable.

Like Pascal's invisible tomb, death is not representable in Freud's unconscious. It is imprinted there, however, as noted earlier, by spacings, blanks, discontinuities, or destruction of representation. Consequently, death reveals itself as such to the imaginative ability of the self in the isolation of signs or in their becoming commonplace to the point of disappearing: such is Holbein's minimalism.

—Translated by Leon S. Roudiez

14

Spurs: *Nietzsche's Styles*

Jacques Derrida

Jacques Derrida (1930–2004) is one of the most renowned philosophers of recent history, notable for his "deconstructive" readings of many of the canonical texts of philosophy[1] and for his contribution to debates about politics, ethics, and the arts. Deconstruction—a term Derrida popularized—is a form of analytic reading that opens up the given text to its own assumptions and contradictions so as to highlight the way in which, often despite itself, the text elides definite meaning or interpretation. Extending Saussure's linguistic theories, Derrida emphasized the multiple and, ultimately, limitless nature of signification as "deferred" through space and time. In addition, Derrida argued that "there is nothing outside the text," thereby emphasizing the paradigmatic nature of writing with respect to all representation. In keeping with this approach, he developed a method and style of writing that employs free association, word plays, and puns in a complex stratagem of intertextuality. For Derrida, deconstruction contrasts with what he calls "phallogocentrism," an ideology of fantasized presence and fixed identity rooted in metaphysics and patriarchy.

The accompanying extract from *Spurs: Nietzsche's Styles* (1979) deconstructs both Nietzsche's text "How the 'True World' Finally Became A Fable" (chapter 3) and Heidegger's reading of this text in "Nietzsche's Overturning of Platonism" (chapter 7). In his lectures on Nietzsche's philosophy,

Heidegger addresses the question of whether Nietzsche's thought "over-
turns" or "twists free" from metaphysics and thus exceeds even the idea of
a revolution (*Umdrehung*). While Derrida concurs with Heidegger that
Nietzsche's writing prompts such a reading (see the line, "He was, he loved
this affirming woman"), he is concerned to stress the fact that the "twisting
free" to which Heidegger refers would, by its very nature, exceed any tradi-
tional conception of understanding. Similarly, in so far as Nietzsche's dis-
course on woman may exceed metaphysics, this excess cannot be identi-
fied even by "Nietzsche himself [who] did not see his way too clearly there.
Nor could he, in the instantaneous blink of an eye." Derrida means that
while blinking supports and aids vision, it also impedes it; the condition of
Nietzsche's vision and his insights is to be blind to what is seen—and this
relationship of blindness and vision is the experience of alterity.[2] This con-
tradictory idea is extended by Derrida through two further terms: *hymen*
(the membrane of the vagina at the threshold of the body) and *pharmakon*
(a poison that is also a medicine). Derrida's adoption of these terms help
him to elide any sense in which Nietzsche's and his own writing could be
considered to be unified—and this includes their potential identification as
heterogeneous or parodic forms of writing.

Derrida states at the outset of *Spurs* that his subject is the question of
woman[3] and, more particularly, Nietzsche's discourse on woman. Given
that woman is traditionally associated by patriarchal discourse with artifice
and (a seductive) falsity, this subject is also connected to traditional defini-
tions of art dating back to the philosophy of Plato. Derrida notes the omis-
sion by Heidegger of any commentary upon Nietzsche's statement in sec-
tion 2 of "How the 'True World' Finally Became A Fable" that the idea of the
true world "becomes female" and pursues the implications of this omission
via the problematic of woman and truth. Deconstructing the traditional op-
positions between truth and falsity and between presence and its lack, Der-
rida withdraws the divisions separating the respective terms from each
other (for further discussion of this issue of lack as this relates to castration
anxiety, see chapters 4 and 8). As Derrida shows, phallogocentrism con-
ceives of woman as the negative term of man who lacks an identity of her
own and, therefore, is a potential threat to his purported identity. Derrida
sums up these "positions" in Freudian terms, using the imperfect tense as a
way of introducing an indeterminate element into the statements about
Nietzsche: "He was, he dreaded this castrated woman; He was, he dreaded
this castrating woman." Patriarchy, however illogically, defines woman's fal-
sity as her truth—that is, as a falsity which attempts to conceal the truth that

she *is* false: "In the first of these propositions . . . once as non-truth." For Derrida, it is not a matter of woman claiming an identity for herself, or of adhering to the idea that she lacks any identity, as these positions would slip into a similar logic to patriarchy. Rather, Derrida posits the view that woman is "Other" and, therefore, unrepresentable. (Her) unrepresentability—which is not in any way a lack—overwhelms the subject by negating any claim as to whether woman conceals the truth or does not possess it: "In the instance of the third proposition . . . overthrown." Derrida summarizes this idea in the third of his statements: "He was, he loved this affirming woman." The excerpt concludes with intertextual allusions to Mallarmé, Lautréamont, and Freud. It also refers to the representation of the Jew, as signified by Abraham, which Derrida believes bears similarities with the representation of woman. Finally, as a way of underlining the undecideable nature of writing, Derrida cites a mysterious reference from one of Nietzsche's letters to Maldiva von Meysenburg concerning their "Council of Basel."

SPURS: NIETZSCHE'S STYLES

"History of an Error"

At this point, where it pierces the veil of truth and the simulacrum of castration in order to impale the woman's body, the question of style must be measured against the larger question of the interpretation of Nietzsche's text, of the interpretation of interpretation—in short against the question of interpretation itself. In such a confrontation either the question of style will be resolved, or its very statement will be disqualified.

In taking the measure of that question, however, there is still the Heideggerian reading of Nietzsche which must be accounted for. Whatever the allowances that have been made for it, whatever the efforts that have been exerted (and for recognizable reasons) in France to conceal, evade or delay its falling due, this account too remains unsettled.

Until now I have often repeated the word *castration* without ever appearing to attach it to a text of Nietzsche. Thus it is that I shall return to it here, proceeding, perhaps somewhat startlingly, from the plenums and lacunas, projections and indentations, of a certain Heideggerian landscape. . . .

Heidegger remarks that, although Nietzsche might seem, or perhaps even ought, to employ the method of *Umdrehung,* it is nonetheless apparent

that he "is seeking something else (*etwas anderes sucht*)." [4] In announcing that other which is no longer coupled here in the operation of an inversion, Heidegger refers to the tale, famous ever since, of a singular fabulous plot. It is the story of "How the True World Finally Became a Fable," which is recounted in "The History of an Error" in *Twilight of the Idols* (1888).

Neither Heidegger's commentary nor those many others which in France have lately clarified this text will be developed here. Rather, I shall single out one or two characteristics which, to my knowledge anyway, have not been elaborated (and most particularly by Heidegger himself) and which bear precisely on the (question of the) woman.

In his consideration of the problematic of *Umdrehung* Heidegger emphasizes the very strongest of torsions, that in which the opposition which has been submitted to reversal is itself suppressed. Thus, as the story goes, "with the true world we have also abolished the apparent one (*mit der wahren Welt haben wir auch die scheinbare abgeschafft*)!" In such a tortured movement not only has the hierarchy of the two worlds of the sensible and the intelligible been reversed, but a new hierarchy with its new order of priorities has been affirmed. Its innovation does not consist in a renewal of the hierarchy or the substance of values, but rather in a transformation of the very value of hierarchy itself. Thus Heidegger says that "a new hierarchy (*Rangordnung*) means to transform the hierarchical *schema* (*das Ordnungs*-Schema *verwandeln*)." What must occur then is not merely a suppression of all hierarchy, for anarchy only consolidates just as surely the established order of a metaphysical hierarchy; nor is it a simple change or reversal in the terms of any given hierarchy. Rather, the *Umdrehung* must be a transformation of the hierarchical structure itself.

Heidegger here is pursuing the Nietzschean operation into the very reaches where it exceeds metaphysics and Platonism. But at the same time it would seem that what he is after there is in fact a form of question more proper to a hermeneutic, and consequently philosophical, order, indeed the very order that Nietzsche's operation should have otherwise *put out of order.*

This question, whether Nietzsche actually succeeded in achieving what he most certainly projected and thus "to what extent" he has surmounted Platonism, is for Heidegger a "critical question" (*Fragen der Kritik*) and consequently must be directed by the "re-thinking of Nietzsche's most intimate thinking will," of Nietzsche's most profound intended meaning (*wenn wir Nietzsches innerstem denkerischen Willen nach-gedacht haben*).

Femina vita

Later, perhaps, after a certain detour, we must come about to the moment where the horizon of this Heideggerian question sets the bearing for its most exacting reading, that is, come about in order to stave it in. Which, of course, will be impossible without the intervention of some practiced stiletto (*pratique stylet*). A stylate practice (*pratique stylée*), of course, but of what genre of gender?

For it cannot be written without the conspired plotting between woman and truth. Betwixt woman. And in spite of the profundity which is modesty. As if in its anticipation, several aphorisms precede by a few pages the story of truth in the *Twilight of the Idols: Maxims and Arrows (Sprüche und Pfeile)—*

16. Unter Frauen. "Die Wahrheit? O Sie kennen die Wahrheit nicht! Ist sie nicht ein Attentat auf alle unsere pudeurs?"

"Truth? Oh, you don't know truth. Is it not an attempt to assassinate all our *pudeurs*?"

27. "Man hält das Weib für tief—warum? weil man Hie bei ihm auf den Grund kommt. Das Weib ist noch nicht einmal flach."

"Women are considered profound. Why? Because one never fathoms their depths. Women aren't even shallow."

29. "Wie viel hatte ehemals das Gewissen zu bei;szen! welche guten Zähne hatte es! Und heute? woran fehlte es?" —Fragen eines Zahnarztes.

"How much conscience has had to chew on in the past! And what excellent teeth it had! And today what is lacking?" —A dentist's question.

So goes the *History of an Error*. In each of its six sequences, its six epochs, with the exception only of the third, there are certain words underlined. And in the second epoch, Nietzsche has underlined only the words *sie wird Weib*, "it becomes female."

Heidegger cites this sequence, even respects its underlining, but in his commentary (as seems to be generally the case) he skirts the woman, he abandons her there. Much as one might skip over a sensible image in a philosophy book or tear out an illustrated leaf or allegorical representation in a more serious volume, Heidegger analyzes all the elements of Nietzsche's

text with the sole exception of the idea's becoming-female (*sie wird Weib*). In such a way does one permit oneself to see without reading, to read without seeing.

But if we ourselves should take a closer look at this "*sie wird Weib*" we would not be proceeding in a way *counter to* Heidegger's (such a counter direction is in fact his own). It is not the contrary (which once again would only amount to the very same thing) of what Heidegger is doing that we ourselves are about to do. It is not that we are about to pluck some mythological flower in order to dissect it in some aside or that we are going to reap this flower rather than let it fall where it will.

Instead let us attempt to decipher this *inscription* of *the woman.* Surely its necessity is not one of a concept-less metaphorical or allegorical illustration. Nor could it be that of a pure concept bare of any fantastic designs. Indeed it is clear from the context that it is the idea that becomes woman. The becoming-female is a "process of the idea" (*Fortschritt der Idee*) and the idea a form of truth's self-presentation. Thus the truth has not always been woman nor is the woman always truth. They both have a history; together they both form a history. And perhaps, if history's strict sense has always been so presented in the movement of truth, their history is history itself, a history which philosophy alone, inasmuch as it is included therein, is unable to decode. In the age before this progress in the history of the true-world, the idea was Platonic. And in this, the idea's inaugural moment, the *Umschreibung,* the transcription, the paraphrase of the Platonic statement, was "Ich, Platon, *bin* die Wahrheit," "I, Plato, *am* the truth."

But once this inaugural moment has given way to the second age, here where the becoming-female of the idea is the presence or presentation of truth, Plato can no more say "I am truth." For here the philosopher is no longer the truth. Severed from himself, he has been severed from truth. Whether he himself has been exiled, or whether it is because he has permitted the idea's exile, he can now only follow in its trace. At this moment history begins. Now the stories start. Distance-woman-averts truth-the philosopher. She bestows the idea. And the idea withdraws, becomes transcendent, inaccessible, seductive. It beckons from afar (*in die Ferne*). Its veils float in the distance. The dream of death begins. It is woman.[5]

"The true world-unattainable for now, but promised for the sage, the pious, the virtuous man ('for the sinner who repents'). (Progress of the idea: it becomes more subtle, insidious, incomprehensible—*it becomes female* . . ."

All the emblems, all the shafts and allurements that Nietzsche found in woman, her seductive distance, her captivating inaccessibility, the ever-veiled promise of her provocative transcendence, the *Entfernung*, these all belong properly to a history of truth by way of the history of an error. And then Nietzsche, as if in apposition or as if to explain or analyze the "it becomes female," adds there "*sie wird christlich*" and closes the parenthesis.

In the epoch described by this parenthesis the story's fabulous plot might be somehow linked with the motif of castration in Nietzsche's text, with its enigma of truth's nonpresence.

In fact, what is emblazoned in the "it becomes female . . . Christian" might be shown to be a "she castrates (herself)." Castrated, she castrates and plays at her castration in the parenthetical epoch. She feigns her castration—which is at once suffered and inflicted. From afar she would master the master and with the same blow (in fact "the same thing") that produced his desire, kill him.

A period, a necessary periphrase, has been marked in the history of woman-truth, of woman as truth, of verification and feminization.

But let us turn this page of *Twilight of the Idols* to the one which follows the "History of an Error." Here opens the *Moral als Widernatur*, "Morality as Anti-Nature," in which Christianity will be interpreted as castratism (*Kastratismus*). Thus, such of its operations as the extraction of a tooth or the plucking out of an eye are described by Nietzsche to be precisely Christian operations. It is these, the violations that are perpetrated by the Christian idea, that are the idea become woman. "All the old monsters are agreed on this: *il faut tuer les passions*. The most famous formula for this is to be found in the New Testament, in that Sermon on the Mount, where, incidentally, things are by no means looked at from a height. There it is said, for example, with particular reference to sexuality: "If thy eye offend thee, pluck it out." Fortunately, no Christian acts in accordance with this precept. Destroying the passions and cravings, merely as a preventive measure against their stupidity and the unpleasant consequences of this stupidity—today this itself strikes us as merely another acute form of stupidity. We no longer admire dentists who "pluck out" (*ausreissen*) teeth so that they will not hurt any more. Nietzsche, however, contrasts the extirpation and castration which he finds inherent in Christianity, or at least in the "early Church" (but, one might object, have we ever left the Church?), with the spiritualization of the passion (*Vergeistigung der Passion*). Yet, in opposing these two in this way, Nietzsche seems to be implying that there is no castration operative in such spiritualization. (This is no

doubt a disputable conclusion, but its question will be left open here.) So the Church, the early Church then, the truth of woman-idea, must proceed by way of ablation, excision, extirpation.

"The Church fights passion with excision (*Ausschneidung*, severance, castration) in every sense: its practice, its 'cure,' is castratism. It never asks: 'How can one spiritualize, beautify, deify a craving?' It has at all times laid the stress of discipline on extirpation (*Ausrottung*) (of sensuality, of pride, of the lust to rule (*Herrschsucht*), of avarice (*Habsucht*), of vengefulness (*Rachsucht*). But attack on the roots of passion means an attack on the roots of life: the practice of the church is hostile to life (*lebensfeindlich*)."

Hostile to life, the Church is hostile thus to woman also who is herself life (*femina vita*). And not only is castration the operation that each sex perpetrates against both itself and the other, castration is that very operation of woman contra woman.[6]

"The same means in the fight against a craving—castration, extirpation—is instinctively chosen by those who are too weak-willed, too degenerate, to be able to impose moderation on themselves. . . . One should survey the whole history of the priests and philosophers, including the artists: the most poisonous things against the senses have been said not by the impotent, nor by the ascetics, but by the impossible ascetics, by those who really were in dire need of being ascetics . . ."

"The spiritualization of sensuality is called *love*: it represents a great triumph over Christianity. Another triumph is our spiritualization of *hostility*. It consists in a profound appreciation of the value of having enemies: in short, it means acting and thinking in the opposite way (*umgekehrt*) from that which has been the rule. The church always wanted the destruction of its enemies; we, we immoralists and Antichristians, find our advantage in this, that the church exists. . . . The saint in whom God delights is the ideal eunuch."

Positions

That Nietzsche had no illusions that he might ever know anything of these effects called woman, truth, castration, nor of those *ontological* effects of presence and absence, is manifest in the very heterogeneity of his text. Indeed it is just such an illusion that he was analyzing even as he took care to avoid the precipitate negation where he might erect a simple discourse against castration and its system. For the reversal, if it is not accompanied by a discrete parody, a strategy of writing, or difference or deviation in

quills, if there is no style, no grand style, this is finally but the same thing, nothing more than a clamorous declaration of the antithesis.

Hence the heterogeneity of the text. However, rather than examine here the large number of propositions which treat of the woman, it is instead their principle, which might be resumed in a finite number of typical and matrical propositions, that I shall attempt to formalize—in order to mark then the essential limit of such a codification and the problem that it entails for reading.

Three types of such a statement are to be found. Furthermore, these three fundamental propositions represent three positions of value which themselves derive from three different situations. (And according to a particular sort of investigation (which can be no more than indicated here) these positions of value might in fact be read in the terms (for example) of the psychoanalytic meaning of the word "position." In the first of these propositions the woman, taken as a figure or potentate of falsehood, finds herself censured, debased and despised. In the name of truth and metaphysics she is accused here by the credulous man who, in support of his testimony, offers truth and his phallus as his own proper credentials. There are numerous examples of such a phallogocentric deposition which represent this reactive instance of negation. Similarly, in the second proposition, the woman is censured, debased and despised, only in this case it is as the figure or potentate of truth. In the guise of the Christian, philosophical being she either identifies with truth, or else she continues to play with it at a distance as if it were a fetish, manipulating it, even as she refuses to believe in it, to her own advantage. Whichever, woman, through her guile and naivety (and her guile is always contaminated by naivety), remains nonetheless within the economy of truth's system, in the phallogocentric space. At the head of the prosecution this time is the masked artist who, because he himself still believes in castration, also does not escape the inversion of negation. The woman, up to this point then, is twice castration: once as truth and once as nontruth.

In the instance of the third proposition, however, beyond the double negation of the first two, woman is recognized and affirmed as an affirmative power, a dissimulatress, an artist, a dionysiac. And no longer is it man who affirms her. She affirms herself, in and of herself, in man. Castration, here again, does not take place. And anti-feminism, which condemned woman only so long as she was, so long as she answered to man from the two reactive positions, is in its turn overthrown.

But if these three types of statement are to form an exhaustive code, if their systematic unity is to be reconstructed, the parodying heterogeneity of the style, the styles, should itself be masterable and reducible to the content of a single thesis. On the other hand, and at the same time that these two conditions remain indissociable, each term that is implicated in the three schemata must be *decidable* within an oppositional couple and in such a way that for each term, such as woman, truth, castration, there should exist a counter term.

But the hymen's graphic, that of the pharmakon, without itself being reduced to it, inscribes castration's effect within itself. Everywhere operative, and most especially in Nietzsche's text, this graphic, which describes a margin where the control over meaning or code is without recourse, poses the limit to the relevance of the hermeneutic or systematic question. It is not that it is necessary to choose sides with the heterogeneous or the parody (which would only reduce them once again). Nor, given that the master sense, the sole inviolate sense, is irretrievable, does it necessarily follow that Nietzsche's mastery is infinite, his power impregnable, or his manipulation of the snare impeccable. One cannot conclude, in order to outmaneuver the hermeneutic hold, that his is an infinite calculus which, but that it would calculate the undecidable, is similar to that of Leibniz' God. Such a conclusion, in its very attempt to elude the snare, succumbs all the more surely to it. To use parody or the simulacrum as a weapon in the service of truth or castration would be in fact to reconstitute religion, as a Nietzsche cult for example, in the interest of a priesthood of parody interpreters (*prêtrise de l'interprête ès parodies, interprêtrise*). No, somewhere parody always supposes a naivety withdrawing into an unconscious, a vertiginous non-mastery. Parody supposes a loss of consciousness, for were it to be absolutely calculated, it would become a confession or a law table.

This inability to assimilate—even among themselves—the aphorisms and the rest— perhaps it must simply be admitted that Nietzsche himself did not see his way too clearly there. Nor could he, in the instantaneous blink of an eye. Rather a regular, rhythmic blindness takes place in the text. One will never have done with it. Nietzsche too is a little lost there. But that there is a loss, that anyway is ascertainable, as soon as there is hymen.

Nietzsche might well be a little lost in the web of his text, lost much as a spider who finds he is unequal to the web he has spun. Much as a spider indeed, several spiders even. Nietzsche's spider. Lautréamont's, that of Mallarmé, those of Freud and Abraham.

He was, he dreaded this castrated woman.

He was, he dreaded this castrating woman.

He was, he loved this affirming woman.

At once, simultaneously or successively, depending on the position of his body and the situation of his story, Nietzsche was all of these. Within himself, outside of himself, Nietzsche dealt with so many women. Like in Basel where he held council.

—Translated by Barbara Harlow

15

Hysteria

Gilles Deleuze

Like many French philosophers of his generation, Gilles Deleuze (1925–1995) traced the origins of political and psychic repression to the afflictive influence of metaphysics upon Western thought and discourse. Informed by Nietzsche's philosophy Deleuze proposed that "the enemy of life" lies in the metaphysical dialectic of presence and lack as this shapes the structure of representation.[1] With this in mind, Deleuze mounted a substantial critique of psychoanalysis and its theory of desire, which, he suggested, supports the notion of the subject through a dialectic of desired phallic unity (presence) and repetition driven by lack.[2] In contrast to this dialectical structure, Deleuze developed a theory of desire as a plurality of inventions, singularities, and forces.[3] The consequence of this conception is that, in *Francis Bacon: The Logic of Sensation* (1981), Bacon's paintings are viewed not as hysterical expressions of the unconscious, but as polymorphous visceral experiences exceeding any system of representational logic or ideal of pure presence.

Deleuze's text offers an affirmative reading of the pathological condition of hysteria, as applied to Bacon's paintings, through Antonin Artaud's idea of "the body without organs."[4] This idea is opposed to a conception of the body as an organism understood as unified and coordinated, within which the parts of the body—its "organs"—are conceived of as constituent and subordinate elements. Deleuze identifies Artaud's libidinal conception of

the body with his own idea of a plurality of irreducible forces in movements of continual flight—"deterritoralized lines of flight"—forming a bodiless zone of ephemeral groupings and metamorphoses. In contrast to the conventional reading of Bacon's art as an expression of postwar humanist angst, Deleuze lays emphasis upon the idea of "sensation" as a way of conveying both a materialist sense of impersonal, heterogeneous forces and a sublime sense of nervous amplitudes affecting Bacon's figures as well as the relationship between viewer and artwork. For Deleuze, Bacon's art is a transmitter of waves of intensity rather than a work of violent or violated figuration. Color, pattern, marks, and "Gothic" lines trace differential changes of intensity. And yet, despite—or because—there is no body (the effect of the forces is always to undo the body and interchange its organs and their functions), there is also "presence": the changes of intensity that produce a "hysterical" perversion of the body's morphology are forces of becoming and, since there is no lack as in metaphysics, they also constitute "presences beneath representation, beyond representation." Deleuze concludes this text with a differential classification defining painting as a hysterical art form lodged in a plane of materiality that music, as a schizophrenic art form, elides.

HYSTERIA

This ground, this rhythmic unity of the senses, can be discovered only by going beyond the organism. The phenomenological hypothesis is perhaps insufficient because it merely invokes the lived body. But the lived body is still a paltry thing in comparison with a more profound and almost unlivable Power [*Puissance*]. We can seek the unity of rhythm only at the point where rhythm itself plunges into chaos, into the night, at the point where the differences of level are perpetually and violently mixed.

Beyond the organism, but also at the limit of the lived body, there lies what Artaud discovered and named: the body without organs. "The body is the body / it stands alone / it has no need of organs / the body is never an organism / organisms are the enemies of bodies."[5] The body without organs is opposed less to organs than to that organization of organs we call an organism. It is an intense and intensive body. It is traversed by a wave that traces levels or thresholds in the body according to the variations of its amplitude. Thus the body does not have organs, but thresholds or levels. Sensation is not qualitative and qualified, but has only an intensive

reality, which no longer determines with itself representative elements, but allotropic variations. Sensation is vibration. We know that the egg reveals just this state of the body "before" organic representation: axes and vectors, gradients, zones, cinematic movements, and dynamic tendencies, in relation to which forms are contingent or accessory. "No mouth. No tongue. No teeth. No larynx. No esophagus. No belly. No anus." It is a whole nonorganic life, for the organism is not life, it is what imprisons life. The body is completely living, and yet nonorganic. Likewise sensation, when it acquires a body through the organism, takes on an excessive and spasmodic appearance, exceeding the bounds of organic activity. It is immediately conveyed in the flesh through the nervous wave—or vital emotion. Bacon and Artaud meet on many points: the Figure is the body without organs (dismantle the organism in favor of the body, the face in favor of the head); the body without organs is flesh and nerve; a wave flows through it and traces levels upon it; a sensation is produced when the wave encounters the forces acting on the body, an "affective athleticism," a scream-breath. When sensation is linked to the body in this way, it ceases to be representative and becomes real; and *cruelty* will be linked less and less to the representation of something horrible, and will become nothing other than the action of forces upon the body, or sensation (the opposite of the sensational). As opposed to a *misérabiliste* painter who paints parts of organs, Bacon has not ceased to paint bodies without organs, the intensive fact of the body. The scrubbed and brushed parts of the canvas are, in Bacon, parts of a neutralized organism, restored to their state of zones or levels: "the human visage has not yet found its face . . ."

A powerful nonorganic life: this is how Worringer defined Gothic art, "the northern Gothic line."[6] It is opposed in principle to the organic representation of classical art. Classical art can be figurative, insofar as it refers to something represented, but it can also be abstract, when it extricates a geometric form from the representation. But the pictorial line in Gothic painting is completely different, as is its geometry and figure. First of all, this line is decorative; it lies at the surface, but it is a material decoration that does not outline a form. It is a geometry no longer in the service of the essential and eternal, but a geometry in the service of "problems" or "accidents," ablation, adjunction, projection, intersection. It is thus a line that never ceases to change direction, that is broken, split, diverted, turned in on itself, coiled up, or even extended beyond its natural limits, dying away in a "disordered convulsion": there are *free marks* that extend or arrest the line, acting beneath or beyond representation. It is thus a geometry or a decora-

tion that has become vital and profound, on the condition that it is no longer organic: it elevates mechanical forces to sensible intuition, it works through violent movements. If it encounters the animal, if it becomes *animalized*, it is not by outlining a form, but on the contrary by imposing, through its clarity and nonorganic precision, a zone where forms become indiscernible. It also attests to a high *spirituality*, since what leads it to seek the elementary forces beyond the organic is a spiritual will. But this spirituality is a spirituality of the body; the spirit is the body itself, the body without organs. . . . (The first Figure of Bacon would be that of a Gothic decorator).

Life provides many ambiguous approaches to the body without organs (alcohol, drugs, schizophrenia, sadomasochism, and so on). But can the living reality of this body be named "hysteria," and if so, in what sense? A wave with a variable amplitude flows through the body without organs; it traces zones and levels on this body according to the variations of its amplitude. When the wave encounters external forces at a particular level, a sensation appears. An organ will be determined by this encounter, but it is a provisional organ that endures only as long as the passage of the wave and the action of the force, and which will be displaced in order to be posited elsewhere. "No organ is constant as regards either function or position . . . sex organs sprout anywhere . . . rectums open, defecate and close . . . the entire organism changes color and consistency in split-second adjustments."[7] In fact, the body without organs does not lack organs, it simply lacks the organism, that is, this particular organization of organs. The body without organs is thus defined by *an indeterminate organ*, whereas the organism is defined by determinate organs: "Instead of a mouth and an anus to get out of order why not have one all-purpose hole to eat *and* eliminate? We could seal up nose and mouth, fill in the stomach, make an air hole direct into the lungs where it should have been in the first place."[8] But what does it mean to speak of a polyvalent orifice or an indeterminate organ? Are not a mouth and an anus very distinct, and is not a passage of time needed to get from one to the other? Even in the meat, is not there a very distinct mouth, recognizable through its teeth, which cannot be confused with other organs? This is what must be understood: the wave flows through the body; at a certain level, an organ will be determined depending on the force it encounters; and this organ will change if the force itself changes, or if it moves to another level. In short, the body without organs is not defined by the absence of organs, nor is it defined solely by the existence of an indeterminate organ; it is finally defined by the *temporary*

and provisional presence of determinate organs. This is one way of in-
troducing time into the painting, and there is a great force of time in
Bacon, time itself is being painted. The variation of texture and color on
a body, a head, or a back (as in *Triptych, Three Studies of the Male Back*
of 1970) is actually a temporal variation regulated down to the tenth of a
second. Hence the chromatic treatment of the body, which is very differ-
ent from the treatment of the fields of color: the chronochromatism of the
body is opposed to the monochromatism of the flat fields. To put time in-
side the figure—this is the force of bodies in Bacon: the large male back as
variation.

We can see from this how every sensation implies a difference of level
(of order, of domain), and moves from one level to another. Even the phe-
nomenological unity did not give an account of it. But the body without
organs does give an account of it, if we look at the complete series:
without organs—to the indeterminate polyvalent organ—to temporary and
transitory organs. What is a mouth at one level becomes an anus at an-
other level, or at the same level under the action of different forces. Now
this complete series constitutes the hysterical reality of the body. If we look
at the "picture" of hysteria that was formed in the nineteenth century, in
psychiatry and elsewhere, we find a number of features that have continu-
ally animated Bacon's bodies. First of all, there are the famous spastics
and paralytics, the hyperesthetics or anesthetics, associated or alternat-
ing, sometimes fixed and sometimes migrant, depending on the passage
of the nervous wave and the zones it invests or withdraws from. Then there
are the phenomena of precipitation and anticipation or, on the contrary, of
delay (hysteresis), of the afterward, which depend on the accelerations
and delays of the wave's oscillations. Next, there is the transitory character
of the organ's determination, which depends on the forces that are ex-
erted upon it. Next, there is the direct action of these forces on the ner-
vous system, as if the hysteric were a sleepwalker, a somnambulist in the
waking state, a "Vigilambulist." Finally, there is a very peculiar feeling that
arises from within the body, precisely because the body is felt *under* the
body, the transitory organs are felt under the organization of the fixed or-
gans. Furthermore, this body without organs and these transitory organs
are themselves *seen,* in phenomena known as internal or external "au-
toscopia": it is no longer *my* head, but I feel myself inside *a* head, I see and
I see myself inside a head; or else I do not see myself in the mirror, but I
feel myself in the body that I see, and I see myself in this naked body when
I am dressed . . . and so forth.[9] Is there a psychosis in the world that might

include this hysterical condition? "A kind of incomprehensible *stopping place* in the spirit, right in the middle of everything . . ."[10]

Beckett's Characters and Bacon's Figures share a common setting, the same Ireland: the round area, the isolator, the Depopulator; the series of spastics and paralytics inside the round area; the stroll of the Vigilambulator; the presence of the attendant, who still feels, sees, and speaks; the way the body escapes from itself, that is, the way it escapes from the organism. . . . It escapes from itself through the open mouth, through the anus or the stomach, or through the throat, or through the circle of the washbasin, or through the point of the umbrella.[11] The presence of a body without organs under the organism, the presence of transitory organs under organic representation. A clothed Figure of Bacon's is seen nude in the mirror or on the canvas (*Two Studies for a Portrait of George Dyer*, 1968). The spastics and the hyperesthetics are often indicated by wiped or scrubbed zones (*Triptych, Three Portraits*, 1973), and the anesthetics and paralytics, by missing zones (as in the very detailed 1972 triptych). Above all, we will see that Bacon's whole "style" takes place in a beforehand and an afterward: what takes place before the painting has even begun, but also what takes place afterward, a hysteresis that will break off the work each time, interrupt its figurative course, and yet give it back afterward. . . .

Presence, presence . . . this is the first word that comes to mind in front of one of Bacon's paintings."[12] Could this presence be hysterical? The hysteric is at the same time someone who imposes his or her presence, but also someone for whom things and beings are present, *too* present, and who attributes to every thing and communicates to every being this excessive presence. There is therefore little difference between the hysteric, the "hystericized," and the "hystericizor." Bacon explains rather testily that the hysterical smile he painted on the 1953 portrait (*Study for a Portrait*), on the human head of 1953 (*Triptych, Three Studies of the Human Head*), and on the 1955 Pope came from a "model" who was "very neurotic and almost hysterical."[13] But in fact it is the whole painting that is hystericized. Bacon himself hystericizes when, beforehand, he abandons himself completely to the image, abandons his entire head to the camera of a photobooth, or rather, sees himself in a head that belongs to the camera, that has disappeared into the camera. What is this hysterical smile? Where is the abomination or abjection of this smile? Presence or insistence. Interminable presence. The insistence of the smile beyond the face and beneath the face. The insistence of a scream that survives the mouth, the insistence of a

body that survives the organism, the insistence of transitory organs that survive the qualified organs. And in this excessive presence, the identity of an already-there and an always-delayed. Everywhere there is a presence acting directly on the nervous system, which makes representation, whether in place or at a distance, impossible. Sartre meant nothing less when he called himself a hysteric, and spoke of Flaubert's hysteria.[14]

What kind of hysteria are we speaking of here? Is it the hysteria of Bacon himself, or of the painter, or of the painting itself, or of painting in general? It is true that there are numerous dangers in constructing a clinical aesthetic (which nonetheless has the advantage of *not* being a psychoanalysis). And why refer specifically to painting, when we could invoke so many writers or even musicians (Schumann and the contraction of the finger, the audition of the voice . . .)? What we are suggesting, in effect, is that there is a special relation between painting and hysteria. It is very simple. Painting directly attempts to release the presences beneath representation, beyond representation. The color system itself is a system of direct action on the nervous system. This is not a hysteria of the painter, but a hysteria of painting. With painting, hysteria becomes art. Or rather, with the painter, hysteria becomes painting. What the hysteric is incapable of doing— a little art—is accomplished in painting. It must also be said that the painter *is not* hysterical, in the sense of a negation in negative theology. Abjection becomes splendor, the horror of life becomes a very pure and very intense life. "Life is frightening," said Cézanne, but in this cry he had already given voice to all the joys of line and color. Painting transmutes this cerebral pessimism into nervous optimism. Painting is hysteria, or converts hysteria, because it makes presence immediately visible. It invests the eye through color and line. But *it does not treat the eye as a fixed organ*. It liberates lines and colors from their representative function, but at the same time it also liberates the eye from its adherence to the organism, from its character as a fixed and qualified organ: the eye becomes virtually the polyvalent indeterminate organ that sees the body without organs (the Figure) as a pure presence. Painting gives us eyes all over: in the ear, in the stomach, in the lungs (the painting breathes . . .). This is the double definition of painting: subjectively, it invests the eye, which ceases to be organic in order to become a polyvalent and transitory organ; objectively, it brings before us the reality of a body, of lines and colors freed from organic representation. And each is produced by the other: the pure presence of the body becomes visible at the same time that the eye becomes the destined organ of this presence.

Painting has two ways of avoiding this fundamental hysteria: either by conserving the figurative coordinates of organic representation, even if that means using them in very subtle ways or making these liberated presences or unorganized bodies pass beneath or between these coordinates; or else by turning toward abstract form, and inventing a properly pictorial cerebrality ("reviving" painting in this direction). Velázquez was undoubtedly the wisest of the classical painters, possessing an immense wisdom: he created his extraordinary audacities by holding firmly to the coordinates of representation, by assuming completely the role of a documentarian.[15] [. . .] What is Bacon's relation to Velázquez, and why does he claim him as his master? Why, when he speaks of his versions of the portrait of Pope Innocent X, does he express his doubt and discontent? In a way, Bacon has hystericized all the elements of Velázquez's painting. We cannot simply compare the two portraits of Innocent X, that of Velázquez and that of Bacon, who transforms it into the screaming Pope. We must compare Velázquez's portrait with all of Bacon's paintings. In Velázquez, the armchair already delineates the prison of the parallelepiped; the heavy curtain in the back is already tending to move up front, and the mantelet has aspects of a side of beef, an unreadable yet clear parchment is in the hand, and the attentive, fixed eye of the Pope already sees something invisible looming up.[16] But all of this is strangely restrained; it is something that is going to happen, but has not yet acquired the ineluctable, irrepressible presence of Bacon's newspapers, the almost animal-like armchairs, the curtain up front, the brute meat, and the screaming mouth. Should these presences have been let loose? asks Bacon. Were not things better, infinitely better, in Velázquez? In refusing both the figurative path and the abstract path, was it necessary to display this relationship between hysteria and painting in full view? While our eye is enchanted with the two Innocent Xs, Bacon questions himself.[17]

But in the end, why should all this be peculiar to painting? Can we speak of a hysterical essence of painting, under the rubric of a purely aesthetic clinic, independent of any psychiatry and psychoanalysis? Why could not music also extricate pure presences, but through an ear that has become the polyvalent organ for sonorous bodies? And why not poetry or theater, when it is those of Artaud or Beckett? This problem concerning the essence of each art, and possibly their clinical essence, is less difficult than it seems to be. Certainly music traverses our bodies in profound ways, putting an ear in the stomach, in the lungs, and so on. It knows all about waves and nervousness. But it involves our body, and bodies in general, in another

element. It strips bodies of their inertia, of the materiality of their presence: it *disembodies* bodies. We can thus speak with exactitude of a sonorous body, and even of a bodily combat in music—for example, in a motif—but as Proust said, it is an immaterial and disembodied combat "in which there subsists not one scrap of inert matter refractory to the mind."[18] In a sense, music begins where painting ends, and this is what is meant when one speaks of the superiority of music. It is lodged on lines of flight that pass through bodies, but which find their consistency elsewhere, whereas painting is lodged farther up, where the body escapes from itself. But in escaping, the body discovers the materiality of which it is composed, the pure presence of which it is made, and which it would not discover otherwise. Painting, in short, discovers the material reality of bodies with its line–color systems and its polyvalent organ, the eye. "Our eye," said Gauguin, "insatiable and in heat." The adventure of painting is that it is the eye alone that can attend to material existence or material presence—even that of an apple. When music sets up its sonorous system and its polyvalent organ, the ear, it addresses itself to something very different than the material reality of bodies. It gives a disembodied and dematerialized body to the most spiritual of entities: "The beats of the timpani in the Requiem are sharp, majestic, and divine, and they can only announce to our surprised ears the coming of a being who, to use Stendhal's words, surely has relations with another world."[19] This is why music does not have hysteria as its clinical essence, but is confronted more and more with a galloping schizophrenia. To hystericize music we would have to reintroduce colors, passing through a rudimentary or refined system of correspondence between sounds and colors.

—Translated by Daniel W. Smith

16

Answering the Question: *What Is Postmodernism?*

Jean-François Lyotard

Jean-François Lyotard (1924–1998) was a major force in debates about the postmodern in the last decades of the twentieth century, to which he brought a reading of Kant's critical philosophy. In his book *The Postmodern Condition: A Report on Knowledge* (1979),[1] Lyotard claims that "the status of knowledge is altered as societies enter what is known as the postindustrial age and cultures enter what is known as the postmodern age."[2] Lyotard argues that knowledge, whether scientific, technological, or otherwise, depends upon its legitimization by ideas of progress and utopias that are ultimately modeled upon the teleological "metadiscourses" of religion and modernity (exemplified by Hegel's dialectics of spirit and capitalism's ideology of the creation of wealth). Knowledge, therefore, is inseparable from power insofar as it is legitimized in the name of a future to come, "who decides what knowledge is, and who knows what needs to be decided . . . is now more than ever a question of government."[3]

To counter this conception of the legitimization of knowledge, Lyotard turns to Kant's theory of the sublime and of an overwhelming experience that cannot be contained in representation (see Kant's "Critique of Judgment," chapter 1), For Lyotard, inasmuch as this theory underlines the limits of representation, it highlights much of what is at stake in modern philosophy and art. As with Kant's theory of the sublime, the key point for Lyotard's theory of postmodernism is that the transcendental "Ideas" bearing upon

any notion of totality or consensus exceed those of representation. Art's task, then, lies in its capacity to represent its own failure to access ideas of totality that, as such, remain unknowable.

Like Kant's theory of the sublime, which is composed of a combination of contrasting feelings of pain and pleasure, so too, according to Lyotard, is the experience of postmodern art: there exists a sense of pain because art, like any type of representation, cannot encapsulate meaning and thus give form to a sense of universality underlying contemporary experience; conversely, there is pleasure both in making this experience, or event, manifest and in preserving the very idea of unpresentability ("Let us save . . . the honor of the name"). Lyotard believes that this situation calls for a type of art that can inquire into its own rules, or lack of them. By implication, thinking is always essentially speculative, as it lacks any foundation, and this is carried on by the work of art insofar as it is reproduced in postmodernism through the question, "What is art?" In Lyotard's view, this form of questioning is exemplified by certain aspects of modernist art and literature, including the work of Montaigne, Proust, Joyce, Malevitch, and Duchamp.[4] Ultimately, for Lyotard, postmodernism is not so much a term for a historical period as the theory, and condition, of the enduring relationship between representation and its failure to present absolute knowledge; thus, Lyotard states that the postmodern precedes *and* postdates the modern.

ANSWERING THE QUESTION: WHAT IS POSTMODERNISM?

A Demand

This is a period of slackening—I refer to the color of the times. From every direction we are being urged to put an end to experimentation, in the arts and elsewhere. I have read an art historian who extols realism and is militant for the advent of a new subjectivity. I have read an art critic who packages and sells "Transavantgardism" in the marketplace of painting. I have read that under the name of postmodernism, architects are getting rid of the Bauhaus project, throwing out the baby of experimentation with the bathwater of functionalism. I have read that a new philosopher is discovering what he drolly calls Judaeo-Christianism, and intends by it to put an end to the impiety which we are supposed to have spread. I have read in a French weekly that some are displeased with *Mille Plateaux* [by Gilles Deleuze and

Felix Guattari] because they expect, especially when reading a work of philosophy, to be gratified with a little sense. I have read from the pen of a reputable historian that writers and thinkers of the 1960 and 1970 avant-gardes spread a reign of terror in the use of language, and that the conditions for a fruitful exchange must be restored by imposing on the intellectuals a common way of speaking, that of the historians. I have been reading a young philosopher of language who complains that Continental thinking, under the challenge of speaking machines, has surrendered to the machines the concern for reality, that it has substituted for the referential paradigm that of "adlinguisticity" (one speaks about speech, writes about writing, intertextuality), and who thinks that the time has now come to restore a solid anchorage of language in the referent. I have read a talented theatrologist for whom postmodernism, with its games and fantasies, carries very little weight in front of political authority, especially when a worried public opinion encourages authority to a politics of totalitarian surveillance in the face of nuclear warfare threats.

I have read a thinker of repute who defends modernity against those he calls the neoconservatives. Under the banner of postmodernism, the latter would like, he believes, to get rid of the uncompleted project of modernism, that of the Enlightenment. Even the last advocates of *Aufklärung*, such as Popper or Adorno, were only able, according to him, to defend the project in a few particular spheres of life—that of politics for the author of *The Open Society*, and that of art for the author of *Ästhetische Theorie*. Jürgen Habermas (everyone had recognized him) thinks that if modernity has failed, it is in allowing the totality of life to be splintered into independent specialties which are left to the narrow competence of experts, while the concrete individual experiences "desublimated meaning" and "destructured form," not as a liberation but in the mode of that immense *ennui* which Baudelaire described over a century ago.

Following a prescription of Albrecht Wellmer, Habermas considers that the remedy for this splintering of culture and its separation from life can only come from "changing the status of aesthetic experience when it is no longer primarily expressed in judgments of taste," but when it is "used to explore a living historical situation," that is, when "it is put in relation with problems of existence." For this experience then "becomes a part of a language game which is no longer that of aesthetic criticism"; it takes part "in cognitive processes and normative expectations"; "it alters the manner in which those different moments *refer* to one another." What Habermas requires from the arts and the experiences they provide is, in short, to bridge the gap between

cognitive, ethical, and political discourses, thus opening the way to a unity of experience.

My question is to determine what sort of unity Habermas has in mind. Is the aim of the project of modernity the constitution of sociocultural unity within which all the elements of daily life and of thought would take their places as in an organic whole? Or does the passage that has to be charted between heterogeneous language games—those of cognition, of ethics, of politics—belong to a different order from that? And if so, would it be capable of effecting a real synthesis between them?

The first hypothesis, of a Hegelian inspiration, does not challenge the notion of a dialectically totalizing *experience*; the second is closer to the spirit of Kant's *Critique of Judgment* but must be submitted, like the *Critique*, to that severe reexamination which post-modernity imposes on the thought of the Enlightenment, on the idea of a unitary end of history and of a subject. It is this critique which not only Wittgenstein and Adorno have initiated, but also a few other thinkers (French or other) who do not have the honor to be read by Professor Habermas—which at least saves them from getting a poor grade for their neoconservatism.

Realism

The demands I began by citing are not all equivalent. They can even be contradictory. Some are made in the name of postmodernism, others in order to combat it. It is not necessarily the same thing to formulate a demand for some referent (and objective reality), for some sense (and credible transcendence), for an addressee (and audience), or an addressor (and subjective expressiveness) or for some communicational consensus (and a general code of exchanges, such as the genre of historical discourse). But in the diverse invitations to suspend artistic experimentation, there is an identical call for order, a desire for unity, for identity, for security, or popularity (in the sense of *Öffentlichkeit*, of "finding a public"). Artists and writers must be brought back into the bosom of the community, or at least, if the latter is considered to be ill, they must be assigned the task of healing it.

There is an irrefutable sign of this common disposition: it is that for all those writers nothing is more urgent than to liquidate the heritage of the avant-gardes. Such is the case, in particular, of the so-called transavantgardism. The answers given by Achille Bonito Oliva to the questions asked by Bernard Lamarche-Nadel and Michel Enric leave no room for doubt about this. By putting the avant-gardes through a mixing process, the artist and critic feel more confident that they can suppress them than by launching a

frontal attack. For they can pass off the most cynical eclecticism as a way of going beyond the fragmentary character of the preceding experiments; whereas if they openly turned their backs on them, they would run the risk of appearing ridiculously neoacademic. The *Salons* and the *Académies*, at the time when the bourgeoisie was establishing itself in history, were able to function as purgation and to grant awards for good plastic and literary conduct under the cover of realism. But capitalism inherently possesses the power to derealize familiar objects, social roles, and institutions to such a degree that the so-called realistic representations can no longer evoke reality except as nostalgia or mockery, as an occasion for suffering rather than for satisfaction. Classicism seems to be ruled out in a world in which reality is so destabilized that it offers no occasion for experience but one for ratings and experimentation.

This theme is familiar to all readers of Walter Benjamin. But it is necessary to assess its exact reach. Photography did not appear as a challenge to painting from the outside, any more than industrial cinema did to narrative literature. The former was only putting the final touch to the program of ordering the visible elaborated by the quattrocento; while the latter was the last step in rounding off diachronies as organic wholes, which had been the ideal of the great novels of education since the eighteenth century. That the mechanical and the industrial should appear as substitutes for hand or craft was not in itself a disaster—except if one believes that art is in its essence the expression of an individuality of genius assisted by an elite craftsmanship.

The challenge lay essentially in that photographic and cinematographic processes can accomplish better, faster, and with a circulation a hundred thousand times larger than narrative or pictorial realism, the task which academicism had assigned to realism: to preserve various consciousnesses from doubt. Industrial photography and cinema will be superior to painting and the novel whenever the objective is to stabilize the referent, to arrange it according to a point of view which endows it with a recognizable meaning, to reproduce the syntax and vocabulary which enable the addressee to decipher images and sequences quickly, and so to arrive easily at the consciousness of his own identity as well as the approval which he thereby receives from others—since such structures of images and sequences constitute a communication code among all of them. This is the way the effects of reality, or if one prefers, the fantasies of realism, multiply.

If they too do not wish to become supporters (of minor importance at that) of what exists, the painter and novelist must refuse to lend themselves

to such therapeutic uses. They must question the rules of the art of painting or of narrative as they have learned and received them from their predecessors. Soon those rules must appear to them as a means to deceive, to seduce, and to reassure, which makes it impossible for them to be "true." Under the common name of painting and literature, an unprecedented split is taking place. Those who refuse to reexamine the rules of art pursue successful careers in mass conformism by communicating, by means of the "correct rules," the endemic desire for reality with objects and situations capable of gratifying it. Pornography is the use of photography and film to such an end. It is becoming a general model for the visual or narrative arts which have not met the challenge of the mass media.

As for the artists and writers who question the rules of plastic and narrative arts and possibly share their suspicions by circulating their work, they are destined to have little credibility in the eyes of those concerned with "reality" and "identity"; they have no guarantee of an audience. Thus it is possible to ascribe the dialectics of the avant-gardes to the challenge posed by the realisms of industry and mass communication to painting and the narrative arts. Duchamp's "ready made" does nothing but actively and parodistically signify this constant process of dispossession of the craft of painting or even of being an artist. As Thierry de Duve penetratingly observes, the modern aesthetic question is not "What is beautiful?" but "What can be said to be art (and literature)?"

Realism, whose only definition is that it intends to avoid the question of reality implicated in that of art, always stands somewhere between academicism and kitsch. When power assumes the name of a party, realism and its neoclassical complement triumph over the experimental avant-garde by slandering and banning it—that is, provided the "correct" images, the "correct" narratives, the "correct" forms which the party requests, selects, and propagates can find a public to desire them as the appropriate remedy for the anxiety and depression that public experiences. The demand for reality—that is, for unity, simplicity, communicability, etc.—did not have the same intensity nor the same continuity in German society between the two world wars and in Russian society after the Revolution: this provides a basis for a distinction between Nazi and Stalinist realism.

What is clear, however, is that when it is launched by the political apparatus, the attack on artistic experimentation is specifically reactionary: aesthetic judgment would only be required to decide whether such or such work is in conformity with the established rules of the beautiful. Instead of the work of art having to investigate what makes it an art object and

whether it will be able to find an audience, political academicism possesses and imposes a priori criteria of the beautiful, which designate some works and a public at a stroke and forever. The use of categories in aesthetic judgment would thus be of the same nature as in cognitive judgment. To speak like Kant, both would be determining judgments: the expression is "well formed" first in the understanding, then the only cases retained in experience are those which can be subsumed under this expression.

When power is that of capital and not that of a party, the "transavant-gardist" or "postmodern" (in Jencks's sense) solution proves to be better adapted than the antimodern solution. Eclecticism is the degree zero of contemporary general culture: one listens to reggae, watches a western, eats McDonald's food for lunch and local cuisine for dinner, wears Paris perfume in Tokyo and "retro" clothes in Hong Kong; knowledge is a matter for TV games. It is easy to find a public for eclectic works. By becoming kitsch, art panders to the confusion which reigns in the "taste" of the patrons. Artists, gallery owners, critics, and public wallow together in the "anything goes," and the epoch is one of slackening. But this realism of the "anything goes" is in fact that of money; in the absence of aesthetic criteria, it remains possible and useful to assess the value of works of art according to the profits they yield. Such realism accommodates all tendencies, just as capital accommodates all "needs," providing that the tendencies and needs have purchasing power. As for taste, there is no need to be delicate when one speculates or entertains oneself.

Artistic and literary research is doubly threatened, once by the "cultural policy" and once by the art and book market. What is advised, sometimes through one channel, sometimes through the other, is to offer works which, first, are relative to subjects which exist in the eyes of the public they address, and second, works so made ("well made") that the public will recognize what they are about, will understand what is signified, will be able to give or refuse its approval knowingly, and if possible, even to derive from such work a certain amount of comfort.

The interpretation which has just been given of the contact between the industrial and mechanical arts, and literature and the fine arts is correct in its outline, but it remains narrowly sociologizing and historicizing—in other words, one-sided. Stepping over Benjamin's and Adorno's reticences, it must be recalled that science and industry are no more free of the suspicion which concerns reality than are art and writing. To believe otherwise would be to entertain an excessively humanistic notion of the mephistophelian functionalism of sciences and technologies. There is no denying the

dominant existence today of techno-science, that is, the massive subordination of cognitive statements to the finality of the best possible performance, which is the technological criterion. But the mechanical and the industrial, especially when they enter fields traditionally reserved for artists, are carrying with them much more than power effects. The objects and the thoughts which originate in scientific knowledge and the capitalist economy convey with them one of the rules which supports their possibility: the rule that there is no reality unless testified by a consensus between partners over a certain knowledge and certain commitments.

This rule is of no little consequence. It is the imprint left on the politics of the scientist and the trustee of capital by a kind of flight of reality out of the metaphysical, religious, and political certainties that the mind believed it held. This withdrawal is absolutely necessary to the emergence of science and capitalism. No industry is possible without a suspicion of the Aristotelian theory of motion, no industry without a refutation of corporatism, of mercantilism, and of physiocracy. Modernity, in whatever age it appears, cannot exist without a shattering of belief and without discovery of the "lack of reality" of reality, together with the invention of other realities.

What does this "lack of reality" signify if one tries to free it from a narrowly historicized interpretation? The phrase is of course akin to what Nietzsche calls nihilism. But I see a much earlier modulation of Nietzschean perspectivism in the Kantian theme of the sublime. I think in particular that it is in the aesthetic of the sublime that modern art (including literature) finds its impetus and the logic of avant-gardes finds its axioms.

The sublime sentiment, which is also the sentiment of the sublime, is, according to Kant, a strong and equivocal emotion: it carries with it both pleasure and pain. Better still, in it pleasure derives from pain. Within the tradition of the subject, which comes from Augustine and Descartes and which Kant does not radically challenge, this contradiction, which some would call neurosis or masochism, develops as a conflict between the faculties of a subject, the faculty to conceive of something and the faculty to "present" something. Knowledge exists if, first, the statement is intelligible, and second, if "cases" can be derived from the experience which "corresponds" to it. Beauty exists if a certain "case" (the work of art), given first by the sensibility without any conceptual determination, the sentiment of pleasure independent of any interest the work may elicit, appeals to the principle of a universal consensus (which may never be attained).

Taste, therefore, testifies that between the capacity to conceive and the capacity to present an object corresponding to the concept, an undeter-

mined agreement, without rules, giving rise to a judgment which Kant calls reflective, may be experienced as pleasure. The sublime is a different senti- ment. It takes place, on the contrary, when the imagination fails to present an object which might, if only in principle, come to match a concept. We have the Idea of the world (the totality of what is), but we do not have the capacity to show an example of it. We have the Idea of the simple (that which cannot be broken down, decomposed), but we cannot illustrate it with a sensible object which would be a "case" of it. We can conceive the infinitely great, the infinitely powerful, but every presentation of an object destined to "make visible" this absolute greatness or power appears to us painfully inadequate. Those are Ideas of which no presentation is possible. Therefore, they impart no knowledge about reality (experience); they also prevent the free union of the faculties which gives rise to the sentiment of the beautiful; and they prevent the formation and the stabilization of taste. They can be said to be unpresentable. I shall call modern the art which devotes its "little technical expertise" (*son "petit technique"*), as Diderot used to say, to present the fact that the unpresentable exists. To make visible that there is something which can be conceived and which can neither be seen nor made visible: this is what is at stake in modern painting. But how to make visible that there is something which cannot be seen? Kant himself shows the way when he names "formlessness, the absence of form," as a possible index to the unpresentable. He also says of the empty "abstraction" which the imagination experiences when in search for a presentation of the infinite (another unpresentable): this abstraction itself is like a presentation of the infinite, its "negative presentation." He cites the commandment, "Thou shalt not make graven images" (*Exodus*), as the most sublime passage in the Bible in that it forbids all presentation of the Absolute. Little needs to be added to those observations to outline an aesthetic of sublime paintings. As painting, it will of course "present" something though negatively; it will there- fore avoid figuration or representation. It will be "white" like one of Malev- itch's squares; it will enable us to see only by making it impossible to see; it will please only by causing pain. One recognizes in those instructions the axioms of avant-gardes in painting, inasmuch as they devote themselves to making an allusion to the unpresentable by means of visible presentations. The systems in the name of which, or with which, this task has been able to support or to justify itself deserve the greatest attention; but they can origi- nate only in the vocation of the sublime in order to legitimize it, that is, to conceal it. They remain inexplicable without the incommensurability of real- ity to concept which is implied in the Kantian philosophy of the sublime.

post-modern not originates in the vocation of the sublime

It is not my intention to analyze here in detail the manner in which the various avant-gardes have, so to speak, humbled and disqualified reality by examining the pictorial techniques which are so many devices to make us believe in it. Local tone, drawing, the mixing of colors, linear perspective, the nature of the support and that of the instrument, the treatment, the display, the museum: the avant-gardes are perpetually flushing out artifices of presentation which make it possible to subordinate thought to the gaze and to turn it away from the unpresentable. If Habermas, like Marcuse, understands this task of derealization as an aspect of the (repressive) "desublimation" which characterizes the avant-garde, it is because he confuses the Kantian sublime with Freudian sublimation, and because aesthetics has remained for him that of the beautiful.

The Postmodern

What, then, is the postmodern? What place does it or does it not occupy in the vertiginous work of the questions hurled at the rules of image and narration? It is undoubtedly a part of the modern. All that has been received, if only yesterday (*modo, modo*, Petronius used to say), must be suspected. What space does Cézanne challenge? The Impressionists'. What object do Picasso and Braque attack? Cézanne's. What presupposition does Duchamp break with in 1912? That which says one must make a painting, be it cubist. And Buren questions that other presupposition which he believes had survived untouched by the work of Duchamp: the place of presentation of the work. In an amazing acceleration, the generations precipitate themselves. A work can become modern only if it is first postmodern. Postmodernism thus understood is not modernism at its end but in the nascent state, and this state is constant.

Yet I would like not to remain with this slightly mechanistic meaning of the word. If it is true that modernity takes place in the withdrawal of the real and according to the sublime relation between the presentable and the conceivable, it is possible, within this relation, to distinguish two modes (to use the musician's language). The emphasis can be placed on the powerlessness of the faculty of presentation, on the nostalgia for presence felt by the human subject, on the obscure and futile will which inhabits him in spite of everything. The emphasis can be placed, rather, on the power of the faculty to conceive, on its "inhumanity" so to speak (it was the quality Apollinaire demanded of modern artists), since it is not the business of our understanding whether or not human sensibility or imagination can match

what it conceives. The emphasis can also be placed on the increase of being and the jubilation which result from the invention of new rules of the game, be it pictorial, artistic, or any other. What I have in mind will become clear if we dispose very schematically a few names on the chessboard of the history of avant-gardes: on the side of melancholia, the German Expressionists, and on the side of *novatio*, Braque and Picasso, on the former Malevitch and on the latter Lissitsky, on the one Chirico and on the other Duchamp. The nuance which distinguishes these two modes may be infinitesimal; they often coexist in the same piece, are almost indistinguishable; and yet they testify to a difference (*un différend*) on which the fate of thought depends and will depend for a long time, between regret and assay. — *determination w/ analysi.*

The work of Proust and that of Joyce both allude to something which does not allow itself to be made present. Allusion, to which Paolo Fabbri recently called my attention, is perhaps a form of expression indispensable to the works which belong to an aesthetic of the sublime. In Proust, what is being eluded as the price to pay for this allusion is the identity of consciousness, a victim to the excess of time (*au trop de temps*). But in Joyce, it is the identity of writing which is the victim of an excess of the book (*au trop de livre*) or of literature.

Proust calls forth the unpresentable by means of a language unaltered in its syntax and vocabulary and of a writing which in many of its operators still belongs to the genre of novelistic narration. The literary institution, as Proust inherits it from Balzac and Flaubert, is admittedly subverted in that the hero is no longer a character but the inner consciousness of time, and in that the diegetic diachrony, already damaged by Flaubert, is here put in question because of the narrative voice. Nevertheless, the unity of the book, the odyssey of that consciousness, even if it is deferred from chapter to chapter, is not seriously challenged: the identity of the writing with itself throughout the labyrinth of the interminable narration is enough to connote such unity, which has been compared to that of *The Phenomenology of Mind*.

Joyce allows the unpresentable to become perceptible in his writing itself, in the signifier. The whole range of available narrative and even stylistic operators is put into play without concern for the unity of the whole, and new operators are tried. The grammar and vocabulary of literary language are no longer accepted as given; rather, they appear as academic forms, as rituals originating in piety (as Nietzsche said) which prevent the unpresentable from being put forward.

Here, then, lies the difference: modern aesthetics is an aesthetic of the sublime, though a nostalgic one. It allows the unpresentable to be put forward only as the missing contents; but the form, because of its recognizable consistency, continues to offer to the reader or viewer matter for solace and pleasure. Yet these sentiments do not constitute the real sublime sentiment, which is in an intrinsic combination of pleasure and pain: the pleasure that reason should exceed all presentation, the pain that imagination or sensibility should not be equal to the concept.

The postmodern would be that which, in the modern, puts forward the unpresentable in presentation itself; that which denies itself the solace of good forms, the consensus of a taste which would make it possible to share collectively the nostalgia for the unattainable; that which searches for new presentations, not in order to enjoy them but in order to impart a stronger sense of the unpresentable. A postmodern artist or writer is in the position of a philosopher: the text he writes, the work he produces are not in principle governed by preestablished rules, and they cannot be judged according to a determining judgment, by applying familiar categories to the text or to the work. Those rules and categories are what the work of art itself is looking for. The artist and the writer, then, are working without rules in order to formulate the rules of what *will have been done*. Hence the fact that work and text have the characters of an *event*; hence also, they always come too late for their author, or, what amounts to the same thing, their being put into work, their realization (*mise en oeuvre*) always begin too soon. *Post modern* would have to be understood according to the paradox of the future (*post*) anterior (*modo*).

It seems to me that the essay (Montaigne) is postmodern, while the fragment (*The Athaeneum*) is modern.

Finally, it must be clear that it is our business not to supply reality but to invent allusions to the conceivable which cannot be presented. And it is not to be expected that this task will effect the last reconciliation between language games (which, under the name of faculties, Kant knew to be separated by a chasm), and that only the transcendental illusion (that of Hegel) can hope to totalize them into a real unity. But Kant also knew that the price to pay for such an illusion is terror. The nineteenth and twentieth centuries have given us as much terror as we can take. We have paid a high enough price for the nostalgia of the whole and the one, for the reconciliation of the concept and the sensible, of the transparent and the communicable experience. Under the general demand for slackening and for appeasement, we

can hear the mutterings of the desire for a return of terror, for the realization of the fantasy to seize reality. The answer is: Let us wage a war on totality; let us be witnesses to the unpresentable; let us activate the differences and save the honor of the name.

—Translated by Régis Durand

17

Privation Is Like a Face

Giorgio Agamben

The Italian philosopher Giorgio Agamben (b. 1942) has come to promi-
nence over recent years for his work on citizens' rights and totalitarian poli-
cies of exclusion enforced by the so-called liberal democracies of the West.
In this regard, Agamben's ideas have been influenced by the work of Han-
nah Arendt, Michel Foucault, and Immanuel Levinas. This extract from *The
Man Without Content* (originally published in 1994) is principally concerned
with aesthetics rather than politics, but it shares a common strategy of think-
ing within the interstices of received assumptions and ideas that run through-
out Agamben's work.

 In "Privation Is Like A Face," Agamben reconsiders one of the central
aesthetic issues raised by Martin Heidegger (chapter 7), Theodor Adorno
(chapter 10), and Walter Benjamin (chapter 6), namely that of the status of
the work of art and its significance in the modern era of alienated labor and
technical reproducibility. For Agamben, the eponymous man without con-
tent epitomizes a problematic in Western attitudes toward ontological
questions of Being and existence that is reflected in the tradition of aesthet-
ics, beginning with Immanuel Kant (chapter 1). The fact that Kantian aes-
thetics is concerned with judgments of taste already tends to assume a
subject who is separated and alienated from the artistic process. Further-
more, as the present text makes clear, the beginning of aesthetics marks
a split between artistic production and technical production accompanied

by an alienated relationship between intellectual and manual labor. Associated with the artist-genius, artistic production is thought of in terms of authenticity and originality (etymologically meaning: being in proximity to the origin), while technical production is associated with reproducibility based upon a preexisting template or mold. Both the traditions of the ready-made and Pop art revolve around this unresolved dialectic between artistic and technical production: the ready-made momentarily transforms a manufactured object into an artistic gesture, while Pop art forsakes originality for reproducibility but remains within the aesthetic sphere.

Agamben believes that modernity marks a rupture with the past and, with it, ideas of (artistic) community and tradition: "Everything that in some way constituted the common space in which the personalities of different artists met in a living unity." Furthermore, the "energetic" character of the work of art is eclipsed: it moves from a sense of completeness in which, as Aristotle proposed, its shape is possessed in its own end, to mere potentiality. Museums and galleries contribute to this effect by subordinating art to its potential for aesthetic enjoyment.

However, Agamben is not necessarily nostalgic for the past, even if this might be suggested by the conclusion to the essay that calls for the restoration of "the poetic status of man on earth [in] its original dimension." In fact, as the allusion in the title to Levinas's philosophy of the Other suggests, Agamben offers an affirmative reading of the notion of privation as a way of reevaluating the significance of the ready-made and Pop art. In this reading, "privation" may be seen as "an extreme gift of poetry, the most accomplished and charged with meaning, because in it nothingness itself is called into presence." Agamben's idea of privation echoes his own argument in his book *The Coming Community* in which he envisions the fate of the souls of unbaptized babies. The "privation" of these babies' souls is that they exist neither in hell (since they are innocent) nor in heaven (since they are not baptized); as a consequence, they are "irremediably lost," thus allowing them to "persist without pain in divine abandon."[1] Agamben follows a similar line of argument in the accompanying text with regard to the ready-made and Pop art. Like the unbaptized babies in *The Coming Community*, these art forms exist in an in-between state, belonging neither to artistic activity nor to technical production. This existence brings their privation from achieving presence to the fore, but Agamben does not read this situation negatively. Rather, these art forms are "turned toward nothingness, and in this way they are able to possess-themselves-in-their-end."

PRIVATION IS LIKE A FACE

If the death of art is its inability to attain the concrete dimension of the work, the crisis of art in our time is, in reality, a crisis of poetry, of *poesis*.[2] Poesis, poetry, does not designate here an art among others, but is the very name of man's *doing*, of that productive action of which artistic *doing* is only a privileged example, and which appears, today, to be unfolding its power on a planetary scale in the operation of technology and industrial production. The question about art's destiny here comes into contact with an area in which the entire sphere of human poesis, productive action in its entirety, is put into question in an original way. Today this productive doing, in the form of work, determines everywhere the status of man on earth, understood from the point of view of praxis, that is, of production of material life; and it is precisely because Marx's thought of the human condition and of human history is rooted in the alienated essence of this poesis and experiences the "degrading division of labor into intellectual and manual labor" that it is still relevant today. What, then, does poesis, poetry, mean? What does it mean that man has on earth a poetic, that is, a productive, status?

In the *Symposium* Plato tells us about the full original resonance of the word poesis: "any cause that brings into existence something that was not there before is poesis."[3] Every time that something is produced, that is, brought from concealment and nonbeing into the light of presence, there is poesis, production, poetry.[4] In this broad original sense of the word, every art—not only the verbal kind—is poetry, production into presence, and the activity of the craftsman who makes an object is poesis as well. To the extent that in it everything brings itself spontaneously into presence, even nature, *physis*, has the character of poesis.

In the second book of the *Physics*, however, Aristotle distinguishes between that which, existing by nature (*physei*), contains in itself its own *arché*, that is, the principle and origin of its entry into presence, and that which, existing from other causes . . . does not have its principle in itself but finds it in the productive activity of man.[5] Of this second category of things, the Greeks said that it is—that it enters into presence—*apo technés*, from or starting out from *technics*, from skill, and *techné* was the name that designated both the activity of the craftsman who shapes a vase and that of the artist who molds a statue or writes a poem. Both of these forms of activity had in common the essential character of being a species of poesis, of the production into presence. This *poietic* character related them back to physis, nature, while yet distinguishing them from it, since nature is

intended as that which contains in itself the principle of its own entry into presence. On the other hand, according to Aristotle, the pro-duction worked by poesis always has the character of the installation into a shape . . . in the sense that the transition from nonbeing to being means taking on a form, a shape—because it is precisely in a shape and starting from a shape that whatever is pro-duced enters into presence.

If we now turn from Greece to our times, we notice that this unitary status of the things not coming from nature . . . as *techné* is broken. With the development of modern technology, starting with the first industrial revolution in the second half of the eighteenth century, and with the establishment of an ever more widespread and alienating division of labor, the mode of presence of the things pro-duced by man becomes double: on the one hand there are the things that enter into presence according to the statute of aesthetics, that is, the works of art, and on the other hand there are those that come into being by way of techné, that is, products in the strict sense. Ever since the beginning of aesthetics, the particular status of the works of art among the things that do not contain their own arché in themselves has been identified with originality (or authenticity).

What does *originality* mean? When we say that the work of art has the character of originality (or authenticity), we do not simply mean by this that this work is unique, that is, different from any other. Originality means proximity to the origin. The work of art is original because it maintains a particular relationship to its origin, to its formal arché, in the sense that it not only derives from the latter and conforms to it but also remains in a relationship of permanent proximity to it.

In other words, originality means that the work of art—which, to the extent that it has the character of poesis, is pro-duced into presence in a shape and from a shape—maintains with its formal principle such a relation of proximity as excludes the possibility that its entry into presence may be in some way reproducible, almost as though the shape pro-duced itself into presence in the unrepeatable act of aesthetic creation.

Things that come into being according techné, on the other hand, do not have this relationship of proximity with the eidos, the image, which governs and determines the entry into presence; the eidos, the formal principle, is simply the external paradigm, the mold (*typos*) to which the product must conform in order to come into being, while the poietic act can be reproduced indefinitely (at least as long as the material possibility of doing so remains). *Reproducibility (intended, in this sense, as paradigmatic relationship of non-proximity with the origin) is, then, the essential status of the*

product of technics, while originality (or authenticity) is the essential status of the work of art. If the dual status of man's pro-ductive activity is con-ceived as starting from the division of labor, it can be explained in this way: the privileged status of art in the aesthetic sphere is artificially interpreted as the survival of a condition in which manual and intellectual labor are not yet divided and in which, therefore, the productive act maintains all its in-tegrity and uniqueness; by contrast, technical production, which takes place starting from a condition of extreme division of labor, remains essen-tially fungible and reproducible.

The existence of a dual status for man's poietic activity appears so natural to us now that we forget that the entrance of the work of art into the aesthetic dimension is a relatively recent event, and one that, when it took place, introduced a radical split in the spiritual life of the artist, changing substantially the aspect of humanity's cultural pro-duction. Among the first consequences of this split was the rapid eclipse of those sciences, such as rhetoric and dogmatics, of those social institutions, such as workshops and art schools, and of those structures of artistic composition, such as the repetition of styles, iconographic continuity, and the required tropes of literary composition, that were based precisely on the existence of a unitary status for human poesis. The doctrine of originality literally exploded the condition of the artist. Everything that in some way constituted the com-mon space in which the personalities of different artists met in a living unity in order then to assume, within the strictures of this common mold, their unmistakable physiognomy became a *commonplace* in the pejorative sense, an unbearable encumbrance: the artist in whom the modern critical demon has insinuated itself must free himself from it or perish.

In the revolutionary enthusiasm that accompanied this process, few recognized the negative consequences that it threatened to have for the condition of the artist himself, who inevitably lost even the possibility of a concrete social status. In his "Remarks on 'Oedipus,'" Hölderlin foresaw this danger and sensed that art would soon find itself in need of reacquiring the craftsmanship it had had in more ancient times:

> It will be good, in order to secure for today's poets a bourgeois existence—taking into account the difference of times and institutions—if we elevate poetry today to the *mechane* of the an-cients. When being compared with those of the Greeks, other works of art, too, lack reliability; at least, they have been judged until today according to the impressions which they made rather than according

to their lawful calculation and their other modes of operation through which the beautiful is engendered. Modern poetry, however, lacks especially training and craftsmanship, namely, that its mode of operation can be calculated and taught and, once it has been learned, is always capable of being repeated reliably in practice.[6]

If we now look at contemporary art, we notice that the need for a unitary status has become so strong that, at least in its most significant forms, it appears to be based precisely on an intentional confusion and perversion of the two spheres of poesis. The need for authenticity in technical production and that for reproducibility of artistic creation have given birth to two hybrid forms, the "ready-made" and pop art, which lay bare the split inherent in man's poietic activity.

As is well known, Duchamp took a common product, such as anyone could purchase in a department store, and, alienating it from its natural environment, forced it into the sphere of art in a sort of gratuitous act. That is, with a creative play on the existence of a double status in man's creative activity, he transferred the object from a technically reproducible and fungible state to one of aesthetic authenticity and uniqueness—at least for the brief instant during which the estrangement effect lasts.

Like the "ready-made," pop art is based on a perversion of the double status of aesthetic activity, but in it the phenomenon appears reversed, and rather resembles that "reciprocal ready-made" that Duchamp had in mind when he suggested that one use a Rembrandt as an ironing board. *While the "ready-made" proceeds from the sphere of the technical product to the sphere of art, pop art moves in the opposite direction: from aesthetic status to the status of industrial product.* While in the "ready-made" the spectator was faced with an object existing according to technics that was inexplicably charged with a certain potential of aesthetic authenticity, in pop art the spectator is confronted with a work of art that appears denuded of its aesthetic potential and that paradoxically assumes the status of the industrial product. In both cases—except for the instant of the alienation effect—the passage from the one to the other status is impossible: that which is reproducible cannot become original, and that which is irreproducible cannot be reproduced. The object cannot attain presence and remains enveloped in shadow, suspended in a kind of disquieting limbo between being and nonbeing. It is precisely this inability of the object to attain presence that endows both the "ready-made" and pop art with their enigmatic meaning.

In other words, both forms push the split we have been talking about to its extreme point, and in this way point beyond aesthetics to an area (still in shadow) in which the pro-ductive activity of man may become reconciled with itself. However, it is the very poietic substance of man that is brought to a crisis point in both cases: that poesis of which Plato said that "any cause that brings into existence something that was not there before is poesis." In the "ready-made" and in pop art, nothing comes into presence if not the privation of a potentiality that cannot find its reality anywhere. "Ready-made" and pop art, then, constitute the most alienated (and thus the most extreme) form of poesis, the form in which privation itself comes into presence. In the crepuscular light of this presence-absence, the question on the fate of art now sounds as follows: how is it possible to attain a new poesis in an original way?

If we now attempt to come closer to the meaning of this extreme destiny of poesis by which it dispenses its power only as privation (though this privation is also, in reality, an extreme gift of poetry, the most accomplished and charged with meaning, because in it nothingness itself is called into presence), we must interrogate the work, because it is in the work that poesis actualizes its power. What, then, is the character of the work, in which the productive activity of man concretizes itself?

For Aristotle, the production into presence, effected by poesis both for the things whose arché is in man and for those that exist according to nature, has the character of *energeia*. This word is usually translated as "actual reality," contrasting with "potentiality," but in this translation the original sonority of the word remains veiled. To indicate the same concept, Aristotle also employs a term he himself coined: *entelecheia*. That which enters into presence and remains in presence, gathering itself, in an end-directed way, into a shape in which it finds its fullness, its completeness; that which, then, *en teleichei*, possesses itself in its own end, has the character of energeia. Energeia, then, means being-at-work, *en ergon*, since the work, *ergon*, is precisely *entelechy*, that which enters into presence and lasts by gathering itself into its own shape as into its own end.

Opposed to energeia in Aristotle is *dynamis* (Latin: *potentia*), which characterizes the mode of presence of that which, not being at work, does not yet possess itself in its own shape as in its own end, but exists simply in the mode of availability, of being useful for . . . as a plank in a carpenter's workshop or a marble block in a sculptor's studio is available for the poietic act that will make it appear as a table or a statue.

The work, the result of poesis, can never be only potential, because it is precisely production into and station in a shape that possesses itself in its

own end. It is for this reason that Aristotle writes, "we would never say that something exists according to techné if, for example, something is a bed only in availability and potentiality (*dynamis*), but does not have the shape of the bed."[7]

If we now consider the double status of the poietic activity of modern man, we will see that, while the work of art has *par excellence* the character of energeia, that is, possesses itself in the unrepeatability of its formal eidos as in its end, the product of technology lacks this energetic station in its own form, as though the character of availability ended up by obscuring its formal aspect. Of course the industrial product is finished, in the sense that the productive process has come to its end, but the particular relationship of distance from its principle of origin—in other words, its reproducibility— causes the product never to possess itself in its own shape as in its own end, and thus the product remains in a condition of perpetual potentiality. That is, *the entry into presence has the character of energeia, of being-at-work, in the work of art, and the character of dynamis, of availability for . . . in the industrial product* (we usually express this by saying that the industrial product is not a "work" but, precisely, a product).

But is the energetic status of the work of art in the aesthetic dimension in fact such? Ever since our relationship with the work of art was reduced (or, if you wish, purified) to mere aesthetic enjoyment achieved through good taste, the status of the work itself has been imperceptibly changing under our very eyes. We see that museums and galleries stock and accumulate works of art so that they may be available at any moment for the spectator's aesthetic enjoyment, more or less as happens with raw materials or with merchandise accumulated in a warehouse. Wherever a work of art is pro-duced and exhibited today, its *energetic* aspect, that is, the being-at-work of the work, is erased to make room for its character as a stimulant of the aesthetic sentiment, as mere support of aesthetic enjoyment. In the work of art, in other words, the dynamic character of its availability for aesthetic enjoyment obscures the *energetic* character of its final station in its own shape. If this is true, then even the work of art, in the dimension of aesthetics, has, like the product of technics, the character of dynamis, of availability for . . . and *the split in the unitary status of man's productive ability marks in reality his passage from the sphere of energeia to that of dynamis, from being-at-work to mere potentiality.*

The rise of the poetics of the open work and of the work in progress, founded not on an energetic but on a dynamic status of the work of art, signifies precisely this extreme moment of the exile of the work of art from its essence, the moment in which—having become pure potentiality, mere

being-available in itself and for itself—it consciously takes on its own inability to possess itself in its end. "Open work" means: work that does not possess itself in its own eidos as in its end, work that is never at work, that is (if it is true that work is energeia), nonwork, dynamis, availability, and potentiality. Precisely because it is in the mode of availability for . . . because it plays more or less consciously on the aesthetic status of the work of art as mere availability for aesthetic enjoyment, the open work constitutes not a surpassing of aesthetics but only one of the forms of its fulfillment, and points beyond aesthetics only negatively.

In the same way, the "ready-made" and pop art play on the double status of the productive activity of the man of our time, perverting it; thus, they are also in the mode of dynamis, and of a dynamis that can never possess itself in its end. Yet precisely because they escape both the aesthetic enjoyment of the work of art and the consumption of the technical product, they actualize at least for an instant a suspension of these two statuses, push the consciousness of laceration much further than does the open work, and present themselves as a true availability-toward-nothingness. Since they properly belong neither to artistic activity nor to technical production, nothing in them really comes into being; likewise, one can say that since they offer themselves neither for aesthetic enjoyment nor for consumption, in their case availability and potentiality are turned toward nothingness, and in this way they are able to possess-themselves-in-their-end.

Availability-toward-nothingness, although it is not yet work, is in some way a negative presence, a shadow of being-at-work: it is energeia, work, and as such constitutes the most urgent critical appeal that the artistic consciousness of our time has expressed toward the alienated essence of the work of art. The split in the productive activity of man, the "degrading division of labor into manual and intellectual work," is not overcome here but rather made extreme. Yet it is also starting from this self-suppression of the privileged status of "artistic work," which now gathers the two sides of the halved apple of human pro-duction in their irreconcilable opposition, that it will be possible to exit the swamp of aesthetics and technics and restore to the poetic status of man on earth its original dimension.

—Translated by Georgia Albert

18

The Vestige of Art

Jean-Luc Nancy

Jean-Luc Nancy (b. 1940) is professor of philosophy at the University of Strasbourg. He was a close associate of Jacques Derrida, and he has also worked in collaboration with Philippe Lacoue-Labarthe. While his writings cover a variety of subjects a consistent theme is that of politics and the idea of a future community organized around singularities of being and experience.

Referring to Hegel's idea of "the end of art," Nancy's paper "The Vestige of Art" (1994) addresses the uncertain situation for art today concerning its definition, purpose, and value. Nancy sees the current anxiety over art's status as part of a more general crisis in the West concerning a loss of collective values and shared truths. Citing Nietzsche, Nancy observes that these circumstances in society can lead to a sense of nihilism in the form of either a cynicism about shared values or, alternatively, a regressive desire to restore a moral sense of communal purpose. Nihilism also effects art resulting in a wish to reveal art's apparent emptiness and lack of significance following its separation from the metaphysical and universal ideals of the past. Nancy believes that Hegel's idea of the end of art has been taken too literally sometimes and that his theory of the Idea (see chapter 2) offers a way of thinking about art that does not succumb to such nihilism.

Nancy suggests that art today cannot be thought of in terms of mimesis—as an imagistic imitation or representation of an original referent, whether

visible in empirical reality or, as in metaphysics, invisible, because it is tran-scendent. Exceeding these forms of thinking, which assign art and repre-sentation a secondary status in comparison with the referent, Nancy be-lieves that art should be conceived of as a trace or a vestige. In this context, the vestige is not a trace of what is past or has disappeared any more than it is a representation of something or someone. Rather the vestige is both disappearance, itself, and its trace (wherein this trace does not point to, or indicate, a referent, since disappearance is always already divided from itself).

Nancy revises Hegel's ideas of the end of art and his transcendental definition of art as "the sensible presentation of the Idea" for a more affir-mative, deconstructive understanding of their import. For this purpose, Nancy combines the oppositional terms of end and progress and of singu-larity and plurality. Nancy asserts that art is, indeed, at an end, but it has always already been in this position, since art is nothing other than an end, "repeated throughout its history." Such a repetition means that art, when it occurs, is an end *every time*. For Nancy, this means that art has to be thought of in terms of singularity—each time art occurs it is singular and, therefore, absolutely different from, and without comparison to, other art works, including those that supposedly belong together in the generic cat-egory known as "the history of art." This is because art is entelechy, perfect in its purpose and end. At the same time, Nancy conceives of art in terms of plurality, meaning that it is irreducible to itself or a singular signification and affect: "art is each time radically *another art*."

Nancy rereads Hegel's notion of the Idea not as a metaphysical es-sence divided from itself and in process of progressive reconstitution through time, but as both essence and appearance. The Idea is equated with art and vice versa as absolutes beyond any notion of negativity or lack, bound up with the infinite and with the invisible. Nancy believes that this change in the conception of art is not simply something that affects the discourse of art but is inseparable from a wholly different sense of "pres-ence" from that which has prevailed previously.

THE VESTIGE OF ART

What remains of art? Perhaps only a vestige. That at least is what we are hearing today, once again. By proposing "The Vestige of Art" as a title for this essay, I have in mind first of all, quite simply, this: on the assumption

that there remains in fact only a vestige of art—both an evanescent trace and an almost ungraspable fragment—that itself could be just the thing to put us on the track of art itself, or at least of something that would be essential to it, if one can entertain the hypothesis that what *remains is* also what *resists* the most. As a next step we will wonder if this something essential might not itself be of the order of a vestige, and if art in its entirety does not best manifest its nature, or what is at stake in it, when it becomes a vestige of itself, when, that is, having retreated from the greatness of works that cause worlds to come into being, art seems past, showing nothing more than its passage. We will come to this in a moment, when we consider in detail what a vestige is.

Thus, there is a debate around contemporary art, and it is by virtue of this debate that you have asked me to speak today, in the Jeu de Paume, in a museum—that is, in this strange place where art *only passes:* it remains there as passed/past, and it is just *passing through* there, among the sites of life and presence that perhaps, doubtless most often, it will never again rejoin. (But perhaps the museum is "not a place, but a history," as Jean-Louis Déotte has put it,[1] an ordering that gives rise to the passage as such, to the *passing* rather than to the *past*—which is the business of the vestige.)

People everywhere are wondering, anxiously, aggressively, if art today is still art. A promising situation, contrary to what disgruntled minds believe, since it proves that people are concerned with what art *is.* In other words, and in a very heavy word, with its *essence.* The word is, in fact, weighty, and no doubt it will cause some to form suspicions about the philosophical seizure or capture it might announce. But we will do our best to pare down the weight of this word, right down to its own vestige. For the moment, let us respond to what is promising there. Does this debate allow us to know a little bit more about the "essence" of art?

To begin with, one must clarify things, because there are several debates, which intertwine. Doubtless they have a common ground or vanishing point in the *being* of art, but one must distinguish several levels. I am going to advance progressively, distributing my remarks in simple successive numbers (exactly ten).

1. First of all, there would be the debate concerning the art market, or concerning art as market—as reducing itself to a market, which would be a first manner of emptying out its proper being. It is a debate, as we know, about the sites or the places, about the instances or the functions of this market, about the public and private institutions that are mixed up in it,

about the place it takes up in a "culture" that, on a larger scale, is already in itself a bone of contention.

I will not fully pursue all of this here, because I am not competent to do so. I propose merely a reflection on the essence of art, or on its vestige— and thus on the history that leads to this vestige. This does not immediately yield principles from which one could deduce practical maxims. The negotiation between the two registers is of another sort. I am therefore not proposing a "theory" for a "practice"—neither a practice of the market nor, and if possible even less, an artistic practice.

But since I have come up against the motif of the relation of art to the discourses put forward about it, and since, in recent years, some have understood certain of these discourses as indicative of a philosophical inflation and as participating, in a more or less underhanded way, in the extortion of a surplus value on, or behind the back of art, I seize the opportunity to affirm, on the contrary, that the work of thinking and speaking art, or its vestige, is itself, in a singular manner, taken or woven into the working of art itself. This has been so ever since there has been "art" (regardless of when one chooses to date its birth, with Lascaux or with the Greeks, or with the detachment, the *distinction*, in effect, that is called "end of art"). In each of its gestures, art also sets in motion the question of its "being": it quests after its own trace. Perhaps it always has with itself a relation of vestige—and of investigation.

(Reciprocally, many works of art today, far too many, perhaps, are finally nothing but their own theory, or at least seem to be nothing but that— yet another form of vestige. But this is itself a symptom of the muffled exigency that is worrying artists and that is not at all "theoretical": the exigency of presenting "art" itself, the exigency of its own *ekphrasis*.)

All the same, I will add this about the market: stigmatizing the subordination of works to financial capitalism is not sufficient to account for what puts art in the position of exorbitant value—or for what makes it, so to speak, exorbit value itself (use value, exchange value, and moral value, as well as semantics).

It is not a matter of excusing, still less of legitimating, anything. It is not a matter of neglecting the fact that the market touches not only on the buying and selling of works, but on the works themselves. It is only a matter of saying: the score is not settled by a condemnation of aesthetic morals. This is nothing new in the history of art, which does not wait for us to come along in order to be a history of merchandizing, too. (What is new is but a state of the economy or of capital; in other words, the question is *political* in

the most intense, abrupt, and difficult sense of the word.) No doubt art has always been *priceless*, by excess or by lack. This exorbitation has to do— across many mediations, deviations, and expropriations—with one of the most difficult, delicate stakes in the task of thinking art: to think, to weigh, to evaluate what is archi-precious or priceless, inestimable about it. In the manner of a vestige.

2. As for the debate that will be called "properly aesthetic," let us distinguish two levels.

First level: the incomprehension and the hostility aroused by contemporary art are matters of *taste*. Thus, all discussion is acceptable. Not by virtue of a subjectivist liberalism of tastes and colors (in which there is no *discussion*), but because taste (as long as one does not go to the other extreme and confuse it with the normative drive or maniacal discrimination), in the debate of tastes and distastes, is but the work of form as it seeks itself, of style that is still unaware of itself as it takes form, and that *senses* itself when it cannot yet recognize its *sense*. Taste, the debate about taste, is the promise or the proposition of art, symmetrical with its vestige. It is the proposition of a form, of a sketch for an age or for a world. For this reason, I would prefer that there be more debate than there is . . . That there be once again, in a different way, battles over *Hernani* or Dada . . . I will not go any further in this direction, which, as we know, comes from Kant (except to remark that if it is not possible, at this moment, to propose a "world," this supposed failing is not in any case to be imputed to art and to artists, as some people do, but rather to the "world" or to its absence . . .).

Second level (which does not exclude the first, but in which it is no longer a question of taste): the incomprehension and the hostility, no less than the frenzied approbation, themselves correspond, without knowing or without wanting to know, to the fact that art can no longer be understood or received according to the schemas that once belonged to it. Any use of the word "art" retains inevitably something of these schemas: when we say "art," the connotation is "great art," that is, something like the idea of a "great form" that would intentionally border on the cosmology of its time (to paraphrase Lawrence Durrell in *The Alexandria Quartet*). In saying "art," we evoke a cosmetics that has a *cosmic, cosmological* even a *cosmogonic* import or stake. But if there is no *kosmos*, how can there be an art in this sense? And that there is no *kosmos* is doubtless the decisive mark of our world: *world* today, does not mean *kosmos*. As a consequence, "art" cannot mean "art" in this sense. (That is why the first title I proposed for today's lecture was "Art Without Art.")

By inscribing the *polis* in the *kosmos*, we could also exemplify the preceding with this sentence from Georges Salles: "An art differs from the one that precedes it and realizes itself because it sets forth a reality of a nature different from a simple plastic modification: it reflects another man. . . . The moment one must seize is the one in which a plastic plenitude responds to the birth of a social type."[2] But just as our world is no longer *cosmic*, our *polis* is perhaps no longer *political* in the sense suggested by these lines.

To the determination of this acosmic world and this "apolitical" city, one must not forget to add this, which plays more than a minor role and is summed up by the well-known sentence from Adorno: "All post-Auschwitz culture, including its urgent critique, is garbage."[3] Besides its value as a name, "Auschwitz" has here the function of a metonymy for so many other instances of the unbearable. This sentence, nonetheless, does not justify the conversion of garbage into works of art. On the contrary, it gives back a terrible echo—for example, of a remark made in 1929, well before the war, by Michel Leiris: "At present, there is no longer any way to make something pass for ugly or repulsive. Even shit is pretty."[4] The intrication of world and filth [*du monde et de l'immonde*] cannot be, for us, either disintricated or dissimulated. It is thus that there is no *kosmos*. But we have no concept for an art without *kosmos* or *polis*, if there must at least be an art of this sort, or if it must still be a question of "art."

Thus, all the accusations, all the attributions, exhortations, and convocations addressed to art from the supposed horizon of a *kosmos* and a *polis* to which there would be reason to respond or to intentionally border on, all of these are in vain because this supposition is, for us, not supported by anything. For this reason, it is not possible to suppose a region or a domain of "art" to which one could address oneself, to which one could address demands, orders, or prayers.

To this extent—an immense extent, in truth, incommensurable—art in our time imposes on itself a severe gesture, a painful move toward its own essence become enigma, a manifest enigma of its own vestige. This is not the first time: perhaps the whole history of art is made up of tensions and torsions toward its own enigma. The tension and the torsion seem to have reached their high point today. This is perhaps but an appearance; perhaps it is as well the concentration of an event that began at least two centuries ago—or since the beginnings of the West. Whatever the case may be, "art" vacillates in its meaning as much as "world" does in its order or in its destination. In this regard, all quarrels are pointless: we *must* accompany this movement, we must *know* how to do it. This is of the order of the strictest

duty and knowledge, and not of the order of blind fits of anger, execrations, or celebrations.

3. It is worth recalling that the fits of anger, the signs of distress, and the certifications of exhaustion are themselves already quite used up. Kant wrote that "a boundary is set to [art] beyond which it cannot go, which presumably has been reached long ago and cannot be extended further."[5] This boundary is opposed, in the Kantian context, to the indefinite growth of knowledge; this is not exactly a certification of exhaustion, but it is the first form of a certification of "end," through the ambiguous motif of a *finishing* of art that is always begun again. Hegel, as is only too well known, declared that art, as manifestation of the true, belonged to the past. At the other end of the century, Renan, in what was no doubt a deliberate replay of Hegel, wrote: "Even great art will disappear. The time will come when art will be a thing of the past." Duchamp stated: "Art has been thought through to the end."[6]

A commentary on merely these four sentences, and on their succession, would require an enormous study. I will anticipate here merely its conclusion: art has a history, it is perhaps history in a radical sense, that is, not progress but passage, succession, appearance, disappearance, event.[7] But *each time* it offers *perfection*, completion. Not perfection as final goal and term toward which one advances, but the perfection that has to do with the coming and the presentation of a single thing inasmuch as it is formed, inasmuch as it is completely conformed to its being, in its *entelechy*, to use a term from Aristotle that means "a being completed in its end, perfect." Thus it is a perfection that is always *in progress*, but which admits no progression from one entelechy to another.

Therefore, the history of art is a history that withdraws at the outset and always from the history or the historicity that is represented as process or as "progress." One could say: art is each time radically *another art* (not only another form, another style, but another "essence" of "art"), according to its "response" to another world, to another *polis;* but it is at the same time each time *all* that it is, *all art* such as in itself finally. . . .[8]

But this completion without end—or rather, this *finite finishing*, if one attempts to understand thereby a completion that limits itself to what it is, but that, to achieve that very thing, opens the possibility of another completion, and that is therefore also *infinite finishing*—this paradoxical mode of perfection is doubtless what our whole tradition demands one to think and avoids thinking *at the same time*. There are profound reasons, which we will touch on later, for this ambiguous gesture. Thus, this tradition designates as a

boundary, as an *end* in the banal sense, and very quickly as a *death*, what might well be in truth the suspension of a form, the instantaneousness of a gesture, the blackout [*syncope*] of an appearance—and thus also, each time, of a disappearance. Are we capable of thinking this? Which is to say, you guessed it, of thinking the vestige?

It will have to be done. For if the event of art completing itself and vanishing is repeated throughout its history, if such an event forms this history as the rhythm of its repetition (and this, I repeat, perhaps in silence ever since Lascaux), it is because some necessity attaches to it. We will not escape from it by way of exorcisms or benedictions. Consequently, just as I am not seeking here a judgment of taste, neither am I proposing a *final* judgment on contemporary art, a judgment that would measure it, for good or for ill, against the ruler of teleological finishing (which would also be, necessarily, theological and thus anthropological and cosmological). I propose, on the contrary, to examine the kind of "perfection" or "finite/ infinite finishing" that is possible from what *remains* once a completion exhibits itself and insists on exhibiting itself. My concern, then, is this: with a *finite or vestigial perfection.*

4. If we pay attention and weigh words and their history carefully, we will agree that there is a definition of art that encompasses all the others (for the West at least, but art is a Western concept). It is, not at all by chance, Hegel's definition: art is *the sensible presentation of the Idea.* No other definition escapes from this one sufficiently to oppose it in any fundamental way. It encloses, up until today, the being or essence of art. If one allows for several versions or nuances, it is valid from Plato to Heidegger (at least to the best-known version of *The Origin of the Work of Art*; things are different in the first version of this text, as published by Emmanuel Martineau in 1987, but I cannot here get into the necessary analysis).[9] Beyond this, there is us: we struggle with each other and we debate over an inside/outside of this definition; to us falls the responsibility of debating with it, with this inevitable and yet already exceeded definition, as I would like to show.

Not only does this definition haunt philosophy, but it commands definitions that would seem to be distant from philosophical discourse. To take a few examples, the formula by Durrell says nothing else; nor does this one, from Joseph Conrad: "Art itself may be defined as a single-minded attempt to render the highest kind of justice to the visible universe, by bringing to light the truth, manifold and one, underlying its every aspect";[10] nor this other one, whose proximity is merely better disguised, which is taken from Martin Johnson and proposed to Norman Mailer in an interview: "Art is the

communication of emotion";[11] nor this one, from Dubuffet: "No art without intoxication. But this means: mad intoxication! let reason be overthrown! delirium! Art is the most enthralling orgy within man's reach."[12]

In order to grasp not the simple identity but the profound homogeneity of these formulae, it suffices to recall that the Hegelian Idea is not at all the intellectual Idea. It is neither the ideas (or product) of a notion, nor the ideal of a projection. Rather, the Idea is the gathering in itself and for itself of the determinations of being (to go quickly, we can also call it truth, sense, subject, being itself). The Idea is the presentation to itself of being or the thing. It is thus its internal conformation and its visibility, or in other words, it is the thing itself as vision/ envisioned [en tant que vue], where, in French, the word vue is taken both as noun (the thing as a visible form) and as adjective (the thing seen, envisioned, grasped in its form, but from within itself or its essence).

In this regard, art is the sensible visibility of this intelligible, that is, invisible, visibility. The invisible form—Plato's eidos—returns to itself and appropriates itself as visible. Thus, it brings into the light of day and manifests the being of its Form and its form of Being. All the great theories of "imitation" have never been anything but theories of the imitation, or the image, of the Idea (which is itself, you understand, but the self-imitation of being, its transcendent or transcendental miming)—and reciprocally, all thinking about the Idea is thinking about the image or imitation. Including, and especially, when it detaches itself from the imitation of external forms or from "nature" understood in this way. All this thinking is thus theological, turning obstinately around the great motif of "the visible image of the invisible God," which for Origen is the definition of Christ.

Therefore, all of modernity that speaks of the invisible or the unpresentable is always at least on the verge of renewing this motif. It is the motif that, to give another example, directs the words of Klee engraved on his tomb, and quoted by Merleau-Ponty: "I cannot be caught in immanence."[13]

What matters, then, is this: a visibility of invisibility as such, or ideality made present, even if it be the paradoxical presence of its abyss, its darkness, or its absence. This is what makes for the beautiful ever since Plato and even more, perhaps, since Plotinus, for whom, in the access to beauty, it is a question of becoming oneself pure light and vision, in beauty's intimacy, and thus becoming "the only eye capable of seeing supreme beauty."[14] Supreme beauty, or the brilliant flash of truth, or the sense of being. Art, or the sensible sense of absolute sense. And once again this is what makes for a beautiful that goes beyond itself into the "sublime," then into the "terrible," as well as into the "grotesque," into the implosion of

"irony," in a general entropy of forms or into the pure and simple position of a ready-made object.

5. Some, perhaps, will hasten to conclude: here indeed is the reason art is in perdition, because there is no longer any Idea to present, or because the artist no longer wants to do so (or else has lost the sense of the Idea). There is no more sense, or else we no longer want any; we are stuck in the refusal of sense and in the will to an end with which Nietzsche characterizes nihilism. So we ask the artist, more or less explicitly, to rediscover the Idea, the Good, the True, the Beautiful . . .

Such is the discourse, as weak here as it is elsewhere, of those who believe that it suffices to wave the flag of "values" and to fling about moral exhortations. Even if one must admit that there is some nihilism in this or that artist (in the one who, as Nietzsche puts it, "advances cynical history, cynical nature"),[15] one will still have to analyze in an altogether different way where it comes from, and consequently also draw other consequences from it. To the extent to which art touches on an extremity, to the extent to which it attains a moment of completion and/or of suspension, but remains at the same time under the definition and under the prescription of "the sensible presentation of the Idea," it comes to a stop and freezes as if on the last brilliant sliver [*éclat*] of the Idea, on its pure and somber residue. At the limit, ultimately, there remains nothing more than the Idea of art itself, like a pure gesture of presentation folded back on itself. But this residue still functions as Idea, and even as pure Idea of pure sense, or like an ideal visibility without any other content than light itself: like the pure kernel of darkness in an absolute self-imitation.

Nothing is more Platonic, or more Hegelian, than certain forms in which a purity or a purification prevails, whether it be material, conceptual, minimalist, performative, or in the form of an event. One could say that this is the art of the residual Idea. Although it is residual, it unleashes no less, indeed more, an infinite desire for sense, and for the presentation of sense. This residual is not the vestigial that I will speak of. It is the reverse.

In truth, the remarkable feature of many works today is not found in the lack of form or in deformity, in the disgusting or in the anything-whatsoever: it is, rather, in the quest, the desire, or the will for sense. People want to *signify*—world and filth, technics and silence, subject and its absence, body, spectacle, insignificance, and pure will-to-signify. A "quest for sense" is the (more or less conscious) *leitmotiv* of those who forget, like the Wagner of *Parsifal*, that the structure of the quest is a structure of flight and loss, where the desired sense little by little sheds all its blood.

Thus the demand or the postulation of the Idea lets itself be grasped in its nakedness, in the flesh. All the more naked and laid bare in that these demands and postulations are the more deprived of both referents and the codes for those referents (which in the past were religion, myth, history, heroism, nature, feeling, before becoming those of vision or sensation itself, of texture and of matter, right up to self-referential form). Where this demand for the Idea is displayed, with fierceness and with naïveté, art exhausts and consumes itself: all that remains is its metaphysical desire. It is no longer anything but the gaping hole stretched toward its *end*, toward an empty *telos/theos* of which it still presents the image. A nihilism, therefore, but as the simple reversal of idealism. If for Hegel art is finite because the Idea comes round to presenting itself in its proper element, in the philosophical concept, for the nihilist art finishes itself by presenting itself in its proper—and empty—concept.

6. With this, however, we have not exhausted the resources of the definition of art—nor the resources of art itself. We are not yet at the end of its *end*. The end of art conceals yet one more supplementary complication, from which arises all the complexity of the stakes of art today. To catch sight of it, we must take one more step in the logic of the "presentation of the Idea."

This step occurs in two moments, the first of which still belongs to Hegel (and through him to the whole tradition), whereas the second touches on Hegel's limit—and passes on to us (via Heidegger, Benjamin, Bataille, Adorno).

The first moment amounts to affirming that the "sensible representation of the Idea" is itself an absolute necessity of the Idea. In other words, the Idea cannot be what it is—presentation of the thing in its truth—except through, in, and as this sensible order that is at the same time its outside, and what is more, that is the outside as that which is withdrawn from the return-in-itself and for-itself of the Idea. The Idea must go outside itself in order to be itself. This is called the dialectical necessity. As you see, its implication is equivocal. On the one hand, art is therefore always necessary, and how could it end? But on the other hand, in the end it is the Idea that is presented. I will not linger any longer on this equivocation, although there is much to learn from the very specific manner in which it is at work in Hegel's *Aesthetics* and secretly complicates there, or even subverts, the schema of the "end of art."

But I move on to the second moment—the one that Hegel does not reach, cannot reach, and that remains as the residue of the equivocation

(and therefore as that onto which this equivocation also opens, in its way). Succinctly put, this second moment can be stated as follows: the Idea, in presenting itself, withdraws as Idea. This statement must be carefully examined.

The presentation of the Idea is not the putting of what was inside on view on the outside, if the inside is what it is—"*inside*"—only outside and as outside. (At bottom, this is the strict logic of self-imitation.) Therefore, instead of finding itself again and returning to itself as the invisible ideality of the visible, the Idea effaces its ideality so as to be what it is—but what it "is," by the same token, it is not and can no longer be.

In other words: perhaps what *remains* to us of the philosophy of the Idea, that is, what remains to us to *think*, is that sense is its own withdrawal. But that the withdrawal of sense *is not once again an unpresentable Idea to be presented*; this is what makes of this remainder, and of its thinking, indissociably a task for art: for if this withdrawal is not an invisible ideality to be visualized, it is because it is wholly tracing itself right at the visible, as the visible itself (or as the sensible in general). A task for an art, consequently, that would no longer be an art of a presentation of the Idea, and that should be defined otherwise.

7. It is here that the remainder is vestige. If there is no invisible, there is no visible image of the invisible. With the withdrawal of the Idea, that is, with the event that shakes up the whole history of the last two centuries (or the last twenty-five centuries . . .), the image also withdraws. And as we shall see, the other of the image is the vestige.

The image withdraws as phantom or phantasm of the Idea, destined to vanish in ideal presence itself. It withdraws therefore as image *of*, image of something or someone that, itself or himself or herself, would not be an image. It effaces itself as simulacrum or as face of being, as shroud or as glory of God, as imprint of a matrix or as expression of something unimaginable. (Note in passing, because we will return to this, that it is perhaps first of all very precise image that gets effaced: man as the image of God.)

In this sense, far from being the "civilization of the image" that is accused of crimes committed against art, we are rather a civilization without image, because without Idea. Art, today, has the task of answering to this world or of answering for it. It is not a matter of making this absence of Idea into an image, for art then remains caught in the ontotheological schema of the image of the invisible, of the god that, as Montaigne said, one had to "imagine unimaginable." It is a question, then, of another task, whose givens we must try to outline.

At the very least, it is clear that if art remains defined as a relation of the image to the Idea, or of the image to the unimaginable (a double relation that throughout the tradition determines more or less the division between the beautiful and the sublime in the philosophical determinations of art), then it is art as a whole that withdraws along with the image. This is indeed what Hegel saw coming. If his formula has known such success, if it has been amplified and hijacked, it is quite simply because the formula was true and art was beginning to be done with its function as image. Which is to say, with its ontotheological function: it is indeed in religion or as religion that Hegelian art becomes a "thing of the past." But in this way it is perhaps art that was beginning or that was beginning again otherwise, beginning to become visible otherwise than as image, coming to make itself felt otherwise.

In a world without image in this sense, a profusion, a whirlwind of imageries unfolds in which one gets utterly lost, no longer finds *oneself* again, in which art no longer finds itself again. It is a proliferation of *views* [vues], the visible or the sensible itself in multiple brilliant slivers [*éclats*], which refer to nothing. Views that give nothing to be seen or that see nothing: views without *vision*. (Think of the effacement of the romantic figure in which the artist was *visionary*.) Or else, and in a symmetrical manner, this world is traversed by an "exacerbated" ban on images, as Adorno says, and thus "the ban itself has . . . come to evoke suspicions of superstition," suspicion that it is but anxiety before the "nothing" which would be the support of every image.[16] This "reference to nothing" thus opens onto a major ambiguity: either the "nothing," in an obstinate and I dare say obsessional manner, is still understood as negative of the Idea, as negative Idea, or as abyss of the Idea (as the void at the heart of its self-imitation)—or else it can be understood otherwise. This is what I would like to propose under the name of the *almost nothing* that is the vestige.

8. What remains withdrawn from the image, or what remains in its withdrawal, as that withdrawal itself, is the *vestige*. The concept of this word has been given to us initially, and doubtless not by chance, by theology and mysticism. We will proceed to take it from there, so as to appropriate it. Theologians put to work the difference between the image and the vestige in order to distinguish between the mark of God on the reasonable creature, on man *Imago Doi*, and another mode of this mark on the rest of creation. This other mode, the vestigial mode, is characterized as follows (I borrow the analysis of Thomas Aquinas): the vestige is an effect that "represents only the causality of the cause, but not its form."[17] Aquinas gives

the example of smoke, of which fire is the cause. He adds, with reference to the sense of the word *vestigium*, which designates first of all the sole of a shoe or the sole of a foot, a trace, a footprint: "A vestige shows that some-one has passed by but not who it is." The vestige does not identify its cause or its model, unlike the way (this is again Aquinas's example) "a statue of Mercury represents Mercury," which is an *image*. (One must also recall here that according to Aristotelian concepts the model is also a cause, the "for-mal" cause.)

In the statue, there is the Idea, the *eidos* and the idol of the god. In the vestigial smoke, there is no *eidos* of the fire. One could also say: the statue has an "inside," a "soul"; the smoke is without inside. Of the fire it keeps only its consumption. We say, "Where there's smoke, there's fire," but here smoke has value first of all as absence of fire, of the form of fire (unlike, Aqui-nas specifies, a fire lit as effect of lighting a fire). However, this absence is not considered as such; it is not to the unpresentability of the fire that one refers but to the presence of the vestige, to its remainder or to its clearing of a path of presence. (*Vestigium* itself comes from *vestigare*, "to follow on the traces," a word of unknown origin, one whose trace has been lost. It is not a "quest"; it is simply the act of putting one's steps in the traces of steps.)

Certainly, for theology, there is fire, the fire of God—and there is only fire that truly and fully is: the rest is cinders and smoke. (This is at least one pole of theological consideration, of which the other remains an affirmation and an approbation of all created things.) I am not seeking, then, a continuous derivation of "vestige" from theology, for in that case I would introduce what is still a remainder of theology. We have an example of how the vestige can be perfectly religious in the legendary margins of Islam: Mohammed's foot-print at the moment of his departure into heaven. There is, moreover, be-hind Christian theology a whole biblical spirituality and theology of the trace and the passage. The point is, however, that the trace of God remains *his trace*, and God is not effaced in it. We are looking for something else: art indicates something else. Even over-attention to this word "vestige," or to any other word, could harbor a tendency to make of it a more or less sa-cred word, a kind of relic (another form of the "remainder"). We have to handle here a semantics that is itself vestigial: do not let the sense get set down any more than the foot of a passerby.

In these conditions, what I am setting down here—which, I believe, has been expressly proposed since Hegel—is that art is smoke without fire, vestige without God, and not presentation of the Idea. End of image-art, birth of vestige-art, or rather, coming into the light of day of this: that art has

always been vestige (and that it has therefore always been removed from the ontotheological principle). But how is one to understand that?

9. It would be necessary to distinguish, in art, between image and vestige—right at the work of art and on the same work, on all works perhaps. It would be necessary to distinguish that which operates or demands an *identification* of the model or the cause, even if it is a negative one, from that which proposes—or exposes—merely the thing, *some thing*, and thus, in a sense, *anything whatsoever*, but not in any way whatsoever, not as the image of the Nothing, and not as pure iconoclasm (which perhaps amounts to the same thing). Some thing as vestige.

To attempt to discern the stakes of this singular concept, lodged as a foreign body, difficult to spot, between presence and absence, between everything and nothing, between image and Idea, in flight from these dialectical couples, let us return to the *vestigium*. Recall first of all that for the theologian the *vestigium Dei* is right at the sensible, it is the sensible itself in its being-created. Man is *imago* inasmuch as he is *rationalis*, but the *vestigium* is sensible. This is also to say that the sensible is the element in which or as which the image effaces and withdraws itself. The Idea gets lost there—leaving its trace, no doubt, but not as the imprint of its form: as the tracing, the step, of its disappearance. Not the form of its selfimitation, nor the form in general of self-imitation, but what remains when self-imitation has not taken place.

Thus, if we do no more than take the step onto the limit of ontotheology, the step that succeeds Hegel, following Hegel but finally outside of him, the step into *the extremity of the end of art*, which ends that end in another event, then we are no longer dealing with the couple of the presenting sensible and the presented ideal. We are dealing with this: the form-idea withdraws and the vestigial form of this withdrawal is what our platonizing lexicon makes us call "sensible." *Aesthetics* as domain and as thinking of the sensible does not mean anything other than that. Here by contrast the trace is not the sensible trace of an insensible, one which would put us on its path or trail (which would indicate the way [*sens*] toward a Sense): it is (of) the sensible (the) *traced* or *tracing,* as its very *sense.* Atheism itself. This is doubtless what Hegel already understood.)

What can this mean? Let us try to advance further in our comprehension of the *vestigium.* This word designates the sole of the foot and its imprint or trace. From that one may draw two nonimagic traits. The foot, first of all, is the opposite of the face; it is the most dissimulated *face* or *surface* of the body. Here one might think of the presentation, which is finally atheological,

of Mantegna's *Dead Christ*, the soles of the feet turned toward our eyes.[18] One may also recall that the word "face" comes from a root that means "to pose, to set": to pose, present, expose without reference to anything. Here, without relation to anything other than a ground that supports, but that is not a substratum or an intelligible *subject*. With the sole or the bottom of the foot [*la plante du pied*], we are in the domain of the flat, of the out-flat [*l'ordre du* plat *et de* l'à-plat], of horizontal extension without reference to vertical tension.[19]

Passage makes for the second trait: the vestige bears witness to a step, a walk, a dance, or a leap, to a succession, an élan, a repercussion, a coming-and-going, a *transire*. It is not a ruin, which is the eroded remains of a presence; it is just a touch right at the ground.

The vestige is the remains of a step, a *pas*.[20] It is not its image, for the step consists in nothing other than its own vestige. As soon as the *pas* is taken or made, it is past. Or rather, it is never, as step, simply "made" and set down somewhere. The vestige is its touch, or its operation, without being its work. Or in still other terms, those I was using a moment ago, it would be its *infinite finishing* (or *infinishing*) and not its *finite perfection*. There is no presence of the step, the *pas;* it is itself but coming to presence. It is impossible to say literally that the step takes *place*: yet a *place* in the strong sense of the word is always the vestige of a step. The step, which is its own vestige, is not an invisible—it is neither God nor the step of God— yet neither is it the simple slack surface of the visible. The step rhythms the visible with the invisible, or the other way around, if we must speak this language. This rhythm comprises sequence and syncopation, trajectory and interruption, gait and gap, phrase and spasm. It thereby cuts a *figure*, but this figure is not an image in the sense I have spoken of here.[21] The step of the figure, or the vestige, is its tracing, its spacing.

We must therefore renounce naming and assigning *being* to the vestige. The vestigial is not an essence—and no doubt this is what puts us on the track of the "essence of art." That art is today its own vestige, this is what opens us to it. It is not a degraded presentation of the Idea, nor the presentation of a degraded Idea; it presents what is not "Idea": motion, coming, passage, the going-on of coming-to-presence. Thus, in Dante's *Inferno*, an added settling of the boat or the sliding of a few stones indicate to the damned—but do not let them see—the invisible passage of a living soul.[22]

10. Having turned aside the question of being, we come upon that of the agent. It remains for us to ask: *whose* step is it? whose vestige?

It is not that of the gods, or at most it would be that of their departure. But this departure is as old as the art of Lascaux. If "Lascaux" does indeed signify "art," that is, if "art" did not arise progressively from under the layers of magic, and then religion, but indicates at the outset another posture, not the imprint of knees but the trace of the step, then the question of the image has never concerned art. Idolatry and iconoclasm have their place only in relation to the Idea. This in no way disputes the fact that art has been homogeneous to religions. (It would be necessary, moreover, to consider many differences among the latter.) But within religion itself, art is not religious. (Hegel would have understood this.)

Concerning the step of animals, there would be much to say: about their rhythms and their gaits, about their proliferated traces, vestiges of their paws or odors, and about that which in man is an animal vestige. Here again, one would have to turn in the direction of what Bataille called the "beast of Lascaux." (All of which presumes that one can overlook, on the other side of animality, all the other sorts of steps or passages, the pressures, frictions, contacts, all the touches, ridges, scratches, blotches, grazes. . . .)

But I will take the risk of saying that the vestige is man's, of man. Not of the man-image, not of the man subject to the law of being the image of his own Idea, or of the Idea of his "own-ness" [son propre]. Thus of a man who fits the name "man" only with difficulty, if indeed it is difficult to remove that name from the Idea, from humanist theology. But let us say, let us try to say, no more than as an essay, the passerby. A passerby, each time, and each time anyone whatsoever—not that the passerby is anonymous, but his or vestige does not identify him or her.[23] Each time then also common.

The passerby passes, is in the passage: what is also called existing. Existing: the passing being of being itself. Coming, departure, succession, passing the limits, moving away, rhythm, and syncopated blackout of being. Thus not the demand for sense, but the passage as the whole taking place of sense, as its whole presence. There would be two modes of being-present, the Idea and the being-before, preceding (not presenting), passing, and thus always-already passed/ past. (In Latin, vestigium temporis was able to mean very brief lapse of time, the moment or the instant: Ex vestigio=right away.)

The name of man, however, remains too much a name, an Idea, and an image—and it is not in vain that its effacement was announced. No doubt, to pronounce it again, in a completely other tone, is also to refuse the anguished prohibition on images without necessarily bringing back the man of humanism, that is, of self-imitation of the Idea. But, to finish and in passing,

one might still try for an instant another word, by speaking of *gens*.[24] *Gens*, a vestige-word if there ever was one, name without name of the anonymous and the uncertain, a *generic* name par excellence, but one whose plural form would avoid generality, would indicate rather and on the contrary the singular insofar as it is always plural, and also the singular of *genres/genders*, of sexes, tribes (*gentes*), of peoples, of kinds [*genres*] of life, of forms (how many *genres* are there in art? how many genres of genres? but never any art that would have no genre . . .), and the singular/plural of *generations* and *engenderings*, that is, of successions and passages, of comings and departures, of leaps, of rhythms. *L'art et les gens*: I leave you with this title for another occasion.

—Translated by Peggy Kamuf

19

Art and Philosophy

Alain Badiou

Alain Badiou (b. 1937) is one of France's leading philosophers. He teaches at the École Normale Supérieure and the Collège International de Philosophie in Paris. Badiou's major work, *Being and Event*, was published in 1988, and its sequel, *Logics of Worlds*, came out in 2006. As the titles to these books suggest, Badiou's philosophy is preoccupied with the history of evental changes to humanity's understanding and beliefs and the way in which these changes are ontological without being metaphysical.

"Art and Philosophy" is the first essay in Badiou's *Handbook of Inaesthetics* (1998), which contains further chapters on Beckett, Mallarmé, Pessoa, dance, theater, and cinema. In the preface, Badiou writes that the term "inaesthetics" arises from his proposition that "art is itself a producer of truths" and not "an object for philosophy . . . inaesthetics describes the strictly intraphilosophical effects produced by the independent existence of some works of art." In "Art and Philosophy," Badiou argues that the independent existence of a given group of works of art stems from their relationship to a respective Truth-Event, of which they are traces. Badiou associates the notion of a Truth-Event with an idea of radical multiplicity that eludes the grasp of any independent objectivization; he likens the Truth-Event to Lacan's notion of the Real, an "originary disappearance . . . of the having-taken-place,"[1] "the act of truth, the one through which I come to know the only thing one may ever know in the element of the real: the void

of being as such."[2] For Badiou, a Truth-Event opposes the metaphysical concept of Being and its desire for presence and unified identity, since it is irreducible to its causes and conditions.

Badiou follows Plato in describing four paradigms of truth events: science, politics, love and art. Truth-Events in all four paradigms configure traces through "generic subsets," "procedures," and "configurations" composed of works. In the accompanying text, Badiou gives historical examples of some of the initiating Events of art: Greek tragedy, the classical style of music, the novel, dodecaphonic music (the twelve-tone system of music), modernist poetry, and the rupture of figurative art in the modern period. Badiou argues that as the configurations and procedures of art are traces of the Truth-Event, and not simply representations, they are both "immanent" and "singular," meaning that they are exclusive yet infinitely pluralistic forms of truth which cannot be rendered by philosophy or, indeed, any outside discourse. The thesis underlying "Art and Philosophy" is that this approach toward art contrasts with the three major schemas of philosophy—the didactic, romantic, and classical—all of which circumscribe art with their own ideas of truth. In the didactic schema truth is considered to be extrinsic to art; in the classical schema art "is incapable of truth," since it is conceived of solely in terms of cathartic pleasure, while in the romantic schema truth is believed to be exclusive to art alone (with philosophy in close attendance). Given its status as truth, Badiou is able to relate art to issues of education, politics, and the idea of community. While philosophy is rigorously delimited from art in Badiou's own schema, he states that it can bear the trace of the Truth-event and, in this way, can make truths "compossible." "Truths are multiple and heterogeneous, but the philosophical act displays them together. In doing so it evaluates its time. . . . A truth is what within time exceeds time. And the philosophical act is its active witness."[3]

One of the critical issues in "Art and Philosophy" is that of the relationship between the infinite and the finite, and how the Truth-Event of the infinite multiplicity of Beings can be represented in a finite work of art. Badiou is concerned to differentiate himself from Heidegger, the chief representative of "the romantic schema" who, he believes, adopts a quasi-religious idea of incarnation with respect to poetry; he also distinguishes his ideas from those of Deleuze who, he argues, misses out on the question of truth while viewing art as a finite configuration of chaos. In contrast to these thinkers Badiou proposes in a paper on drawing that the work of art is "the differential point of truth," which treads the line between chaos and a sense of

fragility, even weakness as it delineates, "the inexistence of any place."[4] It is precisely because of this nomadic nature of art's place that Badiou deconstructs the "place" once assumed by philosophy and aesthetics.

In the conclusion to "Art and Philosophy," and in a further attempt to address the problem of the gap between the Truth-Event and representation, Badiou turns to the subject of education and suggests that there is an obligation to affirm the Event for the purpose of collective organization that exceeds even democracy (although, it should be noted that, for Badiou, this does not negate the fundamental question of equality). Affirming the Event relates to Badiou's idea of "forcing," which is developed elsewhere in his philosophy: "Forcing is the point at which a truth, although incomplete, authorizes anticipations of knowledge concerning not what is but *what will have been if truth attains completion*."[5] Badiou's use of the future perfect tense here refers to his idea that a past Truth-Event legitimizes the work of politicized groups in configuring a truth, or truths, which are to come.

ART AND PHILOSOPHY

This link [between art and philosophy] has always been affected by a symptom—that of an oscillation or a pulse.

At its origins there lies the judgment of ostracism that Plato directed against poetry, theater, and music. We must face the fact that in the *Republic*, the founder of philosophy, clearly a refined connoisseur of all the arts of his time, spares only military music and patriotic song.

At the other extreme, we find a pious devotion to art, a contrite prostration of the concept—regarded as a manifestation of technical nihilism—before the poetic word, which is alone in offering the world up to the latent Openness of its own distress.

But, after all, it is already with the sophist Protagoras that we encounter the designation of artistic apprenticeship as the key to education. An alliance existed between Protagoras and Simonides the poet—a subterfuge that Plato's Socrates tried to thwart, so as to submit its thinkable intensity to his own ends.

An image comes to mind, an analogical matrix of meaning: Historically, philosophy and art are paired up like Lacan's Master and Hysteric. We know that the hysteric comes to the master and says: "Truth speaks through my mouth, I am *here*. *You* have knowledge, tell me who I am." Whatever the knowing subtlety of the master's reply, we can also anticipate

that the hysteric will let him know that it's not yet *it*, that her *here* escapes the master's grasp, that it must all be taken up again and worked through at length in order to please her. In so doing, the hysteric takes charge of the master, "barring" him from mastery and becoming his mistress. Likewise, art is always already there, addressing the thinker with the mute and scintillating question of its identity while through constant invention and metamorphosis it declares its disappointment about everything that the philosopher may have to say about it.

If he balks at amorous servitude and at the idolatry that represents the price of this exhausting and ever deceptive production of knowledge, the hysteric's master hardly has another choice than to give her a good beating. Likewise, the philosopher-master remains divided, when it comes to art, between idolatry and censure. Either he will say to the young (his disciples) that at the heart of every virile education of reason lies the imperative of holding oneself at a remove from the Creature, or he will end up conceding that she alone—this opaque brilliance that cannot but hold us captive—instructs us about the angle from which truth commands the production of knowledge.

And since what we are required to elucidate is the link between art and philosophy, it seems that, formally speaking, this link is thought in accordance with two schemata.

The first is what I will call the *didactic* schema. Its thesis is that art is incapable of truth, or that all truth is external to art. This thesis will certainly acknowledge that art presents itself (like the hysteric) in the guise of effective, immediate, or naked truth. Moreover, it will suggest that this nakedness exposes art as the pure *charm* of truth. More precisely, it will say that art is the appearance of an unfounded or nondiscursive truth, of a truth that is exhausted in its being-there. But—and this is the whole point of the Platonic trial—this pretence or seduction will be rejected. The heart of the Platonic polemic about mimesis designates art not so much as an imitation of things, but as the imitation of the effect of truth. This is an imitation that draws its power from its *immediate* character. Plato will therefore argue that to be the prisoners of an immediate image of truth *diverts us from the detour*. If truth can exist as charm, then we are fated to lose the force of dialectical labor, of the slow argumentation that prepares the way for the ascent to the Principle. We must therefore denounce the supposedly immediate truth of art as a false truth, as the semblance that belongs to the effect of truth. The definition of art, and of art alone, is thus the following: To be the charm of a semblance of truth.

It follows that art must be either condemned or treated in a purely instrumental fashion. Placed under strict surveillance, art lends the transitory force of semblance or of charm to a truth that is prescribed *from outside*. Acceptable art must be subjected to the philosophical surveillance of truths. This position upholds a didactics of the senses whose aim cannot be abandoned to immanence. The norm of art must be education; the norm of education is philosophy. This is the first knot that ties our three terms (art, philosophy, and education) together.

In this perspective, the essential thing is the control of art. This control is possible. Why? Because if the truth of which art is capable comes to it from outside—if art is a didactics of the senses—it follows, and this point is crucial, that the "good" essence of art is conveyed in its public effect, and not in the artwork itself. As Rousseau writes in the *Letter to D'Alembert*— "The spectacle is made for the people, and it is only by its effects upon the people that its absolute qualities can be determined."

In the didactic schema, the absolute of art is thus controlled by the public effects of semblance, effects that are in turn regulated by an extrinsic truth.

This educational injunction is itself absolutely opposed by what I will call the *romantic* schema. Its thesis is that art *alone* is capable of truth. What's more, it is in this sense that art accomplishes what philosophy itself can only point toward. In the romantic schema, art is the real body of truth, or what Lacoue-Labarthe and Nancy have named "the literary absolute." It is patent that this real body is a glorious body. Philosophy might very well be the withdrawn and impenetrable Father—art is the suffering Son who saves and redeems. Genius is crucifixion and resurrection. In this respect, it is art itself that educates, because it teaches of the power of infinity held within the tormented cohesion of a form. Art delivers us from the subjective barrenness of the concept. Art is the absolute as subject—it is *incarnation*.

Nevertheless, between didactic banishment and romantic glorification (a "between" that is not essentially temporal) there is—it seems—an age of relative peace between art and philosophy. The question of art does not torment Descartes, Leibniz, or Spinoza. It appears that these great classical thinkers do not have to choose between the severity of control and the ecstasy of allegiance.

Was it not Aristotle himself who had already signed, between art and philosophy, a peace treaty of sorts? All the evidence points to the existence of a third schema, the *classical* schema, of which one will say from the start that it *dehystericizes art*.

The classical *dispositif*, as constructed by Aristotle, is contained in two theses:

a) Art—as the didactic schema argues—is incapable of truth. Its essence is mimetic, and its regime is that of semblance.

b) This incapacity does not pose a serious problem (contrary to what Plato believed). This is because the *purpose* [*destination*] of art is not in the least truth. Of course, art is not truth, but it also does not claim to be truth and is therefore innocent. Aristotle's prescription places art under the sign of something entirely other than knowledge and thereby frees it from the Platonic suspicion. This other thing, which he sometimes names "catharsis," involves the deposition of the passions in a transference onto semblance. Art has a therapeutic function, and not at all a cognitive or revelatory one. Art does not pertain to the theoretical, but to the ethical (in the widest possible sense of the term). It follows that the norm of art is to be found in its utility for the treatment of the affections of the soul.

The great rules concerning art can be immediately inferred from the two theses of the classical schema.

The criterion of art is first of all that of liking. In no respect is "liking" a rule of opinion, a rule of the greatest number. Art must be liked because "liking" signals the effectiveness of catharsis, the real grip exerted by the artistic therapy of the passions.

Second, the name of what "liking" relates to is not truth. "Liking" is bound only to what extracts from a truth the arrangement of an identification. The "resemblance" to the true is required only to the degree that it engages the spectator of art in "liking," that is, in an identification that organizes a transference and thus in a deposition of the passions. This scrap of truth is therefore not truth per se, but rather what *a truth constrains within the imaginary*. This "imaginarization" of truth, which is relieved of any instance of the Real, is what the classical thinkers called "verisimilitude" or "likelihood."

In the end, the peace between philosophy and art rests entirely on the demarcation of truth from verisimilitude. This is why the classical maxim par excellence is: "The true is sometimes not the likely." This maxim states the demarcation and maintains—*beside* art—the rights of philosophy. Philosophy, which clearly grants itself the possibility of being without verisimilitude. We encounter here a classical definition of philosophy: The unlikely truth.

What is the cost of this peace between philosophy and art? Without doubt, art is innocent, but this is because it is innocent of all truth. In other words, it is inscribed in the imaginary. Strictly speaking, within the classical

schema, art is not a form of thought. It is entirely exhausted by its act or by its public operation. "Liking" turns art into a service. To summarize, we could say that in the classical view, art is a public service. After all, this is how it is understood by the state in the "vassalization" of art and artists by absolutism, as well as in the modern vicissitudes of funding. In terms of the link that preoccupies us here, the state is essentially classical (perhaps with the exception of the socialist state, which was rather didactic).

Let us briefly recapitulate our argument.

Didacticism, romanticism, and classicism are the possible schemata of the link between art and philosophy—the third term of this link being the education of subjects, the youth in particular. In didacticism, philosophy is tied to art in the modality of an educational surveillance of art's purpose, which views it as extrinsic to truth. In romanticism, art realizes within finitude all the subjective education of which the philosophical infinity of the idea is capable. In classicism, art captures desire and shapes [*éduque*] its transference by proposing a semblance of its object. Philosophy is summoned here only qua aesthetics: It has its say about the rules of "liking."

In my view, the century that is coming to a close was characterized by the fact that it did not introduce, on a massive scale, any new schema. Though it is considered to be the century of endings, breaks, and catastrophes, when it comes to the link that concerns us here, I see it instead as a century that was simultaneously conservative and eclectic.

What are the massive tendencies of thought in the twentieth century? Its massively identifiable *singularities*? I can see only three: Marxism, psychoanalysis, and German hermeneutics.

It is clear that as regards the thinking of art, Marxism is didactic, psychoanalysis classical, and Heideggerian hermeneutics romantic.

The proof that Marxism is didactic need not be located immediately in the evidence of the ukases and persecutions that were perpetrated in the socialist states. The surest proof lies in Brecht's unbridled creative thought. For Brecht, there exists a general and extrinsic truth, a truth the character of which is scientific. This truth is dialectical materialism, whose status as the solid base of the new rationality Brecht never cast into doubt. This truth is essentially philosophical, and the "philosopher" is the leading character in Brecht's didactic dialogues. It is the philosopher who is in charge of the surveillance of art through the latent supposition of a dialectical truth. It is in this respect that Brecht remained a Stalinist, if by Stalinism we understand—as indeed we should—the fusion of politics and of dialectical materialist philosophy under the jurisdiction of the latter. We could also say that

Brecht practiced a Stalinized Platonism. Brecht's supreme goal was to cre-
ate a "society of the friends of dialectics," and the theater was, in more than
one respect, the instrument of such a society. The alienation effect is a
protocol of philosophical surveillance *in actu* with regard to the educational
ends of theater. Semblance must be alienated [*mis à distance*] from itself so
as to *show*, in the gap thus formed, the extrinsic objectivity of the true.

Fundamentally, Brecht's greatness lay in having obstinately searched
for the immanent rules of a Platonic (didactic) art, instead of remaining con-
tent, like Plato, with classifying the existing arts as either good or bad. His
"non-Aristotelian" (meaning nonclassical and ultimately Platonic) theater is
an artistic invention of the first caliber within the reflexive element of a sub-
ordination of art. Brecht theatrically reactivated Plato's antitheatrical mea-
sures. He did so by turning the possible forms of the subjectivation of an
external truth into the focal point of art.

The importance of the epic dimension also originates in this program.
The epic is what exhibits—in the interval of the performance—the *courage*
of truth. For Brecht, art produces no truth, but is instead an elucidation—
based on the supposition that the true exists—of the conditions for a cour-
age of truth. Art, under surveillance, is a therapy against cowardice. Not
against cowardice in general, but against cowardice *in the face of truth*.
This is obviously why the figure of Galileo is central, and also why this play
is Brecht's tormented masterpiece, the one in which the paradox of an epic
that would be internal to the exteriority of truth turns upon itself

It is evident, I think, that Heideggerian hermeneutics remains romantic.
By all appearances, it exposes an indiscernible entanglement between the
saying of the poet and the thought of the thinker. Nevertheless, the advan-
tage is still with the poet, because the thinker is nothing but the announce-
ment of a reversal, the promise of the advent of the gods at the height of
our distress, and the retroactive elucidation of the historiality of being. While
the poet, in the flesh of language, maintains the effaced guarding of the
Open.

We could say that Heidegger unfolds the figure of the poet-thinker as
the obverse of Nietzsche's philosopher-artist. But what interests us here
and characterizes the romantic schema is that between philosophy and art
it is *the same truth that circulates*. The retreat of being comes to thought in
the conjoining of the poem and its interpretation. Interpretation is in the end
nothing but the *delivery* of the poem over to the trembling of finitude in
which thought strives to endure the retreat of being as clearing. Poet and
thinker, relying on one another, embody within the word the opening out of

its closure [*le déclos de sa cloture*]. In this respect, the poem, strictly speaking, cannot be equaled.

Psychoanalysis is Aristotelian, absolutely classical. In order to be persuaded of this, it suffices to read Freud's writings on painting and Lacan's pronouncements on the theater or poetry. In Freud and Lacan, art is conceived as what makes it so that the object of desire, which is beyond symbolization, can subtractively emerge at the very peak of an act of symbolization. In its formal bearing, the work leads to the dissipation of the unspeakable scintillation of the lost object. In so doing, it ineluctably captivates the gaze or the hearing of the one who is exposed to it. The work of art links up to a transference because it exhibits, in a singular and contorted configuration, the blockage of the symbolic by the Real, the "extimacy" of the *objet petit a* (the cause of desire) to the Other (the treasure of the symbolic). This is why the ultimate effect of art remains imaginary.

I can therefore conclude as follows: This century, which essentially has not modified the doctrines concerning the link between art and philosophy, has nevertheless experienced the *saturation* of these doctrines. Didacticism is saturated by the state-bound and historical exercise of art in the service of the people. Romanticism is saturated by the element of pure promise— always brought back to the supposition of a return of the gods—in Heidegger's rhetorical equipment. Classicism, finally, is saturated by the self-consciousness conferred upon it by the complete deployment of a theory of desire. Whence, if one has not already fallen prey to the lures of an "applied psychoanalysis," the ruinous conviction that the relationship between psychoanalysis and art is never anything but a service rendered to psychoanalysis itself: Art as free service.

That today the three schemata are saturated tends to produce a kind of disentanglement of the terms, a desperate "disrelation" between art and philosophy, together with the pure and simple collapse of what had circulated between them: the pedagogical theme.

From Dadaism to Situationism, the century's avant-gardes have been nothing but escort experiments for contemporary art, and not the adequate designation of the real operations of this art. The role of the avant-gardes was to represent, rather than to link. This is because they were nothing but the desperate and unstable search for a mediating schema, for a didactico romantic schema. The avant-gardes were didactic in their desire to put an end to art, in their condemnation of its alionated and inauthentic character. But they were also romantic in their conviction that art must be reborn immediately as absolute—as the undivided awareness of

its operations or as its own immediately legible truth. Considered as the harbingers of a didactico-romantic schema or as the partisans of the absoluteness of creative destruction, the avant-gardes were above all anticlassical.

Their limit lay in their incapacity to place a lasting seal on their alliances, with respect either to the contemporary forms of the didactic schema or to those of the romantic one. In empirical terms: Just like the fascism of Marinetti and the Futurists, the communism of Breton and the Surrealists remained merely allegorical. The avant-gardes did not achieve their conscious objective: to lead a united front against classicism. Revolutionary didactics condemned them on the grounds of their romantic traits: the leftism of total destruction and of a self-consciousness fashioned ex nihilo, an incapacity for action on a grand scale, a fragmentation into small groups. Hermeneutic romanticism condemned them on the grounds of their didactic traits: an affinity for revolution, intellectualism, contempt for the state. Above all, it condemned them because the didacticism of the avant-gardes was marked by a brand of aesthetic voluntarism. And we know that, for Heidegger, the will constitutes the last subjective figure of contemporary nihilism.

Today, the avant-gardes have disappeared. The global situation is basically marked by two developments: on the one hand, the saturation of the three inherited schemata, on the other, the closure of every effect produced by the only schema that the century applied, which was in fact a synthetic schema: didacto-romanticism. . . .

In this situation of saturation and closure, it is necessary to propose a new schema, a fourth modality of the link between philosophy and art.

The method of our inquiry will at first be negative: What do the three inherited schemata—didactic, romantic, classical—have in common, that today we would need to rid ourselves of? I believe that the "common" of these three schemata concerns the relation between art and truth.

The categories of this relation are immanence and singularity. "Immanence" refers to the following question: Is truth really internal to the artistic effect of works of art? Or is the artwork instead nothing but the instrument of an external truth? "Singularity' points us to another question: Does the truth testified by art belong to it absolutely? Or can this truth circulate among other registers of work-producing thought [la pensée uvrante]?

What can we immediately observe? First, that in the romantic schema, the relation of truth to art is indeed immanent (art exposes the finite descent of the Idea), but not singular (because we are dealing with *the* truth and the thinker's thought is not attuned to something different from what is

unveiled in the saying of the poet). Second, that in didacticism, the relation is certainly singular (only art can exhibit a truth *in the form of semblance*), but not at all immanent, because the position of truth is ultimately extrinsic. And third, that in classicism, we are dealing only with the constraint that a truth exercises within the domain of the imaginary in the guise of verisimilitude, of the "likely."

In these inherited schemata, the relation between artworks and truth never succeeds in being at once singular and immanent.

We will therefore affirm this simultaneity. In other words: Art *itself* is a truth procedure. Or again: The philosophical identification of art falls under the category of truth. Art is a thought in which artworks are the Real (and not the effect). And this thought, or rather the truths that it activates, are irreducible to other truths—be they scientific, political, or amorous. This also means that art, as a singular regime of thought, is irreducible to philosophy.

Immanence: Art is rigorously coextensive with the truths that it generates.

Singularity: These truths are given nowhere else than in art.

According to this vision of things, what becomes of the third term of the link, the pedagogical function of art? Art is pedagogical for the simple reason that it produces truths and because "education" (save in its oppressive or perverted expressions) has never meant anything but this: to arrange the forms of knowledge in such a way that some truth may come to pierce a hole in them.

What art educates us for is therefore nothing apart from its own existence. The only question is that of *encountering* this existence, that is, of thinking through a form of thought [*penser une pensée*].

Philosophy's relation to art, like its relation to every other truth procedure, comes down to *showing* it as it is. Philosophy is the go-between in our encounters with truths, the procuress of truth. And just as beauty is to be found in the woman encountered, but is in no way required of the procuress, so it is that truths are artistic, scientific, amorous, or political, and not philosophical.

The problem is therefore concentrated upon the *singularity* of the artistic procedure, upon what authorizes its irreducible differentiation—vis-à-vis science or politics, for example.

It is imperative to recognize that beneath its manifest simplicity—its naiveté, even—the thesis according to which art would be a truth procedure sui generis, both immanent and singular, is in fact an absolutely novel

philosophical proposition. Most of the consequences of this thesis remain veiled, and it demands from us a considerable labor of reformulation. The symptom of this novelty can be registered when we consider that Deleuze, for example, continues to place art on the side of sensation as such (percept and affect), in paradoxical continuity with the Hegelian motif of art as the "sensible form of the Idea." Deleuze thereby disjoins art from philosophy (which is devoted to the invention of concepts alone), in line with a modality of demarcation that still leaves the destination of art as a form of thought entirely unapparent. This is because if one fails to summon the category of truth in this affair, one cannot hope to succeed in establishing the plane of immanence from which the differentiation between art, science, and philosophy can proceed.

I think that the principal difficulty in this respect derives from the following point: When one undertakes the thinking of art as an immanent production of truths, *what is the pertinent unity of what is called "art"*? Is it the artwork itself, the singularity of a work? Is it the author, the creator? Or is it something else?

In actual fact, the essence of the question has to do with the problem of the relation between the infinite and the finite. A truth is an infinite multiplicity. I cannot establish this point here by way of formal demonstration, as I have done elsewhere. Let us say that this was the insight proper to the partisans of the romantic schema, before they obliterated their discovery in the aesthetic diagram of finitude, of the artist as the Christ of the Idea. Or, to be more conceptual: The infinity of a truth is the property whereby it subtracts itself from its pure and simple identity with the established forms of knowledge.

A work of art is essentially finite. It is trebly finite. First of all, it exposes itself as finite objectivity in space and/or in time. Second, it is always regulated by a Greek principle of completion: It moves within the fulfillment of its own limit. It signals its display of all the perfection of which it is capable. Finally, and most importantly, it sets itself up as an inquiry into the question of its own finality. It is the persuasive procedure of its own finitude. This is, after all, why the artwork is irreplaceable in all of its points (another trait that distinguishes it from the generic infinite of the true): Once "left" to its own immanent ends, it is as it will forever be, and every touch-up or modification is either inessential or destructive.

I would even happily argue that the work of art is in fact the only finite thing that exists—that art creates finitude. Put otherwise, art is the creation of an intrinsically finite multiple, a multiple that exposes its own organization

in and by the finite framing of its presentation and that turns this border into the stakes of its existence.

Thus, if one wishes to argue that the work is a truth, by the same token, one will also have to maintain that it is the descent of the infinite-true into finitude. But this figure of the descent of the infinite into the finite is precisely the kernel of the romantic schema that thinks art as incarnation. It is striking to see that this schema is still at work in Deleuze, for whom art entertains with the chaotic infinite the most faithful of relationships precisely because it configures the chaotic within the finite.

It does not appear that the desire to propose a schema of the art/philosophy link that would be neither classical, didactic, nor romantic is compatible with the retention of the work as the pertinent unit of inquiry—at least not if we wish to examine art under the sign of the truths of which it is capable.

All the more so given a supplementary difficulty: Every truth originates in an event. Once again, I leave this assertion in its axiomatic state. Let us say that it is vain to imagine that one could *invent* anything at all (and every truth is an invention) were nothing to happen, were "nothing to have taken place but the place." One would then be back at an "ingenious" or idealistic conception of invention. The problem that we need to deal with is that it is impossible to say of the work *at one and the same time* that it is a truth and that it is the event whence this truth originates. It is very often argued that the work of art must be thought of as an evental singularity, rather than as a structure. But every fusion of the event and truth returns us to a "Christly" vision of truth, because a truth is then nothing but its own evental self-revelation.

I think the path to be followed is encapsulated in a small number of propositions.

—As a general rule, a work is not an event. A work is a fact of art. It is the fabric from which the artistic procedure is woven.

—Nor is a work of art a truth. A truth is an artistic procedure initiated by an event. This procedure is *composed of* nothing but works. But it does not manifest itself (as infinity) in any of them. The work is thus the local instance or the differential point of a truth.

—We will call this differential point of the artistic procedure its *subject*. A work is the subject of the artistic procedure in question, that is, the procedure to which this work belongs. In other words: An artwork is a subject point of an artistic truth.

—The sole being of a truth is that of works. An artistic truth is a (infinite) generic multiple of works. But these works weave together the being of an artistic truth only by the chance of their successive occurrences.

—We can also say this: A work is a situated *inquiry* about the truth that it locally actualizes or of which it is a finite fragment.

—The work is thus submitted to a principle of novelty. This is because an inquiry is retroactively validated as a real work of art only inasmuch as it is an inquiry *that had not taken place,* an unprecedented subject-point within the trajectory of a truth.

—Works compose a truth within the post-evental dimension that institutes *the constraint of an artistic configuration.* In the end, a truth is an artistic configuration initiated by an event (in general, an event is a group of works, a singular multiple of works) and unfolded through chance in the form of the works that serve as its subject points.

In the final analysis, the pertinent unit for a thinking of art as an immanent and singular truth is thus neither the work nor the author, but rather the artistic configuration initiated by an evental rupture (which in general renders a prior configuration obsolete). This configuration, which is a generic multiple, possesses neither a proper name nor a proper contour, not even a possible totalization in terms of a single predicate. It cannot be exhausted, only imperfectly described. It is an artistic truth, and everybody knows that there is no truth of truth. Finally, an artistic configuration is generally designated by means of abstract concepts (the figural, the tonal, the tragic . . .).

What are we to understand, more precisely, by "artistic configuration"?

A configuration is not an art form, a genre, or an "objective" period in the history of art, nor is it a "technical" *dispositif.* Rather, it is an identifiable sequence, initiated by an event, comprising a virtually infinite complex of works, when speaking of which it makes sense to say that it produces—in a rigorous immanence to the art in question—a truth *of this art,* an art-truth. Philosophy will bear the trace of this configuration inasmuch as it will have to show in what sense this configuration lets itself be grasped by the category of truth. The philosophical montage of the category of truth will in turn be singularized by the artistic configurations of its time. In this sense, it is true to say that, more often than not, a configuration is thinkable at the juncture of an effective process within art and of the philosophies that seize this process.

One will point to Greek tragedy, for example, which has been grasped as a configuration time and again, from Plato or Aristotle to Nietzsche. The

initiating event of tragedy bears the name "Aeschylus," but this name, like every other name of an event, is really the index of a central void in the previous situation of choral poetry. We know that with Euripides, the configuration reaches its point of saturation. In music, rather than referring to the tonal system, which is far too structural a *dispositif*, one will refer to the "classical style" in the sense that Charles Rosen speaks of it, that is, as an identifiable sequence stretching out between Haydn and Beethoven. Likewise, one will doubtless say that—from Cervantes to Joyce—the novel is the name of a configuration for prose.

It will be noted that the saturation of a configuration (the narrative novel around the time of Joyce, the classical style around that of Beethoven, etc.) in no way signifies that said configuration is a finite multiplicity. Nothing from within the configuration itself either delimits it or exposes the principle of its end. The rarity of proper names and the brevity of the sequence are inconsequential empirical data. Besides, beyond the proper names retained as significant illustrations of the configuration or as the "dazzling" subject points of its generic trajectory, there is always a virtually infinite quantity of subject points—minor, ignored, redundant, and so on—that are no less a part of the immanent truth whose being is provided by the artistic configuration. Of course, it can happen that the configuration no longer gives rise to distinctly perceivable works or to decisive inquiries into its own constitution. It can also happen that an incalculable event comes to reveal in retrospect a configuration to be obsolete with respect to the constraints introduced by a new configuration. But in any case, unlike the works that constitute its material, a truth configuration is intrinsically infinite. This clearly means that the configuration ignores every internal maximum, every apex, and every peroration. After all, a configuration may always be seized upon again in epochs of uncertainty or rearticulated in the naming of a new event.

From the fact that the thinkable extraction of a configuration often takes place on the edges of philosophy—because philosophy is conditioned by art *as singular truth* and therefore by art as arranged into infinite configurations—we must above all not conclude that it is philosophy's task to think art. Instead, *a configuration thinks itself in the works that compose it*. Let's not forget that a work is an inventive inquiry into the configuration, which therefore thinks the thought that the configuration *will have been* (under the presumption of its infinite completion). To put it more precisely: The configuration thinks itself through the test posed by an inquiry that, at one and the same time, reconstructs it locally, sketches its "to come," and retroactively reflects its temporal arc. From this point of view, it is necessary to

maintain that art—as the configuration "in truth" of works—is in each and every one of its points the thinking of the thought that it itself is [*pensée de la pensée qu'il est*].

We can therefore declare that we've inherited a threefold problem:

—What are the contemporary configurations of art?

—What becomes of philosophy as conditioned by art?

—What happens to the theme of education?

We will leave the first point alone. The whole of contemporary thinking about art is full of inquiries—often enthralling ones—about the artistic configurations that have marked the century: dodecaphonic music, novelistic prose, the age of poets, the rupture of the figurative, and so on.

On the second point, I cannot but reiterate my own convictions: Philosophy, or rather *a* philosophy, is always the elaboration of a category of truth. Philosophy does not itself produce any effective truth. It seizes truths, shows them, exposes them, announces that they exist. In so doing, it turns time toward eternity—since every truth, as a generic infinity, is eternal. Finally, philosophy makes disparate truths compossible and, on this basis, it states the being of the time in which it operates as the time of the truths that arise within it.

Concerning the third point, let us recall that the only education is an education *by* truths. The entire, insistent problem is that there be truths, without which the philosophical category of truth is entirely empty and the philosophical act nothing but an academic quibble.

This question of the existence of truths (that "there be" truths) points to a coresponsibility of art, which produces truths, and philosophy, which, under the condition that there are truths, is duty-bound to make them manifest (a very difficult task indeed). Basically, to make truths manifest means the following: to distinguish truths from opinion. So that the question today is this and no other: Is there something besides opinion? In other words (one will, or will not, forgive the provocation), is there something besides our "democracies"?

Many will answer, myself among them: "Yes." Yes, there are artistic configurations, there are works that constitute the thinking subjects of these configurations, and there is philosophy to separate conceptually all of this from opinion. Our times are worth more than the label on which they pride themselves: "democracy."

—Translated by Alberto Toscano

20

The Janus-Face of Politicized Art

Jacques Rancière

Jacques Rancière (b. 1940) taught at the University of Paris VIII from 1969 to 2000, occupying the chair of aesthetics and politics from 1990 until his retirement. He was a pupil of the Marxist theorist Louis Althusser, but, after the events of May 1968, he rejected Althusser's claims for Marxism as an objective science. Since then Rancière has pursued Marxist concerns through a structuralist account of history allied to an inquiry into the relationship between discourse and the image as this informs, and is shaped by, dialectical thinking.

Rather than subscribe to a postmodern rupture with the past, Rancière believes that postmodernism can be understood within a revised conception of modernism. In an attempt to overcome conventional ideas about the beginnings of modernism and its characteristic tendencies, Rancière, in his book *The Politics of Aesthetics: The Distribution of the Sensible* (2000), develops an epistemic methodology as this applies to art. "The distribution of the sensible" refers to the predominant means of legitimizing and thereby structuring the function and purposes of art during its respective regimes, of which Rancière proposes that, historically, there have been three: the ethical regime of images, the poetic or representative regime of art, and the aesthetic regime of art. According to Rancière, the principal operations at stake in all of these three regimes are those concerning the relationship of the sayable to the visible, and the visible and the invisible. The former set of

terms bring into play an interrelation between discourse, literature, and art (including, in the twentieth century, film), while the latter pairing opens onto issues regarding the status of the image and its relationship with politics and ideology.

Rancière argues in this interview with Gabriel Rockhill, conducted in 2003, that the aesthetic regime no longer operates through a hierarchical ordering of genres or a controlled organization of narrative, actions, gestures and composition in art, as was the case in the representative regime (the operations of this previous regime were shaped by the hierarchical order established under the rule of absolutist monarchies and by a desire to control and give "sensible" form to art).[1] For Rancière, the aesthetic regime is first exemplified by Gustave Flaubert's *Madame Bovary* (1856), in which he claims the same intensity of feeling is given to all the aspects of the scenes in the narrative. This results in a sense of indifference, since each scene is treated with the same regard. However, the equalization of affects and things in *Madame Bovary* has implications not just for understanding modernist art (in which, for instance, collage and montage were used extensively for the first time), but also for evaluating the characteristics of pastiche and eclecticism that are often said to distinguish postmodern art. (Nevertheless, Rancière is keen to differentiate various kinds of equality, especially those pertaining to art and literature on one hand and commerce and politics on the other. Thus, he argues that the formal effects of *Madame Bovary* are not necessarily comparable to the equalizing treatment of commodities and monetary exchange within capitalism—or, indeed, to the equality that Marxism or other radical political forms seek. Referring to Plato's concerns about controlling the written word in the *Phaedrus*, Rancière believes that political equality can only come into being when the excluded claim a place in discourse.)

The loss of a hierarchy of meaning in art and literature in the aesthetic regime has coincided with an increased desire to found a new set of social relations organized along aesthetic lines. Some of Balzac's novels and stories highlight a yearning to discover within the social certain underlying aesthetic forms and relations that might constitute a new communal life. Alternatively, many modernist artists and writers have sought to create an aesthetic form within art itself, separate from existing social relations but potent enough to provide a model for a future, unalienated society (such a tendency is treated ironically by Flaubert in *Madame Bovary*, whose eponymous heroine desires to transform her life along the lines of the romance novels she reads). In the hands of certain writers such as Virginia Woolf,

James Joyce, and Cesare Pavese, a tension takes hold between the at-tempt to create an autonomous form of writing and the search through the marginalized sources of such an autonomous form for a new language of social import. Rancière proposes that this tension within such writers may be rethought in terms of a "positive contradiction." By adopting this for-mula, Rancière retains a sense of the dichotomies at stake in modernism but allows them to function in terms of an unresolved challenge to thought, rather than as a utopic desire to exceed it.

THE JANUS-FACE OF POLITICIZED ART

Universality, Historicity, Equality

—I would like to begin with a question concerning methodology. On several occasions, you call into question the symptomatology that attempts to un-veil the truth hidden behind the obscure surface of appearances, whether it is Althusser's science, Freud's etiology, or the social sciences in general. In your own research on the distribution of the sensible that underlie historical configurations of art and politics, how do you avoid this logic of the hidden and the apparent? How would you describe your own historical and her-meneutic methodology if "there is no science . . . but of the hidden"?[2]

—Concerning art, it seemed necessary to me to emphasize the exis-tence of historical regimes of identification in order to dismiss, at one and the same time, the false obviousness of art's eternal existence and the confused images of artistic "modernity" in terms of a "critique of repre-sentation." I evoked the fact that art in the singular has only existed for two centuries and that this existence in the singular meant the upheaval of the coordinates through which the "fine arts" had been located up to then as well as the disruption of the norms of fabrication and assessment that these coordinates presupposed. I showed that if the properties of each one of these regimes of identification was studied, it was possible to dissipate quite a lot of the haze surrounding the idea of a "modern proj-ect" of art and its completion or failure. This was done, for example, by showing that phenomena considered to be part of a postmodern rupture (such as the mixture of the arts or the combination of mediums) actually fall within the possibilities inherent in the aesthetic regime of art. In both cases, it is a matter of setting a singularized universal against an undeter-mined universal and contrasting one form of historicizing (in terms of

contingent regimes organizing a field of possibilities) with another form of historicizing (in terms of teleology).

The second question concerns the universal and its historicity. My thesis is indeed that the political universal only takes effect in a singularized form. It is distinguished, in this way, from the State universal conceived of as what makes a community out of a multiplicity of individuals. Equality is what I have called a presupposition. It is not, let it be understood, a founding ontological principle but a condition that only functions when it is put into action. Consequently, politics is not based on equality in the sense that others try to base it on some general human predisposition such as language or fear. Equality is actually the condition required for being able to think politics. However, equality is not, to begin with, political in itself. It takes effect in lots of circumstances that have nothing political about them (in the simple fact, for example, that two interlocutors can understand one another). Secondly, equality only generates politics when it is implemented in the specific form of a particular case of dissensus.

—*Is this actualization of equality also to be found in aesthetics, and more specifically in what you call democratic writing? Is it the same universal presupposition that is at work?*

—I do not set down equality as a kind of transcendental governing every sphere of activity, and thus art in particular. That said, art as we know it in the aesthetic regime is the implementation of a certain equality. It is based on the destruction of the hierarchical system of the fine arts. This does not mean, however, that equality in general, political equality, and aesthetic equality are all equivalent. Literature's general condition as a modern form of the art of writing is what I have called, by rerouting the Platonic critique, the democracy of the written word. However, the democracy of the written word is not yet democracy as a political form. And literary equality is not simply the equality of the written word; it is a certain way in which equality can function that can tend to distance it from any form of political equality. To state it very crudely, literature was formed in the nineteenth century by establishing its own proper equality. Flaubert's equality of style is thus at once an implementation of the democracy of the written word and its refutation. Moreover, this equality of style aims at revealing an immanent equality, a passive equality of all things that stands in obvious contrast with the political subjectivization of equality in all its forms.

—*What then are the heuristic advantages of the notion of equality for explaining the major changes between "classical art" and "modern art"? Why do you propose the notion of equality for thinking through the specificity of*

the aesthetic regime of the arts instead of accepting all of the preconceived opinions on the destiny of modern art: the transition from the representative to the non-representative, the realization of the autonomy of the aesthetic sphere, art's intransitive turn, etc.?

—Once again, I am not proposing equality as a conceptual category for art, but I think that the notion of aesthetic equality allows us to rethink certain incoherent categories integral to what is called artistic "modernity." Let's take intransitivity for example. Intransitivity is supposed to mean that writers will henceforth deal with language instead of telling a story, or that painters will distribute fields of color instead of painting warhorses or naked women (Maurice Denis). However, this supposed dismissal of subject matter first presupposes the establishment of a regime of equality regarding subject matter. This is what "representation" was in the first place, not resemblance as some appear to believe, but the existence of necessary connections between a type of subject matter and a form of expression. This is how the hierarchy of genres functioned in poetry or painting. "Intransitive" literature or painting means first of all a form of literature or painting freed from the systems of expression that make a particular sort of language, a particular kind of composition, or possibly a particular type of color appropriate for the nobility or banality of a specific subject matter. The concept of intransitivity does not allow us to understand this. It is clear that this concept does not work in literature. In a way, literature always says something. It simply says it in modes that are set off from a certain standard idea of a message. Some have attempted to contrast literary intransitivity with communication, but the language of literature can be as transparent as the language of communication. What functions differently is the relationship between saying and meaning. This is where a dividing line becomes visible, which coincides with the implementation of another form of equality, not the equality of communicators but the equality of the communicated. Likewise, for abstract painting to appear, it is first necessary that the subject matter of painting be considered a matter of indifference. This began with the idea that painting a cook with her kitchen utensils was as noble as painting a general on a battlefield. In literature, it began with the idea that it was not necessary to adopt a particular style to write about nobles, bourgeois, peasants, princes, or valets. The equality of subject matter and the indifference regarding modes of expression is prior to the possibility of abandoning all subject matter for abstraction. The former is the condition of the latter.

I am not looking to establish a way of thinking modern art on the basis of equality. I try to show that there are several kinds of equality at play, that

literary equality is not the same thing as democratic equality or the universal exchangeability of commodities.

—*Regarding the different forms of equality, how do you distinguish writing, criticized by Plato as an orphan letter that freely circulates without knowing who it should address, and the indifferent flow of capital? More specifically, how do you distinguish, in the nineteenth century, between the literary equality that you pinpoint in an author like Flaubert and the equality of exchange?*

—The equality of the written word is not the same thing as the equality of exchange. The democracy of the written word does not come down to the arbitrary nature of signs. When Plato criticizes the availability of the written word, he calls into question a form of unsupervised appropriation of language that leads to the corruption of legitimacy. The circulation of the written word destroys the principle of legitimacy that would have the circulation of language be such that it leaves the proper transmitter and goes to the proper receiver by the proper channel. "Proper" language is guaranteed by a proper distribution of bodies. The written word opens up a space of random appropriation, establishes a principle of untamed difference that is altogether unlike the universal exchangeability of commodities. To put it very crudely, you cannot lay your hands on capital like you can lay your hands on the written word. The play of language without hierarchy that violates an order based on the hierarchy of language is something completely different than the simple fact that a euro is worth a euro and that two commodities that are worth a euro are equivalent to one another. It is a matter of knowing if absolutely anyone can take over and redirect the power invested in language. This presupposes a modification in the relationship between the circulation of language and the social distribution of bodies, which is not at all at play in simple monetary exchange.

An idea of democracy has been constructed according to which democracy would be the simple system of indifference where one vote is equal to another just as a cent is worth a cent, and where the "equality of conditions" would be equal to monetary equivalence. From this perspective, it is possible to posit literary indifference, Flaubert's indifference of style for example, as analogous to democratic and commercial indifference. However, I think that it is precisely at this point that it is necessary to bring the differences back into play. There is not an analogy but a conflict between forms of equality, which itself functions at several levels in literature. Let's take *Madame Bovary* as an example. On the one hand, the absolutization

of style corresponds to a principle of democratic equality. The adultery committed by a farmer's daughter is as interesting as the heroic actions of great men. Moreover, at a time when nearly everyone knows how to read, almost anyone has access, as a result of the egalitarian circulation of writing, to the fictitious life of Emma Bovary and can make it their own. Consequently, there is a veritable harmony between the random circulation of the written word and a certain literary absolute. On the other hand, however, Flaubert constructs his literary equality in opposition to the random circulation of the written word and to the type of "aesthetic" equality it produces. At the heart of *Madame Bovary* there is a struggle between two forms of equality. In one sense, Emma Bovary is the heroine of a certain aesthetic democracy. She wants to bring art into her life, both into her love life and into the décor of her house. The novel is constructed as a constant polemic against a farm girl's desire to bring art into life. It contrasts "art in life" (this will later be called the aestheticization of daily life) with a form of art that is in books and only in books.

Nonetheless, neither art in books nor art in life is synonymous with democracy as a form for constructing dissensus over "the given" of public life. Neither the former nor the latter, moreover, is equivalent to the indifference inherent in the reign of commodities and the reign of money. Flaubert constructs a literary indifference that maintains a distance from any political subjectivization. He asserts a molecular equality of affects that stands in opposition to the molar equality of subjects constructing a democratic political scene. This is summed up in the phrase where he says he is less interested in someone dressed in rags than in the lice that are feeding on him, less interested in social inequality than in molecular equality. He constructs his book as an implementation of the microscopic equality that makes each sentence equal to another—not in length but in intensity—and that makes each sentence, in the end, equal to the entire book. He constructs this equality in opposition to several other kinds of equality: commercial equality, democratic political equality, or equality as a lifestyle such as the equality his heroine tries to put into practice.

Positive Contradiction

—What is the historical status of the contradiction between incorporation and disincorporation—the struggle between body and spirit—that you find at work in Flaubert as well as in Balzac, Mallarmé, and Proust? Why has this contradiction been a crucial determining factor for modern literature, as well as for egalitarian democracy?

—Incorporation and disincorporation do not mean body and spirit. In the Christian tradition, body and spirit go together and stand in opposition to the "dead letter." Language is incorporated when it is guaranteed by a body or a material state; it is disincorporated when the only materiality that supports it is its own. The conflict between these two states of language is at the heart of literature such as it was developed in the nineteenth century as an aesthetic regime of writing. In one respect, literature means disincorporation. The traditional expressive relationships between words, feelings, and positions collapsed at the same time as the "social" hierarchies they corresponded to. There were no longer noble words and ignoble words, just as there was no longer noble subject matter and ignoble subject matter. The arrangement of words was no longer guaranteed by an ordered system of appropriateness between words and bodies. There was, on the one hand, a vast egalitarian surface of free words that could ultimately amount to the limitless indifferent chatter of the world. On the other hand, however, there was the desire to replace the old expressive conventions with a direct relationship between the potential of words and the potential of bodies, where language would be the direct expression of a potential for being that was immanent in beings. This is what is at work in Balzac, as I have attempted to show in *La Parole muette*[3] and *The Flesh of Words*.[4] In his work, it is the things themselves that speak. The course of destiny is already written on the façade of a house or on the clothing worn by an individual. An "everything speaks" (Novalis) is immanent in things, and literature conceives of itself as a revival, an unfurling, a deciphering of this "everything speaks." It dreams of constructing a new body for writing on this foundation. This will later become Rimbaud's project in developing an "Alchemy of the Word" or Mallarmé's dream of a poem choreographing the movements of the Idea, before becoming the Futurist language of new energies or the Surrealist dream of a language of desire that can be read in graffiti, shop signs, or catalogues of out-of-date merchandise.

The nineteenth century was haunted—negatively—by the Platonic paradigm of the democratic dissolution of the social body, by the fanciful correlation between democracy/individualism/ Protestantism/revolution/the disintegration of the social bond. This can be expressed in more or less poetic or scientific terms (sociology as a science was born from this obsession with the lost social bond), more or less reactionary or progressive terms, but the entire century was haunted by the imminent danger that an indifferent equality would come to reign and by the idea that it was necessary to oppose it with a new meaning of the communal body. Literature

was a privileged site where this became visible. It was at one and the same time a way of exhibiting the reign of indifferent language and, conversely, a way of remaking bodies with words and even a way of leading words toward their cancellation in material states. I studied this tension in Balzac's *The Village Rector*. The novel is the story of a crime caused by a book that intervenes in the working-class life of a young girl not destined to read it. In contrast with the fatal words written on paper, there is a good form of writing, one that does not circulate but is inscribed in things themselves. However, this form of writing can only mean, in the end, the self-cancellation of literature: the daughter of the people, lost by book, "writes her repentance" in the form of canals that will enrich village. This is the precise equivalent of the Saint-Simonian theory that opposes the paths of communication opened up in the earth to the chatter of democratic newspapers.

This tension is expressed in a completely different manner in the work of Mallarmé or Rimbaud. Mallarmé attempted to identify the poetic function with a symbolic economy that would supplement the simple equality of coins, words in the newspaper, and votes in a ballot box. He opposes the vertical celebration of the community to the horizontality of the "democratic terreplein" (Plato's arithmetical equality). Rimbaud attempts, for his part, to elaborate a new song for the community, expressed in a new word that would be accessible to all the senses.[5] This is, however, where the contradiction appears. The "alchemy of the word" that is supposed to construct a new body only has at its disposition a bric-a-brac of various forms of orphaned writing: books in school-taught Latin, silly refrains, small erotic books with spelling errors. . . .

—*Are there authors who escape this logic that dominates the nineteenth century? How would you react to the criticism that consists in accusing you of privileging a certain negative dialectic of history, a dialectic without a definitive resolution between incorporation and disincorporation, at the expense of the social dynamic of history or the plurality of literary and artistic practices?*

—It all depends on what one calls a "negative dialectic." What I have attempted to think through is not a negative dialectic but rather a positive contradiction. Literature has been constructed as a tension between two opposing rationalities: a logic of disincorporation and dissolution, whose result is that words no longer have any guarantee, and a hermeneutic logic that aims at establishing a new body for writing. This tension is, for me, a galvanizing tension, a principle of work and not by any means a principle of "inertia" or "non-work."

Are there authors who escape this tension? Undoubtedly. I have not sought to privilege a particular type of author. I have obviously chosen authors that belong to a homogenous universe —France in the century "after the Revolution" —which very forcefully lays down the political stakes of writing. An identical tension is still however to be found in non-French authors from the twentieth century. Take Virginia Woolf, for instance, and you will see that she strives in the same way toward a language that eliminates its contingency, at the risk of brushing shoulders with the language of the mad. Take Joyce, and you will find a vast expanse of stereotypes without end at the same time as the ascent toward language's necessity, which would also be the necessity of myth. Take, for instance, an Italian communist author like Pavese. In his work, there is a paratactic style and a realist language that is faithful to the ways of mediocre and commonplace characters, working-class or middle-class characters without depth. There is a modernism that borders on minimalism. At the same time, there is an entire mythological dimension that, like in Joyce's work, refers back to Vico: a desire to rediscover, within "modern" triviality, the powers of myth enveloped in language. I am thinking, in particular, of the *Dialogues with Leuco* that he wrote as though in the margin of his "realist" narratives, as a way of mining beneath their horizontal language. The same kind of tensions are to be found in all of modern literature.

—Translated by Gabriel Rockhill

Notes

Introduction

1. Roland Barthes, *Camera Lucida: Reflections on Photography*, trans. Richard Howard (London: Vintage Books, 1993), 117.

2. Ibid., 81.

3. The term "alterity" is derived from the Latin *alteritas*, meaning being other. The issue of alterity bears not just upon issues of race and gender, but also upon all forms of difference. In postmodern philosophy, the Other designates not simply an idea of divergence, but also one of an absolute difference that is by definition unknowable and, therefore, unrepresentable. Within this conceptualization, any relation with the Other is also, by implication, unrepresentable, leaving no room for a controlling subject.

4. Aesthetics was introduced into the study of philosophy by two eighteenth-century philosophers: Alexander Gottlieb Baumgarten (1714–1762), who first used the term in 1735, and, more famously, Immanuel Kant (1724–1804). The word aesthetics (the plural form of aesthetic) is derived from the Greek word *aisthetikos* (the feminine is *aisthetiki*), meaning things perceptible by the senses.

5. This reader focuses primarily upon writings about visual artists, works of art, and the imago. However, it should be noted that the usage of the word "art" by philosophers often encompasses literature, poetry, theater, and cinema as much as visual art. Furthermore, as this introduction attempts to

show, philosophers approach the notion of art as a site of experience and desire, which may exceed conventional understandings of art.

6. Friedrich Nietzsche, *The Portable Nietzsche*, ed. and trans. Walter Kaufmann (New York: Penguin Books, 1982), 483.

7. First stated in Descartes's *Discourse on Method* (1637).

8. Such an interpretation draws upon Nietzsche's reading of Plato in his book *The Genealogy of Morals: An Attack* (1887). Nietzsche believed that Plato's philosophy was motivated by a political ambition for thinkers and philosophers, like himself, to succeed the ruling warrior caste of Athens—and, in seizing power, thereby to obtain the warrior's imperialistic power and confidence.

9. Lacan's essay can be understood as a variation upon the Greek myth of Narcissus, who, following his mother's bargain with the gods, forsook love for immortality. The myth encapsulates the underlying ideal of ultimate control after which the subject strives. Lacan's theory in this essay that the self is constructed through an "imago" links the interests of psychoanalysis with those of aesthetics and theories of art and visual representation.

10. Following de Saussure's death in 1913, his theories were collated by his students and published as *Cours de Linguistique Générale* in 1916. See Ferdinand de Saussure, *Course in General Linguistics*, trans. Roy Harris (London: Duckworth, 1983).

11. See Immanuel Kant, *Critique of Pure Reason*, preface to the 2nd ed., trans. Norman Kemp Smith (London: Macmillan, 1990), 29.

12. *Noumenon* (singular), *noumena* (plural). The term is derived from the Greek, referring to processes of apprehension and conception; Kant uses the term in a transcendental sense.

13. The notion of the simulacrum applies to the episode where Plato claims that the Sophist philosophers use arguments that appear utterly convincing and true, although they are, in fact, deceptively false. As has been pointed out, if it is impossible to distinguish the true from the false, then Plato is in no position to make a judgment about the Sophists. This marks an implosion between truth and falsity. See Gilles Deleuze, "Plato and the Simulacrum," *The Logic of Sense*, ed. Constantin V. Boundas (New York: Columbia University Press, 1990), 253–265.

14. Alain Badiou, "Drawing," *lacanian ink* 28 (2006): 44.

15. See Jean-Luc Nancy, "The Vestige of Art," *The Muses*, trans. Peggy Kamuf (Stanford: Stanford University Press, 1996), 89.

16. Ibid., 93–94.

17. Theodor Adorno, *Aesthetic Theory*, trans. and ed. Robert Hullot-Kentor (Minneapolis: University of Minnesota Press, 1997), 260.

18. Ibid.

19. Ibid., 128.

20. See Theodor Adorno, "Dedication," *Minima Moralia: Reflections on a Damaged Life* (New York: Verso, 2005), 16.

21. The way in which materialism and mysticism are combined in Benjamin's work is one of the chief aspects that make his work so unusual and irreducible to organized theory. Ideas of the sacred and profane are explored in a number of essays written in the early 1930s, including "Critique of Violence" and "Theologico-Political Fragment"; see *One-Way Street and Other Writings*, trans. Edmund Jephcott and Kingsley Shorter (London: Verso, 1992), 132–156. Additionally, these ideas of the sacred and profane inform Benjamin's "Theses on the Philosophy of History" (1940), where he makes a distinction between human, historical time (encompassing modernity and all previous history), and messianic time, the time of the future liberation from the alienation characterizing modernity and which belongs to God, and is known only to him. See Walter Benjamin, *Illuminations* (London: Fontana/Collins, 1982), 255–266.

22. Ibid., 257.

23. Ibid.

24. Martin Heidegger, *Nietzsche*, trans. David Farrell Krell (San Francisco: HarperCollins, 1991), 209.

25. Sarah Kofman, *The Childhood of Art: An Interpretation of Freud's Aesthetics*, trans. Winifred Woodhull (New York: Columbia University Press, 1988), 79. Kofman's reading of Freud's aesthetics was made against a background of criticism of his work by philosophers in France in the 1970s, most notably Gilles Deleuze—her teacher—and Félix Guattari. They argued that Freud did not pursue the consequences of his ideas concerning psychosis, in which he posited certain fundamental differences with the condition of neurosis, namely that it is not subject to the Oedipus complex. For Deleuze and Guattari, this theoretical lacuna perpetuated not just dialectics, as embodied in the psychoanalytic discourse of neurosis, but it also helped legitimize the institution of psychoanalysis, itself, whereby the psychoanalyst extends dialectics even as she or he identifies this as a problem: "The function of Oedipus as dogma, or as the 'nuclear complex', is inseparable from a forcing by which the psychoanalyst as theoretician elevates himself to the conception of a generalized Oedipus." See Gilles Deleuze and Félix Guattari, *Anti-Oedipus: Capitalism and Schizophrenia*, trans. Robert Hurley, Mark Seem, and Helen R. Lane (London: Athlone Press, 1984), 51. An essay on the Renaissance artist Giovanni Bellini by

Julia Kristeva also raises questions about Freud's idea that the work of art is a fetishistic projection of the subject's anxieties and conflicts. See Julia Kristeva, "Motherhood According to Giovanni Bellini," *Desire in Language: A Semiotic Approach to Literature and Art* (Oxford: Basil Blackwell, 1987), 237–270.

26. Jacques Derrida, *Spurs: Nietzsche's Styles* (Chicago: University of Chicago Press, 1979), 101.

27. Jean-François Lyotard, "Answering the Question: What Is Postmodern-ism?" *The Postmodern Condition: A Report on Knowledge*, trans. Geoff Bennington and Brian Massumi (Manchester: Manchester University Press, 1986), 80–81.

28. Ibid., 81.

29. Ibid., 79.

30. For Rancière's views about Badiou's and Lyotard's philosophies of art, see *Aesthetics and Its Discontents* (Cambridge: Polity Press, 2009), 61–105, and *The Future of the Image*, trans. Gregory Elliott. London: Verso, 2007), 109–138.

31. For further discussion of these points, see Jacques Rancière, *The Future of the Image* (London: Verso, 2007).

32. Badiou, "Drawing," 48.

33. Ibid.

34. Nancy, "The Vestige of Art," 86–87.

1. Critique of Judgment

1. See Immanuel Kant, "On Taste as a Kind of Sensus Communis," *Critique of Judgment*, trans. Werner S. Pluhar (Indianapolis: Hackett, 1987), §40, 159–161. —Editor

2. Ibid. §50, 319. —Editor

3. Genius reveals the power of the faculty of the imagination, which "is very mighty when it creates" (ibid., §49, 314). In doing so, both nature and the imagination are seen to be shaped by "principles which reside higher up, namely, in reason" (ibid. §49, 319). Kant's recourse to these transcendent ideas residing in the faculty of reason affirms that the imagination, as a fac-ulty of the senses, is commensurate with the supersensible. —Editor

4. Kant believes in a hierarchy of the arts: "among all the arts poetry holds the highest rank" (ibid., §53, 326). —Editor

5. In relation to this point, Kant decries the then-growing tourist industry for witnessing the romantic sublime (ibid., §29, 265). —Editor

6. Jacques Rancière suggests that Kant's ideas about genius, in which "the power of a form of thought . . . has become foreign to itself," can be considered to belong to the discourse of the "the aesthetic regime." Jacques Rancière *The Politics of Aesthetics: The Distribution of the Sensible* (New York: Continuum, 2006), 23. For further discussion of Rancière's ideas of epistemic "regimes," see chapter 20. —EDITOR

7. *Vorstellung*, traditionally rendered as "representation." See Ak. 175. (Ak. refers to the system of numbering in the margins adopted from the Akademie edition of Kant's writings, *Kants gesammelte Schriften*, edited by the Königlich Preussische Akademie der Wissenschaften [Berlin: de Gruyter, 1902–].) "Presentation" is a generic term referring to such objects of our direct awareness as sensations, intuitions, perceptions, concepts, cognitions, ideas, and schemata. See Immanuel Kant, *Critique of Pure Reason,* A 320=B 376–77 and A 140=B 179. —EDITOR

8. *Erkenntnis*. See Ak. 167. The third *Critique*, ed. Wilhelm Windelband, is in volume 5 (1908); the first introduction, ed. Gerhard Lehmann, is in volume 20 (1942). —EDITOR

9. The definition of taste on which I am basing this [analysis] is that it is the ability to judge the beautiful. But we have to analyze judgments of taste in order to discover what is required for calling an object beautiful. I have used the logical functions of judging to help me find the moments that judgment takes into consideration when it reflects (since even a judgment of taste still has reference to the understanding). [They fall under four headings: quantity, quality, relation, modality. See Kant's *Critique of Pure Reason*, A 70=B 95.] I have examined the moment of quality first, because an aesthetic judgment about the beautiful is concerned with it first. [*Urteilskraft,* in this case. See Ak. 167.]

10. *Beurteilung.* —EDITOR

11. From the Greek *aisthésthai*, "to sense." —EDITOR

12. Wilhelm Windelband, the editor of the Akademie edition of the *Critique of Judgment*, notes (Ak. 5:527) that Kant's reference has been traced to Pierre François Xavier de Charlevoix, *Histoire et déscription générale de la Nouvelle-France* (History and General Description of New France) (Paris, 1744). Windelband quotes a passage (3:322): "Some Iroquois went to Paris in 1666 and were shown all the royal mansions and all the beauties of that great city. But they did not admire anything in these, and would have preferred the villages to the capital of the most flourishing kingdom of Europe if they had not seen the rue de la Huchette, where they were delighted with the rotisseries that they always found furnished with meats of all sorts." —EDITOR

13. For an elaborate discussion of our different senses, see Kant's *Anthropology from a Pragmatic Point of View* (1798), §§15–27, Ak. 7:153–167. —EDITOR

14. As distinguished from taste of reflection. —EDITOR

15. Emphasis added. —EDITOR

16. Walter Cerf notes, "The phrase *à la grecque* was apparently used in the eighteenth century—and is still used by some present-day French art historians—to characterize the classicism in what is now called the Louis XVI style. Stimulated by the excavations at Pompeii, which began around 1748, the style *à la grecque* put an end to the style *rocaille* or rococo (*rocaille,* rock or grotto work) of Louis XV and flourished from about 1760 to 1792." Walter Cerf, *Analytic of the Beautiful* (Indianapolis: Bobbs-Merrill, 1963), 111. —EDITOR

17. It might be adduced as a counterinstance to this explication that there are things in which we see a purposive form without recognizing a purpose in them [but which we nevertheless do not consider beautiful]. Examples are the stone utensils sometimes excavated from ancient burial mounds, which are provided with a hole as if for a handle. Although these clearly betray in their shape a purposiveness whose purpose is unknown, we do not declare them beautiful on that account. And yet, the very fact that we regard them as work[s] of art already forces us to admit that we are referring their shape to some intention or other and to some determinate purpose. That is also why we have no direct liking whatever for their intuition. A flower, on the other hand, e.g., a tulip, is considered beautiful, because in our perception of it we encounter a certain purposiveness that, given how we are judging the flower, we do not refer to any purpose whatever.

18. Emphasis added. On modality, see Kant's *Critique of Pure Reason*, A 80=B 106. —EDITOR

19. See Kant, *Anthropology from a Pragmatic Point of View*, §§67–68, Ak. 7:239–243. —EDITOR

20. See Ak. 226. —EDITOR

21. See Kant's *Observations on the Feeling of the Beautiful and Sublime* (1764): "The sublime moves us, the beautiful charms us." Ak. 2:209. —EDITOR

22. On admiration, respect, and positive and negative pleasure, see Kant, *Critique of Practical Reason*, Ak. 5:71–89. —EDITOR

23. *Zusammenfassung*. "Comprehension" and "comprehend" are used in this translation only in this sense of "collecting together and holding together" (cf. "comprehensive"), never in the sense of "understanding." —EDITOR

24. *Lettres sur l'Égypte* (*Letters on Egypt*), 1787, by Anne Jean Marie René Savary, Duke of Rovigo (1774–1833), French general, diplomat, and later minister of police, notorious for his severity, under Napoleon Bonaparte,

but active even after the latter's banishment to Saint Helena in 1815. Savary took part in Bonaparte's expedition to Egypt. —EDITOR

25. See Ak. 245 and 226. —EDITOR

26. From the Greek *dynamis*, "might," "power." —EDITOR

27. See *Anthropology*, Ak. 7:225. —EDITOR

28. The reader must not judge this sketch of a possible division of the fine arts as if it were intended as a theory. It is only one of a variety of attempts that can and should still be made.

2. Introductory Lectures on Aesthetics

1. See Georg Wilhelm Friedrich Hegel, *Introductory Lectures on Aesthetics*, trans. Bernard Bosanquet (New York: Penguin Books, 2004), section xlvii, 34. —EDITOR

2. Ibid., section lix, 44. —EDITOR

3. See Georg Wilhelm Friedrich Hegel, *Hegel's Aesthetics: Lectures on Fine Art*, trans. T. M. Knox (Oxford: Clarendon Press, 1988), 1:303–426. —EDITOR

4. Because "particular sensuous materials have a close affinity and secret accord with the spiritual distinctions and types of art" (ci), Hegel classifies the different arts as embodiments of the three stages of art history: architecture (symbolic art), sculpture (classical art), painting, music and poetry (romantic art). See *Introductory Lectures on Aesthetics*, cviii–cxv, 88–97. —EDITOR

3. How the True World Finally Became a Fable

1. See also Heidegger's analysis of this text, "Nietzsche's Overturning of Platonism" (chapter 7). —EDITOR

2. *The Will to Power* is a collection of writings from Nietzsche's notebooks. His sister Elisabeth published them in 1901, after Nietzsche's death. Although this text is now recognized to be "unfinished," its epigrammatic form is typical of Nietzsche's late style of writing. —EDITOR

3. See *The Genealogy of Morals: An Attack* (1887). It should be noted that Heidegger proposes a different reading of this section of "How the 'True World' Finally Became A Fable" from ours (see chapter 7). —EDITOR

4. For further discussion of this issue of woman and femininity in Nietzsche's text and in Heidegger's reading of it in "Nietzsche's Overturning of Platonism," see Jacques Derrida, "Spurs: Nietzsche's Styles" (chapter 14). —EDITOR

5. Exemplified especially by the writings of Sophocles and Aeschylus. —EDITOR

6. See Georges Bataille, *Visions of Excess, Selected Writings, 1927–1939*, ed. A. Stoekl (Minneapolis: University of Minnesota Press, 1991), 116–129. —EDITOR

7. [The following notes are from Friedrich Nietzsche, *The Portable Nietzsche*, edited and translated by Walter Kaufmann (New York: Penguin Books, 1976). —EDITOR] 1911, p. 511: "Contemporaneous with the beginning of work on *Beyond Good and Evil*, and initially planned as the continuation of the preface. . . . Line 1: After 'The artist-philosopher' the MS goes on: '(hitherto mentioned scientific procedure, attitude to religion and politics)' . . . In the margin, this comment on the whole aphorism: 'here belongs the *sequence of rank* of the higher men, which must be described."

8. A child playing. —EDITOR

9. With this and the following sections compare *Twilight of the Idols*, "Skirmishes," sections 8–11 [*Portable Nietzsche*, 518–521]. —EDITOR

10. The following words in the MS are omitted in all editions: "Becoming more beautiful as a necessary consequence of the enhancement of strength." —EDITOR

11. Title omitted in all editions, which substitute the following phrase. —EDITOR

12. Nietzsche uses the English term, as in *Genealogy of Morals* III, section 4. —EDITOR

13. Cf. *Twilight of the Idols,* "Maxims and Arrows," aphorism 25: "Contentment protects even against colds. Has a woman who knew herself to be well dressed ever caught cold? I am assuming that she was barely dressed." [*Portable Nietzsche*, 470.]

4. Beyond the Pleasure Principle | Leonardo da Vinci

1. [The following texts are cited in Freud's text and footnotes: Sigmund Freud, "On the Psychical Mechanism of Hysterical Phenomena," (1893); "The Interpretation of Dreams" (1900); "The Psychopathology of Everyday Life" (1901); "Fragment of an Analysis of a Case of Hysteria" (1905); "On the Sexual Theories of Children" (1908); "Analysis of a Phobia in a Five-Year-Old Boy" (1909); "Notes Upon a Case of Obsessional Neurosis" (1909); "A Childhood Recollection from *Dichtung und Wahrheit*" (1917); "Introduction to Psycho-Analysis and the War Neuroses" (1919); "Memorandum on the Electrical Treatment of War Neurotics" (1920); "Inhibitions, Symptoms and Anxiety" (1926); "Moses and Monotheism" (1939); and "Psychopathic Characters on the Stage" (1942), all in *The Standard Edition of the Complete Psychological Works of Sigmund Freud*, ed. and trans. James Strachey (London: Hogarth Press and

the Institute of Psycho-Analysis, 1981); Havelock Ellis, "Review of S. Freud's *Eine Kindhteitserinnerung des Leonardo da Vinci*," *J. Ment. Sci.* 56 (1910): 522; H. Hartleben, *Champollion: sein Leben und sein Werk* (Berlin, 1906); M. Herzfeld, *Leonardo da Vinci: Der Denker, Forscher und Poet* (Jena, 1906); C. G. Jung, "Über konflikte der kindlichen Seele," *Jb. Psychoanalyt. Psychopath. Forsch.* 2 (1910): 33; A. Konstantinova, *Die Entwicklung des Madonnentypus bei Leonardo da Vinci* (Strasburg, 1907); R. von Krafft-Ebing, *Psychopathia sexualis* (Stuttgart, 1893); R. Lanzone, *Dizionario di mitologia egizia*, vol. 2, (Turin, 1982); C. Leemans, ed., *Horapollonis Niloï Hieroglyphica* (Amsterdam, 1985); D. S. Merezhkovsky, *Leonardo da Vinci* (Leipzig, 1903); E. Müntz, *Léonard de Vinci* (Paris, 1899); R. Muther, *Geschichte der Malerei* (Leipzig, 1909); Walter Pater, *Studies in the History of the Renaissance* (London, 1873); S. Pfeifer, "Äusserungen infantile-erotischer Triebe im Spiele," *Imago* 5 (1919): 243; O. Pfister, "Kryptolalie, Kryptographie und unbewusstes Vexierbild bei Normalen," *Jb. Psychoanalyt. Psychopath. Forsch.* 5 (1913): 115; J. P. Richter, *The Literary Works of Leonardo da Vinci* (Oxford, 1939); L. von Römer, "Über die androgynische Idee des Lebens," *Jb. Sex. Zwischenst.*, 5 (1903): 732; W. H. Roscher, ed., *Ausführliches Lexikon der friechischen und römischen Mythologie* (Leipzig, 1884–97); A. Rosenberg, *Leonardo da Vinci* (Leipzig, 1898); L. Schorn, *Leben der ausgezeichnetsten Maler, Bildhauer und Baumeister* (Stuttgart, 1843); W. von Seidlitz, *Leonardo da Vinci, der Wendepunkt der Renaissance* (Berlin, 1909); N. Smiraglia Scognamiglio, *Ricerche e documenti sulla giovinezza di Leonardo da Vinci (1452–1482)* (Naples, 1900). —EDITOR] Cf. the discussion on the psycho-analysis of war neuroses by Freud, Ferenczi, Abraham, Simmel and Jones (1919) ["Introduction to Psycho-Analysis and the War Neuroses" (1919). See also "Report on the Electrical Treatment of War Neuroses"]. —EDITOR

2. In German, *Schreck, Furcht*, and *Angst*. —EDITOR

3. Freud is very far indeed from always carrying out the distinction he makes here. More often than not he uses the word *Angst* to denote a state of fear without any reference to the future. It seems not unlikely that in this passage he is beginning to adumbrate the distinction drawn in *Inhibitions, Symptoms, and Anxiety* (1926) between anxiety as a reaction to a traumatic situation— probably equivalent to what is here called *Schreck*—and anxiety as a warning signal of the approach of such an event. See also his use of the phrase "preparedness for anxiety." —EDITOR

4. "On the Psychical Mechanism of Hysterical Phenomena" (1090). —EDITOR

5. The last fifteen words of this sentence were added in 1921. For all this, see *The Interpretation of Dreams* (1900), 5:550ff. —EDITOR

6. A further observation subsequently confirmed this interpretation. One day the child's mother had been away for several hours and on her return was met with the words "Baby o-o-o-o!" which was at first incomprehensible. It soon turned out, however, that during this long period of solitude the child had found a method of making *himself* disappear. He had discovered his reflection in a full-length mirror which did not quite reach to the ground, so that by crouching down he could make his mirror-image "gone." [A further reference to this story will be found in ibid., 5:461n.]

7. When this child was five and three-quarters, his mother died. Now that she was really "gone" ("o-o-o"), the little boy showed no signs of grief. It is true that in the interval a second child had been born and had roused him to violent jealousy.

8. Cf. my note on a childhood memory of Goethe's ["A Childhood Recollection from *Dichtung und Wahrheit*" (1917)].

9. Freud had made a tentative study of this point in his posthumously published paper on "Psychopathic Characters on the Stage," which was probably written in 1905 or 1906. —EDITOR

10. "Questo scriver si distintamente del nibio par che sia mio destino, perchè nella mia prima recordatione della mia infantia e' mi parea che, essendo io in culla, che un nibio venissi a me e mi aprissi la collua sua coda e molte volte mi percuotesse con tal coda dentro alle labbra" (*Codex Atlanticus*, F.65 v., as given by Scognamiglio [1900, 22]). [In the German text, Freud quotes Herzfeld's translation of the Italian original. The version here is a rendering of the German. There are in fact two inaccuracies in the German: *nibio* should be "kite," not "vulture," and *dentro*, "within," is omitted. This last omission is in fact rectified by Freud himself; see notes 11 and 13. —EDITOR]

11. [Footnote added in 1919:] In a friendly notice of this book Havelock Ellis (1910) has challenged the view put forward above. He objects that this memory of Leonardo's may very well have had a basis of reality, since children's memories often reach very much further back than is commonly supposed; the large bird in question need not of course have been a vulture. This is a point that I will gladly concede, and as a step towards lessening the difficulty I in turn will offer a suggestion—namely that his mother observed the large bird's visit to her child—an event which may easily have had the significance of an omen in her eyes —and repeatedly told him about it afterwards. As a result, I suggest, he retained the memory of his mother's story, and later, as so often happens, it became possible for him to take it for a memory of an experience of his own. However, this alteration does no damage to the force of my general account. It happens, indeed, as a

general rule that the fantasies about their childhood which people construct at a late date are attached to trivial but real events of this early, and normally forgotten, period. There must thus have been some secret reason for bringing into prominence a real event of no importance and for elaborating it in the sort of way Leonardo did in his story of the bird, which he dubbed a vulture, and of its remarkable behavior.

12. Chapter 4 of *The Psychopathology of Everyday Life* deals with childhood memories and screen-memories, and, in an addition made to it in 1907, Freud makes the same comparison with historical writing. —EDITOR

13. [Footnote added in 1919:] Since I wrote the above words I have attempted to make similar use of an unintelligible memory dating from the childhood of another man of genius. In the account of his life that Goethe wrote when he was about sixty (*Dichtung und Wahrheit*) there is a description in the first few pages of how, with the encouragement of his neighbors, he slung first some small then some large pieces of crockery out of the window into the street, so that they were smashed to pieces. This is, indeed, the only scene that he reports from the earliest years of childhood. The sheer inconsequentiality of its content, the way in which it corresponded with the childhood memories of other human beings who did not become particularly great, and the absence in this passage of any mention of the young brother who was born when Goethe was three and three-quarters, and who died when he was nearly ten—all this induced me to undertake an analysis of this childhood memory. (This child is in fact mentioned at a later point in the book, where Goethe dwells on the many illnesses of childhood.) I hoped to be able as a result to replace it by something which would be more in keeping with the context of Goethe's account and whose content would make it worthy of preservation and of the place he has given it in the history of his life. The short analysis ["A Childhood Recollection from *Dichtung und Wahrheit*" (1917)] made it possible for the throwing-out of the crockery to be recognized as a magical act directed against a troublesome intruder; and at the place in the book where he describes the episode the intention is to triumph over the fact that a second son was not in the long run permitted to disturb Goethe's close relation with his mother. If the earliest memory of childhood, preserved in disguises such as these, should be concerned—in Goethe's *case* as well as in Leonardo's—with the mother, what would be so surprising in that? [In the 1919 edition the phrase "and the absence in this passage of any mention of the young brother" reads, "and the remarkable absence of any mention whatever of a young brother." It was given its present form, and the parenthesis that follows it was added, in 1923. The

alteration is explained in a footnote added in 1924 to the "A Childhood Recollection from *Dichtung und Wahreit*" (1917), 17:151n. —EDITOR]

14. [Cf. "Fragment of an Analysis of a Case of Hysteria," also known as the "Original Record of the Case of the 'Rat Man,'" 10:311.] It may be pointed out (supposing the bird to have been in fact a kite) that the kite's long forked tail is one of its noticeable features and plays a large part in the virtuosity of its movements in the air and no doubt attracted Leonardo's attention in his observations of flight. The symbolic meaning of its coda, discussed by Freud in this passage, seems to be confirmed by a remark in an ornithological account of the kite published recently in *The Times* (July 7, 1956): "At times the tail is fanned out at right angles to its normal plane." —EDITOR

15. See end of note 11. —EDITOR

16. On this point compare my "Fragment of an Analysis of a Case of Hysteria."

17. "While I was in my cradle.'" See Scognamiglio 1900, 82. —EDITOR

18. "Analysis of a Phobia in a Five-Year-Old Boy," 10:7. —EDITOR

19. This refers to the charge of homosexuality brought against Leonardo while studying in Verrochio's studio. Freud discusses this at 11:71–72. —EDITOR

20. In 1910 only: "a homosexual." —EDITOR

21. Horapollo (*Hieroglyphica* 1, 11) ["To denote a mother . . . they delineate a vulture."]

22. W. H. Roscher, *Ausführliches Lexikon der griechischen und römischen Mythologie*, Leipzig, 1894–97, R. Lanzone, *Dizionario di mitologia egizia*, 5 vols., Turin, 1882.

23. H. Hartleben, *Champollion: Sein Leben und sein Werk*, Berlin, 1906.

24. ["They say that no male vulture has ever existed but all females," Aelian, *De Natura Animalium,* II, 46.] Quoted by L. von Römer, "Über die androgynische Idee des Lebens," *Jb. sex. Zwischenst.*, 5, 1903, p. 732.

25. Plutarch: "Veluti scarabaeos mares tantum esse putarunt Aegyptii sic inter vultures mares non inveniri statuerunt." ["Just as they believed that only male scarabs existed, so the Egyptians concluded that no male vultures were to be found." Freud has here inadvertently attributed to Plutarch a sentence that is in fact a gloss by C. Leemans, ed., *Horapollonis Niloi Hieroglyphica*, 171, on Horapollo].

26. Ibid, p. 14. The words that refer to the vulture's sex run ["(They use the picture of a vulture to denote) a mother, because in this race of creatures there are no males." It seems as though the wrong passage from Horapollo is quoted here. The phrase in the text implies that what we should have here is the myth of the vulture's impregnation by the wind.]

27. E. Müntz, *Léonard da Vinci*, Paris, 1899, p. 282.

28. Ibid.

29. "But this story about the vulture was eagerly taken up by the Fathers of the Church, in order to refute, by means of a proof drawn from the natural order, those who denied the Virgin Birth. The subject is therefore mentioned in almost all of them." —EDITOR

30. This refers to the registry drawn up of the members of the household of the Vinci family mentioning the five-year-old illegitimate child Leonardo. —EDITOR

31. See "The Sexual Theories of Children" (1908). —EDITOR

32. Ibid. —EDITOR

33. Compare the observations in the *Jahrbuch für psychoanalytische und psychopathologische Forschungen* [Freud 10:11] and Jung, 1910. [Added 1919:], in the *Internationale Zeitschrift für ärztliche Psychoanalyse* and in [the section dealing with children in] *Imago.* —EDITOR

34. [Footnote added 1919:] The conclusion strikes me as inescapable that here we may also trace one of the roots of the anti-semitism which appears with such elemental force and finds such irrational expression among the nations of the West. Circumcision is unconsciously equated with castration. If we venture to carry our conjectures back to the primaeval days of the human race we can surmise that originally circumcision must have been a milder substitute, designed to take the place of castration. [Further discussion on this will be found at 10:36, and in *Moses and Monotheism* (1939).]

35. See note 10. —EDITOR

36. [Footnote added 1919:] The connoisseur of art will think here of the peculiar fixed smile found in archaic Greek sculptures—in those, for example, from Aegina; he will perhaps also discover something similar in the figures of Leonardo's teacher Verrocchio and therefore have some misgivings in accepting the arguments that follow.

37. ["For almost four centuries now Mona Lisa has caused all who talk of her, after having gazed on her for long, to lose their heads."] The words are Gruyer's, quoted by W. von Seidlitz (1909, 2, 280).

38. We know what an insoluble and enthralling enigma Mona Lisa Gioconda has never ceased through nearly four centuries to pose to the admirers that throng in front of her. No artist (I borrow the words from the sensitive writer who conceals himself behind the pseudonym of Pierre de Corlay) "has ever expressed so well the very essence of femininity: tenderness and coquetry, modesty and secret sensuous joy, all the mystery of a heart that holds aloof, a brain that meditates, a personality that holds back and yields nothing of itself save its radiance."

39. "The lady smiled in regal calm: her instincts of conquest, of ferocity, all the heredity of the species, the will to seduce and to ensnare, the charm of deceit, the kindness that conceals a cruel purpose—all this appeared and disappeared by turns behind the laughing veil and buried itself in the poem of her smile. . . . Good and wicked, cruel and compassionate, graceful and feline, she laughed." —EDITOR

40. The title of this subject in German is *Heilige Anna Selbdritt, Saint Anne with Two Others*. See note 43. —EDITOR

41. ["Heads of laughing women."] Quoted by N. Scognamiglio (1900, 32).

42. The same assumption is made by D. Merezhkovsky. But the history of Leonardo's childhood as he imagines it departs at the essential points from the conclusions we have drawn from the fantasy of the vulture. Yet if the smile had been that of Leonardo himself [as Merezhkovsky also assumes] tradition would hardly have failed to inform us of the coincidence.

43. That is, Saint Anne was the most prominent figure in the picture. —EDITOR

44. Konstantinowa (1907 [44]): "Mary gazes down full of inward feeling on her darling, with a smile that recalls the mysterious expression of La Gioconda." In another passage [ibid., 52] she says of Mary, "The Gioconda's smile hovers on her features."

45. Von Seidlitz (op. cit., 2, 274, notes).

46. The words in parentheses were added in 1923. —EDITOR

47. [Footnote added 1919:] If an attempt is made to separate the figures of Anne and Mary in this picture and to trace the outline of each, it will not be found altogether easy. One is inclined to say that they are fused with each other like badly condensed dream-figures, so that in some places it is hard to say where Anne ends and where Mary begins. But what appears to a critic's eye [in 1919 only: "to an artist's eye"] as a fault, as a defect in composition, is vindicated in the eyes of analysis by reference to its secret meaning. It seems that for the artist the two mothers of his childhood were melted into a single form. [Added 1923:] It is especially tempting to compare the "St. Anne with Two Others" of the Louvre with the celebrated London cartoon [figure 1], where the same material is used to form a different composition. Here the forms of the two mothers are fused even more closely and their separate outlines are even harder to make out, so that critics, far removed from any attempt to offer an interpretation, have been forced to say that it seems "as if two heads were growing from a single body."

Most authorities are in agreement in pronouncing the London cartoon to be the earlier work and in assigning its origin to Leonardo's first period in Milan (before 1500). Adolf Rosenberg (1898), on the other hand, sees the

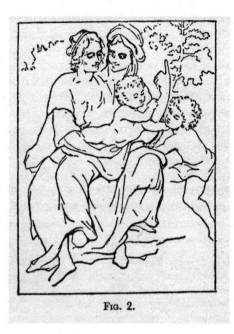

FIG. 2.

composition of the cartoon as a later—and more successful—version of the same theme, and follows Anton Springer in dating it even after the Mona Lisa. It would fit in excellently with our arguments if the cartoon were to be much the earlier work. It is also not hard to imagine how the picture in the Louvre arose out of the cartoon, while the reverse course of events would make no sense. If we take the composition shown in the cartoon as our starting point, we can see how Leonardo may have felt the need to undo the dream-like fusion of the two women—a fusion corresponding to his child-hood memory—and to separate the two heads in space. This came about as follows: From the group formed by the mothers he detached Mary's head and the upper part of her body and bent them downwards. To provide a reason for this displacement the child Christ had to come down from her lap on to the ground. There was then no room for the little St. John, who was replaced by the lamb.

[Added 1919:] A remarkable discovery has been made in the Louvre picture by Oskar Pfister, which is of undeniable interest, even if one may not feel inclined to accept it without reserve. In Mary's curiously arranged and rather confusing drapery he has discovered the *outline of a vulture* and he interprets it as an *unconscious picture-puzzle:*—

"In the picture that represents the artist's mother *the vulture, the sym-bol of motherhood,* is perfectly clearly visible.

"In the length of blue cloth, which is visible around the hip of the woman in front and which extends in the direction of her lap and her right knee, one can see the vulture's extremely characteristic head, its neck and the sharp curve where its body begins. Hardly any observer whom I have confronted with my little find has been able to resist the evidence of this picture-puzzle." (Pfister, 1913, 147.)

At this point the reader will not, I feel sure, grudge the effort of looking at the accompanying illustration [figure 2], to see if he can find in it the outlines of the vulture seen by Pfister. The piece of blue cloth, whose border marks the edges of the picture-puzzle, stands out in the reproduction as a light gray field against the darker ground of the rest of the drapery.

Pfister continues: "The important question however is: How far does the picture-puzzle extend? If we follow the length of cloth, which stands out so sharply from its surroundings, starting at the middle of the wing and continuing from there, we notice that one part of it runs down to the woman's foot, while the other part extends in an upward direction and rests on her shoulder and on the child. The former of these parts might more or less represent the vulture's wing and tail, as it is in nature; the latter might be a pointed belly and—especially when we notice the radiating lines which resemble the outlines of feathers—a bird's outspread tail, whose right-hand

FIG. 3.

end, *exactly as in Leonardo's fateful childhood dream* [sic], *leads to the mouth of the child, i.e. of Leonardo himself.*"

The author goes on to examine the interpretation in greater detail, and discusses the difficulties to which it gives rise.

48. See my *Three Essays on the Theory of Sexuality* [7:223].

5. The Lugubrious Game

1. See especially the extracts from Nietzsche's "The Will to Power" in chapter 3, especially section 811. —EDITOR

2. See especially Georges Bataille, "The Notion of Expenditure" (first published in 1933), in *Visions of Excess: Selected Writings, 1927–1939*, trans. Allan Stoekl (Minneapolis: University of Minnesota Press, 1991), 116–129. The text and subsequent notes here are taken from that volume. —EDITOR

3. Georges Bataille, *My Mother, Madame Edwarda, The Dead Man*, trans. Austryn Wainhouse (London: Marion Boyars, 1989), 141. —EDITOR

4. This is a portion of an unpublished essay on the inferiority complex. The title is borrowed from the painting by Salvador Dali . . . (this painting belongs to the Viscount de Noailles and appeared in the Dali show at the Galerie Goemans in November 1929). The *Lugubrious Game*, as moreover the text of the schema indicates, is nothing other than the complex in question. This complex was already apparent in relatively early Dali paintings. *Blood is Sweeter than Honey* (published in *Documents* 4) is characteristic; the body with the head, hands, and feet cut off, the head with the face cut, the ass, symbol of grotesque and powerful virility, lying dead and decomposed, the systematic fragmentation of all the elements of the painting. . . .

Even more explicit is the episode of the sliced eye in *An Andalusian Dog*, the film of Luis Buñuel and Salvador Dali (see *Documents 4*, p. 218, and the text of the screenplay in *Revue du cinema*, November 1929, and *Révolution surréaliste 12*, December 1929).

Bunuel himself told me that this episode was the invention of Dali, to whom it was directly suggested by the real vision of a narrow and long cloud cutting across the lunar surface (I can add here that the dead and decomposing asses that reappear in *An Andalusian Dog* represent an obsession shared by Buñuel and Dali, and go back for each of them to the identical discovery, during childhood, of a decomposing ass-cadaver in the countryside).

Even the title, *Lugubrious Game*, adopted by Dali can be taken as an indication of the explicit value of this painting, in which the genesis of emasculation and the contradictory reactions it carries with it are translated with

an extraordinary wealth of detail and power of expression. Without pretending to exhaust the psychological elements of this painting, I can indicate here their general development. The very act of emasculation is expressed by Figure A, whose body, from the waist up, is completely torn off. The provocation that immediately caused this bloody punishment is expressed in B by dreams of virility of a puerile and burlesque temerity (the masculine elements are represented not only by the bird's head but by the colored umbrella, the feminine elements by men's hats). But the profound and early cause of the punishment is nothing other than the ignoble stain of the man in his underwear (C), a stain moreover without provocation, since a new and real virility is rediscovered by this person in ignominy and horror themselves. Yet the statue on the left (D) still personifies the unusual satisfaction found in sudden emasculation and betrays a hardly virile need for the poetic amplification of the game. The hand concealing the virility of the head is a suppression of a rule in the painting of Dali, in which persons who for the most part have lost their heads find them only on the condition that they grimace with horror. This permits one to inquire seriously about the orientation of those who see here for the first time *the mental windows opening wide*, who place an emasculated poetic complacency where there appears only the screaming necessity of a recourse to ignominy.

5. That is, moreover, the only similarity between two bodies of work, which differ from each other as much as a cloud of flies differs from an elephant.

6. I must thank M. Maurice Heine, to whom nothing about Sade is unknown, who kindly authorized me to mention the facts that he recounted orally, to me. These facts are found in the deposition of Rose Keller, which is included among the authentic documents of a trial soon to be published, through M. Heine's efforts, by Stendhal and Co.

7. I must say that it is not at all a question of something people commonly would call "suspect," but *certain* stories of the "artistic and literary milieu" genre could in any case provoke intractable disgust.

6. A Small History of Photography

1. The title of this essay, from *Illuminations* (London: Fontana/Collins, 1982), is more widely known in English as "The Work of Art in the Age of Mechanical Reproduction." I adopt this alternative title in order to indicate more fully the issue of technology at stake in the essay. The later essay arguably contains a less complex account of the concept of aura. —EDITOR

2. Writing on the philosophy of history, Benjamin proposed that the realization of the class struggle in the present has its counterpart in the rediscovery of the unofficial histories of the past. See particularly Walter Benjamin, "Theses on the Philosophy of History" (written in 1940), in *Illuminations* (London: Fontana/Collins, 1982), 255–266. However, in "A Small History of Photography," Benjamin seems careful not to assign to the daguerreotypes about which he speaks so ardently any use-value for the purposes of the present. —EDITOR

3. Helmuth Bossert and Heinrich Guttmann, *Aus der Frühzeit der Photographie 1840–1870. Ein Bildbuch nach 200 Originalen*. Frankfurt a. M. 1930. Heinrich Schwarz, *David Octavius Hill, der Meister der Photographie*. With 80 plates. Leipzig 1931.

4. Karl Blossfeldt, *Urformen der Kunst. Photographische Pflanzen bilder*. Published with an Introduction by Karl Nierendorf. 120 plates. Berlin 1931.

5. Eugène Atget, *Lichtbilder*. Paris and Leipzig 1931.

6. August Sander, *Das Antlitz der Zeit*. Berlin 1930.

7. Nietzsche's Overturning of Platonism

1. Two previous versions of "The Origin of the Work of Art" exist. The first elaboration of the subject was given as a lecture by Heidegger on November 13, 1935, in Freiburg. The text is published in *Heidegger Studies* 5 (1989). A second elaboration of the same lecture was published by E. Martineau, *De l'origine de l'oeuvre d'art* (Paris: Authentica, 1987). This second elaboration is based upon a photocopy of the typewritten transcript of Heidegger's own manuscript. The version included here is taken from Martin Heidegger, *Basic Writings*, ed. David Farrell Krell (Abingdon: Routledge, 2004); the original translation is in *Poetry, Language, Thought* (New York: Harper & Row, 1971), 17–87. —EDITOR

2. Martin Heidegger, "Nietzsche's Overturning of Platonism," in *Nietzsche*, trans. David Farrell Krell (San Francisco: HarperCollins, 1991). The essay was first published in 1961 but originally given as part of a lecture series, 1936–37. —EDITOR

3. For a discussion regarding the identification of Van Gogh's painting referred to by Heidegger, see Jacques Derrida, *The Truth in Painting*, trans. Geoff Bennington and Ian McLeod (Chicago: University of Chicago Press, 1987). —EDITOR

4. [Heidegger's references to Nietzsche's *The Will to Power* (*Der Wille zur Macht*) are cited as WM, followed by aphorism—not page—number, (e.g.

WM, 794). His references to all of Nietzsche's other texts are to the *Gros-soktavausgabe* (Leipzig, 1905 ff.); in the text they are cited by volume and page, e.g. (XIV, 413–67).] In these two complex notes Nietzsche defines the "perspectival relation" of will to power. Whereas in an earlier note (WM, 566) he spoke of the "true world" as "always the apparent world *once again*," he now (WM, 567) refrains from the opposition of true and apparent world as such: "Here there remains not a shadow of a right to speak of *Schein*" . . . which is to say, of a world of mere appearances.

5. Martin Heidegger, *The Essence of Reason*, trans. Terence Malick (Evanston, Ill.: Northwestern University Press, 1969.)

6. "*Unerschütterter theologisch-christlicher Voraussetzungen.*" The formulation is reminiscent of Heidegger's words in *Being and Time*, section 44C: 'The assertion of 'eternal truths' and the confusion of the phenomenally grounded 'ideality' of Dasein with an idealized absolute subject belong to those residues of Christian theology in philosophical problems which have not yet been radically extruded [*zu den längst noch nicht radikal ausgetriebenen Resten von christlicher Theologie innerhalb der philosophischen Problematik*]."

8. The Mirror Stage as Formative of the Function | Of the Gaze
as *Objet Petit a*

1. Earlier versions of this essay date back to 1936. The first version, entitled "The Mirror Stage," was delivered at the fourteenth International Psychoanalytical Congress in Marienbad. The version published here is from Jacques Lacan, "The Mirror Stage as Formative of the Function of the I," *Écrits: A Selection*, trans. Alan Sheridan (London: Routledge, 2006). —EDITOR

2. Jacques Lacan, "Of The Gaze as *Objet Petit a*," *The Four Fundamental Concepts of Psychoanalysis*, ed. Jacques-Alain Miller, trans. Alan Sheridan (London: Penguin Books, 1991). —EDITOR

3. Jean-Paul Sartre discusses this idea in *Being and Nothingness*, trans. Hazel E. Barnes (New York: Routledge, 2001), 252–302. —EDITOR

4. Throughout this article I leave in its peculiarity the translation I have adopted for Freud's *Ideal-Ich* [i.e., "je-idéal"], without further comment, other than to say that I have not maintained it since.

5. Cf. Claude Lévi-Strauss, *Structural Anthropology*, Chapter X.

6. See "Aggressivity in Psychoanalysis," 9, and "Agency of the Letter in the Unconscious," 180, in *Écrits: A Selection*, trans. Alan Sheridan (New York: Routledge, 2006). —EDITOR

7. "*Concentrationnaire*," an adjective coined after World War II (this article was written in 1949) to describe the life of the concentration camp. In the hands of certain writers it became, by extension, applicable to many aspects of "modern" life. —EDITOR

9. Las Meninas

1. "*Las Meninas*" is excerpted from Michel Foucault, *The Order of Things* (New York: Random House, 1970). —EDITOR

10. Society

1. The passage in *Aesthetic Theory* from which this statement is taken is worth quoting in full: "Suffering remains foreign to knowledge; though knowledge can subordinate it conceptually and provide means for its amelioration, knowledge can scarcely express it through its own means of experience without itself becoming irrational. Suffering conceptualized remains mute and inconsequential, as is obvious in post-Hitler Germany. In an age of incomprehensible horror, Hegel's principle, which Brecht adopted as his motto, that truth is concrete, can perhaps suffice only for art. Hegel's thesis that art is consciousness of plight has been confirmed beyond anything he could have envisioned" (18). This quotation, and the accompanying selection here, are from Theodor Adorno, *Aesthetic Theory*, ed. Robert Hullot-Kentor (Minneapolis: University of Minnesota Press, 2006). —EDITOR

11. The Work of Art and Fantasy

1. This excerpt is from Sarah Kofman, "Freud's Method of Reading: The Work of Art as a Text to Decipher," *The Childhood of Art: An Interpretation of Freud's Aesthetics*, trans. Winifred Woodhull (New York: Columbia University Press, 1988). Kofman's thesis was published as *Nietzsche and Metaphor* in 1972 and republished in a translation by Duncan Large (Stanford: Stanford University Press, 1993). —EDITOR

2. The German title of the essay, "Der Dichter and das Phantasieren," in fact contains no possessive adjective. —Trans.

3. See "On the Sexual Theories of Children": "A knowledge of infantile sexual theories in the shapes they assume in the thoughts of children can be of interest in various ways—even, surprisingly enough, for the elucidation of myths and fairy tales" (9:211).

4. References to Freud's writings are to volumes and pages of *The Standard Edition of the Complete Psychological Works of Sigmund Freud*, ed. and trans. James Strachey, 24 vols., London: Hogarth Press and the Institute of Psycho-Analysis, 1953. —EDITOR

5. See *Introductory Lectures*: "[Day-dreams] are the raw material of poetic production, for the creative writer uses his day-dreams, with certain remodellings, disguises, and omissions, to construct the situations which he introduces into his short stories, his novels, or his plays. The hero of the daydreams is always the subject himself, either directly or by an obvious identification with someone else" (15:99).

6. The importance of staging in the game with the wooden reel was suggested to me by Dr. Green during a seminar at the Institut de Psychanalyse. My work owes much to this seminar, which I attended for two years. Cf. André Green, "Répétition, différence, réplication," *Revue française de psychanalyse*, May 1970.

7. Note added in the third edition: See also Jean-Claude Bonne, "Le Travail d'un fantasme," *Critique* (August/September 1973), 315/316:725–753.

8. See also "The Wolf Man": "Of the wishes concerned in the formation of the dream the most powerful must have been the wish for the sexual satisfaction which he was at that time longing to obtain from his father. The strength of this wish made it possible to revive a long-forgotten trace in his memory of a scene which was able to show him what sexual satisfaction from his father was like" (17:35–36).

9. The division of an image into two figures following upon an unconscious identification could be likened to the division characteristic of paranoid psychoses. Whereas hysteria condenses, the latter divide, or rather, "paranoia resolves once more into their elements the products of the condensations and identifications which are effected in the unconscious. . . . [Schreber's] decomposition of the persecutor [the father] into Flechsig and God [is] a paranoid reaction to a previously established identification of the two figures or their belonging to the same class" ("Notes on a Case of Paranoia," 12:49–50).

 This division can also be compared to the one found in myths and in the child's family romance. According to the psychoanalytic interpretation, the two families are one except that they are separated in time. In both cases (and this justifies the date Freud assigns Leonardo's cartoon), identification comes first and division, second.

 Doesn't Freud's interpretation go against what Leonardo himself says about the role of sketches as a means of varying forms and playing with them freely?

"Painter of narrative compositions, do not paint the elements of your painting with sharp outlines, for the same will happen to you as to many painters of all kinds who want the least little stroke of charcoal to be definite; and these may very well acquire riches but not fame for their art, since the creature represented often does not have movements appropriate to the intention, but when the artist has finished a beautiful and agreeable arrangement of elements, it seems damaging to him to move them either higher or lower, or more to the back or to the front. These masters do not deserve any praise for their art.

"Have you never seen poets compose their verses? They do not become tired of writing beautiful letters and do not object to crossing out certain verses in order to write them again better. Therefore, painter, compose the limbs of your figures in general terms, and first see to it that the movements are appropriate to the state of mind of the beings who occupy your composition, and only then think of the beauty and the quality of the details.

"For you must understand that if this unfinished sketch does happen to agree with your idea, it will be all the better when it is enhanced by the perfection of all its parts. I have seen clouds and stains on walls which have stimulated me to make beautiful inventions on different subjects; and these stains, although in themselves devoid of any perfection in any part, did not lack perfection in the movements and other effects." (*The Genius of Leonardo da Vinci*, Andre Chastel ed., and Ellen Callmann, tr. [New York: Orion Press, 1961], p. 205)

In fact, Freud's interpretation does not rule out Leonardo's. Instead, it allows us to understand why, in this play of forms, one ends up being adopted rather than another, or after another.

10. Note added in 1919, p. 115. [In fact, Freud is talking about Mary's drapery in this passage. —Trans.]

11. In Pfister's letter to Freud of April 3, 1922, he refers to Rorschach's method as "truly remarkable." In his reply of April 6, 1922, Freud says that Pfister is overestimating Rorschach as an analyst.

12. It would be interesting to compare Freud's conception of the relationship between the work of art and the past with the Proustian conception. Proust is clearly aware of this relationship, as he proposes the "remembrance of things past" as the aim of his work. Remembrance is supposed to yield the very essence of things, a spiritual equivalent of eternity. But the work of art seems to him to be the transcription of a book which has already been written within, of which the writer is merely the translator. Hence the sense of constraint at the time of creation.

To translate is to make an individual experience communicable. Art has the privilege of enabling individual consciousnesses to break out of their solitude, "as if our finest ideas were like tunes which, as it were, come back to us although we have never heard them before and which we have to make an effort to hear and to transcribe" (*Remembrance of Things Past*, C. K. Scott Moncrieff and Terence Kilmartin, tr., with Andreas Mayor [London: Chatto and Windus, 1982], p. 912).

"Whether I considered reminiscences of the kind evoked by the noise of the spoon or the taste of the madeleine, or those truths written with the aid of shapes for whose meaning I searched in my brain, where—church steeples or wild grass growing in a wall—they composed a magic scrawl, complex and elaborate, their essential character was that I was not free to choose them, that such as they were they were given to me. And I realized that this must be the mark of their authenticity. . . . As for the inner book of unknown symbols (symbols carved in relief they might have been, which my attention, as it explored my consciousness, groped for and stumbled against and followed the contours of, like a diver exploring the ocean-bed), if I tried to read them no one could help me with any rules, for to read them was an act of creation in which no one can do our work for us or even collaborate with us. . . .

"This book, more laborious to decipher than any other, is also the only one which has been dictated to us by reality, the only one of which the 'impression' has been printed in us by reality itself. . . . The book whose hieroglyphs are patterns not traced by us is the only book that really belongs to us. . . . Only the impression, however trivial its material may seem to be, however faint its traces, is a criterion of truth and desires for that reason to be apprehended by the mind, for the mind, if it succeeds in extracting this truth, can by the impression and by nothing else be brought to a state of greater perfection and given a pure joy. The impression is for the writer what experiment is for the scientist, with the difference that in the scientist the work of the intelligence precedes the experiment and in the writer it comes after the impression. . . .

"I had then arrived at the conclusion that in fashioning a work of art we are by no means free, that we do not choose how we shall make it but that it pre-exists us and therefore we are obliged, since it is both necessary and hidden, to do what we should have to do if it were a law of nature, that is to say to discover it." (pp. 913–915)

"So that the essential, the only true book, though in the ordinary sense of the word it does not have to be 'invented' by a great writer—for it exists in

each one of us—has to be translated by him. The function and task of a writer are those of a translator." (p. 926)

"Through art alone we are able to emerge from ourselves, to know what another person sees of a universe which is not the same as our own." (p. 932)

"And I understood that all these materials for a work of literature were simply my past life; I understood that they had come to me, in frivolous pleasures, in indolence, in tenderness, in unhappiness, and that I had stored them up without divining the purpose for which they were destined." (p. 935)

"There is a feeling for generality which, in the future writer, itself picks out what is general and can for that reason one day enter into a work of art." (p. 937)

Proust, even more than Freud, seems to be dependent upon the traditional logic of the sign. Moreover, a voluntary transcription of the past no longer "puts it into play." The unconscious primary processes should no longer intervene. In this case, can we still be talking about a work of art?

12. Camera Lucida

1. The accompanying text is from Roland Barthes, *Camera Lucida: Reflections on Photography*, trans. Richard Howard (London: Flamingo, 1984). —EDITOR

2. Roland Barthes, *Roland Barthes by Roland Barthes*, trans. Richard Howard (New York: Hill and Wang), 1977. —EDITOR

3. The Tel Quel ("as is") group emphasized the way in which language is a construct, "as" in a metaphor, while also positing a relationship between language and being through the use of the present verb "is." —EDITOR

4. Roland Barthes, *Image Music Text*, ed. and trans. Stephen Heath (London: Fontana Press, 1977), 15–51. —EDITOR

5. Barthes, *Camera Lucida*, 117. —EDITOR

6. Ibid., 26. —EDITOR

7. Regarding this relationship between representation and unrepresentability in *Camera Lucida*, Jacques Rancière states, Barthes "tells us that the image speaks to us precisely when it is silent, when it no longer transmits any message to us." Jacques Rancière, *The Future of the Image* (London: Verso, 2007), 11. —EDITOR

13. Giotto's Joy

1. Julia Kristeva, "Giotto's Joy," *Desire in Language: A Semiotic Approach to Literature and Art*, ed. Leon S. Roudiez (Oxford: Basil Blackwell, 1987); "Holbein's Dead Christ," *Black Sun: Depression and Melancholia*, trans. Leon S. Roudiez (New York: Columbia University Press, 1989). —EDITOR

2. Julia Kristeva, *Powers of Horror: An Essay on Abjection*, trans. Leon S. Roudiez (New York: Columbia University Press, 1982). —EDITOR

3. Ruskin notes that before Giotto, "over the whole of northern Europe, the colouring of the eleventh and early twelfth centuries had been pale: in manuscripts, principally composed of pale red, green, and yellow, blue being sparingly introduced (earlier still in the eighth and ninth centuries, the letters had often been coloured with black and yellow only). Then, in the close of the twelfth and throughout the thirteenth century, the great system of perfect colour was in use; solemn and deep; composed strictly, in all its leading masses, of the colours revealed by God from Sinai as the noblest; —blue, purple, and scarlet, with gold (other hues, chiefly green, with white and black, being used in points or small masses, to relieve the main colours. In the early part of the fourteenth century the colours begin to grow paler; about 1330 the style is already completely modified; and at the close of the fourteenth century, the colour is quite pale and delicate." John Ruskin, *Giotto and his Work in Padua*, London: Levey, Robson and Franklyn, 1854, p. 21.

4. "To see a blue light, you must not look directly at it."

5. I. C. Mann, *The Development of the Human Eye* (Cambridge: Cambridge University Press, 1928), p. 68.

6. In this context, it seems that notions of "narcissism" (be it primary) and autoeroticism suggest too strongly an already existing identity for us to apply them rigorously to this conflictual and imprecise stage of subjectivity.

7. White, *Birth and Rebirth of Pictorial Space*, p. 75.

8. Ibid., p. 68.

9. G. W. F. Hegel, *Lectures on the Philosophy of Religion*, trans. E. B. Speirs (New York: Humanities Press, 1962), 3:93. Emphasis mine.

10. Ibid., emphasis mine. (This is basically my translation, although I have relied on Speirs' vocabulary and phrasing—LSR.)

11. Blaise Pascal, *Thoughts: An Apology for Christianity*. (My translation from "Le Sépulcre de Jésus-Chrust," no. 362, in Zacharie Tourneur, ed., *Pensées de M. Pascal sur la religion* (Paris: Cluny, 1938), 2:101—LSR.)

12. (The text is from Pascal, "Le Mystère de Jésus," no. 297, *Pensées*, 2:12—LSR.)

14. Spurs

1. Jacques Derrida, *Spurs: Nietzsche's Styles*, trans. Barbara Harlow (Chicago: University of Chicago Press, 1979). The excerpt does not follow Derrida's original typographical layout, which resembles a poem.

 Besides the text in this book, the key writings of Derrida include readings of texts by Plato, Descartes, Hegel, Kant, Freud, Marx, Saussure, Benjamin, Lévi-Strauss, and Heidegger. For Derrida's reading of Kant's and Heidegger's writings on aesthetics and art, see Jacques Derrida, *The Truth in Painting*, trans. Geoff Bennington and Ian McLeod (Chicago: University of Chicago Press, 1987). Derrida's reading of Kant revolves around a passage of writing on "parerga" in the *Critique of Judgment* (see chapter 1). Parerga (from the Greek meaning "incidental" or "by-work") are those things attached to the work of art but not intrinsic to its form or meaning. Derrida questions Kant's attempt to specify the place or location of the work of art as belonging inside an enclosing frame. In contrast, Derrida argues that the work of art is inextricably bound up with its frame (where the notion of "frame" refers to the idea of a picture frame as well as an architectural and discursive frame). In the section on Heidegger, Derrida discusses and, in the process, deconstructs the philosopher's claim that the shoes depicted in van Gogh's painting cited in "The Origin of the Work of Art" (see chapter 7) belong to a peasant woman; as part of this deconstruction, he addresses the art historian Meyer Schapiro's counterclaim that the shoes in the painting belong to a city dweller. —EDITOR

2. The relationship between vision and blindness was developed by Derrida in an exhibition of drawings that he curated at the Louvre in 1990. In the text to the catalogue Derrida discusses the organ of the eye as a wound that, in its fluidity and weeping, oozes ambiguity. Jacques Derrida, *Memoirs of the Blind: The Self-Portrait and Other Ruins*, trans Pascale-Anne Brault and Michael Naas (Chicago: University of Chicago Press, 1993). —EDITOR

3. "The title for this lecture was to have been *the question of style*. However—it is woman who will be my subject. Still, one might wonder whether that doesn't amount to the same thing." Derrida, *Spurs*, 35, 37. —EDITOR

4. See chapter 7. —EDITOR

5. Derrida has in mind here a particular passage of writing: Friedrich Nietzsche, *The Gay Science, With A Prelude in Rhymes and an Appendix of Songs*, trans. Walter Kaufmann (New York: Vintage Books, 1974), "Woman and their action at a distance," book 2, section 60, 123–124. —EDITOR

6. At the moment that the sexual difference is determined as an opposition, the image of each term is inverted into the other. Thus the machinery of contradiction is a *propositio* whose two x are at once subject and predicate and whose copula is a mirror. If Nietzsche, then, is following tradition when he inscribes the man in the system of activity (and if all the values which this implies are taken into account) and the woman in the system of passivity, he in fact arrives at either an inversion of the meaning of the couple, or else an explanation of the meaning of the couple. Whereas, in *Human, All Too Human* (411), woman is endowed with understanding and mastery, the man, whose intelligence is "in itself something passive" (*etwas Passives*), is gifted with sensitivity and passion. Because passion's jealous desire is narcissistic, passivity loves itself there as "ideal." Its partner, who is thus transfixed, comes in turn to love its own activity and, by an active renunciation, refuses both to produce its model and to seize the other in it. The active/passive opposition speculates reflectively its own homosexual effacement into infinity, where it is assumed in the structure of idealization or the desiring machine. "Women are often silently surprised at the great respect men pay to their character. When, therefore, in the choice of a pattern, men seek specially for a being of deep and strong character, and women for a being of intelligence, brilliancy, and presence of mind, it is plain that at the bottom men seek for the ideal man, and women for the ideal woman—consequently not for the complement (*Ergänzung*) but for the completion (*Vollendung*) of their own excellence."

15. Hysteria

1. The accompanying text is from Gilles Deleuze, "Hysteria," in *Francis Bacon: The Logic of Sensation*, trans. Daniel W. Smith (New York: Continuum, 2003).

 See Gilles Deleuze, *Nietzsche and Philosophy*, trans. Hugh Tomlinson (London: Athlone Press, 1983), 8–10. For further discussion of the ideas and context of Deleuze's philosophy, see the introduction. —EDITOR

2. See especially Gilles Deleuze and Félix Guattari, *Anti-Oedipus: Capitalism and Schizophrenia* (London: Athlone Press, 1984). —EDITOR

3. "The essential relation of one force to another is never conceived of as a negative element in the essence." Deleuze, *Nietzsche and Philosophy*, 8. —EDITOR

4. See Antonin Artaud, "To Have Done with the Judgment of God," in *Antonin Artaud: Selected Writings*, ed. Susan Sontag (Berkeley: University of California Press, 1976), 571. —EDITOR

5. Antonin Artaud, "The Body is the Body," trans. Roger McKeon, *Semiotext(e)*, vol. 2, no. 3 (1977), pp. 38–9.

6. Wilhelm Worringer, *Form in Gothic* (New York: G. P. Putnam, 1927), pp. 32–151.

7. William S. Burroughs, *Naked Lunch* (New York: Grove Press, 1959), p. 9.

8. Burroughs, *Naked Lunch*, p. 131.

9. One might consult any nineteenth-century manual on hysteria, but see especially the study by Paul Bonier, *Les Phénomènes d'autoscopie* (Paris: Alcan, 1903), who created the term "vigilambulator."

10. Antonin Artaud, " 'The Nerve Meter," in *Antonin Artaud: Selected Writings,* ed. Susan Sontag, trans. Helen Weaver (New York: Farrar, Straus & Giroux, 1976), p. 86.

11. Ludovic Janvier, in his *Beckett par lui-même* (Paris: Seuil, 1979), had the idea of making a lexicon of Beckett's principal notions. These are operative concepts. The articles entitled "Corps," "Espace-temps," "Immobilité," "Témoin," "Tête," and "Voix" ["Body," "Space-Time," "Immobility," "Witness," "Head," and "Voice"] should be noted in particular. Each of these articles has parallels with Bacon. And it is true that Bacon and Beckett are too close to know this themselves. But one should refer to Beckett's text on the painter Bram van Velde, "La Peinture des van Valde, ou le monde et le pantalon" (1948), in *Disjecta: Miscellaneous Writings and a Dramatic Fragment,* ed. Ruby Cohn (New York: Grove Press, 1984), pp. 118–32. Many things in it could apply to Bacon—notably the absence of figurative and narrative relations as a limit of painting.

12. Michel Leiris has devoted a superb text to this action of "presence" in Bacon. See *Ce que m'ont dit les peintures de Francis Bacon* (Paris: Maeght, 1966).

13. *Interviews*, p. 48.

14. Sartrean themes such as excessive distance (the root of the tree in *Nausea)* or of the flight of the body or the world (as if down the toilet drain in *Being and Nothingness)* have their place in a hysterical painting.

15. *Interviews*, pp. 28–9.

16. Velásquez, Diego, *Pope Innocent X*, 1650. Oil on canvas, 152.5 x 116.5 cm. Galleria Doria-Pamphili, Rome.

17. *Interviews*, p. 37.

18. Marcel Proust, *In Search of Lost Time*, vol. 3, *The Guermantes Way*, trans. C. K. Scott Moncrieff and Terence Kilmartin; rev. D. J. Enright (New York: Modern Library, 1993), p. 55; Marcel Proust, *A la recherche du temps perdu. Le Côté de Guermantes*, Part 1 (Paris: Pléiade, 1954), vol. 2, p. 48.

19. Marcel Moré, *Le Dieu Mozart et le monde des oiseaux* (Paris: Gallimard, 1971), p. 47.

16. What Is Postmodernism?

1. Jean François Lyotard, "Answering the Question: What Is Postmodernism?" *The Postmodern Condition: A Report on Knowledge*, trans. Régis Durand (Manchester: Manchester University Press, 1986). The essay was originally published in *Critique* 419 (April 1982). —Editor

2. Ibid., 3. —Editor

3. Ibid., 9. —Editor

4. It may be noted that in his essay "Newman: The Instant," Lyotard adopts a different, more critical stance toward Duchamp's work, suggesting that it is burdened by a sense of alienation and loss under which lies a nostalgia for presence. Instead, it is the lightning flash of Barnett Newman's so-called zip paintings that exemplifies the postmodern condition, bearing witness to the unpresentable; see Jean-François Lyotard, *The Inhuman: Reflections on Time* (Cambridge: Polity Press, 1988), 78–88. —Editor

17. Privation Is Like a Face

1. "Privation Is Like a Face" is taken from *The Man Without Content*, trans. Georgia Albert (Stanford: Stanford University Press, 1999).

Giorgio Agamben, *The Coming Community* (Minneapolis: University of Minnesota Press, 2007), 5–7. For a further discussion of these ideas, see Slavoj Žižek, *The Parallax View* (Cambridge, Mass.: MIT Press, 2006), 265. —Editor

2. Greek terms in the original have been transliterated for the convenience of the reader. —Editor

3. Plato, *Symposium*, trans. Michael Joyce, in Plato, *The Collected Dialogues*, ed. Edith Hamilton and Huntington Cairns (Princeton, N.J.: Princeton University Press, 1961), 205b, p. 557.

4. We write "pro-duction" and "pro-duct" to indicate the essential character of poesis, that is, the pro-duction into presence; we write "production" and "product" to refer in particular to the doing of technology and industry.

5. See Aristotle, *Physics* 192 b. For an enlightening interpretation of the second book of this work, see Martin Heidegger, "Vom Wesen und Begriff der [Physis]: Aristoteles' Physik B, I" (1939), now in *Wegmarken* (Frankfurt a.M.: Vittorio Klostermann, 1976), pp. 239–301.

6. Friedrich Hölderlin, "Remarks on 'Oedipus,'" in *Essays and Letters on Theory*, trans. and ed. Thomas Pfau (Albany: State University of New York Press, 1988), p. 101.

7. Aristotle, *Physics*, trans. R. P. Hardie and R. K. Gaye, in *The Basic Works of Aristotle*, ed. Richard McKeon (New York: Random House, 1941), 193a, pp. 237–38.

18. The Vestige of Art

1. [Jean-Luc Nancy, "The Vestige of Art," *The Muses*, trans. Peggy Kamuf (Stanford: Stanford University Press, 1996).] Jean-Louis Déotte, *Le Musée, origine de l'esthétique* (Paris: L'Harmattan, 1993).

2. Quoted in ibid., p. 17.

3. Theodor W. Adorno, *Negative Dialectics*, trans. E. B. Ashton (New York: The Seabury Press, 1973), p. 367.

4. Michel Leiris, *Journal 1922–1989* (Paris: Gallimard, 1992), p. 154.

5. Immanuel Kant, *Critique of Judgment*, §47.

6. Ernest Renan, *Dialogues et fragments philosophiques* (n.p., n.d.), Second Dialogue, "Probabilités," p. 83. M. Duchamp, quoted in Nella Arambasin, *La Conception du sacré dans la critique d'art en Europe entre 1880 et 1914*, Ph.D. diss., University of Paris-Sorbonne, 1992, 1: 204. This thesis contains a mine of valuable information concerning the consideration of the "end of art" and its effects within art and within the discourse on art during the period studied.

7. Jan Patocka has introduced reflections in this direction; see *L'Art et le temps*, French trans. E. Abrams (Paris: POL, 1990).

8. In French: "tout l'art tel qu'en lui-même enfin," which echoes the first line of Mallarmé's "Tombeau pour Edgar Poe." —Trans.

9. For details about this translation, see chapter 1, note 1. —Editor

10. Joseph Conrad, Preface to *The Nigger of the "Narcissus"* (Oxford: Oxford University Press, 1984), p. xxxix.

11. Norman Mailer, *Pieces and Pontifications* (Boston: Little, Brown, 1982), p. 46.

12. Jean Dubuffet, *Prospectus et tous écrits suivants*, vol. I (Paris: Gallimard, 1967), p. 79.

13. M Merleau-Ponty, *Eye and Mind*, trans. Carleton Dallery, in *The Essential Writings of Merleau-Ponty*, ed. Alden L. Fisher (New York: Harcourt, Brace & World, 1969), p. 284.

14. Plotinus, *Enneads*, 2.6.

15.　Friedrich Nietzsche, *Werke in drei Bänden*, ed. Karl Schlechta, vol. 3 (Munich: Carl Hanser Verlag, 1958), p. 617.

16.　Adorno, *Negative Dialectics*, p. 402.

17.　Thomas Aquinas, *Summa Theologiae*, 1a, q. 45, art. 7. On the image and vestige, in Thomas Aquinas and elsewhere, one should consult the analyses of Georges Didi-Huberman in his *Fra Angelico*: *Dissemblance et figuration* (Paris: Flammarion, 1990). I diverge from him by proposing a nondialectical interpretation of the *vestigium*; however, in the context of theology, Didi-Huberman's dialectical interpretation is absolutely correct.

18.　One can further compare it, among other examples, with Rembrandt's *The Anatomy Lesson of Doctor Joan Deyman*.

19.　With the association of *plante* (*du pied*) and of *plat*, the text signals toward some idiomatic expressions in French: for example, *mettre les pieds dans le plat* (to put one's foot down, but also to put one's foot in it) or a *pieds-plats* (an awkward individual, a lout). —Trans.

20.　To evoke the *pas* is to salute Blanchot and Derrida.

21.　On the question of the figure, see Philippe Lacoue-Labarthe and Jean-Luc Nancy, "Scène," in *Nouvelle Revue de Psychanalyse*, Fall 1992.

22.　Dante, *Inferno*, VIII, 27, and XII, 29.

23.　This time the salute goes to Thierry de Duve ("Do anything whatsoever . . ."), *Au nom de l'art* (Paris: Editions de Minuit, 1981).

24.　The common French term *gens* has no simple equivalent in English. When used in a general or indefinite sense, it is ordinarily translated as "people." —Trans.

19. Art and Philosophy

1.　Alain Badiou, "Art and Philosophy," *Handbook of Inaesthetics*, trans. Alberto Toscano (Stanford: Stanford University Press, 2005).

　　Alain Badiou, "Truth: Forcing and the Unnameable," in *Theoretical Writings*, ed. and trans. by Ray Brassier and Alberto Toscano (New York: Continuum 2004), 122. —Editor

2.　"On Subtraction," ibid., 103. —Editor

3.　Lauren Sedofsky, "Being by Numbers, Lauren Sedofsky Talks with Alain Badiou," *Artforum* (October 1994): 87. —Editor

4.　Alain Badiou, "Drawing," *lacanian ink* 28 (2006): 49. —Editor

5.　Badiou, *Theoretical Writings*, 127. Regarding the issue of the politics of place and the work of art, Badiou has written further, "We have to create a new trend of politics, beyond the domination of the places, beyond social,

national, racial places, beyond gender and religions. A purely displaced politics, with absolute equality as its fundamental concept. This sort of politics will be an action without place. An international and nomadic creation with—as in a work of art—a mixture of violence, abstraction and final peace." "Drawing," 49. —Editor

20. The Janus-Face of Politicized Art

1. Jacques Rancière, "The Janus-Face of Politicized Art: Jacques Rancière in Interview with Gabriel Rockhill," *The Politics of Aesthetics*, trans. Gabriel Rockhill (London and New York: Continuum, 2005). The interview was originally conducted in French on October 18, 2003. —Editor

2. *The Names of History: On the Poetics of Knowledge*. Hassan Melehy, trans. Minneapolis and London: University of Minnesota Press, 1994, p. 52 (*Les Mots de l'histoire*. Paris, Éditions du Seuil, 1992, p. 109). Translation slightly modified. —Trans.

3. *La Parole muette: Essai sur les contradictions de la literature* (Paris: Hachette Pluriel, 2005). —Editor

4. *The Flesh of Words: The Politics of Writing*, trans. Charlotte Mandell (Stanford: Stanford University Press, 2004. —Editor

5. Rimbaud's '*Alchimie du verbe*' contains an implicit reference to Lemaître de Sacy's translation of the Gospel according to St. John: 'Au commencement était le Verbe'. The King James version and other major English translations prefer to render *logos* as 'Word' ('In the beginning was the Word'), thereby leading to the English translation of Rimbaud's poem as 'The Alchemy of the Word'. For this reason, the term 'word' has been used here as a translation of 'verbe'. —Trans.

Bibliography

Adorno, Theodor. *Aesthetic Theory*. Edited by Robert Hullot-Kentor. Minneapolis: University of Minnesota Press, 2006.

——. *Minima Moralia: Reflections on a Damaged Life*. Translated by E. F. N. Jephcott. New York: Verso, 2005.

Adorno, Theodor, Walter Benjamin, Ernst Bloch, Bertolt Brecht, and Georg Lukács. *Aesthetics and Politics: The Key Texts of the Classic Debate Within German Marxism*. New York: Verso, 2007.

Adorno, Theodor, and Max Horkheimer. *Dialectic of Enlightenment*. Translated by John Cumming. New York: Verso, 1997.

Agamben, Giorgio. *The Coming Community*. Translated by Michael Hardt. Minneapolis: University of Minnesota Press, 2007.

——. *The Man Without Content*. Translated by Georgia Albert. Stanford: Stanford University Press, 1999.

——. *The Time That Remains*. Translated by Pat Dailey. Stanford: Stanford University Press, 2005.

Althusser, Louis. *Essays on Ideology*. New York: Verso, 1984.

——. *For Marx*. Translated by Ben Brewster. London: Verso, 1986.

Aristotle. *Poetics*. Translated by Malcolm Heath. New York: Penguin Books, 1996.

Artaud, Antonin. *Antonin Artaud: Selected Writings*. Edited by Susan Sontag. Berkeley: University of California Press, 1976.

Augustine, Saint. *The Confessions of St. Augustine*. Edited by Rex Warner. New York: Penguin Books, 2001.

Badiou, Alain. *Being and Event*. Translated by Oliver Feltham. New York: Continuum, 2005.

——. *The Century*. Translated by Alberto Toscano. Cambridge: Polity Press, 2008.

——. "Drawing." *lacanian ink* 28 (2006): 44.

——. *Handbook of Inaesthetics*. Translated by Alberto Toscano. Stanford: Stanford University Press, 2005.

——. *Logics of Worlds: Being and Event II*. Translated by Alberto Toscano. New York: Continuum, 2009.

——. *St. Paul: The Foundation of Universalism*. Translated by Ray Brassier. Stanford: Stanford University Press, 2003.

——. *Theoretical Writings*. Edited and translated by Ray Brassier and Alberto Toscano. New York: Continuum, 2004.

Balzac, Honoré de. *The Village Rector*. Charleston, S.C.: Biblio Bazaar, 2006.

Barasch, Moshe. *Theories of Art*. 3 vols. New York: Routledge, 2000.

Barthes, Roland. *Camera Lucida: Reflections on Photography*. Translated by Richard Howard. London: Vintage, 1993.

——. *Image Music Text*. Edited and translated by Stephen Heath. London: Fontana Press, 1977.

——. *A Lover's Discourse: Fragments*. Translated by Richard Howard. New York: Penguin Books, 1990.

——. *Mythologies*. Edited and translated by Annette Lavers. London: Vintage, 2000.

——. *The Pleasure of the Text*. Translated by Richard Miller. Oxford: Basil Blackwell, 1990.

——. *Roland Barthes by Roland Barthes*. Translated by Richard Howard. New York: Hill and Wang, 1977.

——. *S/Z*. Translated by Richard Miller. Oxford: Basil Blackwell, 1990.

Bataille, Georges. *Manet*. Translated by Austryn Wainhouse and James Emmons. New York: Rizzoli, 1983.

——. *My Mother, Madame Edwarda, The Dead Man*. Translated by Austryn Wainhouse. London: Marion Boyars, 1989.

——. *On Nietzsche*. Translated by Bruce Boone. London: Athlone Press, 1992.

——. *Story of the Eye*. Translated by Joachim Neugroschel. New York: Penguin Books, 1987.

——. *The Tears of Eros*. Translated by Peter Connor. San Francisco: City Lights Books, 1989.

——. *Visions of Excess: Selected Writings, 1927–1939*. Edited and translated by Allan Stoekl. Minneapolis: University of Minnesota Press, 1991.

Baudrillard, Jean. *The Conspiracy of Art: Manifestos, Interviews, Essays*. Edited by Sylvère Lotringer. New York: Semiotext(e), 2005.

Benjamin, Walter. *Illuminations*. London: Fontana/Collins, 1982.

——. *One-Way Street and Other Writings*. Translated by Edmund Jephcott and Kingsley Shorter. London: Verso, 1992.

Bernstein, Jay, ed. *Classic and Romantic German Aesthetics*. Cambridge: Cambridge University Press, 2003.

Blanchot, Maurice. *The Gaze of Orpheus and Other Literary Essays*. Edited by P. Adams Sitney. New York: Station Hill Press, 1981.

Bowie, Andrew. *Aesthetics and Subjectivity, From Kant to Nietzsche*. Manchester: Manchester University Press, 2003.

Burke, Edmund. *A Philosophical Enquiry Into the Origin of Our Ideas of the Sublime and Beautiful*. Edited by James T. Boulton. London: Routledge & Kegan Paul, 1958.

Caygill, Howard. *Walter Benjamin: The Colour of Experience*. London: Routledge, 1998.

Cooper, David, ed. *A Companion to Aesthetics*. Oxford: Blackwell, 2003.

Debord, Guy. *Society of the Spectacle*. London: Rebel Press Aim Publications, 1987.

Deleuze, Gilles. *Francis Bacon: The Logic of Sensation*. Translated by Daniel W. Smith. New York: Continuum, 2003.

——. *Kant's Critical Philosophy: The Doctrine of the Faculties*. Translated by Hugh Tomlinson and Barbara Habberjam. Minneapolis: University of Minnesota Press, 1984.

——. *The Logic of Sense*. Edited by Constantin V. Boundas. New York: Columbia University Press, 1990.

——. *Nietzsche and Philosophy*. Translated by Hugh Tomlinson. London: Athlone Press, 1983.

Deleuze, Gilles, and Félix Guattari. *Anti-Oedipus: Capitalism and Schizophrenia*. Translated by Robert Hurley, Mark Seem, and Helen R. Lane. London: Athlone Press, 1984.

——. *A Thousand Plateaus: Capitalism and Schizophrenia*. Translated by Brian Massumi. London: Athlone Press, 1988.

Derrida, Jacques. *Memoirs of the Blind: The Self-Portrait and Other Ruins*. Translated by Pascale-Anne Brault and Michael Naas. Chicago: University of Chicago Press, 1993.

——. *Of Grammatology*. Translated by Gayatri Chakravorty Spivak. Baltimore: Johns Hopkins University Press, 1976.

——. *Spurs: Nietzsche's Styles*. Translated by Barbara Harlow. Chicago: University of Chicago Press, 1979.

——. *The Truth in Painting*. Translated by Geoff Bennington and Ian McLeod. Chicago: University of Chicago Press, 1987.

Eagleton, Terry. *The Ideology of the Aesthetic*. Oxford: Blackwell, 1990.

Eco, Umberto, ed. *On Beauty: A History of a Western Idea*. London: Secker and Warburg, 2004.

Emerling, Jae. *Theory for Art History*. London: Routledge, 2005.

Flaubert, Gustave. *Madame Bovary*. Edited by Paul de Man. New York: Norton, 1965.

Foucault, Michel. *The Order of Things: An Archeology of the Human Sciences*. London: Tavistock, 1986.

——. *This Is Not a Pipe*. Edited by James Harkness. Berkeley: University of California Press, 1983.

Freud, Sigmund. *The Standard Edition of the Complete Psychological Works of Sigmund Freud*. Edited by James Strachey. London: Hogarth Press and the Institute of Psychoanalysis, 1981.

Gaut, Berys, and Dominic McIver Lopes. *The Routledge Companion to Aesthetics*. London: Routledge, 2002.

Halliwell, Stephen. *The Aesthetics of Mimesis: Ancient Texts and Modern Problems*. Princeton: Princeton University Press, 2002.

Harrison, Charles, and Paul Wood, eds. *Art in Theory, 1900–1990: An Anthology of Changing Ideas*. Oxford: Blackwell, 1992.

Harrison, Charles, Paul Wood, and Jason Gaiger, eds. *Art in Theory, 1648–1815: An Anthology of Changing Ideas*. Oxford: Blackwell, 2000.

Hegel, Georg Wilhelm Friedrich. *The Encyclopaedia Logic*. Translated by T. F. Geraets, W. A. Suchting, and H. S. Harris. Indianapolis: Hackett, 1991.

——. *Hegel's Aesthetics: Lectures on Fine Art*. Translated by T. M. Knox. 2 vols. Oxford: Clarendon Press, 1988.

——. *Hegel's Philosophy of Mind*. Translated by W. Wallace and A. V. Miller. Oxford: Clarendon Press, 1971.

——. *Hegel's Philosophy of Nature*. Translated by A. V. Miller. Oxford: Clarendon Press, 1970.

——. *Hegel's Philosophy of Right*. Translated by T. M. Knox. Oxford: Clarendon Press, 1967.

——. *Hegel's Science of Logic*. Translated by A. V. Miller. Atlantic Highlands, N.J.: Humanities Press International, 1989.

——. *Introductory Lectures on Aesthetics*. Translated by Bernard Bosanquet. London: Penguin Books, 2004.

——. *Phenomenology of Spirit*. Translated by A. V. Miller. Oxford: Oxford University Press, 1977.

Heidegger, Martin. *Basic Writings*. Edited by David Farrell Krell. New York: Routledge, 2004.

——. *Being and Time*. Translated by John Macquarrie and Edward Robinson. Oxford: Blackwell, 2006.

——. *Nietzsche*. Translated by David Farrell Krell. San Francisco: HarperCollins, 1991.

Institute of Contemporary Arts. *Postmodernism*. London: ICA, 1986.

Jameson, Fredric. *Postmodernism: or, the Cultural Logic of Late Capitalism*. New York: Verso, 1991.

Joyce, James. *Ulysses: The 1922 Text*. Edited by Jeri Johnson. Oxford: Oxford University Press, 1993.

Kant, Immanuel. *Critique of Judgment*. Translated by Werner S. Pluhar. Indianapolis: Hackett, 1987.

——. *Critique of Practical Reason*. Translated by Werner S. Pluhar. Indianapolis: Hackett, 2002.

——. *Critique of Pure Reason*. Translated by Norman Kemp Smith. London: Macmillan, 1990.

——. *Observations on the Feeling of the Beautiful and Sublime*. Translated by John T. Goldthwait. Berkeley: University of California Press, 1991.

Kearney, Richard, and David Rasmussen. *Continental Aesthetics, Romanticism to Postmodernism: An Anthology*. Oxford: Basil Blackwell, 2001.

Kofman, Sarah. *The Childhood of Art: An Interpretation of Freud's Aesthetics*. Translated by Winifred Woodhull. New York: Columbia University Press, 1988.

——. *Nietzsche and Metaphor*. Translated by Duncan Large. Stanford: Stanford University Press, 1993.

Kristeva, Julia. *Black Sun: Depression and Melancholia*. Translated by Leon S. Roudiez. New York: Columbia University Press, 1989.

——. *Desire in Language: A Semiotic Approach to Literature and Art*. Edited by Leon S. Roudiez. Oxford: Basil Blackwell, 1987.

——. *Powers of Horror: An Essay on Abjection*. Translated by Leon S. Roudiez. New York: Columbia University Press, 1982.

Kul-Want, Christopher. *Introducing Aesthetics*. Cambridge: Icon, 2007.

——. *Introducing Kant*. Cambridge: Icon, 1996.

Lacan, Jacques. *Écrits: A Selection*. Translated by Alan Sheridan. New York: Routledge, 2006.

——. *The Four Fundamental Concepts of Psychoanalysis*. Edited by Jacques-Alain Miller. London: Penguin Books, 1991.

Lyotard, Jean-François. *The Inhuman: Reflections on Time*. Translated by Geoff Bennington and Rachel Bowlby. Cambridge: Polity Press, 1993.

—— *Libidinal Economy*. Translated by Iain Hamilton Grant. London: Athlone Press, 1993.

——. *The Postmodern Condition: A Report on Knowledge*. Translated by Régis Durand. Manchester: Manchester University Press, 1986.

Marx, Karl. *Capital: A Critique of Political Economy*. Translated by Ben Fowlkes. New York: Penguin Books, 1990.

——. *Grundrisse*. Translated by Martin Nicolaus. New York: Penguin Books, 2005.

Nancy, Jean-Luc. *The Muses*. Translated by Peggy Kamuf. Stanford: Stanford University Press, 1996.

Nietzsche, Friedrich. *The Birth of Tragedy and The Case of Wagner*. Translated by Walter Kaufmann. New York: Vintage Books, 1967.

——. *The Birth of Tragedy and The Genealogy of Morals*. Translated by Francis Golffing. New York: Doubleday, 1956.

——. *The Gay Science, With a Prelude in Rhymes and an Appendix of Songs*. Translated by Walter Kaufmann. New York: Vintage Books, 1974.

——. *The Portable Nietzsche*. Edited by Walter Kaufmann. New York: Penguin Books, 1976.

——. *The Will to Power*. Edited by Walter Kaufmann. New York: Vintage Books, 1968.

Onfray, Michel. "The Body of the Dead Christ in the Tomb." *Tate Etc* 8 (Autumn 2006): 62–63.

Pavese, Cesare. *Dialogues with Leuco*. Translated by W. Arrowsmith and D. S. Carne-Ross. London: Peter Owen, 1965.

Plato. *The Portable Plato*. Edited by Scott Buchanan. New York: Penguin Books, 1977.

——. *The Sophist*. Indianapolis: Hackett, 1993.

Proust, Marcel. *In Search of Lost Time*. Translated by C. K. Scott-Moncrieff, Terence Kilmartin, and Andreas Mayor. London: Chatto and Windus, 1992.

Rancière, Jacques. *Aesthetics and Its Discontents*. Cambridge: Polity Press, 2009.

——. *The Aesthetic Unconscious*. Cambridge: Polity Press, 2009.

——. *The Future of the Image*. Translated by Gregory Elliott. London: Verso, 2007.

——. *The Philosopher and His Poor*. Translated by John Drury, Corinne Oster, and Andrew Parker. Durham, N.C.: Duke University Press, 2003.

——. *The Politics of Aesthetics: The Distribution of the Sensible*. Translated by Gabriel Rockhill. London and New York: Continuum, 2005.

——. *The Politics of Literature*. Cambridge: Polity Press, 2009.

Sartre, Jean-Paul. *Being and Nothingness: An Essay on Phenomenological Ontology*. Translated by Hazel E. Barnes. London: Routledge, 2001.

Saussure, Ferdinand de. *Course in General Linguistics*. Translated by Roy Harris. London: Duckworth, 1983.

Schopenhauer, Arthur. *The World as Will and Representation*. Translated by E. F. J. Payne. New York: Dover, 1969.

Sedofsky, Lauren. "Being by Numbers: Lauren Sedofsky Talks with Alain Badiou." *Artforum* 33, no. 2 (October 1994): 84–87.

Taubes, Jacob. *The Political Theology of Paul*. Edited by Aleida Assmann and Jan Assmann. Stanford: Stanford University Press, 2004.

Thomas Aquinas. *The Pocket Aquinas*. Edited by V. Bourke. New York: Washington Square Press, 1996.

Woolf, Virginia. *To the Lighthouse*. London: Vintage, 2004.

——. *The Waves*. London: Penguin Books, 1992.

Žižek, Slavoj. *The Parallax View*. Cambridge, Mass.: MIT Press, 2006.

Index

Abbot, Bernice, 111

Abstract attributes, 55

Accessory beauty, 31

Adlinguisticity, 239

Adorno, Theodor: *Aesthetic Theory* by, 8–9, 178–79; art and, 9, 178–79, 250; Auschwitz and, 264; Benjamin and, 9, 102; dialectics and, 8–10, 178; Frankfurt School founded by, 178; Hegel influencing, 9; Marxism and, 178; postmodernism and, 240; *see also* "Society"

Aesthetic(s): art and beginning of, 4–5, 250, 303n4; domain, 273; equality and, 296; judgment, 22, 25–26; Kant and, 4–6, 24, 303n4; modern, 248; paradigmatic shift and, 1–2; pleasure and, 80–81; politics and, 102–3; "properly," 263–65; range of, 43–49; realism, 180; regime, 17, 293–97; state, 66, 71; swamp of, 258; woman's, 72; *see also* *Introductory Lectures on Aesthetics*

Aesthetic Theory (Adorno), 8–9, 178–79; *see also* "Society"

Agamben, Giorgio: alienation and, 250–51, 258; citizens' rights and, 250; *The Coming Community* by, 251; *The Man Without Content* by, 250; *see also* "Privation Is Like a Face"

Agent, 274–76

Agreeable, 27–28

Albums, 109, 202

The Alexandria Quartet (Durrell), 263

Alienation, 9, 178, 182, 250–51, 258

Allegory, 131

Allusion, 247–48

Alterity, 1–2, 303n3

Althusser, Louis, 293

Altruism, 71